FIGURE AND ABSTRACTION
IN CONTEMPORARY PAINTING

FIGURE AND ABSTRACTION IN CONTEMPORARY PAINTING

RONALD PAULSON

RUTGERS UNIVERSITY PRESS

NEW BRUNSWICK AND LONDON

Library of Congress Cataloging-in-Publication Data
Paulson, Ronald
 Figure and abstraction in contemporary painting / Ronald Paulson.
 p. cm.
 Includes bibliographical references.
 ISBN 0-8135-1604-8
 1. Figurative art. 2. Human figure in art. 3. Art, Abstract. 4. Art, Modern–20th century.
I. Title.
N6494.F5P38 1990
759.06′09′045—dc20 90-31079
 CIP

British Cataloging-in-Publication information available

CONTENTS

PREFACE

This book began as a series of occasional pieces on art written between 1977 and 1984. The original pieces—reviews of exhibitions and books—are extensively revised, but I have followed (while elaborating) the unplanned thread that connected them at the time. They seem to have shared one issue: the persistence of figuration in an age dominated by abstraction—dominated in theory at least, for in art, as in literature, it has been an age of theory.

A visitor to an exhibition of neofigurative painting in those years noticed how the paintings hardly conceal their desperation to recover the human figure without losing touch with the traditions of nonrepresentational painting in its many forms, from Abstract Expressionism to Op and Minimal art. One heard many formulas about figurative painters, for example: All artists divide into those who use figuration to continue painting abstraction and those who paint abstraction in order to continue their obsession with figuration. Or: All artists find their own balance between figural abstraction and abstract figuration. Willem de Kooning, for example, was an "Abstract Expressionist" who repeatedly returned to the human form, though primarily the female, and to landscape. Many if not all figure painters still paint in the shadow of the Abstract Expressionists, who forced them to accept the ideas that the picture plane and the canvas surface must be one and that the artist's gesturing hand, manipulating the paint on the canvas surface, is the measure of all things. The banner held aloft by the neofigurative painters, therefore, is anti–de Kooning and Company while in mysterious ways perpetuating the forms and gestures of the earlier "abstractionists."

Making not too arbitrary a division, it is possible to consider the figurative painters as either picture-plane artists or adherents of the old perspective-box world we have known in Western painting since the Renaissance. The two continuing art movements of this century, corresponding roughly to the two modes I

have mentioned, are Cubism and Surrealism. It is no secret that at least some of the painters of the New York School began as Surrealists while continuing to see space and form through Cubist eyes—that is, as flat and largely depthless. And Surrealism itself, basically a figural mode, was of at least two different sorts: one devoted to a surface that imitated the conventions of old master (or popular) art, the other interested in a surface that imitated the immediate and unconscious movements of the artist's mind as reflected in a kind of automatic writing, as in Max Ernst's frottages and grattages and in André Masson's glue drippings onto which sand was scattered to form chance figures.

I was writing a book called *Representations of Revolution (1789–1820)* during those years, and in one way or another these occasional pieces also had to do with revolution, the responses of different countries to "revolution," and in particular the 1930s response of a Surrealism that claimed to be revolutionary. In addition, the present book reflects lectures, symposia, discussions, and random thoughts on the French Revolutionary bicentennial, 1989.

A more precise title might have been *Fictions of Figure and Abstraction*, by which I mean, first, fictions utilized by the artists in order to paint one way or the other, and second, fictions imposed upon the artist by theorists, art historians, and other artists, for example the fiction of an abstract or a nonrepresentational painting as somehow an advance on or complete break from the figural or representational. The first group are enabling fictions, like de Kooning's woman or Marsden Hartley's mountain or Richard Diebenkorn's (or Henri Matisse's) studio. These fictions—they are really subjects chosen from among many possible ones—mediate between abstraction and figuration. In these cases, they allow an artist who wants to abstract the figurative ways with which to do it. There are also fictions that do the opposite, for example Jackson Pollock's of the artist as an actor, or de Kooning's of the painting as an event. But these are all within the artist's control.

The second type are fictions imposed upon artists—although often they take up the particular fiction gladly—of the artist as revolutionary, for example, or of the artist's work as a breakthrough. These are little more than metaphors, assumed and reified in an unconsidered way by artists and writers on art. A major one is the metaphor of "progress," or the notion that art has a "story" or "genealogy." An offshoot that carries considerable weight for 20th-century art is the metaphor of "revolution"—inherited from the French Revolution and the various political revolutions of 1848 to 1917, supported by the Hegelian metaphor of dialectical progress, and lived by artists like Pablo Picasso.

The application of the term "revolutionary" to art produced a kind of artist narrative corresponding to the phases of the French Revolution, from the Fall of the Bastille to the Terror to Thermidor and Brumaire to Empire, and based on fictions of Jacobinism, "breakthrough," and counterrevolution. (This artist narrative was a departure from the traditional career, still advocated by John Graham in the 1940s, of apprenticeship to the old masters, trying out various ways for

oneself, and the mature resolution to follow one of these ways.) For example, the Abstract Expressionist "revolution" (which paralleled, or took the place of, a political revolution) replaced both the perspective box and the Cubist space with completely open, total field painting. But it was in fact—as one comes to expect from the revolutionary narrative—based on figuration of various kinds, and was consolidated and domesticated by the next generation of artists.

The next generation, or a part of it—Robert Rauschenberg, Andy Warhol, and Jasper Johns—were in many ways *counter*revolutionaries in that they returned to the most basic representational (if not always precisely figural) subject matter, once again by way of Surrealism and the Surrealist principle of the umbrella meeting the sewing machine on the dissecting table. On the other hand, William Bailey (the artist of flat tabletops and carefully placed utensils) has called it a basically revolutionary act to break with the doctrine of the unity of picture plane/canvas, and has argued the need to maintain the integrity of the objects themselves, as shapes and as they appear in space. Revolution, it emerges, may be to abstraction as counterrevolution is to figuration; and yet, as I suggest in Chapter One, this simple relationship, based on pronunciamentos, is in practice problematized, and the terms turn out to be only "words" and virtually interchangeable (or at least interpenetrating), chiastic as well as parallel.

It is time to clarify the terms "abstract" and "nonrepresentational" art, which I have been using too cavalierly. Representational art, after all, is going to be somewhere on a spectrum between photorealism (or propaganda) and abstraction (or formalism). Abstraction is merely a formalization at the expense of (or to the benefit of) particularity and meaning or message. Nonrepresentational art claims to be on a different spectrum altogether, one based on some principle other than representation, for example the unity of picture plane and canvas surface.

The revolutionary metaphor *frees* the artist to express something other than particular objects or these objects in various degrees of abstraction. There is, in our time at least, always a polemical edge that distinguishes nonrepresentational art. It may be regarded as a guard against theatricality, or a claim for purity or for a teleology of art. There is always an overreaching vaunt in the nonrepresentational, since art can never (or only at great cost) shake itself completely free of representation and reference. For this reason there is also a need for theory, without the accompaniment of which the object may be mistaken for something other than art. The various forms of nonrepresentational art refer primarily to theory or to the metaphor of artistic progress or revolution.

This book is about the figural (or representational) painting that coexisted with the more touted tradition of nonrepresentational, nonfigurative, theory-oriented painting. But it includes the Abstract Expressionists by exploring the ways in which "revolution" meant more than simply artistic progress to Pollock, de Kooning, Franz Kline, Mark Rothko, and others, who continued to paint with a figural, even political basis in their drips, rectangles, and aleatory dislocations of the human figure when their terms of self-reference were formalist.

This is by no means an original insight; but it will be useful to examine some examples of what has come to be regarded as a secondary tradition. The primary tradition has been well formulated by Arthur Danto in his excellent collection of pieces for *The Nation, The State of the Art* (1987). Danto's schema for modern art history supposes "a sequence of revolutionizing questions of increasing scope," and Danto automatically slips into a revolutionary vocabulary to plot the movement from Cubism to Abstract Expressionism: His use of the words "broke," "fierce interaction," "erase . . . boundaries," and "revolution" is characteristic of writers on American art since the 1940s.[1] His narrative derives from Clement Greenberg's thesis that the progress of modern art is a matter of subtraction and ever increasing approximation of picture plane to canvas surface. It was Greenberg who said to de Kooning, when he saw him painting one of his "woman" canvases (Fairfield Porter tells the story), "You can't paint this way nowadays."[2] Each new phase eliminates (in a kind of revolutionary Terror) all aspects of art but its own. For the Abstract Expressionists, Danto remarks, painting is simply paint, the act of painting, or action of a certain sort, and "everything else that seems to belong to the essence of art is really incidental."

It is within this general narrative that I wish to explore some specific artists, primarily American but also French and British. My question, however, is not Danto's "But is it art?" ("Was it a painting at all?" or "What are the philosophical limits of 'art,' its 'pure essence' or 'pure being'?") This is a question, as he says, that "has been raised at every stage of modern art since Impressionism," and it is a philosopher's question; indeed a question that suggests the confusion of the artist with the philosopher, the hard materialist of paint with the conceptualizer of words. Practice and theory are ever at odds during this period, with theory often seeming to wish to lead. I am less interested in, or entranced by, theory than practice—or rather the artists' practice as it plays against their theories, or their explanation for their practice.

Danto's narrative of art begins with the assumption of a "history" of art, and so with Ernst Gombrich's version of history "as the progressive conquest of visual appearances," that is, a narrative of representability, of mimetic progress. Danto believes that mimesis came to a crisis with the advent of cinematography, which "showed something not in principle attainable by painting." What followed, therefore, were the great experiments of the Fauves, Cubists, Surrealists, on down to the Abstract Expressionists, Minimalists, and performance artists. Thus, as Danto continues, "the immense problem of self-definition had been imposed on painting. . . . Art must now, whatever else it does, come to terms with its own nature." And this reflected, of course, a particular, Hegelian sense of history as "the progressive coming to philosophical consciousness of its own processes," which is as good a way as any of indicating the discourse of painting that has accompanied, ever more emphatically, the painting itself.

"Without theory, who could see a blank canvas, a square lead plate, a tilted beam, some dropped rope, as works of art?" So, with the purely conceptual pos-

sibility introduced by Marcel Duchamp's urinal, theory became as important as practice. And in 1964 Warhol "exhibited the Brillo box [that] asked, in effect, why it was art when something just like it was not"—calling for someone, as often the artist as the critic (but with the critics often confusing themselves with artists, as artists confuse themselves with critics, as each group struggles for precedence), and ultimately a philosopher like Danto, to straighten things out.

My position in this book, closer to Erwin Panofsky's in *Die Perspektive als symbolische Form* (1927), is that the history of art is less adequately described by a progress narrative than as a congeries of different symbolic forms or discourses that interpenetrate and supersede each other as (only possibly) a series of successive forms and discourses.

I suppose one origin of this book was an attempt to recover something of my own past in the Great Depression and to try to understand how a group of artists in the 1940s and '50s could have suddenly produced an art that at the time seemed to me (a teenager) outrageous. The focus was determined by my own coming of age in those years, but also by the exhibitions that took place during the years 1977–1984, when I happened to be writing about contemporary art. The subjects or themes were determined largely by what happened to be there to be seen and written about, but also of course contained a strong element of choice. Thus some omissions were by chance: I'd like to have written on Joseph Cornell, certainly on Lee Krasner, and especially on Helen Frankenthaler, whose paintings map new relationships between the representational and the nonrepresentational. But the omissions are also to some extent purposeful in that I omit the teleological painters (who are to a large extent painting a theory or a history of art), the Conceptualists, and the formalists. Important as they are in their own way, their works do not raise the issues I find most interesting.

Acknowledgment is due John Irwin of *The Georgia Review*, Robert and Peggy Boyers of *The Bennington Review*, Jack Beatty of *The New Republic*, and Richard Poirier of *Raritan*, who invited me to write the majority of these pieces and assisted me in their construction. Thanks also to Michael Fried, who has in no way changed his opinions about the superiority of the artists I do not treat over those I do, for a close reading of the manuscript that has corrected errors and clarified issues in a field in which I remain an enthusiastic amateur. As also to Leslie Mitchner and David Frankel for their careful readings and suggestions, and to Nicholas Humez for the index.

Baltimore, August 1989

FIGURE AND ABSTRACTION
IN CONTEMPORARY PAINTING

ONE

REVOLUTION AND COUNTERREVOLUTION

Art of the Revolution; Revolutionary Art

The art *of* the revolution, the art that emerges from the revolution and that we might say represents or illustrates it, has two distinct aspects. First, there is the prorevolutionary art of, say, Jacques-Louis David in graphic images or of Mirabeau, Danton, and Robespierre in words; this art expresses in the sense of celebrates, or at least finds graphic or verbal (in any case metaphoric) equivalents for, the political action, and propagandizes it.[1] David begins with images of republican Rome, which become, in all good time, imperial art, images of Napoleon as a Roman emperor. David thought of this as the fulfillment of the Revolution. But then there also is the *anti*revolutionary art of the counterrevolutionaries, in France of the artists who worked for Boyer de Nîmes or of writers along the line of the Abbé Barruel, in England of James Gillray and Edmund Burke.

The second half of my subheading refers to the art that is not merely illustrative of the revolution but itself revolutionary, insofar as David's paintings overthrew and replaced the tradition of pre-1790s French art. But of course "revolutionary" in this sense can also refer to art that is unconnected with the French or with *any* sociopolitical revolution, I mean art that creates a revolution of its own that is analogous to one of these sociopolitical revolutions.

At this point we introduce the *metaphor* of "revolution"—an overturning, or even (its original meaning) a complete revolution that returns to an original, a former point. We are no longer in the real, or relatively real, world of political actions. Since the French Revolution—since the day Louis XVI said "This is a rebellion" and was told "No, sire, this is a *revolution*"—the word "revolution," applied to art or literature, has become a valuative metaphor. What happened in France is designated a "revolution," a complete overturning, and therefore the new turn taken by a painter or a writer is also called a "revolution." This means that the facts, the scenario, of the French Revolution (or a part of it) have come

to inform artists' every new departure, their sense of their mission, and their picture of themselves as "revolutionary artists." Could Picasso, for example, have made so much of the subversion and overturning of a graphic tradition—and have done so repeatedly, obsessively, up to his last paintings, demonstrating that there always has to be yet another departure—had the models of the French Revolution, the revolutions of 1848, and so on, not existed and been valorized (and excoriated)? But then: *Is* there something in art or literature that is the equivalent—not just metaphorically—of what happened in Paris in 1789? (Let alone in 1793–1794 and in 1798–1815?)

Before the French Revolution the painter's intention cannot have been even metaphorically "revolutionary." Art following the Reformation may in some sense have been "reformative," reflecting that political upheaval, or indeed have been stimulated by Martin Luther and his followers—as we might think the art of the Counter-Reformation, in relation to what went before, was equally "reformative" or "counterreformative." But was the phenomenon of Caravaggio around 1600 a "revolution" of painting? The kind of painting Caravaggio produced certainly redefined artistic conventions and produced assumptions about art that lead straight to "French Revolutionary" painters like Gustave Courbet and Edouard Manet. It also, incidentally, involved the "masses" in the sense that it broadened the subject and appeal of history painting and included within itself representations of Christ and the Virgin Mary as if they were of the masses (showing the dirty soles of Mary's feet). But was Caravaggio's new kind of painting a response to the Reformation, and to the Roman Catholic theologian's response to *that*? Presumably yes, in the sense that such a phenomenon, however expressive of Caravaggio himself as a tormented, etc., individual, was at least rendered possible and necessary by the assumptions of theologians and politicians.

With David the word *revolutionary* becomes first a possibility, then a formula; with Baron Gros, with Théodore Géricault and Courbet, with Manet and Paul Cézanne, Henri Matisse and Picasso, the model has been set, and the intention—the basic assumptions of the artist—almost assures us of a Pollock and a de Kooning. The model in which Jacobinism is followed by Thermidor may also assure us of a Julian Schnabel and a David Salle.

The question I wish to raise is whether it is the revolutionary or the counterrevolutionary who will employ a style or iconography that is more or less "revolutionary." Given the nature of the French Revolution, is *counter*revolutionary art necessarily more conservative than revolutionary? And indeed, does "counterrevolution" refer to the royalists or to the Girondists, to the followers of Jacques Hébert or to the Committee of Public Safety itself seen in the context of Thermidor?

For of course the question is whether we take "revolution" to mean the continuing revolution or a political overturning followed by consolidation; whether

it refers to the process or the product of revolution. For example, a characteristic French revolutionary definition states,

 —REVOLUTIONARY means outside of all forms and all rules.
But the same speaker goes on to say,

 —REVOLUTIONARY means that which strengthens, consolidates the
 revolution, that which removes all the obstacles which impede its progress.[2]
These two statements are mutually contradictory: The second presumes a closed form for the revolution and has already prescribed (censored) the individual's liberty to be "outside of all forms and all rules." What it means is that there is an originating act that is "outside of all forms and all rules"; but then this act has to be frozen, turned from process into product, and institutionalized. Revolution, by being institutionalized, is therefore put into a position where a counterrevolution—by virtue of the first of the two statements about revolution—is revolutionary, at least as art, if not as politics.

There are, of course, subcategories that describe the chronological sequence of events within the revolutionary narrative: first, subversion and the development of revolutionary consciousness; then consolidation; and then the phase of celebrating and memorializing the successful revolution. Each calls for a very different representation, iconography, and style. In the midst of these phases, there is also probably something like the Terror (or Jacobinism), that is, the discourse or rhetoric required for the purging of so-called counterrevolutionary factions, the groups that are either impeding the progress of the revolution or (from another perspective) offering alternative discourses in a struggle for supreme power. It would appear that there is a historical phenomenon called "a revolution" that may be almost anything, including Stalinism or Hitlerism, and then there is the art of this revolution.

In the summer of 1789 there was David's *Brutus* at the Salon *and* there was the storming of the Bastille: a father exalting republican law over the lives of his own sons *and* a crowd of people acting without law to destroy, liberate, and lynch. And David's *Brutus* became a revolutionary painting, as his *Oath of the Horatii* was to become the paradigm of the Tennis Court Oath, itself later represented by David. But this art of revolution is not *revolutionary*. It is art *of* the revolution in the sense, first, that it represents the way the revolutionaries want to see themselves, and second, that it represses the revolution itself, much as the revolutionary "discourses" described by François Furet repressed the individual *acts* that made up the French Revolution.[3] And of course we have to agree, then, that the revolution was not (what it may in reality have been) Brutus and Collatinus bloodily dispatching Brutus's sons.

During revolutions, planned action takes place in a context of uncontrollable forces. These can be labeled, or at least are usually associated by Marxist analysts with, the "groups and masses" of the people. Lenin was undoubtedly right in seeing an enormous explosion of public activity among the masses as characteris-

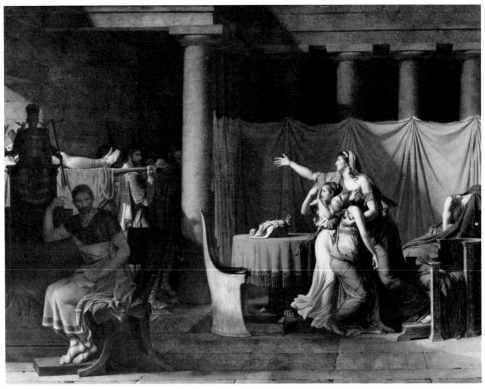

Jacques-Louis David, *Brutus Receiving the Bodies of His Sons,* 1789, oil on canvas. Paris, Louvre (Photo: Giraudon).

tic of revolutionary situations. And with this explosion comes an extreme form of contingency, which is the most salient feature of what is usually regarded as "modern art," the art that emerged in reaction to the universalizing and idealizing of Renaissance art and was summed up in Sir Joshua Reynolds's *Discourses.* We can say that with artists, as with politicians, part of the revolutionary achievement lies in turning contingency, by which we mean a changing situation, to their own advantage. In its most radical, most recent form, this becomes the introduction and then the utilization (and sometimes the control) of accident. But the relation between the revolutionary "tempest" or "hurricane" and the republican Brutus or Collatinus (the revolution as vital, destructive process *and* as static product) is at the heart of the problem, in politics as in art.

For Lenin, the essentials were a "crisis of the upper classes" and (what his emphasis falls on) the rebellion of the lower classes. The essential third element is the manipulation—or we might say the representation—of the lower classes' inchoate desires and actions by the Lenin figure, designated as the revolutionary cadre, the elite, the brotherhood or fraternity that governed, ultimately the men on the Committee of Public Safety.[4]

Trotsky, the theorist of art who was also the experienced, successful revolu-

tionary, makes the two crucial points: First, that "the most indubitable feature of a revolution is the direct interference of the masses in historic events"; but to which he adds: "Not a single progressive idea has *begun* with a 'mass base,' otherwise it would not have been a progressive idea. It is only *in its last stage* that the idea finds its masses"—which will be used and guided by the fraternal Robespierres and Davids.[5]

His second point is that—perhaps in a parallel way—the art of the revolution is in fact a transitional art, or the art of a transitional phase *between* reaction and consolidation:

> Revolutionary art, which inevitably reflects all the contradictions of a revolutionary social system, should not be confused with socialist art for which no basis has as yet been made [i.e., by the success of the revolution]. On the other hand, one must not forget that socialist art will grow out of the art of this transitional period.[6]

The murals of Trotsky's good friend Diego Rivera in Mexico were presumably socialist art; and in 1790s France, for "socialist" one can read "republican." As "revolutionary" art becomes "socialist" or "republican" art it turns from subversion and gestures of overthrow to support of the politicoeconomic principles of the new regime (realistically, of the new ruling elite).

Revolutionary art itself is defined by Trotsky as an art that "reflects all the contradictions of a revolutionary social" situation, all of the tensions of a moment of cataclysmic change. This formulation presumes that revolutionary art represents the revolution in process (not retrospectively as product), and confers upon this art all the power that accompanies a mimesis of such "contradictions." But of course an art that "reflects all the contradictions of a revolutionary social system" is a formulation that could apply as well to a *counter*revolutionary art, like Gillray's or Burke's, that attacks the political revolution as it represents it.

In his essay "Art and Politics in our Epoch"—a crucial document for American artists of the left, published in *The Partisan Review* in 1938—Trotsky expresses a stronger formulation that makes art itself a parallel and independent phenomenon, not one that merely acts as a handmaiden to political revolution (or at least to its inherent contradictions). He makes revolution the model for one form of the art process itself, one that supplements Ernst Gombrich's peaceful one of making and matching with "a protest against reality":

> Generally speaking, art is an expression of man's need for a harmonious and complete life, that is to say, his need for those major benefits of which a society of classes has deprived him. That is why a protest against reality, either conscious or unconscious, active or passive, optimistic or pessimistic, always forms part of a really creative piece of work. Every new tendency in art has begun with rebellion.

Trotsky even acknowledges the conflict between art of the revolution and revolutionary art: "Art, like science, not only does not seek orders but by its very essence, cannot tolerate them. Artistic creation has its laws—even when it consciously serves a social movement. . . . Art can become a strong ally of revolution only in so far as it remains faithful to itself."[7] Thus Trotsky posits an avant-garde that is parallel with but independent of the political elite. He cannot, however, conceive of the work of art outside "a society of classes" that has "deprived" the artist of "major benefits"; and when he makes a strong statement of artistic independence, he takes back with one hand what he has given with the other: "True art, which is not content to play variations on ready-made models but rather insists on expressing the inner needs of man and of mankind in its time—true art is unable *not* to be revolutionary," says Trotsky, but then (picking up on "of man and of mankind") he adds, unable "*not* to aspire to a complete and radical reconstruction of society." He assumes that in a work of "true art" a reconstruction of the history of art must necessarily be accompanied by a reconstruction of society as well. But here he returns art again to the role of handmaiden.

It was Morse Peckham who wrote, in the activist 1960s, that great art "offers not order but the opportunity to express more disorder than does any other human artefact, and that artistic experience, therefore, is characterized, at least from one point of view and in one of its aspects, by disorientation."[8] On the face of it, one associates disorienting or disruptive styles with "revolution"; but in practice, David's *Brutus* and *The Death of Marat* (1793) were "revolutionary" only in the sense that they subverted and replaced the Rococo art associated (rightly or wrongly) with the ancien régime; and since David's art specifically returned to an older, *pre*-Rococo style associated with Greek bas-reliefs and their modern equivalents in the paintings of Poussin, it was etymologically (at least) revolutionary in that David was bringing art back 360 degrees. But it did not produce (to use Trotsky's words) a "radical reconstruction," as Francisco Goya did a few years later in Spain. (I will discuss Goya shortly in detail.) At his most "progressive," David combined the neoclassical style with the contingency of contemporary realistic detail and content in *The Death of Marat*.

In "revolutionary art" everything depends on what went before: If the given is a Rococo style, then the revolutionary style will be neoclassical; if the French revolutionaries express their ethos in Roman clothes, the counterrevolutionary images will travesty the myths and twist and erode the geometric forms. Then the revolutionary generation of neoclassicists is replaced by the postrevolutionary generation of so-called romantics: David is replaced by Géricault and Eugène Delacroix. The problem is recalled in T. E. Hulme's well-known words in the aftermath of World War I and the Russian Revolution: "If you asked a man of a certain set whether he preferred the classics to the romantics, you could deduce from that what his politics were." What Hulme meant was "that it was romanticism that made the revolution. They [who] hate the revolution . . . hate ro-

manticism." And hence the concerted effort he advocates to recapture "the dry hardness which you get in the classics."[9] One might ask: Was romanticism the concealed agenda of the neoclassical revolutionists? And were Goya and Géricault the reality of the revolution that David was repressing?

If we associate revolution with great natural upheavals, that is with revolution-as-process (as the French did in some of their speeches), we infer a painting quite the contrary, in fact, to the clear-cut, closed images David offered throughout the course of the 1790s, but oddly congruent with the effects of Burke and Gillray—popular, crude, explosive, and disorienting—and of some of the counterrevolutionary artists subverting (or revolutionizing) the French Revolution in London. But there is also the fact that the artist William Blake and the writer Thomas Paine produced images that were as revolutionary as Gillray's and Burke's counterrevolutionary ones. The point may be to contrast England and France rather than revolutionary and counterrevolutionary. Blake, for instance, takes off from a neoclassical style as distinctive as David's; but he lives out the subversive phase against the proscriptions of George III and Pitt the Younger, and then goes on to treat Robespierre and the universals of the French Tablets of the Law in the same destructive way.

In England, the possibility of a thoroughgoing iconoclasm, one that did not stop short of breaking *any* idol, was much stronger than in France,[10] and by the 1790s English artists had at their call a far more powerful strategy for expressing the violent act of iconoclasm in revolution (as in Blake's prophetic books) or in *counter*revolution (as in Gillray's caricatures) than the academy-oriented, high-art-fixated French artists, including the studio of David. It is not surprising that the works of both Blake and Gillray are more redolent of subversion and overthrow than those of David, which led logically from the celebrations of the Horatii and of Marat to the imperial iconography of Napoleon. The revolution, in short, can be more *revolutionary* seen from abroad: The same Blake and Paine who celebrated what they saw happening in Paris saw the Americans as fiery Orcs—dismantling the statue of George III, dressed up as Indians and throwing British tea into Boston Harbor, or tar-and-feathering British excise officers; whereas the Americans saw themselves as a line of passive victims being shot down by a firing squad of British soldiers (in the famous engraving by Paul Revere)—in what Mary Wollstonecraft and others later described as a heroic attack *on* the British.

It is clear that the French, like the Americans, wanted to put forward a good public image. But if Lawrence Stone is correct in a recent review in *The New Republic* of Simon Schama's *Citizens*, a history of the French Revolution, the French-English relationship of action and image in the 1790s was chiastic:

> As early as the fall of the Bastille, the mobs were parading around in the streets carrying the heads of their fellow countrymen on spikes, something that the English and the Americans *never* did. It was no accident that when a madman tried

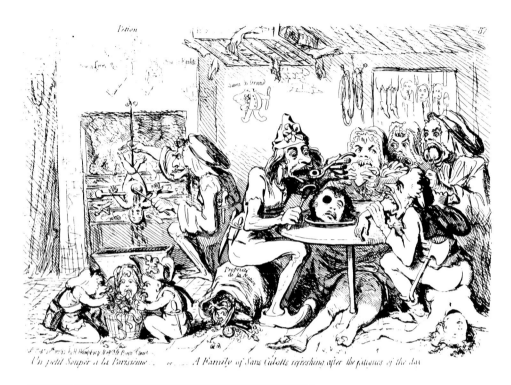

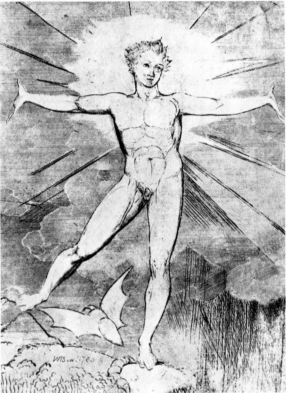

Above: James Gillray, *Le Petit Souper à la Parisienne,* 1792, etching. Private collection.

Left: William Blake, *Albion Rose,* 1780, etching. Private collection.

to assassinate Louis XV, his body was slowly, publicly, and excruciatingly torn to pieces, a spectacle of cruelty that lasted for most of a day. When a madman tried to kill George III, by contrast, he was quietly put away in a lunatic asylum for life. The difference surely tells us something not only about concepts of monarchy in England and France, but also about attitudes toward cruelty.

And, I would add, toward *violence*. France had the violent actions but no mode (let alone the desire) for expressing the actions in images. Writing of William Hogarth in 1747, the Abbé Le Blanc referred to the English "who delight in strong representations" (as opposed to the "sensible reflections" and "pathetic discourses" of the French): the "English genius spares nothing that can inspire it," he wrote.[11] While in England, artists had access to a mode of representation but not the reality, and this very fact—this frustration—together with the violence seen from abroad, may have sharpened their images. Even the British riot—the so-called "crowd ritual"—was only mimic and parodic, carrying effigies and miming executions; whereas the French carried real heads on pikes and then represented these scenes in the chaste allegories of their revolutionary festivals (which, as Mona Ozouf nostalgically claims, *were* the revolution).[12]

Our terms have focused on a contrast between the caricature produced in England in the 1780s and '90s by Gillray and Thomas Rowlandson (and, I would add, Blake) and the classical republican art, the art of David's *Oath of the Horatii* and *Brutus,* produced in France. Both of these, English caricature and French neoclassicism, shared the fact that they preceded the events of 1789— that they were already to hand. They differed, of course, in the fact that with the events of 1789, while both focused on the politics of the phenomenon in France, the English caricature continued English, in England, and almost exclusively— on the surface at least—critical or destructive, whether of the French Revolution or of English repression; while the French neoclassicism of David remained in France and was used to explain, justify, and glorify the early stages—the specifically republican (which became, logically, the imperial) stages—of the political revolution.

There is, of course, also French caricature of the 1780s and during the Revolution. This is the third element by means of which the relationship between English caricature and French neoclassicism may be better understood. In a preliminary phase, caricature served as a handmaiden to revolution, its aim being to destroy the prestige of the governing order in the eyes of the people so that that order could be replaced. Once the Revolution itself took place, however, censorship was required to keep this double-edged weapon under control: The revolutionary government censored caricature from the end of July 1789 onward, strongly reaffirming the censorship at the height of the Terror in April 1794. For caricature finds it hard to be official; it presupposes Liberty from censorship and

implies Liberty from restraint on the part of the artist, as it presupposes Equality of the subject, the equality of ruler and ruled.

In fact, except for their bathroom humor, David's caricatures are nearly as decorous as his paintings.[13] The great exception is his sketch of Marie Antoinette on her way to execution: a "caricature" that materializes Burke's words (from the opposite point of view) about the reduction of Marie Antoinette by contact with the Parisian mob from "queen" to "but a woman," and thus "but an animal; and an animal not of the highest order."[14] This sketch is a powerful revolutionary image, but it was never engraved or published.

Caricature aids in the revolution-as-processs but exceeds the needs, requirements, and desires of the revolution-as-product. Once the revolution is in control, as the case of David shows, caricature can be used only as a police force to attack *les autres*. Like iconoclasm, caricature is institutionalized: The broken heads of Christ and the apostles have been replaced by Marat & Co. But as the case of England shows, iconoclasm once started will not stop with religious images and eventually breaks *anything* that takes the place of, or stands between, humanity and nature. This is the crucial fact about caricature, as about iconoclasm, at least as practiced in England—at least by Gillray.

The dual aspects of caricature, placed historically in the 18th century, were its lowness—indecency, pornography, and bad taste—that is, its of-the-people aspect as it dredged up the old carnival imagery of the body as well as projecting new populist images of Equality; and then its etymological sense of *charge* (*caricare*), its exaggeration, quite literally its Liberty, in the handling of people, reducing the high to the low, and therefore its Equality, its even-handed leveling, its exposure of every universal to contingency. Liberty draws attention to the origins of caricature as the plaything of an elite, as opposed to the more complex thing it came to be in England. To understand the phenomenon of English caricature in the 1790s we have to recall its reputation earlier in the century. In the 1730s, when it was first introduced to England from Italy, caricature was associated with young noblemen traveling on their grand tour in Italy, scribbling likenesses of each other, recognizable probably only to the members of a tiny elite but based on the practice of high-art painters (beginning in the academic studio of the Carracci in 17th-century Bologna) who sought release from academicism (or, if you will, academic eclecticism) in the relaxing play of a likeness based on a single feature or line. Caricature, in short, assumed the conscious slumming of a sophisticated artist; the donning of lower-class trappings (in the way that the politician Charles James Fox affected a plebeian dress and hairstyle) in order to be more expressive than was possible within the conventions of high art. It was caricature as the plaything of an irresponsible elite from which Hogarth recoiled in the 1740s; I think the evidence indicates that this was the way David still regarded it in the 1790s when he made two caricatures himself that were anti-English, relating the English style of caricature back to English decadence—as opposed to the strong, virile, neoclassical/republican style, which was itself in

part a response to the English image of the French as effeminate and fashion-ridden.

There is, however, a great leap from the first political use of caricature by the aristocratic amateur George Townshend in the 1750s—single heads juxta-posed—to the complexly disturbing scenes of Gillray in the 1780s. I have argued of Gillray in *Representations of Revolution* that even when speaking for the government, in what David would have regarded as typically decadent Rococo forms, his satire cuts down the right as well as the left, friend as well as foe. The forms and myths that Gillray employs are clearly not Rococo, as Rowlandson's probably were (based, for example, on the incongruity of a lovely aristocratic Duchess of Devonshire and a grotesquely plebeian Jeffrey Dunstan or Samuel House, or of the masquerading Fox himself: David would rightly have regarded this as *playing* at revolution). Gillray's style was wildly, parodically Baroque; and his Baroque was not normative but subversive, both aesthetically and politically, of all that the Baroque stood for in England—the England of Saint Paul's Cathe-dral and the Naval Hospital at Greenwich; of Peter Paul Rubens's ceiling in the Banqueting Hall, and of Sir James Thornhill's Greenwich Hospital. Gillray's anti-Baroque—whether parody or plebeian alternative—was something we might, if we are permitted to use these old stylistic distinctions, call romantic (or pre-romantic) *contra* the neoclassicism of the French Revolution—what I referred to earlier as the Goya or Géricault repressed by David.

I have referred to "romanticism," but the precise aesthetic term in this En-glish connection is the Picturesque, a term that includes Fox as well as Hogarth and even Gillray (though the revolutionary context virtually raises the term into something more libertarian). The Picturesque involved a choice, for example, on the part of a country gentleman landscaping his estate, to live consciously below his means, with hedges untrimmed and walls cracked—a genteel version of Hogarth's deployment of the contemporary and contingent in his "modern history paintings," which always involved consciousness of the great tradition *withheld* by someone who does have control of it. Thus Fox's "dressing down" and Gillray's reduction of neoclassical myth and imagery to shapes that encom-pass both Baroque and plebeian chapbook are gestures posited on a position of power. But the important fact is the close interaction in this mode (which by Gillray's time at least we can call caricature) of art with politics, specifically in its transgression of aesthetic authority as it is linked to political: in Michel Melot's words, "transgression (of an aesthetic norm) for the purpose of aggression (against a social model)."[15]

It is reasonable to conclude that Gillray, in effect as well as intention, produced an iconoclastic, not a "revolutionary" art; one that broke *anything* that could be "idolized," and so did not make a complete rotation, a "revolution" as practiced by David as a plan for the future, "positive objectives aiming at renova-tion, further development or the progress of humanity."[16] But then we have to confront Gombrich's thesis that Gillray's caricatures only served the establish-

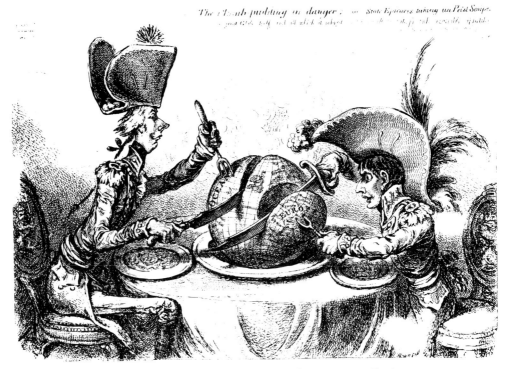

James Gillray, *The Plum-Pudding,* 1805, etching. Private collection.

ment; that their exuberant fantasy enclosed, domesticated, and sanitized *by making comic* the threatening images of sans-culottes and Napoleon, and even more (because he was English, not French) of William Pitt.[17]

Gombrich's thesis (based on the assumption that printsellers and engravers were primarily interested in selling prints) has to be placed in the context of a larger closure: the fact that "revolution-as-process" itself was a metaphor that sanitized the brute facts, that served the function of aesthetic containment. The aesthetic that was privileged by the participants in the French Revolution was, of course, not the Picturesque but the Sublime. And the Sublime was supposedly something one found primarily in nature and only secondarily in art. The imagery applied to the Revolution by the hostile Burke as well as by the proponent Robespierre was of extraordinary upheaval based on nature in the form of a volcanic eruption, an avalanche, or a storm—a mixture of the accidental and the inevitable, with a very small role played by human agents. The artist in this regard was analogous to the human revolutionary agent, the Brissot, Danton, or Robespierre (even, for Tolstoy, the Napoleon) caught within the natural hurricane. The equation of revolution and Sublime assumed revolution to be an uncontrollable upheaval, sweeping along its human agents; and the human agents who tried to deal with revolution either were swept away (or devoured), or transformed its energy into a tyranny, if their aim was political; or, if their aim

was aesthetic, they transformed it into beauty. In short, they derevolutionized the Sublime.

What I am suggesting is that art with a capital A, which probably undeniably entails closure and completion, may be said *to beautify* both the Sublime (which is limitless and normless) and the revolutionary phenomenon (at least so long as that model is the one its agents entertain and honor). In a sense, the metaphor creates the limits of action the actors permit themselves. Analogous to the rhetoric of the politicians, art is required to bring the primal energies under control, and so, by definition of function, is postrevolutionary.

Art enters upon the scene as the practical political accommodation that attempts to render the Sublime, or the revolution per se, manageable. Whenever one tries to simulate the Sublime, whether through human heroism or stubbornness or through artistic poeticizing or painting (whether by a David, a Rivera, a Turner, or a Goebbels), inevitably one transforms it into the beautiful—by which I mean one transforms the Sublime into the (in quotes) "Sublime," as one turns the French Revolution into a festival: one aestheticizes it. It is impossible to circumvent this unbridgeable dualism between Sublime reality and beautiful art. Humble metrics, as Kant argued, enclose, define, and thus destroy the measureless Sublime; and the same can be said for any framing action, from the line and form to the pigment of the painter.

But—to return to Gombrich—caricature, on the contrary (whatever its mercenary aim), is a mode of expression that ruptures the revolutionary Sublime. Specifically, in the terms I have been using, it renders the Sublime "Picturesque." Recall the crucial event that took place in the Convention on 9 Thermidor, when a deputy named Vadier made a joke at Robespierre's expense—and for the first time produced a *laugh* from the assembled body: a laugh, I have no doubt, of release from the extreme pressure, the intolerable tension, of Robespierre's sobriety and Terror.[18]

If tragedy, as Kant noted, beautifies the Sublime, comedy manifests an open-ended confrontation without accommodation, mediation, or closure. Tragedy, Schiller remarked, relies on "established legends or history," in other words on conventional closure, while comedy depends on nothing but invention: "By the power of its will it can tear itself out of any state of limitation." And Marx, in *The Eighteenth Brumaire of Louis Napoleon*, exposed the comedy of repetition (internalization, cyclic repetition, and repression) in the multiple French revolutions and multiple Napoleons.[19]

Repetition, however, is a term (like internalization) that is associated with both art and comedy. It is outside, circumscribing the Sublime, and so the aspect of comedy that must be isolated as in some sense revolutionary is not the Plautine repetition of conventional patterns but the more primitive Aristophanic, or Old Comedy, explosion of energy, which breaks asunder the comic plot. Plautine comedy denotes reconciliation and usually contains or domesticates the explosive energy of the young lovers and the conniving servants; it speaks at its

conclusion for society, and has reabsorbed the antisocial energies that elicited laughter along the way. It may represent a formal conservatism that is part of most comedy, at least when it is enclosed in the art form of a theatrical performance. It bespeaks the revolutionary product that finally absorbs the unmanageable process that has now served its purpose.

The great revolutionary caricaturist—more precisely the great painter who elevated caricature into a modus operandi—who emerged directly from the era of the French Revolution was Goya. Goya's politics were ambiguous—expedient and upwardly mobile but with a strong grounding in provincial, lower-class, subculture life—but his paintings mark the absolute end and destruction of the European tradition of decorative wall painting as beauty, glory, and indeed "art" (qualities most often to be associated with the supposedly analogous qualities of the monarchy that commissioned them). The tradition Goya dismantled not only survived in David's art of simplified geometrical forms but was bolstered by and used to serve a new master, Napoleon. Instead of consolidating the tradition—apparent in the Spanish royal palaces—as it was developed from Titian to Veronese to Tiepolo, or even to the weak (compared to David's) neoclassical style of Anton Raffael Mengs, from which he also learned, Goya reduced its components to the barest but highly charged minimum: to the detail or fragment of the great academic "machine" and to the crudest, most sketchy and scratchy application of paint; to the lowest subject matter and the most irrational forms (from the genre of history painting to *caprichos* and *sueños*, or nightmares); and to the denial of every sense of comfortable closure, including the edges of a canvas or the borderlines of an etching. This conception of art as fragmented, open, and unconnected to traditional iconography I would venture to call revolutionary in relation to the tradition and to the "revolutionary" art of David.

As an artist, Goya was, in this sense, revolutionary because he consciously cut himself off from both the Baroque and neoclassical traditions available to artists of his time; for example, by the isolation and magnification (the caricature) of details to monstrous proportions, he destroyed the *beau idéal* and rejected the subordination of a traditionally unified picture space. But at the same time that he was upsetting the old academic assumptions (still held to, for example, by Géricault and even Courbet), he was of course creating a new art idiom, perhaps even form, based on alternative principles. These principles he found on the one hand in the revolutionary times in which he lived, and more specifically in the subculture art of the people—those superstitious, grotesque, detestable mobs that in fact carried out the revolution in Spain (however wrong the reasons and counterrevolutionary the results). Goya's version of the mob should be put alongside David's *Death of Marat* and the great revolutionary fêtes and renamings that had attempted in some sense to represent the revolutionary participation—or importance—of the people, the *grotesque* people.

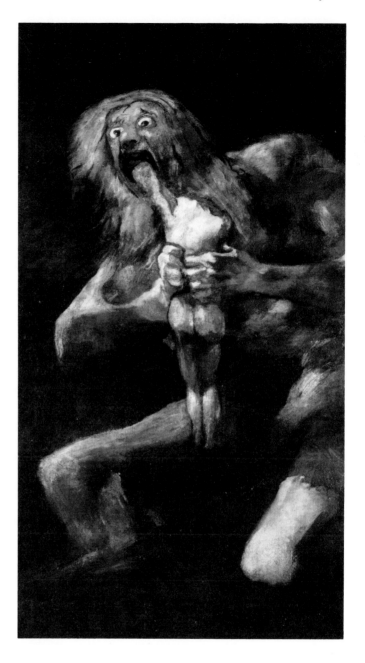

Francisco Goya, *Saturn,*
1820–1823, oil on board.
Prado, Madrid.

In the sense that Goya "represented" a revolution (however dubious and un-
supported by the historical facts), he distinguishes in his art between the "pro-
gressive ideas" (terms like "reason," "liberty," "equality," and so on, inherited
from the French) of an intellectual elite and the reactionary, atavistic notions of
the "people," which in France corresponded to the two phases of iconoclasm,
replacing ancien régime symbols first with Enlightenment constructs and then
with popular superimpositions. The question is whether an art of the people—

both representing and appealing to the people we see in Goya's great paintings of popular uprisings, the *Second* and *Third of May, 1808*—need merely represent the people interfering in historic events, whether fulfilling the plans of an elite or taking the initiative. In *The Second of May, 1808* (1814) Goya felt he had to elevate the people by painting the very kind of Baroque composition he was re-pudiating in his more private works. Nor does he show backstage nobles and re-actionary clergy pulling the strings. But in the pendant (1814–1815), showing the killing of the people on the third of May, he employed subculture iconog-raphy and crude forms drawn from popular prints, not necessarily Spanish (in-cluding, for example, Revere's *Boston Massacre*), and from low-life genres of painting, though he expanded them to the size and scale of history painting. It is not clear, however, that he drew or painted *for* the people. The people's assump-tions served only as a foundation for Goya's very personal, virtually private style. For the extreme of his aesthetic revolution manifested itself in the paintings of the Quinta del Sordo, his private house, and in the print series of 1800 to 1820, shared with a small group of friends.

"Popular" therefore refers to the people, the masses, and the subculture. If we can use "people" to cover all of these categories, we can ask whether there is a revolutionary art that is an art of the people, by the people, and for the people. I mean "of" in the sense of an art not only representing the people's acts but ex-pressive of the people, taken from their own forms; *for* in the sense of understood and absorbed by them; and *by*, actually made by them. Can such as art *still* be in some sense "revolutionary" as opposed to stabilizing or celebratory? In the case of Goya, the answer is clear: He utilized these materials—as had Hogarth in England before him, and as Courbet would in France after him—to produce an art that overthrew old accepted assumptions in the "realm" of art, but that art was for the delectation of an elite, so small it may have been largely limited to the artist himself.

The Mexican Revolution: Rivera and Orozco

The one revolution successfully represented as a popular phenomenon was the Mexican (1910–1921). The artists of this revolution were muralists, their art an art *of* and *for* the people in the only way this could possibly be—in public build-ings and the open air. As one of the muralists, Jean Charlot, has said, their reac-tion was against "the twin myths of personality and art for art," and their aim was to create "anonymous masterpieces beamed to the people at large" (which he compared with the making of Gothic cathedrals). Iconoclastically, the surfaces they had to paint on were "the majestic walls of ancient *palaces.*" The artists were appropriately "troweling, frescoing, desecrating these hallowed places"— or so it seemed to them—as part of the act of revolutionary painting.[20] José Clemente Orozco himself observed that mural art is of all art "the most disin-

terested, as it cannot be converted into an object of personal gain, nor can it be concealed for the benefit of a few privileged people. It is for the people. It is for everybody."[21] There are implications here of climatic determinants, such as the warmth of Mexico, for murals to be an environmental experience; but Orozco's main point, that a mural cannot be a commodity, rings true in a commodity culture in which easel painting arose with private-enterprise capitalism as a way to frame and make personal possessions of the objects represented (whether a landscape or a nude woman). These remarks pretty well sum up the usefulness of mural painting in a revolution that aims at realizing Equality as well as Liberty.

Moreover, this was an art not only *of* and *for* but *by* the people. Given the fact that it was represented (albeit after the fact) as a revolution of the Mexican people against foreign domination, against a small elite who were cut off from the original inhabitants, the artists were themselves reacting against the academic painting of the Mexican elite, even against the formalism of international Cubism; they sought a style that was more immediate than the former, closer to its referent, less an art for art's sake, than the latter. The Mexican muralists happened to be uniquely suited to represent a popular revolution—or perhaps we should say, to make their revolution appear popular (or to emphasize its popular, by which we mean agrarian, roots). They were able not only to destroy the extant forms—religious and cultural, hierarchical and foreign—but to connect the worker-peasants who epitomized the Mexican Revolution in its propaganda aspect with their ancient indigenous Mexican forebears, making modern revolutionary Mexico a revival of pre-Hispanic or pre-Columbian (or what is also called pre-Latin) Mexico.

The essential fiction was of a return to pre-Hispanic origins, which embodied (in the words of Carlos Pellicer) an "organic unity between social living and art" that had long been lost but was still recoverable from primitive artifacts and remote tribes. This was felt to be an art that had been simultaneously religious, ideological, public, monumental, and civic. Even writing had been pictographic, and painting had merged with sculpture and architecture in a statement of public virtue: "Mexico's pre-Hispanic societies spoke the great language of forms, volumes, lines, colors," which was a language, it was argued, of unity.[22]

The second stage of the myth, corresponding to the Fall, was the Spanish occupation, which broke this unity into a dissociation of sensibility. "Indigenous art ceased as public, state, monumental art, and was converted into furtive, inhibited, domestic art of little reach."[23] It was replaced by European, specifically Spanish, ideals and principles, which assimilated some aspects of the indigenous art to its own ends (as Christianity did Greek and Near Eastern art). The situation changed little after independence, when the criollos, of Spanish descent, assumed power and considered the Indians and mestizos "foreign elements, strangers on their own soil." By the end of the 19th century—in the everlasting regime of Porfirio Diaz—the official art was academic. But pre-Hispanic art survived as a

subculture, and so as a vocabulary ready to hand for revolutionary nationalist movements that wished to cut through the repressive official culture to something that could be regarded as pure, original, and Mexican.

The man usually given special credit for the reaction against official Mexican art on the eve of the political revolution—and who filled the role of the subversive, consciousness-raising revolutionary artist—was the caricaturist José Guadalupe Posada. His simple and sensational prints were essentially broadsides, either cut out of zinc plates to resemble woodcuts or drawn directly on plates that were then cut away with acid. They were often printed on pink or red paper surrounded by crude typefaces that set off the figures. Enlivened by the *calavera*, the living-skeleton figures of Mexican folk culture, they could also be apocalyptic in a way that would stimulate Diego Rivera and Orozco on the larger scale of the mural.

At the very center of his huge Hotel del Prado mural in Mexico City (1947–1948), Rivera placed one of Posada's female skeletons in fantastic headdress, flanked on one side by Posada himself, in his middle-class Sunday best, and on the other by the young Diego, the artist of the revolution (represented as he looked at the time of Posada's innovations, the stimulation to his revolutionary consciousness). The skeleton woman has one hand on Posada's arm and the other holds Diego's hand. Posada is presented as Rivera's spiritual father, with his mother (Posada's image of) death, and between the youth Diego and the skeleton is his wife to be, Frida Kahlo, who holds a bitten apple. With the imagery of true and false paternity (the figure of Porfirio Diaz looks frowningly down on this subversive family group), the Christian iconography of Adam and Eve and their Fall, and the conventional revolutionary imagery of youth and sexuality, the artist places himself at the heart of an eclectic—and of course retrospective—revolutionary myth.

For Rivera came upon the scene—or saw himself as doing so—when the continental academic tradition was dominant in Mexican easel painting, and the school of Honoré Daumier and the Kepplers in Mexican political cartoons. Against these, Posada's crude block-print shapes offered a "revolutionary" alternative, both in a "people's" art and in the subversive implications of the death's-heads mimicking the activities of polite society. Posada's Dance of Death, which levels kings and peons, draws upon the tradition of Mexican carnival, the subculture's way of expressing itself in the 18th-century Spain of Goya as in the 20th-century Mexico of Rivera. One of the prominent images is the firing squad, in front of which all the victims assume heroic stances and are of the people—those earlier leaders of unsuccessful revolutions. Posada, in fact, probably draws on Goya's *Third of May, 1808* and his *"Desastres de la guerra"* for these images of prerevolutionary agitation.

And yet, despite Rivera's official history, as his own forms in all of his murals attest, the original response to the revolution was not exclusively indigenous. Rather it involved the artist's search for equivalents wherever he could find

5. *Calavera* of Don Quijote. Broadside; tm. 95% of original size.

José Guadalupe Posada, Calavera of Don Quixote, n.d., simulated woodcut (engraving on type metal). The Museum of Modern Art, New York, Larry Aldrich Fund.

them, especially in what he regarded as the *high style*. Rivera, a young artist who had assimilated all the latest Parisian styles, in 1922 returned to Mexico after ten years in Europe. The political phases of the revolution were already over and could be seen in selective—we might say official—retrospect. Rivera was well schooled in the principles of Cubism, but the model both he and Orozco chose to employ in the great experimental studio for the revolutionary muralists, the National Preparatory School in Mexcio City, was Italian trecento fresco-painting in the manner of Giotto, or quattrocento in the manner of Ambrogio Lorenzetti and Uccello. The common factors were mild climate and open-air loggias, public display, a "primitive" art, and a religio-political purpose. The Giotto-attributed Saint Francis cycle in Assisi exemplifies all of these, including a subversive subject, the saint who turns against the worldliness of the Church. In short, while the ethnic subculture—oppressed as well as national and primitive in the sense of pre-Hispanic—offered a large part of the imagery for these artists, they conveyed it (made it artistically viable) by mediating its forms through early Renaissance Italian frescoes, on the one hand, while also retaining (though strenuously denying) the tight surface tensions of contemporary Cubist art, on the other.[24]

The Preparatory School (an appropriate starting place because of its history as a center of dissent) is a building with open loggias around courtyards, and also, pointing toward the later Baroque phase of the muralists, with irregularly shaped

walls and ceilings in the stairways. The dominant figure in the National Pre-
paratory School was Orozco, a more sardonic, less easily satisfied painter than
Rivera. Orozco's Giottoesque panels on the stairway secularize the religious fer-
vor of pietàs and Franciscan charity. When he painted the unbroken wall of the
second-floor loggia, he let the panels merge into one long political comic strip;
beginning as a planar procession in profile, the mural turns at the left corner into
a Baroque confrontation of capitalists and workers. Along the way are purely
symbolic decorations, like a huge church poor box being emptied into a capi-
talist's grasping hand.

For Orozco also derives from Posada. To base mural history painting on the
conventions of political cartoons is not a strange strategy, since the point of both
is an emphasis, either heroic or monstrous, that exalts or denigrates, in extremis,
human aspirations. Posada showed the way toward the popular imagery of politi-
cal cartoons, as toward the conventions of popular parades, carnivals, and ritu-
als. The imagery of Goya's walls in the Quinta del Sordo is probably also in the
background of Orozco's paintings, but his immediate graphic model was the car-
toons of the New York publication *The Masses*, with their popular implications
and simple metaphoric relationships: A gigantic hand or fist comes down on help-
less masses or on cringing capitalists; a huge virtuous head of Father Hidalgo or
Juarez overwhelms the little wicked foreigners, or exhorts the Mexican people.
The forms are rendered more awesome by size and by the infusion of elements of
German Expressionism, in particular the agitated brushwork, which shows up to
powerful effect in the free application of Orozco's fresco painting.

There are images of man-monsters made of barbed wire, or of humans
wrapped in chains (or of the Emperor Maximilian wrapped in his grave clothes,
based on a photograph taken at the time of his reburial), that remind one more of
Blake than of Posada. In the Hospicio Cabañas in Guadalajara, Orozco's ceilings
suggest Blake designs blown up to gigantic size. Hernando Cortes resembles
Urizen, with a sphinx or harpy whispering advice in his ear; the rising man of
fire in the central cupola is a monstrous Orc figure; and the mechanical horses of
the Apocalypse and the Urizen-like face of God in the "Bewilderment of Reli-
gions" panels all recall the iconography of Blake's "Bible of Hell." Even Orozco's
colors are usually reds and grays, grays and blacks, whites and reds—perhaps
symbolically fire and earth, but also the basic colors of Posada's newsprint art,
and of the heavy blacks surrounding Blake's figures and appearing in German
Expressionist woodcuts.

The popular political cartoon carries Orozco from the trecento into the Ba-
roque, and to the garish foreground whores in the Palacio de Bellas Artes mural,
which, with its red- or green-tinted female faces (in foreground close-up, out of
scale with the background figures), resembles a blowup of Toulouse-Lautrec
interiors of the Moulin Rouge. These are, of course, images of bourgeois counter-
revolutionary corruption and degeneracy. From the genuinely Baroque experi-
ence of the murals in Guadalajara, Orozco goes on to the Scarlet Woman, the

Whore of Babylon riding on the Beast of the Apocalypse (a Mexican jaguar) in the Gabina Ortiz library in Jiquilpan: in the background are the Mexican eagle and snake, but the snake is now strangling the eagle. While consciously rewriting the old, outmoded Christian iconography, Orozco's perverse apocalypse acknowledges that nothing is ever going to be finally right, revolution or no revolution.

Orozco shows the combat, the moment of confrontation, the never-ending conflict between bourgeoisie and proletariat—and, above all, the awareness of the discrepancy between what the Mexican Revolution intended and what it achieved. The strength of Orozco's art, and his importance for the Mexican example, lies in the unresolved quality of the continuing and faltering revolution. In the 1930s he continues, representing the phase of disillusionment that Byron and Goya depicted following the decline of the French Revolution into the profit-making of the Thermidorians and the conquests of Napoleon. But he also embodies the view of a Marat or Hébert, an anarchism that will not be satisfied with anything but a permanent revolution.

Rivera, on the other hand, while he delights in showing corrupt capitalists, tends to celebrate the triumph of Mexico's social revolution, the consummation of the process, and he is able to do so because of the continuity he creates between the ancient Mexican past and the revolutionary present. He always retains the integrity of the wall surface (which Orozco constantly violates), showing better than any of the other painters the continuity with pre-Hispanic art. He combines the peasant images of folk rituals, carnivals and *calaveras*, masks and banners, with the *horror vacui* of Aztec decorative painting, on the one hand,

Diego Rivera, *Blood of the Revolutionary Martyrs,* 1926–1927. Chapel, Universidad Autonoma de Chapingo (Photo: Detroit Institute of Arts, Dirk Bakker).

and with its Baroque Spanish equivalent in Catholic altarpieces, on the other. The huge, looming, out-of-scale figures or faces of the carnival become the telescopic lens, the hands and eyes of the *Man at the Crossroads* mural; which, however, operate quite differently from the giant foreground figures of Orozco. Rivera's figures, less Baroque and disorienting, serve to organize a great deal of disparate material on a single wall, to establish symbolic relationships (as opposed to narrative ones), and to recall the Aztec temple walls or the cutaways of Spanish mines in which the Indians slaved. In various ways, his paintings all express the strong sense of layers or of archaeological strata, of excavations, of capitalist brain centers and hidden origins deep down under the city streets. The model remains the colonial mine that fed the rich and fueled the state, but the image is updated in certain respects by the American comic strip.

The myth Rivera relates begins in the insurgent phase with the rogues' gallery of oppressors—the white invaders, from Quetzalcoatl to Cortes to the frock-coated Maximilian and the French-English-American capitalists who governed through Diaz. Then there is the Mexican hero who rebels, dies a martyr, and is followed by another and yet another martyr (one is reminded of the revolutionary myth that grew up in 19th-century Ireland) until at last freedom is achieved. The heroes include the Lafayette-Madero figure, the idealist of the first phase of the revolution who is swept away in the counterrevolution of Victoriano Huerta. Finally there are the Orc figures (to use Blake's name) of Pancho Villa and Emilio Zapata—the bandit leaders, anarchistic, truly reaching up from the bottom (as opposed to the Maderos, Caranzas, and Obregons, who survive after the Villas and Zapatas are dead—who accomplish what the martyrs began but then refuse to play the Cincinnatus or George Washington, and so are assassinated in their turn).

Two facts are at the bottom of the myth: its origin in agrarian uprising and the redistribution of land to the rural masses, with the peasant heroes Zapata and Villa; and the fact of sacrifice, of freedom rising simultaneously from the land and from the blood of the martyrs that "nourished" it. These are not ancient Aztec sacrifices, which Rivera associates with Spanish oppression of the Indians, but images of natural growth and fruition, most impressively expressed in the Baroque forms of the chapel in Chapingo, which exploit not only the Romanesque vaulting of the chapel but its rounded windows, which become wombs, seed pods, and tree boles. The cross-section of Zapata and Otilio Monteaño dead and buried in the earth, with luxuriant cornfields rising above their corpses, embodies the myth of revolution in Mexico. The earth can be mined by slave labor and used as a brain center from which to control cities above, in a huge, machinelike operation; but this is a colonialist corruption of its true, natural function of genesis, the source from which grow plants like the ones Paine described at the close of *The Rights of Man*. The imagery of spring and fruition is one of assertion and reassertion, related to those countergestures in the political cartoons of pressing down, striking low, and bursting upward.

Where did the popular mural art lead in Mexico? The Rivera aspect of the mural movement led to the façade of Juan O'Gorman's University of Mexico Library, a familiar postcard image. The Baroque of Orozco led to the dissolution of the wall, the change of architectural boundaries to correspond to visionary ones—everything focused in the contrast between static areas of wicked capitalism and surging, advancing masses, or lunging three-dimensional male arms and female breasts. The convolutions of the walls of the Sala de Revolución at Chapultepec Castle (by David Siqueiros) suggest a fun house or a cinema lobby. Like the ceilings of the La Raza hospital, these are intended to disorient visitors, to subvert their capitalist assumptions, stimulate their revolutionary consciousness, and thrust the truth at them in the most cinematic terms. The end product, however, of both the Rivera and the Siqueiros types of popular art was the Rufiro Tamayo murals in the Sanborn department store along the Reforma and in the National Anthropological Museum and the O'Gorman murals in the National History Museum in Chapultepec Castle. The intention was no longer to arouse revolutionary consciousness (a stimulus to patriot identification), not even "to transform the public into esthetes," but only "to express and validate its social aspirations."[25]

The Russian Revolution: Malevich and Zhdanov

The most obvious test case of revolutionary art was the Russian, where the concept of a revolutionary "elite" complemented or compromised the myth of the rise of the people. For parallel to the small political elite led by Lenin was an elite of avant-garde painters, innovators who, in Wassily Kandinsky and others, produced the first totally nonrepresentational paintings. Lenin's overthrow and reconstitution of the traditional form of Russian government was "revolutionary," and so was Kasimir Malevich's painting of a canvas allover white, or consisting only of a geometrical figure.

Avant-garde and revolutionary artists are not, of course, identical: In many cases in Russia, "avant-garde" meant the theosophical or spiritualist but hardly the revolutionary. Malevich was reacting against conventional figurative, academic painting in a genuinely "revolutionary" way, but in the 1920s his proposal for a cube as Lenin's mausoleum simply equated this symbol in a theosophical way (recalling, Etienne-Louis Boullée in the 18th century) with eternity and the fourth dimension. Lenin's and Malevich's "revolutions" shared only a single point of similarity.

There was a brief period when part of the Russian avant-garde did help (in Robert C. Williams's words) to "legitimize the revolution through its artistic innovation and its political propaganda."[26] Moreover, though no one used the word "avant-garde," many artists did associate "artistic innovation and opposition to accepted social and political behavior," especially after the 1905 rebellion. Williams even believes that the latter may have "facilitated, but did not

initiate, the importing of innovative elements" into Russian art, counteracting academic art in much the same way as a few years later in Mexico. It acted as a catalyst, and some artists did try to fuse artistic innovation and revolutionary commitment in their work. But the real innovators had already reached maturity around the turn of the century.

Suprematism and Constructivism were the two avant-garde modes that took up the successful revolution of 1917. Both were nonobjective systems based on Cubist principles, already in existence and looking for a banner, but while the first sought an upward abstraction into theosophical spirit, the second moved down into a utilization of the materials of working-class culture. In terms of the art tradition, both were revolutionary and iconoclastic. An old order was overthrown, and essential parts of what was considered art were repudiated and replaced. In Suprematism, for example, the meaning of a work of art was to consist not in its representational quality but only in its pictorial elements and their interactions: The flatness of the picture became its sole content. Yet in these assumptions both Suprematists and Constructivists were also returning in important ways to the Russian icon, for the idealism of the first and the carpentry of the second find their equivalents in the art of Andrei Rublev and in the crafts of medieval Russia.

The aims of these avant-garde movements could be verbalized to resemble Marxist revolutionary doctrine. Constructivist architecture or stage design exposed trusses, skewed and tilted planes, and twisted the structural frames, beams, and columns. This vocabulary proposed the building not as a product—static and reactionary—but as a process, analogous to the building of a new society. The assumption was that architects have traditionally sought through the use of simple geometrical forms to sustain the "central cultural values" of order, stability, and unity. The Constructivists then shattered this conservative tradition of cultural stability.

There was much talk about reductivist means to express plastic values. A work based on only a compass and a ruler, devoid of all subjective elements or of any idea of "style," that bourgeois affectation, was said to express dynamic space and dynamic form. The Constructivist use of materials gathered at random and not previously associated with "high art" was seen as a materialization of Trotsky's argument about the revolution and the people. Wood, metal, tar, and glass were proletarian materials used by the Constructivists not for their elitist associative and narrative values (as in, say, a Cubist collage) but for their inherent formal, textural, and coloristic possibilities—and often, as in Liubov Popova's designs, for utilitarian purposes as well. These were modern industrial materials associated with factory labor, with the machine age, and with the dynamic movement that replaced the stasis of the ancien régime. This synthesis of material, volume, and construction was in its dynamic sense *for* the people; as it consisted of open structures integrated with the viewer's own space, it was *of* the people; and as

it emphasized the collaborative action of a group, it was even *by* the people. Vladimir Tatlin and others attempted by this strategy to represent the revolutionary ideals of aesthetic materialism and utilitarianism, of artistic self-effacement and depersonalization, and thereby to produce an art of both the people *and* the revolution.[27]

This art did not completely cancel the idea of an avant-garde elite. As Harold Rosenberg has observed, Constructivism could imply a self-effacement of opposite kinds, either "the utilitarian de-personalization of the factory hand" or "the metaphysical (or mystical) self-negation of the saint or seer": "Negation of self was also a necessary condition for an art of essences or metaphysical entities. The same abstract forms could represent either the anonymity of the conveyor belt *or* that of mystical revelation."[28] Much the same could be said of Suprematism. But the striving for the spiritual content of Marxist revolution in Suprematism, on the one hand, and for the material in Constructivism, on the other, were alternatives both doomed to failure, because of their essential lack of contact with the "people." Ironically, in this case it was probably not the "people" (if by that we mean the masses of Russia) who rejected this art but the petit-bourgeois civil servants of the Communist state, who, like Lenin, were educated in the old, conservative, academic art forms—precisely those that were branded bourgeois in Mexico. Soviet "realism," according to Trotsky, far away in Mexican exile, "consists in the imitation of provincial daguerreotypes of the third quarter of the last century."[29]

It is not impossible to sympathize with Andrei Zhdanov when he laid down the party line at the All-Union Congress of 1934. Looking around him, he saw a plethora of eccentric art movements, each trying to discredit the other, all apparently examples of bourgeois subjectivism, of formalism with no reference except to the art object itself. And so he discredited Constructivism and the rest, replacing them with "socialist realism," which was, in fact, "a romanticism of a new kind, a revolutionary romanticism" that showed only heroes and allowed the masses "to catch a glimpse of our tomorrows"—an attempt, as rhetoric, to transform "the human consciousness in the spirit of Socialism."[30] In practice, however, painters turned back to the art of the Wanderers, rebels of the 1860s but academicians of the 1930s, and especially to Ilya Repin, who survived into the Soviet period. Repin's famous painting of Ivan the Terrible clasping the czarevitch he has just murdered (1885) shows the son slumped in the pose of a dead Christ. Repin's student Isaac Brodsky produced the official image of Lenin in an urban version of the Garden of Gethsemane, redeeming his people. Walking through the Tretyakov Museum in Moscow and the Russian Museum in Leningrad, one sees that the genealogy of Russian socialist realism can be traced on the one hand back to French academicism and on the other to Russian religious icons. Lenin appears full face as a bald-Jesus icon, and his birth is celebrated as a movable feast that every year falls on Good Friday. As a man of ideas

Isaac Brodsky, *Lenin in the Smolni Institute,* 1930, oil on canvas. Tretyakov Gallery, Moscow.

and actions, he is a vigorously arguing Christ in the Temple or Among the Disciples.[31] The martyred-workers-soldiers of the history paintings are posed in Crucifixions and Depositions, just as David portrayed the heroes of his revolution.

The additional heritage of the avant-garde survived—for a time, at least, and in increasingly modified form—in posters and films. The film, the mass medium par excellence, is the best place to look for the Russians' popular representations of revolution—in Alexander Dovzhenko's melting ice floes and budding spring trees, or in Sergei Eisenstein's surging crowds contrasted with small groups of cigar-smoking, frock-coated capitalists enclosed in luxurious offices and clubs. The scenario of Eisenstein's *Strike* (1924) is of oppression, revolt, suppression, but spiritual (and potentially physical) victory—the same scenario used in his retellings of the Battleship Potemkin episode and of the October Revolution, but in the last followed by the release of the people by the Bolsheviks into crowds that flow into and over the palaces of the ancien régime as in the irreverent murals of Rivera and Orozco.

If on the public level the image is of the people flowing like a great river, overflowing its banks, the private version is the young couple in love—the subject of many paintings in the Zhdanov era. They too are accompanied by budding branches and melting ice floes, as well as by bursting fireworks and tumescent cannons. The echoes relied on are, quite simply, sexual when they

are not religious: Figures invoking Christ and the Virgin Mary are balanced by young lovers.

The American Revolution: John Trumbull

As the events of July 1789 approached, Mary Wollstonecraft describes the French, invoking the Americans: "All had heard of the glorious firmness of a handful of raw Bostonian militia, who, on Bunker's Hill, resisted the British disciplined troops, crimsoning the plains of Charlestown with the blood of the flower of their enemy's army."[32] Wollstonecraft's image is of the Americans killing British troops, launching an equivalent of the storming of the Bastille. One has to notice, however, that the image of the American Revolution as Fiery Orc was primarily an English one, promulgated by sympathetic propagandists in the 1770s and in the 1790s. Even Burke, who was to find these qualities noxious in the French revolutionaries, praised the Americans' active, energetic, youthful course of action, which he contrasted with "the listlessness that has fallen upon almost all" Englishmen. The Americans are "savage . . . uncouth," but "animated with the first glow and activity of juvenile heart."[33]

On the American side, however, the most memorable images were passive scenes of atrocities. The best known was *The Boston Massacre*, engraved by Revere.[34] The British troops, in a single rank resembling a firing squad, are mowing down the disorganized crowd of helpless civilians. The scene of brute military order crushing a natural human instinct for liberty was one that Goya was to develop into a far more powerfully compact image in his *Third of May, 1808*, where the huddled figure in Revere's foreground becomes a Spaniard, "shapeless and pathetic" (Kenneth Clark has observed) as an old sack. The "stroke of genius" Clark attributes to Goya of contrasting "the fierce repetition of the soldiers' attitudes and the steely line of their rifles, with the crumbling irregularity of their target" was already present in Revere's *Boston Massacre*.[35]

Little was made by the Americans of their positive gestures leading up to the revolution. The dropping of tea in Boston Harbor by colonists dressed as American Indians was itself a markedly symbolic action—a materialized cartoon. The colonists in reality tarred and feathered Tories and forced customs officers to drink large quantities of tea, in one case in toasts to a large variety of subversive subjects, a gesture reminiscent of the radical Wilkite crowd actions of the 1770s. This was the dimension of the revolution that Blake was to develop in his naked Orc figures disrupting the Urizenic order. Blake would have shown the colonists tar and feathering or pouring tea down the throats of British excisemen and sympathizers. It was not the colonists themselves, however, but hostile or sympathetic English artists who projected these scenes, extending the treatment to demure, naked young women.

It is possible to trace the origin of one graphic image. In April 1774, an

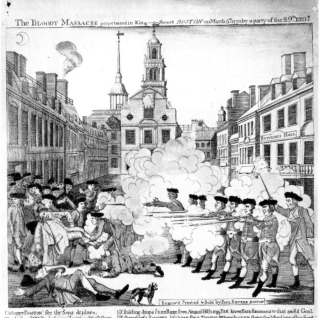

Paul Revere, *The Bloody Massacre Perpetrated in King Street Boston on March 5, 1770*, 1770, engraving. Yale University Art Gallery, The John Hill Morgan Collection.

English satiric print called *The Whitehall Pump* showed Lord North pumping water over and into the mouth of a prone Britannia in order to revive her.[36] She has collapsed on top of the prone Indian brave who represents America. In *The Able Doctor or America Swallowing the Bitter Draught*, published in the May issue of *London Magazine* that year, the female figure has been turned into an American. Lord North is now forcing the Boston tea down the throat of this bare-breasted Indian maid, held by Lord Mansfield, with Lord Sandwich (notorious womanizer that he was) securing her legs and peering up her skirt. Britannia, standing by, covers her eyes in shame. Even here, however, the British artist shows America gallantly spitting the tea back in Lord North's face. By June, this image of America, in a role of victim corresponding to that of the Americans in Revere's *Boston Massacre*, was copied by Revere for *The Royal American Magazine*, but with the Indian maid somewhat more passively vomiting or regurgitating than actively spitting. In October the roles were reversed in a series of English mezzotint prints: The active American colonists are now forcing tea down the throat of, and tarring and feathering, English customs officers. There follows the hostile atrocity print, *Hancock's Warehouse for Tarring and Feathering*, where the party being mishandled by the patriots has become a seminude English woman.

There is no indication that the prints in which the Americans are portrayed as the aggressors were copied in America, though they were probably imported.

Another in the same English mezzotint series is *The Patriotic Barber of New York*, which shows the barber chasing a Tory out of his shop, razor at the ready. Especially interesting is the rearing horse of *A Political Lesson*, a vigorous American beast casting off his English master. These show precisely the graphic image that the Americans themselves repressed.

The difference between the internal and external images is that the Americans initially wished to see themselves as underdogs and oppressed victims. They did not want to associate themselves officially with the kind of Wilkite insubordination upon which in many ways they actually modeled their actions. The self-image produced at the time of the Stamp Act crisis, and used from then onward, was drawn from the literary tradition of "Whig Sentimentalism" (as Kenneth Silverman has called it), which portrayed the "brutalization of those who sigh and are tender."[37] One form this took was of the father who disowns his child, invoking William Pitt's words of 1766, "The Americans are the sons, not the bastards, of England," and emerging in pleas to "GEORGE! Parent! King!" Another was the disdainful lover or seducer/rapist of the fragile young girl. Starting with Libertas, and feminizing her as Fair Liberty, the colonist propagandists fitted her into the sentimental tradition of Samuel Richardson's Clarissa—a tradition from which Burke also, of course, drew the imagery for his *Reflections on the Revolution in France*.

When the Bostonians carried out their Tea Party they were, from one point of view, turning themselves into American Indians, using Indian costumes as the sign of an active energy against tyranny. But with the occupation of Boston by the British troops, the active gesture was followed by a return to the pathetic. It was even reported as a fact that the British troops did tar and feather a colonist and parade him through Boston with fife and drum, with a label on his back, "AMERICAN LIBERTY, OR A SPECIMEN OF DEMOCRACY."[38] But much was also made of the potential of the occupying soldiers for raping Boston girls (pictured as "Fair Liberty"). "How will you feel," asks "Cato" in the *Newport Mercury*, "to see a ruffian's blade reeking from a daughter's heart, for nobly preserving her virtue?"[39] And when the war broke out, the American soldiers were presented as lovers arming to protect their women from seducers and rapists. In "To the American Soldiery" the author asks his comrade soldiers "whether we will see our wives, with every thing that is dear to us, subjected to the merciless rage of uncontrolled despotism"[40]

It was at this point that the Englishman Paine came to America. Just before the meeting that brought forth the Declaration of Independence, he published *Common Sense*, with its powerfully active images and its insistent connection of the sundering of the family with the parting or "separation" of the colonies from the father country in American "independence." From the image of the false father, the Saturn who can approve the slaughter of his own children, he moves (a few pages later) to the demand for something like Freud's primal horde figuratively to break up and ingest the royal symbol of the father: "Let the crown at

the conclusion of the ceremony ['a day . . . solemnly set apart for proclaiming the charter'], be demolished, and scattered among the people whose right it is."

There were a few other outspoken oedipal outbursts, such as the poem *HOPE* (1775), which urged that Lord North, the king's chief minister and surrogate, be castrated: "Barbaqu'd, broil'd, his MANHOOD toss'd in air."[41] Paine's wishes were virtually fulfilled a few months later when the equestrian statue of George II in New York City was pulled down, broken into pieces, and laid "prostrate in the dirt" by "Sons of Liberty" celebrating the Declaration of Independence. A newspaper block-print of the scene followed within days, but only some years later (1795) came the elaborate engraving that has become famous. Here are the Orc overtones so noticeably missing in earlier American propaganda. Indians are even present in the crowd, as a sort of reference to one sturdy aspect of the Americans, and perhaps also to the Boston Tea Party. There is even present that ubiquitous 18th-century symbol of dissent and natural subversion, a dog. But at the time, none of the ritual crowd action (from Baltimore to Boston) following the Declaration was recorded in graphic imagery.

The Boston Massacre, however, was a trial run for the history paintings of John Trumbull, the artist who celebrated the successful revolution in a series of eight paintings, intended for engraving and ending eventually as enormous canvases around the rotunda of the Capitol in Washington, D.C. The series was begun in 1784, the year after the Peace of Paris. The eight completed were *The Death of General Warren at the Battle of Bunker's Hill, The Death of General Montgomery in the Attack on Quebec, The Declaration of Independence, The Capture of the Hessians at Trenton, The Death of General Mercer at the Battle of Princeton, The Surrender of General Burgoyne at Saratoga, The Surrender of Lord Cornwallis at Yorktown*, and *The Resignation of General Washington* (all in the Yale University Art Gallery). These are small, freely painted canvases, of a size appropriate for engravings or for the *modelli* for paintings.[42]

Trumbull was an aristocrat, the son of a governor of Connecticut, and a soldier who had himself participated in the early battles (was present at Bunker Hill) and knew or could obtain access to all the leaders of the revolution, those "founding fathers." Thus the heavy emphasis on accuracy, on milieu, and on portraits. The subscription for the engravings made much of the fact that the artist was a Trumbull, a participant and survivor of the revolution, and these advantages later proved decisive when Trumbull was chosen to decorate the Capitol rotunda with the same pictures.

He was a colonial artist who, like Benjamin West and John Singleton Copley, was brought up on the primitive portraiture of local painters and on engravings imported from England. His first self-portrait shows him leaning on a copy of Hogarth's *Analysis of Beauty*, and his model seems to have been the Hogarthian conversation picture, with its small full-length figures in unceremonious poses, which by the 1770s was represented by Johann Zoffany's crowded groups. Zoffany's *Life Class of the Royal Academy* (1771–1772) was a work containing just the sense of founding fathers posed in the symbolic center

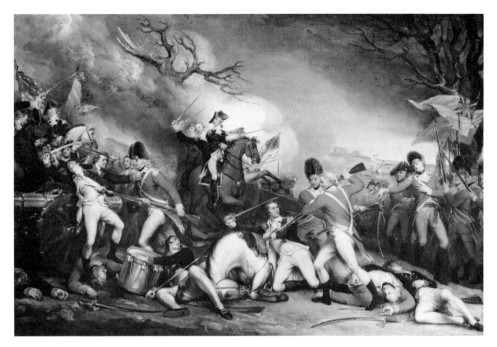

John Trumbull, *The Death of General Mercer at the Battle of Princeton,* 1787–1794, oil on canvas. Copyright © by the Yale University Art Gallery.

of their creation that Trumbull sought to recapture.[43] On the larger scale that Trumbull's sketches would assume when they graced the Capitol, this sort of conversation had been expanded into the genre of "history painting" in the famous works of his countrymen, West's *Death of General Wolfe* (1770) and Copley's *Death of Chatham* (1779–1781). Indeed, *The Death of General Wolfe* helps to explain Trumbull's peculiar choice of subjects.

Three of the eight completed pictures show dying commanders in the midst of a losing battle (or, in one case, of a battle that has not yet turned into a winning one). Irma Jaffe rightly connects these with the convention of painting the dead hero that West had employed so successfully in his *Death of General Wolfe.* She is, however, mistaken to pass off the death scene as simply another *exemplum virtutis,* a secularized version of a religious subject that wishes to stress not faith or martyrdom but "loyalty, courage, generosity, honor, and self-sacrifice in the service of one's country."[44] The contemporary critics who complained that Trumbull always showed defeats rather than victories also had a point, which neither Jaffe nor Trumbull answers very satisfactorily. Bunker Hill was a Pyrrhic victory for the English, who lost over eighteen hundred men and more officers in that one battle than in the rest of the war. And yet what Trumbull paints is the death of the American general, Dr. Joseph Warren. Or if he avoids the positive aspect of the battle, why does he not represent the victory of Lexington and Concord, which preceded Bunker Hill by just two months? Jaffe thinks Trumbull's concern was "not the outcome, but the behavior of the partici-

pants. He was concerned with personal morality as the virtue of the aristocratic and wealthy, and as an attribute of the officer class, whether British or American"[45]—and so portrays, for example, the British officer restraining his soldier from bayoneting General Warren.

The English (and continental) secularization of religious subjects into bravery-loyalty-patriotism is not sufficient to explain the painting of the Americans West and Trumbull. All one has to do is compare the use of pietàs in English art before *The Death of General Wolfe*: In Hogarth's hands they are subverted into the poses of the Rake and his cast-off mistress, or of Earl Squander and his erring Countess. Reynolds offered the alternative in which the model could elevate the figure, but his model was secular. When Reynolds used religious models it was for slightly witty purposes, as in his *Young Saint John the Baptist* or *Nelly O'Brien*. West, however, came from a much more vigorous and living religious tradition, from a center of Quakerism, and the pietà for him becomes a typological structure in which Wolfe is living out a micro-Christic fate, losing himself in the model. His death *is* in some sense a rebirth and redemption, because in his death is the birth of the British Empire. The suggestion is that his death not only plays out his own salvation but the providential pattern of his people's history in America.

It may be useful to think of Trumbull as following *The Boston Massacre* rather than all those deathbed scenes chronicled by Robert Rosenblum.[46] For Trumbull's scenes were not, as in West's *General Wolfe*, famous deaths at the moment of victory, but only the deaths of Americans fighting at great odds against the overwhelming force of the British troops. The death of General Mercer at Princeton was followed by Washington's rallying the troops to victory, but Trumbull chose to portray in the foreground Mercer dying in a losing engagement and only secondarily the victorious General Washington (who appears in the background) saving the battle after Mercer's failure.[47] Only in the perspective of final victory, when the paintings were conceived, could this be seen as a sacrifice leading to redemption. Trumbull and West were part of the sentimental ambience in which passive suffering can redeem. At the time, classical Roman analogies were also summoned up, for example in the poems on Warren's martyrdom, which compared him to Cato:

> Immortal Hampden leads the awful band,
> And near him Raleigh, Russell, Sidney stand;
> With them each Roman, every Greek whose name
> Glows high recorded in the roll of fame,
> Round *Warren* press, and hail with glad applause,
> This early victim in fair Freedom's cause.[48]

But with West, and much more noticeably with Trumbull, there is a sense of predestination hanging over these scenes. Trumbull shows the elect in tribulation but with sure knowledge (both in theological terms and existential, since the war *has* been won) of the outcome.

Only faintly does Trumbull reflect the youth-and-age metaphor so power-
fully used by Paine, Blake, and the English writers to represent the overthrow of
a decadent regime. In *The Death of General Warren* the British tend to be fairly
elderly and jowled, while the central American figures are young. Something
like the British oak appears in the battle scenes that follow, decaying from paint-
ing to painting until it has fallen to the ground in *The Surrender of General Bur-
goyne*, where a luxuriantly leafy tree first appears, a Liberty Tree of the sort seen
in the background of the prints in which Americans tar and feather British cus-
toms officers. But these are background details, like the appearance of Washing-
ton in *The Death of General Mercer*.

The other five scenes are all convenants, the most famous and successful
being the presentation of the Declaration of Independence to the Continental
Congress. The surrenders of the British troops are also covenants (the "capture"
of the Hessians is shown as their surrender—a compact), leading up to the resig-
nation of General Washington. Significantly, the Declaration of Independence
does not show the signing but the presentation of the document—of a precious
personal possession (to judge by the echo of N. G. Brenet's *Piety and Generosity
of Roman Women* in the central group at the table).[49] The responses of the mem-
bers are therefore important, as Trumbull would have known from having im-
bibed the treatises on history painting (under *l'expression des passions*).

The document is crucial because it combines the violation of the covenant
(by the British) and the establishment of another covenant just at the moment of

John Trumbull, *The Declaration of Independence,* 1786, oil on canvas.
Copyright © by the Yale University Art Gallery.

free choice, which was the center of the covenantal drama. Some congressmen who chose not to sign are pointedly depicted. Perry Miller, whose discussion of the profound significance of the Old Testament covenant between God and his Chosen People is still standard, emphasizes its preeminence in Massachusetts and Connecticut (Trumbull's state). The American order, "founded upon voluntary choice, upon the deliberate assumption of obligation, upon unconstrained pacts, upon the sovereign determination of free wills,"[50] was the theme Trumbull tried to suggest. His relatively muted secularization of the covenantal intention can be seen in the presence of the banners and battle trophies on the back wall, which seem to hover over the heads of the central group like an image of the Holy Spirit.

Thus Trumbull paints Baroque battle scenes constructed on long diagonals from upper left to lower right, focusing on an attacking, dying man; and he paints covenant scenes constructed on a central axis, frontal, with groups of portraits of the covenanters (or noncovenanters) in the act of choice. These are images of sundering and joining, and they lead up to the sundering/joining of Washington's resignation as general; Cincinnatus-like, he resigns, but again with the viewer's sure knowledge that this resignation will lead to (and make possible) his civilian presidency of the republic.

Most of Trumbull's paintings of the American Revolution were planned if not executed by 1789, when the French Revolution broke out, but the world situation had already markedly changed before he began. The Englishman Richard Price's *Observations on the Importance of the American Revolution* (1784) opened with the conviction that "next to the introduction of Christianity among mankind, the American revolution may prove the most important step in the progressive course of human improvement," but by the end he was writing that he has heard they are losing "those virtuous and simple manners by which alone Republics can long subsist," that "false refinement, luxury, and irreligion" are spreading. Should "excessive jealousy distract their governments; and clashing interests, subject to no strong controul, break the federal union—The consequence will be, that the fairest experiment ever tried in human affairs will miscarry."[51] Price and others were looking across the Atlantic and finding at work a natural process of change into corruption and personal anarchy, a very mild version of what would be sensed in the French Revolution. The prize essay subject offered in 1782 by the Academy of Lyon was "Was America a Mistake?" But then there was also the Federalist need after 1790 to distinguish the American from the French "revolution" as part of the propaganda war between the parties of John Adams and Thomas Jefferson. The American version has to be portrayed as only a conservative defense of established rights against the encroachment of British masters: pretty much the image Trumbull projects.

More characteristic than battle scenes and heroes, however, was the American "untamed" landscape—the sense of "savage America." In 1807, Trumbull painted a view of Niagara Falls to send for exhibition to England, but from a

John Trumbull, *Niagara Falls from an Upper Bank on the British Side,* 1807 or 1808, oil on canvas. Wadsworth Atheneum, Hartford, bequest of Daniel Wadsworth.

position above the falls from which one sees the waters disappearing down beyond the spectator's sight: Only mist rises up from the chasm. Having sensed this dimension of the falls, Trumbull domesticated it by framing and enclosing it in a Picturesque convention and reducing it to part of a Claudian landscape. He painted this Sublime scene—then the most famous natural phenomenon in America, a cataclysm to which the French émigrés gravitated in the 1790s—in such a way as to minimize the cataclysm, suppressing or civilizing the energy in precisely the same way he suppressed America's active, aggressive, energetic force in his revolutionary paintings into passivity and the signing of covenants.[52] As the Niagara Falls painting was made for an English public, and therefore transformed the falls into an image civilizing the American wilderness, so the revolutionary paintings repressed the same natural forces of cataclysm—those forces associated with the new, untamed continent.

When the French Revolution broke out, Trumbull immediately set sail for Paris. There he found David adapting his *Brutus* to the circumstances of the moment and making the same sort of parallel Trumbull had made between contemporary events and the heroism of republican Rome. His own response to the French Revolution was typical. It was the news of the fall of the Bastille that made him sail to France, writing: "The wonderful events which have taken place in Paris

afford such a field for my purpose that I cannot refrain from running there at least for a few days to reconnoitre."[53] His "purpose," of course, was the representation of his own revolution.

Trumbull viewed the French Revolution as arising from the American (as did Washington himself, in a letter to Lafayette urging him to support Trumbull's subscription) and believed that American "courage would be the inspiration for struggles for liberation throughout the world."[54] He also typically reacted against England's anti-French sentiment—the "mean malignant spirit," he wrote his brother Jonathan, that cannot bear to hear "that Frenchmen should have acted gloriously, and still less that America should be regarded as having given the great Example." Even the first serious madness of George III was part of his picture: "While France is rising to the highest dignity of Human Nature this paltry degenerate race are Idolizing a mad King & a drunken Prince."[55]

Trumbull in fact planned paintings titled *The Fall of the Bastille* and *The King's Visit to Paris*, the two scenes on which Paine focused in *The Rights of Man*, the first showing the populace breaking down the prison, the second showing the king, the other symbol of the past and the monarchy, surrounded by the Paris crowd—the passive, crumpling crowd of *The Boston Massacre* now actively leading the king. But already Trumbull had heard rumors of violence and was beginning to express his own fears of the American Jacobins who were struggling for preeminence in the 1780s. The turn taken by the French Revolution may have led to his curtailment of his large plans for the paintings of the American Revolution, as it certainly explains why he did not continue with his French paintings. Trumbull confined the dawning and changing significance of the French Revolution to his letters. Even his American pictures changed under the impact of history: Only the victories and covenants were finally used for the decoration of the Capitol Rotunda. The three death scenes were no longer suitable.

What we see are two different responses to the American Revolution competing by the 1790s, but by then one of them was advocated most strongly by Americans, the other by the Englishmen Paine and Blake. The images summed up by Trumbull probably represent the fact that Americans considered their relationship with the king as contractual, and indeed believed all political authority to be based on compacts. But they also reflect the position of Adams and the Boston Calvinists, who still drew on a belief in election (for an elite) and in government by covenant, its model ultimately the covenant of the Chosen People of God. Adams's *Defense of the Constitution* (1787), a book Trumbull would have known, admitted that one would be "foolish to believe that Americans were exceptional for being more virtuous than any other people" and that accordingly the republic needed a system of checks and balances. Naturally Trumbull used images of providential suffering and martyrdom as preparation for the victory he knew was to follow. Paine and Blake shared the same roots and traditions of English working-class radicalism, which kept alive the heresies of the Ranters and Levelers. They believed not in election for an elite governing

body but in election for all, not in government by covenant and passivity in the hands of God but in active energetic attack—on the Father Himself and on all figures of authority. It is understandable that Trumbull represented the covenant as the essence of the American Revolution; it was Paine's purpose to destroy this idea, and he exploited the subliminal feelings of the colonists for the paternal relationship, which they as earnestly repressed. It should have surprised no one that Paine went on to demystify the Father Himself in heaven in his *Age of Reason*, or that the American government was in no hurry to acknowledge him as one of themselves by seeking his release from a French prison during the Terror.

While I do not mean to set up equations that pin the essays that follow wriggling to the wall, it might be helpful to summarize what we have said so far. For example, "counterrevolution" can have two senses: It can, as in the case of Goya's art, share or surpass the revolution's own violence and change—or may be an extension of it; or it can curtail and close those aspects of the revolution, even repress the revolution itself. Second, there is a close relationship between the revolutionary metaphor and metaphors of the Sublime, metaphors of sexual intercourse and natural rebirth. These are, needless to say, strongly macho, active, and assertive images—summed up in Blake's story in *America* of Orc's rape of his master's daughter. But there is also sometimes a marked difference between the generation that carries out this revolutionary action and those who follow, and who propose, if not a counterrevolutionary account of the action, at least a secondary revision of it. Secondary revision is carried out, however, by three agencies: by the successful revolutionaries themselves (covering their tracks, so to speak), by the artists who work for them, and by the artists of the succeeding generation.

In the case of the French Revolution, however, the succeeding generation (Géricault and Delacroix) seems to have exposed much that was repressed by the official artists of the 1790s; but then again it can be argued that they were only representing their disillusion with the counterrevolution of the Bourbon Restoration. In America—to which we now turn—the repression was immediate and continuing through the 19th century. The idea of a "good" revolution, contrasted with the French "bad" one, ran parallel to the conviction that covenants—and so a narrative that substitutes for revolution a personal conversion—defined political reality on this continent.

TWO

THE NEW YORK SCHOOL

Tom Sawyer and American Painting

> It is a certain burden, this American-ness. . . . I feel sometimes an American
> artist must feel, like a baseball player or something—a member of a team writ-
> ing American history.[1]

Thus Willem de Kooning, the Dutch émigré who was a cornerstone of the re-
markable "revolution" or "breakthrough" most commonly known as Abstract
Expressionism (but also, not inaccurately, called "action painting") that took
place between the late 1940s and the 1950s. De Kooning, Pollock, Clyfford Still,
Mark Rothko, Arshile Gorky, Robert Motherwell, and Franz Kline—the great
"masters" of American painting in its Sublime aspect—saw themselves as
making a conscious break with Europe and the European past. The important
qualities of their "revolutionary" art (which they stressed during their lifetimes)
were supposed to be "American" and not merely the last gasp of a European
tradition. Perhaps painting in America partook of the idea of the "Great Ameri-
can Novel," equating Americanism with raw newness rather than with tradition,
as with vastness rather than with delicacy, shouts (or those endless sentences of
Thomas Wolfe and William Faulkner) rather than whispers, crude strength
rather than elegance, one powerful image rather than the protean variety of a
Picasso or the finesse of a Matisse.

But "America" carried along its own baggage. De Kooning remembered his
arrival in America as a youth, a stowaway on a ship from Holland: "I didn't ex-
pect that there were any artists here. We never heard in Holland that there were
artists in America. There was still the feeling that this was where an individual
could get places and become well off, if he worked hard; while art, naturally, was
in Europe." One went to America to be Horatio Alger, not Roderick Hudson,
and some unsympathetic witnesses (such as the journalist Tom Wolfe) would see

this as just what happened. The literary paradigm of the American painter was (according to the New York School's self-fashioning fictions) Mark Twain's Tom Sawyer and his whitewashing of his Aunt Polly's fence. This is painting as labor. But recall that the last thing Tom wanted to do on that marvelous day was to *paint*:

> The Locust trees were in bloom and the fragrance of the blossoms filled the air. Cardiff Hill, beyond the village and above it, was green with vegetation, and it lay just far enough away to seem a Delectable Land, dreamy, reposeful, and inviting.

Tom prefers experience, and the experience of a landscape, to a painting project that is work. What he wants is "half an hour of pure freedom," which is "the fun he had planned for this day," and instead he must whitewash

> Thirty yards of board fence nine feet high. Sighing he dipped his brush and passed it along the topmost plank; repeated the operation; did it again; compared the insignificant whitewashed streak with the far-reaching continent of un-whitewashed fence, and sat down on a tree-box discouraged.

Outside this *locus amoenus*, inside the house (which the fence protects), is the very paternal figure of Aunt Polly, against whom Tom is plotting rebellion.

Tom's realization, which turns him into the prototypical American artist, is "that Work consists of whatever a body is *obliged* to do, and that Play consists of whatever a body is not obliged to do." First, he "took up his brush and went tranquilly to work. . . . Tom surveyed his last touch with the eye of an artist, then he gave his brush another gentle sweep and surveyed the result, as before." Then, when his friend Ben passes and says he is going swimming and jeers at Tom for having to work, Tom replies complaisantly:

> "What do you call work?"
> "Why, ain't *that* work?"

Tom's reply sums up the intent of American Abstract Expressionism as it appears in the manifestos of its artists: "Well, maybe it is, and maybe it ain't. All I know is, it suits Tom Sawyer." It is Tom Sawyer's invention; it, in that sense, *is* Tom Sawyer: his identity, his choice, his freedom, and both his sublimation of the "Delectable Land, dreamy, reposeful, and inviting," and—because it does not itself contain a discernible trace of that landscape—the replacement that will allow him to enjoy that landscape itself. For his strategy, of course, succeeds, and all his friends pay him to allow them to continue (to participate in) the painting process, while "the retired artist sat on a barrel in the shade close by, dangled his legs, munched his apple, and planned the slaughter of more innocents."

The great "continent" of wall (Tom's thirty yards of board) bears a cathectic relationship to the landscape it does not physically represent, and the matter of how it is painted (how it is completed by Tom's audience and to what rewards that leads) is as important as how it looks: In short, the *way* it is painted serves for Tom as his act of rebellious self-assertion—even though he sits around watching the fence being painted rather than retiring to the *locus amoenus* that is the ostensible aim of his painterly strategy.

The cooperative enterprise of the fence recalls the Cedar Bar and the importance of the "group" for the Surrealists as well as for the Communists, for the "avant-garde" as well as for the revolutionary "elite." There was a striking tension in the thought of the New York School painters between the solidarity of the depressed (potentially revolutionary) social unit and the free gesture of the individual. Danto contrasts "the convivial three-holer of Long Island," the privy seat that bears the marks of de Kooning's painting, with Alberto Giacometti's lonely water closet in the courtyard outside his studio in Paris.[2] The New York School—however the degree of intimacy may have varied between individual members—presented itself as a "school" or "group," and thought of itself as a revolutionary cadre.

But if the first phase for Tom is to paint as if for the pleasure of the action, the second is to stand aside and collect the objects offered him in return for the pleasure of painting itself: namely,

> a kite, in good repair, . . . a dead rat and a string to swing it with, twelve marbles, part of a jews'-harp, a piece of blue bottle-glass to look through, a spool cannon, a key that wouldn't unlock anything, a fragment of chalk, a glass stopper of a decanter, a tin soldier, a couple of tadpoles, six firecrackers, a kitten with only one eye, a brass door-knob, a dog-collar—but no dog—the handle of a knife, four pieces of orange-peel, and a dilapidated old window-sash.

The whitewash and these peripheral objects (dog collars but no dogs, knife handles but no blades) point to the physical as to the useless quality of this art, which the artists themselves described not as Abstract Expressionist but as "direct" or "concrete," by which they meant self-assertive, emphatically empirical, unfinished, homemade, with the emphasis on—depending on how one looks at it—the freedom (and accompanying randomness or ambiguity) of the performance, or on the performance as "work": Pollock's pouring, or the wielding of Kline's or de Kooning's house painter's brushes (or of David Smith's acetylene torch), later the building of Robert Rauschenberg's and Jasper Johns's carpentered constructs out of paintbrushes, stuffed goats, and such objects as those in Tom's list.

First, the personal freedom: This is one of the qualities that D. H. Lawrence, in his *Studies in Classic American Literature* (1923), linked to the American penchant for "the pitch of extreme consciousness" reached by Edgar Allan Poe, Herman Melville, Nathaniel Hawthorne, and Walt Whitman: "The European

moderns are all *trying* to be extreme. The great Americans I mention just were it." Men went to America with Reformation and then Enlightenment ideas of liberty, "and so repudiated the old world altogether. Went one better than Europe," says Lawrence. "Liberty in America has meant so far the breaking away from *all* dominion." The idea of "breaking away from *all* dominion" connects with (perhaps helped to determine) the critic-painter Fairfield Porter's assumption, applied to the Abstract Expressionists, that "the American Revolution verified the nonexistence of any traditional system on this continent. It also verified the physical break with the European background."[3] American literature is punctuated with such assertions. In Hawthorne's *The Scarlet Letter*, Chillingworth converses with Dimsdale about Pearl, the illegitimate offspring of Hester Prynn (Chillingworth is Prynn's husband, and he is talking to her lover, for Dimsdale is the father of Pearl):

> "There is no law, nor reverence for authority, no regard for human ordinances or opinions, right or wrong, mixed up with that child's composition. . . . Hath she any discoverable principle of being?"
> "None, —save the freedom of a broken law."

Freedom of this sort—which in Pearl's case is identified with nature (seaweed, leaves, and twigs)—means a freedom (or at least the *assertion* of a freedom) from genealogy, from history, and from rational law, and it projects a world in which a pervasive law no longer exists. In the New World the individual must discover on the basis of his or her own freedom a new law. And Henry James's Isabel Archer, as well as Tom Sawyer and Horatio Alger, demonstrates that one may have to acquire money—and collect objects—in order to achieve freedom of action, though this exposes one to constraints of a different sort.

Behind all of these examples lies something like Hegel's pronouncement, following in the wake of the French Revolution, that the chief character of "modern" was going to be freedom. And in this respect American art carried within itself the potential to lead European art. "The European moderns are all *trying* to be extreme. The great Americans . . . just were it."

Freedom in this context means essentially to be oneself, and nature (in the form of landscape) is the ground base of this enterprise in that it allows human subjectivity to realize itself. The deep concern with self and personal identity is usually traced back to the Puritan fathers but was developed to a fever pitch by the generation of the American Revolution, with its ideas of personal liberty embodied in the relationship of a son to a bad or threatening father (George III). But if in American writing a poetic analogue of Abstract Expressionism was the confessionalism of Robert Lowell's *Life Studies*, in the novel it was Joseph Heller's *Catch-22*, and all the satires in which the self also asserted itself in a political way, as a Yossarian asserts himself against the faceless death of the flight lists by going without clothes or simply bugging out. The painters of the 1940s and '50s, a generation that came to maturity in the 1930s during the Depression, the

Spanish Civil War, and World War II, believed that the political situation, as well as the American preference for Horatio Alger, contributed to the great "breakthrough." The American ignoring of art allowed for what came to be called a *heroic* period of American art.

Second, Tom Sawyer's fence suggests the aspect of performance as "work." Porter was the spokesman, and de Kooning his example, for the view that these paintings more than any earlier painting are *about* the paint and the process of painting itself. Porter argued that while the Impressionists taught us to look at nature more carefully than hitherto, and the Cubists and Picasso taught us to look at the art of the past, the Americans "teach us to look very carefully at the painting. Paint is as real as nature." He cites, for example, the fact that "instead of feminine grace, de Kooning's women have the grace of the stroke of the brush at the end of his arm."

Leo Steinberg makes the point about different paintings of the artist's studio by Jean Léon Gérome and Thomas Eakins—the French and the American painter: Gérome paints a vertical rectangle corresponding to the figure of the model, Galatea coming to life under Pygmalion's embrace, whereas Eakins paints the artist and his model resolutely separate in a horizontal rectangle corresponding to the shape of the shop in which the sculptor works.[4] A modification of the Marxist sense of labor in the 1930s, labor is the issue in American art of the 1940s and '50s—not decoration, not conceptualizing, not even, as is sometimes thought, art for art's sake. It was art about the worker and the life model (Tom Sawyer's "Delectable Land"), not about the magic moment of transformation through love. The shop, the materials, the artists themselves—like Tom Sawyer and his fence—were the symbols of the art. The standard artist's costume was the uniform of labor—"the paintstreaked overalls, the dirty jeans and muddy boots and smelly flannel shirt of the laborer [which] implied a certain honesty"—and the tools were the buckets of paint and the wide house-painting brushes.[5]

When, as in de Kooning's paintings, an imaginative metamorphosis is the subject, the metamorphosis is the artist's, not the model's, and it takes the form of a conscious documentation of the artist's use of materials, with the signs of the work remaining in the overlaps of trial runs and even the simulated pinheads on the canvas. Rosenberg's "action painting" thesis, while expressing a truth about the painter's self-projection onto the canvas (and missing the symbolic content of the image painted), also points to a very powerful emphasis on the work done, on the application of paint, and on "the nature of paint" itself: we might say, the Constructivist aspect. It is not, I think, Clement Greenberg's "growing rejection of an illusion of the third dimension" that is revealed in this painting so much as Thomas Hess's counterformulation, the "increasing revelation of the artist's means, both technical and conceptual"—the brushstrokes that Roy Lichtenstein subsequently parodied in his blowups of a halftone comic strip brushstroke.

The corollary (or so goes these artists' fiction of themselves) is the idea that

European artists, including the nonobjective painters, were inhibited by their knowledge of the great tradition that lay behind them, whereas Americans, who had no sense of a past, or at least a national past, could, like Tom Sawyer, take pleasure only in the doing (or the nondoing), the carpentry or the house painter's flourishes, and the sense of freedom that joins painting and the experience of living in America in a peculiarly "homemade" way. This is not to deny that the Americans, though reacting against the past and denying it, in all sorts of ways still drew upon that past. But it does mean that their relationship to history, like their relationship to conventional content, was secondary.

What Porter meant by the paint or the painting process itself was "the labor of the process," which these artists, for the first time, demonstrate is a material out of which art can be made. Porter thinks that the object of these artists is "to turn work into art," or, even closer to Tom Sawyer, into play or foolery. But what labor or "workmanship" means in fact is "process," "not knowing what you are going to do ahead of time. The ability to be open to what is happening while you work"—or "accident," which is "an element unworthy of the ends of a completed painting that has been willed in advance." The Abstract Expressionists habitually contrasted this American process with the "European" desire for product, the American amateurism, the empirical or "homemade" quality, with the European tradition of art, of craft, of professionalism, and in particular (what all of these add up to) the European assumption that one wills a painting, subordinating everything (certainly accident) toward the preconceived end.

The Abstract Expressionists also contrasted themselves with the French painters on the grounds of finish versus openness, as of concepts versus empiricism. Motherwell remarks, "They have a real 'finish' in that the picture is . . . a beautifully made object. We are involved in 'process' and what is a 'finished' object is not so certain." To which Hans Hofmann adds, "The French approach things on the basis of a cultural heritage—that one feels in all their work. It is a working toward a refinement and quality rather than working towards new experiences."[6]

The idea of process as opposed to product—as of the unbounded interrelatedness of all things—can take either a contractive or an expansive form, with in both cases the sense of palimpsest, or of process of a layered sort in a limited space (though by comparison with other paintings a very large space). In a strange way, for total knowledge of one of these paintings both beginning and ending have to be charted: Pollock has to film the process of a painting, or de Kooning has to tell us—and include in his painting, in his pins and pentimenti—his total process from beginning to end. On the subject of "finishing" a painting, de Kooning has this to say: "I refrain from 'finishing' it. I paint myself out of the picture, and when I have done that, I either throw it away or keep it."

Rosenberg has explained this phenomenon by the American quality he calls "coonskinism," which in America meant painting a frontier, not a "landscape": "No wonder that the edges of the canvas meant nothing to the Hudson River

panoramists."[7] We could go much further, recalling Ralph Waldo Emerson's idea of the center everywhere and the circumference nowhere; or perhaps even Matthew Arnold's argument that a civilized (English) society is one in which the center prevails, in which metropolitan standards constrain the regions, but America is centerless, a chaos of disparate realities. Porter surmises that "to remove the object for which the landscape is the setting, or indicate that nothing smaller than the whole world is significant, is to make a strike into non-objectivity": literally so, as there is no central dominant object; and therefore, Porter argues, moving into his favorite thesis, there is finally only the objectivity of the paint and the paintings themselves.[8]

The size of these paintings fits into the context of self-consciousness in two ways. For one, as Lawrence Alloway has pointed out, the big pictures "made it possible to create works of art which are objects because they are large enough to affect our perception of them in relation to their surroundings." They become our environment. For another, as Frank O'Hara said, "The scale of the painting became that of the painter's body, not the image of a body, and the setting for the scale, which would include all referents, would be the canvas surface itself. . . . It is the physical reality of the artist and his activity of expressing it."[9] This included, in the case of Pollock for instance, even the imprint of his own hands, as well as the bodily gestures with which he poured the paint. From the imprint of Pollock's hands in his paint—the body part that paints and gestures—we move in the next generation of the New York School to Johns's imprint of his genitals, buttocks, and other body parts associated with other functions than painting: in short, producing a work less about painting than about a personal history or a social subset. Painting for the first generation, I am suggesting (and I will develop this idea in the next section), is still about art, and therefore, in their terms, is a social act.

Faulkner was one of the novelists read by de Kooning, and used for naming at least one of his paintings (*Light in August*); and there was in those novels the quality of carefully cultivated vastness. It was Faulkner's discovery (in Hugh Kenner's words) "that the symbolist expansion of an incident, provided we imagine the incident in a real world and not in an art-world like that of Mallarmé's *Igitur*, expands it into a kind of unbounded interrelatedness"[10]—and it was this American expansion of the symbolist convention that we see in that moment when Kline, for example, blows up a sketch from a few inches into several feet. As Faulkner said, the writer wants "to put all that experience into one word"—but "then he has got to add another word, another word becomes a sentence, but he's still trying to get it into one unstopping whole . . . before he finds a place to put a full stop":[11] a description that sounds very like Kline's spatial expansion, on the one hand, or, on the other, like de Kooning's unending process of painting canvases that were sometimes brought to a halt only by a friend's intervention.

Tom Sawyer's "continent" of wall and the landscape to which he contrasts it,

or at least the ambiguous relationship between the painting and the landscape to which he yearns to escape *from* it, are just another example of a preoccupation with the landscape of the vast American continent. Critics from Meyer Schapiro and Porter to Rosenblum have argued that Abstract Expressionism, as a prototypically American phenomenon, was a landscape art. American art, while it began with portraiture (with Copley, the first original American artist), emerged into something like a tradition or school at a time when landscape was the viable genre, in painting as in poetry, and when the American ideals were best expressed in a view of liberating yet threatening mountains and valleys. These scenes of extensive, really unending landscape were the American equivalent of the heroic homocentric myths of the European countries.

In this sense Abstract Expressionism represented one aspect of the American continent—however indirectly the authenticity of the vision was arrived at through European theories of the Sublime, and (originally) through the practices of Richard Wilson, J.M.W. Turner, and John Martin as they passed into the work of the Americans Thomas Cole and Frederick Church. Pollock was connecting himself with these painters when he said, "I have a definite feeling for the West: the vast horizontality of the land, for instance; here [on the East Coast] only the Atlantic ocean gives you that."[12] (Pollock's explanation has to be set against Greenberg's argument—I think largely after the fact—that American scale and environmental aim, as well as paint application, derive from Monet's "Waterlilies" series.)

De Kooning, whose women and landscapes are often interchangeable (he turns a woman on her side and develops a landscape) and are his two chief representational referents, put it this way: First, that while European abstractions derive from still life painting, his (American) abstractions derive from or refer to landscape; and second, that while European landscape tends to have "an objective center, as if the landscape were a still life, or, say, a mountain, . . . American painting does not have this sort of center, this division into 'subject' and 'background.'"[13] Tom's fence, in short, is the ideal cancellation of distinction between figure and ground, achieved briefly but decisively in Pollock's paintings of 1949—*Lavender Mist* or *Number One*—that have no visible figuration.

The alternative explanation is that the Abstract Expressionist generation internalized the Sublime of nature initiated by Cole and Church in the private subjective self of the artist. Barnett Newman's *Vir Heroicus Sublimis*, however, is the image not of a subjective artist but of a public man. Porter's assertion that "what continues to interest in such a work of art is the work itself and no outside references" is also a half-truth, missing one of the essential qualities of Abstract Expressionism. The art, Porter would say, is in some sense *about* labor, though "labor" or "work" turns out to be a sort of clowning or play, the ideal of Marxist society when the worker is no longer alienated from the work. But more to the point is the fact that the label of art-for-art's-sake, which may apply to the for-

malists, the Op artists, and the Minimalists of the next decade (represented for us by Tom Sawyer's exhibiting a single plank of his fence), simply cannot apply to the Abstract Expressionists.

Along with the extremes of consciousness and the assertion of personal freedom, Lawrence read a symbolic consciousness into the American character: "The Americans refuse everything explicit and always put up a sort of double meaning." Moby Dick the whale: "Of course he is a symbol. Of what? I doubt if even Melville knew exactly. That's the best of it." It is the tension between figuration and abstraction out of which the best of the American painters emerge.

Clyfford Still

Still was Greenberg's example of the painter who first demonstrated how to narrow the picture box of post-Renaissance art to coincide with the flat surface of the canvas. The influence *from* Still is obvious. Greenberg pointed out that if Newman's vertical divisions derive from Still's images, so also if you turn the Still canvas on its side you will see how Rothko's rectangles came about. Still's paintings, carefully arranged in series, seem intended to create both a total environment and a self-contained world.[14] As a series, they raise questions of representation: What does the small anchoring touch of a different color at the bottom of a canvas (a spot, a streak, a dividing line, like the touch of differentiation that startles the largely undifferentiated surface of some Turner landscapes) signify? Or the fringe of black ground along the bottom (or base) of a rich brown "sky"? There are basic questions of representation here, as in the "jagged line of lightning color" (as he called it) that persists, sometimes as the vertical line bisecting the whole canvas; as in the resemblance to the apocalyptic representations of Albert Pinkham Ryder in some canvases and to the English painters Martin and Turner in others; as in the sense of flames that persists in so many of the canvases, and the memory of primarily black and red. These shapes, like Kline's black-and-white shapes, suggest lost, abstracted, and generalized old master paintings, in this case specifically of the Turner tradition of the English Sublime.

Further, there is the question of what color covers what other (which came first), the contrast of shiny and mat (usually black) surfaces, and the constant use of the palette knife to apply paint, leading to surfaces of differentiated texture only (except when the palette knife is applying one color over another), and so the question of process, correction, and modification.

On the other hand, one notes in the few surviving paintings from before the late 1940s the same signs of Surrealism and Jungian archetypes employed by Pollock and Rothko. Still differs, however, in two respects: His images rise up out of the bottom edge of the canvas into a space as palpable in a painterly way as themselves, and so already challenge the distinction between figure and ground; and once past these introductory paintings, there is no indication of further develop-

ment into or out of the style of the "breakthrough" phase, which persisted for 35 years.

The catalogue of the Still exhibition in 1979 at the Metropolitan Museum of Art, New York, was largely in his own words. Here is Still on his own painting:

> One must not drag in past primitives or erudition to corroborate our position. This is a *different* thing.—a different meaning. . . . My work is equally independent at the moment—alive now, not proven by a continuum. I am myself,—not just the sum of any ancestors, and I know myself best by my gestures, meanings, and the implications of my thoughts and acts, not through a study of my family tree.

He talks obsessively about walls—"those gas-chamber white walls"—and his key word is "freedom":

> For it was in two of those arenas some thirteen years ago that was shown one of the few truly liberating concepts man has ever known. There I had made it clear that a single stroke of paint, backed by work and a mind that understood its potency and implications, could restore to man the freedom lost in twenty centuries of apology and devices for subjugation. It was instantly hailed, and recognized by two or three men that it threatened the power ethic of this culture, and challenged its validity. The threat was vaguely felt and opposed by others who presented an almost united front of their institutions.[15]

The words serve notice that Still's paintings are analogous to this kind of expansive, Whitmanesque—or, more recently, Carl Sandburgesque—rhetoric. He defines himself in Rosenberg's terms of action painting ("I know myself best by my gestures, meanings, and the implications of my thoughts and acts"), but he goes one step farther, establishing an architectural environment, associated with the Bauhaus style and white gas-chamber walls ("the limits of psychological repression characterized by walls"), to which he opposes the breaking, the absolute shattering, of these walls by his own paintings that hang on them. There is the conventional artist who merely represents or reinforces the walls (here he recalls Greenberg's premodern artist of the perspective-box room); and then there is the artist who breaks through the walls, creating a wholly new environment—which in a way relates Still to the Baroque artists. There is, of course, always a sense of one layer of paint breaking through or out of—or lying beneath—another.

Moreover, Still recalls for us Lawrence's warning (in *Studies in Classic American Literature*) that American artists "set up a sort of double meaning. They revel in subterfuge." This is a discrepancy Lawrence is pointing to between words and product: "The artist usually sets out . . . to point a moral and adorn a tale. The tale, however, points the other way, as a rule. Two blankly opposing morals, the artist's and the tale's. Never trust the artist. Trust the tale. The proper

function of a critic is to save the tale from the artist who created it." If you ask the artist about his work of art, "He'll tell you the lie you expect." But the point is that he does expect the representation to be symbolic—a gesture of liberation against some kind of oppression.

As to the words of the painters themselves, especially Still, it is well to remember that the rhetoric was conventional. Compare it with that of the photographer Edward Weston, who called photography "a way of self-development, a means to discover and identify oneself with all the manifestations of basic forms—the nature, the source—or wrote, "Photography has opened the blinds to a new world vision." This is what Susan Sontag has called (in *On Photography*) "typical of the overoxygenated hopes of modernism in all the arts during the first third of the century," but it is perhaps more truly in the rhetorical tradition of Whitman and Ezra Pound.

Pollock and Revolution

Although Pollock for a period reached the point of total field painting, Tom Sawyer's whitewashed fence, this was a very short phase. He began with figuration and went on to a *kind* of figuration in most of his poured paintings, and in the work following *Lavender Mist* (1950) he was returning to forms of central figuration. His own words were, "I don't care for 'abstract expressionism' . . . and it's certainly not 'nonobjective,' and not 'nonrepresentational' either, I'm very representational some of the time, and a little all of the time. But when you're painting out of your unconscious, figures are bound to emerge.[16] Pollock's earlike, broken-ovoid forms, for example, go back to the screaming mouths with jutting triangular tongues in Picasso's *Guernica*, the most famous political statement in art for New York artists of the 1940s. Moreover, the forms in the poured paintings still faintly recall Pollock's earlier, more representational abstractions, which were based on Orozco's angry forms.

Pollock was forming himself at a time when the latest exhibitions in New York City were Cubist, Surrealist, and "Twenty Centuries of Mexican Art" (all in 1940). The titles of the Surrealist reviews *La Révolution Surréaliste* and *Le Surréalisme au Service de la Révolution* show how Pollock, Rothko, Adolph Gottlieb, and other artists could be equally interested in Surrealism, Mexican primitive art, and the art of the Mexican Revolution.[17] The message of "Twenty Centuries of Mexican Art" to the WPA artists was "that the way for artists in the United States to achieve a distinctively original style was to look first to their own indigenous roots and then to transform them into a modern idiom."[18] The roots in Mexico were "indigenous" in the sense of pre-Columbian. Pollock abandoned Thomas Hart Benton as a model and replaced him with Orozco, whose forms (with an infusion of Picasso's *Guernica*) led into the shapes to be discerned in the palimpsests of his poured paintings. What Pollock took from both Benton and Orozco was an infrastructure. The question that hovers over the early can-

Jackson Pollock, *Naked Man with Knife,* ca. 1938–1941, oil on canvas. Tate Gallery, London.
Copyright © 1990 by Pollack-Krasner Foundation (Photo: ARS, New York).

vases is whether the abstract forms based on figurations of Benton and Orozco carried with them into the poured paintings any or all of the meaning of the original representations. Something of the passionate, twisted, El Greco-like folk ballads of Benton and the angry revolutionary cartoons of Orozco may remain in Pollock's Jungian archetypes, and even in his poured abstractions.

I take Robert Goldwater's comment that Pollock or de Kooning "views his art as more than pure vehicle" to mean that the painter reflects the forms of an Orozco, forms that express social protest, but removes their representations— their tenor—and makes of these vehicles an independent expression, that is, gives us anger, outrage, the assertion of personal freedom in the face of tyranny, without the accompaniment of the figures of fat capitalists, hungry masses, and heroic leaders.[19] Looked at in one way, the process is to take the agitated brushwork of a Vincent van Gogh or a Chaïm Soutine and to remove the representation—the manifest content—and then, to let the brushwork produce "automatically" its own approximation of representation, suggesting (in the dream sense) a latent content. Looked at in another way, the Marxist-oriented artist—as many of these artists were in the 1930s—might have agreed that literary or graphic forms are historically determined by the kind of "content" or ideology they have to embody. As that content changes, the forms are transformed, perhaps revolutionized, just as in society a mode of production determines the "forms" of its superstructure. Thus a Marxist artist might conceive of simply dropping the ostensible (represented) content and letting the form do the work by itself, carrying with it the same outrage.

It could be argued, therefore, that the action painting of the 1940s was the real style that evolved to express the American social unrest that had been expressed in the more conventional social-realist forms of Ben Shahn, William Gropper, and others in the 1930s. Rosenberg may still have been very close to the truth when he saw the "gesture on the canvas" in these paintings as a "gesture of liberation, from value—political, aesthetic, moral."[20]

The careers of the American Abstract Expressionists began with the Great Depression and the public activism of the 1930s, including the assumption that painting should raise the revolutionary (or at least social) consciousness of its viewers. One lesson of this propaganda art was the idea that committed artists show their outrage at the status quo in the marks with which they score great expanses of flat wall. Pollock's drip paintings relate in certain important ways back to the assumptions, figuration, and forms he learned from the mural paintings of the Mexicans. He presumably discarded the content, then the figuration, but retained the forms, which in Orozco's angry attack were the gestures of the artist as activist corresponding to the social gestures of the political revolutionary: perhaps the best an artist could do in post-Depression and post–World War II America; and, as we have seen, the greatest revolutionary art usually comes from peripheral countries where the revolution is aborted or contained, like Goya's Spain, Blake's and Gillray's England, and Pollock's U.S.A.

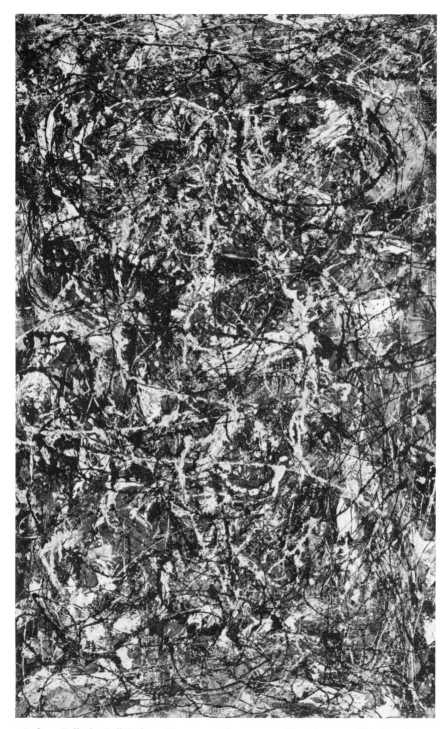

Jackson Pollock, *Full Fathom Five,* 1947, oil on canvas. The Museum of Modern Art, New York, Gift of Peggy Guggenheim.

While Pollock would have claimed that by the 1940s he was thinking in purely formal (for which we may also read *subjective*) terms—open, to use yet another terminology, to the sway of his own body above the prone canvas—there is no way that we can subtract from those forms the political content they embodied prior to their emptying, any more than we can ignore the actual act of emptying, or for that matter the powerful emotional—many would feel "revolutionary"—charge in Pollock's most "abstract" canvases. Pollock may have wanted to free himself from certain painterly restraints, but he did so with gestures and forms that had once carried a political meaning, and that—I think it is generally agreed—still did, though their immediate end was now probably formal rather than political. Not only their method but their self-affirming gestures are as close as we can come to the expansive energy that has been referred to as revolutionary in the scenarios of Robespierre, Blake, and Orozco, or of Aristophanes, Rabelais, and the Marx Brothers. We might want to argue that these expansive forms, once attached to depictions of political revolution, were then embodied in an aesthetic revolution, which they expressed better than if Pollock had been following, say, Reginald Marsh or Rivera, whose walls depicted a subject closer to Mikhail Bakhtin's Edenic carnival.

Finally, these paintings, however personal their body language, also remained in some sense—though obviously at a remove from—"popular" art. The size was an assertion that public space (initially public walls, in the event museum walls) was the only suitable space for them. (The Abstract Expressionists could not at that time have envisaged the corporate wall, or the modifications of private spaces that would come to accommodate their huge paintings.)

The best of the American muralists—Marsh, Grant Wood, Benton, and John Steuart Curry—had produced a consciously frescolike style, or rather different versions of one, in oil. They painted mainly scenes of "American" life, but had no indigenous style to connect with as the Mexicans did. The Futurist or Vorticist distortions of Benton approximated the folk vitality he tried to evoke, the severe Florentine (or Flemish) primitivism of Wood tried to dignify the rural Midwest, and the vaguely Michelangeloesque shapes of Curry's trapeze artists and faith healers said "Attention must be paid." But they all represented a culture, or at least a respectable subculture striving to become a culture, rather than a counterculture. They attempted a "popular" art in the sense of one that was to be experienced by as many people as could experience the Mexican murals.

At the time, however, these artists' styles bothered some middle Americans accustomed to the conventions of *Saturday Evening Post* covers, the murals of Dean Cornwell, and the book illustrations of N. C. Wyeth. Moreover, they had only "Americanism" to express, or at best a vague "Workers unite!" out of Marx and the Russians. There was only the dimmest indigenous folk culture—Paul Bunyan, John Henry, Daniel Boone—compared to the Mexicans' very specific one, with its violent, revolutionary content. Ignored were the many fragmented folk heritages of the American Indians and the blacks, but also of the Chicanos,

Puerto Ricans, Irish, Jews, Germans, and Italians—all groups, like the Mexican peasants, "deprived of their native arts" and especially of their "visual arts, because of their non-transportability."[21] Not that these were unmediated styles. Blacks themselves were using Art Deco versions of African forms in the 1920s and '30s. By contrast, the subculture artists involved in the mural movement of the 1970s in New York and Chicago found themselves, by way of Pollock, much closer to the Mexican experience: These artists went into communities and guided people, mostly the young, to cover the walls of their buildings with paintings. The iconographic, and often the formal, model was in most cases the Mexican murals, and especially those of Siqueiros for both politics and expansive style. This was a popular art in the sense that anyone, given the principles of composition the artists had discovered, revealed, and publicized, could assist in the painting. By the 1970s they were using Pop art or Mexican forms and images; Chicanos were using pre-Columbian allusions (via Siqueiros), and so on, as they went about representing their particular subcultures in splintered popular art. Americans had by that time been taught to accept images that could be produced, arranged, and improved by untutored, nonacademic persons.

The new element, however, in the wake of Abstract Expressionism, was that people did sometimes add their own thing. The one case of total independence (though artists naturally adjust whatever they paint to the panels that surround it) was the graffiti painters who worked more or less spontaneously and sequentially in the 1970s and early '80s. There were no planned areas, not even any clearly defined boundaries, and the only rule was that you not paint over what someone else had done. (Interesting effects on New York subway cars, however, depended on palimpsest.) Pollock was an artist whose effects became possibilities long since institutionalized for the nonprofessional painter.

In a larger sense Pollock's "revolution" was officially preempted by the U.S. media, packaged as a product labeled "American Freedom in Action Painting," and used as a stick to beat the timid, representational company art of the U.S.S.R. Pollock's painting thus became another paradigm of the art-of-revolution/revolutionary-art nexus. As Serge Guilbaut has argued, it was appropriated—not by Harry Truman and the government in Washington but by Henry Luce, by the media, especially Time-Life Inc.[22] The chief critical term was "universal," used by the artists to refer to the universal image each sought, but used by Time-Life to refer to internationalism (for which the cynic read nationalism), with the assumption (shared by artists and media-makers) that America had taken the place of France, and New York of Paris, as cultural center. Thus "universal" equaled American, as in "The American Century," and replaced isolationism in politics, regionalism in painting, and so Benton and Wood, as well as the Maine artist Marsden Hartley. The decisive Cold War act was to move not just from social realism but from figure itself, not just from abstraction (Cubism was abstract) but from representation itself, to nonrepresentational painting—but a nonrepresentational painting which Time-Life identified as Tom Sawyer's landscape regis-

tered on his Aunt Polly's picket fence. This was a painting with a strong macho painter wielding homely indigenous materials and expressing the endless stretch of the American continent.

Thus the avant-garde art of Abstract Expressionism—like the work of David's studio—came to "represent" (in the sense of typify) "America" as seen by the political elite. This appropriation domesticated the art in one way, in terms of the public understanding of it, as critics like Greenberg, who categorized it as primarily subjective and formalist, domesticated it in another.

Breakthrough

"Breakthrough" is the word most commonly applied to what happened to the styles of Pollock, Rothko, de Kooning, Kline, and Still in the mid-1940s. The word was not in the *OED*—was not an English term. In Webster's second edition its reference is military or mining—in the former, against resistance, as in a battle (or as in sports, breaking through the line). In a psychoanalytic sense, as in the mining sense, the patient's "breakthrough" is to an inner part of the mind. In a sexual sense, as in the revolutionary and sexual analogy, it is the penetration of the hymen, an equivalent of Newman's "Make it new."

The term raises the question of the threshold phenomenon or great leap forward shared by all of these artists. They are minor artists until, in the late 1940s, each discovers a new style and makes a "breakthrough" into a characteristic, definitive image that is not thereafter improved upon, that is ever after *the* "Pollock" or "Rothko" image. Their deaths or stagnations almost seem a consequence of the quintessential image and the impossibility of escaping or going beyond it.

Barbara Rose refers to "art history as a series of sensational breakthroughs."[23] "Breakthrough" implies that the work is seen *in* history, rather than as timeless, and so is susceptible to fictions of revolution, progress, and breakthrough. But "breakthrough" exposes a different model from the European model of the artist, for example Picasso, who develops from one style to another, progressing in some probably revolutionary sense. The American model is one of a single great discontinuity. It was the conflict of the two models that led to the dilemma of fulfillment in their styles and the need to continue to "develop" or "evolve."

Writing in the 1980s, Danto can elegize the idea of "breakthrough" as "those saving moments in the creative life that come rarely and to very few, when it is as though a dark glass had shattered or a blank wall had fallen, and the person to whom this happens enters, abruptly, onto fresh artistic or cognitive territory, his or her energy augmented, secure in the knowledge of having been graced." The word "grace" recalls Elaine de Kooning's account of the occasion when she and Willem blew up one of Kline's small ideograms with their slide projector, and Kline realized what scale could do: It represented, she recalled, a "total and instantaneous conversion." It was naturally seen as part of the characteristic American conversion plot. Danto thus describes Kline's discovery of "the expres-

sive power of size": "Kline became Kline in a way so immediate and unpremedi-
tated that the concept of decision has no application. . . . Kline could have
changed his name at that point, as Saint Paul did, so slight was the continuity
between the new Kline and the old."[24] These words are Danto's, but they suggest
(he uses the word "revelation") the way the Abstract Expressionists' breakthrough
was read as both revolution and conversion. Danto continues by comparing the
"moment" to Newton's experience with the apple, Röntgen's with fluorescence,
and Proust's with the madeleine.

The imagery of the paintings and the lives and deaths of the artists allowed
for overtones of death/transfiguration in the same kind of single self-sacrificing
but ultimately victorious act that we saw embodied in the American revolution-
ary paintings of Trumbull. The "breakthrough" also, of course, contained mem-
ories of the covenant (or of covenants, a series of them, to be renewed at each
stage). But the main point of sanction for a painter like Pollock was the resem-
blance less to Puritan fathers than to the Founding Fathers. There was the as-
sumption that toward the end of the 1940s he and the other artists found a way to
free themselves from the past, of both Benton & Co. in America and Picasso &
Co. in Paris. The next step after independence was imperialism. In 1950s Amer-
ica, with the size, handling, painting-in-series, valuation of the Sublime, and
landscape derivation, the concept of "breakthrough" was inevitably related to the
fulfillment in stages of the American "errand" or "Manifest Destiny," the move-
ment "west."

Michael Fried distinguishes between personal and instrumental break-
throughs: those that artists have in terms of their own development, but that have
no effect on the tradition of art, as opposed to those (like the breakthroughs of the
Abstract Expressionists, one by one) that also introduce new possibilities in art.[25]
For example, Kline's breakthrough opened up new possibilities of size, of draw-
ing on the scale of painting, of merging line and volume, of painterly gesture,
and of a sort of suggestive form and texture. But it also produced a distinctive,
personal, and signature *image*. Suddenly, all of these artists discovered what size
did to the small, Surrealist image of marked idiosyncracy, as well as to the libera-
tion of one's arms and body as the paint was applied.

Veiling

In de Kooning's words, Pollock "broke the ice" with his technique of pouring
thin skeins of paint, which produced a completely different effect from either the
repetitive pattern of the *Untitled* of around 1937 (an early experiment in total
field painting) or the calligraphic paintings of Lee Krasner and Mark Tobey. But
this was also an *image*, and the breakthrough phenomenon, which Hilton
Kramer saw as a "descent into the literary myths of the unconscious followed by
its rejection in favor of pure painting," left a painting that, at least for the painter
himself, remained full of content and meaning.[26]

Barnett Newman expressed the art-historical context:

> We do not need the obsolete props of an outmoded and antiquated legend. We
> are creating *images whose reality is self-evident* and which are devoid of props
> and crutches that evoke associations with outmoded images, both sublime and
> beautiful. We are freeing ourselves of the impediments of memory, association,
> nostalgia, legend, myth, or what have you, that have been the devices of West-
> ern European painting. Instead of making *cathedrals* out of Christ, man, or
> "life," we are making it out of ourselves, out of our own feelings.

The aspects are: size, inclusiveness, freedom of expanse, and at the same time
the *reduction* to a single, simple image or (as with Pollock) image system—and
often the concern with luminosity in the sense of a *shining through*. The lumi-
nosity, not the palimpsest, is what counts.

Thus the complementary aim of the Abstract Expressionists, especially
Rothko, Newman, and Kline (but by no means excluding Pollock and de Koon-
ing), was to secure *the* archetypal image, *the* mythic Jungian archetype, whether
this was a luminous, numinous square or a single vertical line. The powerful,
haunting, mysterious image emerging from paint (possibly arrived at through au-
tomatic gestures), the end product of the New York School, was the totemic im-
age, itself sublime in the way that an image of God in Glory would have been to
a medieval Christian, or that the omnipotent sun was to Turner.

The most obvious qualities are reduction and abbreviation, until (to use
Robert Carleton Hobbs's words) "the gesture and the medium itself coupled with
the barest hint of a schema were sufficient," and then expansion into monu-
mentality—but carried out in the particular context of the Surrealist and Cubist
movements of the 1920s and '30s.[27] The many exhibitions of Surrealist art—
which was in effect being transported from Paris to New York in the late 1930s—
elicited and were complemented by not only "Twenty Centuries of Mexican
Art" but such anthropological shows as "Prehistoric Rock Pictures in Europe and
Africa" (1937), whose effects were apparent in the pictographs and indeterminate
cave-wall backgrounds of Pollock, Hofmann, and others.

Looking at the Surrealist works imported from Europe, and at the Surrealist
collections and collages of miscellaneous items ("chosen objects"), it is easy to
see how Pollock could have overpacked as he did his bulging canvases of the
1940s. Surrealist images were the ones from which he chose, and Surrealist
forms those from which he sought ways of escape. It may be that the forms of
Surrealist art had proved inadequate to the content. In a sense, to expand an
André Masson drip painting to the size of a wall—adding the presence of
Orozco—gives the possibility of a Pollock.

But what the Abstract Expressionists retained and perhaps perfected was the
subject orientation of Surrealism, evoked by Jóan Miró's words: "To me it seems
vital that a rich and robust theme should be present to give the spectator an im-
mediate blow between the eyes before a second thought can interpose."[28] And

alongside the importance of content is the Surrealist artist's dependence on the unconscious. To quote John Graham, whose words carried weight with the artists who became the Abstract Expressionists, "the purpose of art in particular is to re-establish a lost contact with the unconscious . . . with the primordial racial past and to keep and develop this contact in order to bring to the conscious mind the throbbing events of the unconscious mind.[29] It was this end that the Surrealists sought to encompass, but they offered various and divergent means for doing so. The Abstract Expressionists did not follow the poetic automatism of Giorgio de Chirico, Salvador Dali, René Magritte, and Paul Delvaux, in which dream elements were represented "with the clarity of a nineteenth-century academic painting"; nor the free association from stains and frottage to consciousness and discovery in the works of Max Ernst.

What they developed was "physiological automatism," which Nicolas Calas (writing in 1942) attributed to "the free movement of the agent, the arm and hand. When Arp or Tanguy create their forms one has the impression that objects have been produced by a rhythmic movement of the arm and hand." Calas contrasts these "harmonious" movements of the artist's hand with the "spasmodic" movements of a child's scribblings, "interrupted by such obstacles as weakness of the hand and lack of attention."[30] The point that should be made is that the Abstract Expressionists modified the Surrealist unconscious into active choice—a more expansive, open, positive message, more Marxist and/or "American." (The more basically pessimistic message of Surrealism goes into the figurative tradition, and emphasizes the perspective box in the form of a closed, claustrophobic room.)

The practical result is forms that are loosely "biomorphic as opposed to the geometric forms" of the other powerfully influential school of the time, Cubism. The Cubist grid, however, "provided a basic modernist vocabulary while Surrealism supplied a working method. . . . Cubism provided a means for structuring even the most inchoate doodles occurring from psychic automatist procedures; and, more importantly, it was fluctuant enough to provide a needed indeterminacy."[31] The actual effect was to start with something like the Cubist armature and then to destroy it with the heavy coruscations of paint we associate with Pollock's early phases.

We are dealing, then, with the symbol as the one polyvalent word, the single all-expressive image, as with Rothko, Kline, Gottlieb, Newman, and Still; but also with the constant revision, the sense of process rather than product, the effort shown in action by Pollock and de Kooning, which reflects the Faulknerian attempt "to put all that experience into one word," but ending by adding another and yet another. With Pollock and de Kooning it is the infinite expansion in search of the one word that takes the form of size or the expansion of an incident into a kind of unbounded interrelatedness of all things, as a de Kooning image shifts from woman to landscape, from mouth to mailbox.

Cubist syntax was constantly qualified by the investigatory tool of the

Surrealist methods of automatism and indeterminacy, and this was done *on top of* the Cubist grid—by, for example, de Kooning's "superimposition of numerous cut and torn sketches" and by his "overlapping sketches of anatomical parts." The procedure relates directly to the method of Pollock's poured paintings, as described by Lee Krasner, which was to start with recognizable, usually biomorphic shapes, "heads, parts of the body, fantastic creatures," and then to obscure them as he continued to paint—precisely as in the earlier works he had done by worrying the image and not knowing when to stop. But when asked "why he didn't stop the painting when a given image was exposed," he answered: "I choose to veil the imagery."[32] Even in the late ideographic figures, clear in themselves, the paint is left to soak through a stack of rice paper from the top, the "representational" sheet, thus producing a series of "secret" or coded signs that obscured the sense of the original sheet.

In terms of veiling or making ambiguous, which is yet another Surrealist characteristic, Pollock's most telling work is *The Deep* (1953), in which the meaning, the interior, the "primitive layers of self," are focused in a single chasmlike opening, apparently in a foaming sea but equally suggestive of a vulva, down into which we look vertiginously. (The vulva was another vestige of Surrealist imagery, and was still to carry significance—though contrary—for Johns.) And so, if one coordinate of Surrealist imagery was political, the other was sexual, and the Pollocks of the 1930s and '40s might be said to have "veiled" both aspects.

Ellen Johnson (in *Modern Art and the Object*, 1977) interprets the need to "veil the imagery" as meaning to veil the object represented—the East Hampton field or the ocean. She directs us back to the issue of *Life* in which a photographer juxtaposed his photographic images of various natural phenomena (probably from East Hampton) with examples of Abstract Expressionism by Pollock, de Kooning, and others, in order to naturalize them, to make them acceptable to *Life* readers. Another fact to notice is that Pollock's titles changed at his "breakthrough." The titles of the 1940s—*Guardians of the Secret*, *Moon Woman Cuts the Circle*, or *Male and Female*, with their Jungian overtones—toward the end of the decade became first simple numbers and then landscape titles such as *Sounds in the Grass*, *Full Fathom Five*, *Shimmering Substance*, and *Autumn Rhythm*. Landscape painting has always been one way the artist could break away from literary painting without losing the need to convey personal meaning.

But "landscape" is only another metaphor, and representation and meaning are not in any case separable. When Pollock says of some of his paintings, "My concern is with the rhythms of nature . . . the way the ocean moves. . . . I work from the inside out, like nature," we have to ask, *in what sense of* "the way the ocean moves"? I have no doubt it was as Turner portrayed the way air or ocean currents move—that is, as his own mind moved. For the American Transcendentalists, for example, landscape was only one metaphor (related to the endless American continent) for the eternal "I." For there is also Pollock's often-stated

Whitmanesque wish to be himself "more a part of the painting," to "literally be *in* the painting." With the canvas stretched out on the floor, he says, "I feel nearer, more a part of the painting, since this way I can walk around it, work from the four sides and literally be *in* the painting."[33] He entitled no. 31 of 1950 *One* because he said he felt at one with it. "Every good artist paints what he is."

If there is a dominant image in the prebreakthrough paintings it is a totem or series of totems, the son's representation of the murdered father, which is essentially a rite of expiation. But the image Pollock is seeking in the pouring and the veiling goes back to the mirror image, the encounter that, as Jacques Lacan notes, "marks a fundamental gap between the subject and its own self or *imago* which can never be bridged"—that is, which has to be (can only be) recovered through the painted representation, into which the painter increasingly tries to insert himself. The aim is to reintegrate or recreate one's alienated image in the mirror. But Lacan associates this mirror experience with both primary narcissism and, "owing to the equally irreducible gap it opens between the infant and its fellows, the very source of human aggressivity."[34] Narcissism and aggressivity are the terms I would most closely associate with Pollock's essentially nonverbal but violent gestures both toward his canvas and toward himself, leading to the fatal car crash.

What one thinks of, confronted with the great Pollock canvases of 1947 onward, is the relation of the artist to the canvas—the distance required, or the obliteration of distance; the flatness of the canvas and the need to be able to walk over and on it, even to embed one's fingers and hands in its paint, leaving a handprint, or to embed in it objects found lying around the studio; but to make it oneself. I take this to be an expression of the paradox of the mirror phase: of the knowledge of separation, of the unbridgeable gap between oneself and one's image, and the furious attempt to bridge that gap and become the painting. In this sense Rosenberg's original formulation of Pollock's art as action painting can be justified; and we can also appreciate the usefulness of Charles Stuckey's essay on Pollock's handprints in *Art in America*, and see how this relates to Fried's discussion of "Realist" painting in France (Courbet, for example) as an attempt to bridge the gap between the figure in the canvas, the mirror substitute, and the viewer/artist.[35] The question, however, is whether the artist is leaving a trace (or a mark, as the dog does when it raises its leg) or, like Alice, trying to get into the mirror. The latter case leaves us with the possibility that the "breakthrough" was artistic only and not personally satisfying or self-expressive—that the closest he could bring himself to the canvas was those handprints.

We could, as Stuckey has done, go into the contents of Pollock's library, especially examining his admiration for Melville's *Moby-Dick* in relation to such paintings as *Full Fathom Five*. Or we could look closely at his sketches, where the imagery is not yet "veiled," and in which he makes certain kinds of representation. One image picked up is Picasso's horse with the spike protruding from its mouth in *Guernica*; another is the fat teardrop that he found in Orozco's

muscled figures, but that was also to be found in some Futurist and Vorticist art. The sheets of drawings show him making isolated circles—pages of them—that are essentially ovaries or embryos, eggs divided and undivided, rather like paramecia, bristling with cilia; or, alternatively, mouths bristling with teeth. These take over the canvases for a time before the breakthrough, and then return in the last years of Pollock's life, when—again looking for a new form, another breakthrough, after the immense, perhaps smothering success of the poured paintings—he returned to the one or two or three large shapes of this sort.

Whether we think of *The Deep* as vulva or whirlpool, female body or landscape, we could relate the Pollock image to the psychological experience of the Sublime, which means either the viewer's sense before the painting of unlimited space or of envelopment—an experience different from the normal act of scrutinizing a painting. For the problem of perception itself is raised by all those who write on Pollock. Hobbs connects the subject with Anton Ehrenzweig's theory that "the stratification of the mind into conscious and unconscious may well have its origin in the physiological structure of vision"—that much Abstract Expressionist form is based on peripheral, even scotopic (night) vision. This may or may not be true, but it is certainly the case that, as Hobbs says, "the more one stares at" many Pollock paintings before the breakthrough, "the less one knows about the figure. . . . Try as one might with *Water Figure*, one simply cannot get closer to understand the full articulation of the figure." Just to look for any length of time at these canvases or their pigments "is troubling to the eyes." [36]

But troubling in different ways: In the totemic pictures, where representation remains an issue, the effect is simply murky, overloaded, and unarticulated. (It is remarkable how unrealized—in the sense of confused—are the early works of Pollock. He was not an artist like Piet Mondrian, whose early works, though part of a development toward a totally distinctive form, stand on their own merits and might even be preferred by some to the ultimate abstractions. This is one important sense in which Pollock was a "breakthrough" artist.) In the poured paintings, where representation has become "veiled," the "troubling" of the eyes is partly a result of the veiling, partly of the absolute elision of figure and ground. When you step back from the invitation to immersion in this total-field painting, you see a spiderweb or a builder's framework, a scaffolding, or *something*—but something totally unrandom that corresponds to the figure in the earlier paintings. The *confusion* of the earlier paintings may have merely dramatized the struggle between these two elements, which is successfully resolved in the breakthrough paintings.

ABSTRACT FIGURATION I: WOMAN AND LANDSCAPE

Rothko

In an even more intense way than Pollock's, Rothko's art is complicated or compromised (depending on the point of view) by his statements and those of his critics.[1] His titles progress from *The Syrian Bull* and *Sacrifice of Iphigenia* to *Three Reds* and *Yellow, Blue and Orange*. The title forces the viewer to look at the aspect the painter wants attended to, but we also have Rothko's words: "We assert that the subject is crucial and only that subject matter is valid which is tragic and timeless."[2] And we have the stories that he surreptitiously dimmed the lights at his exhibitions and that he reduced his palette to degrees of black in order to keep the viewer's attention from wandering to incidentals away from the essentially "tragic and timeless" meaning. Peter Selz, in a Rothko retrospective in the 1960s, saw the late, darkening paintings as representing (or being) "doors of the dead" or "open sarcophagi."[3] Diane Waldman sums it up in her catalogue of the 1978 retrospective at the Solomon R. Guggenheim Museum, New York, as "a total environment, a unified atmosphere of all-encompassing, awe-inspiring spirituality."[4] Encouraged by Rothko himself, the critics have (Robert Hughes has acerbically pointed out) fallen invariably into the vocabulary of the Sublime. Hughes recounts the story of the American gospeler who was asked for a description of God, and who replied that He was not an old man with a beard: "My conception of Him is something like a great, oblong, luminous blur."[5]

Hughes, who believes that the rectangles serve as just a simple matrix for experiments in color, concludes that "Rothko's dilemma was that he wanted to employ the vocabulary of Symbolism—the fluttering space, the excruciatingly refined, sensuous color, the obsession with nuance—to render the patriarchal despair and elevation of the Old Testament." But Hughes's is only another formulation like Selz's or Waldman's, which in his case juxtaposes the critic's sensibility for art history with the painter's own view of what he wanted (or

thought he wanted; or after the fact wished) to do. We cannot afford to ignore either of these views; they are both ways of translating the experience of the painting, which certainly deserves it, into another, more readily comprehensible language.

Rothko forces us to qualify the generalization that the breakthrough involved enlargement.[6] He had already employed large size (in *Rites of Lilith* and *Slow Swirl at the Edge of the Sea*), and his breakthrough, when it came, had relatively little to do with scale. Perhaps in his case we have to call it the discovery that he could rely on color and tonality alone, without any assistance from lines or representational elements—something he did with the particular form of the "great, oblong, luminous blur."

Rothko had an amazing sense of color and texture, which is not approached by Pollock in subtlety (not even after the discovery of the skeins of thin paint). The paintings from 1950 on make plain what incredible things he could do within the limitations of the simple formal relations to which he reduced himself. In this sense, Mondrian is his particular precursor. But a more relevant analogy is with Claude Monet's haystacks, Rouen Cathedrals, and waterlilies. Those simple forms operated in the same way, as excuses for color and texture; and yet "excuse" is a totally misleading word. They were haystacks, cathedrals, and waterlilies. The point is that much more than Pollock, Rothko painted serial compositions that signify in groups, *as* rectangles or whatever they are, and in terms of difference.

These matters are subjective, of course, and all I can offer is testimony, which can be compared with that of other viewers (Hughes and Waldman, for example) and perhaps eventually used to approach some generalizations. I must, however, confess that given the long waiting line at the Guggenheim elevator, my procedure was (as it often is) to walk up the ramp and then down again. This meant that I saw the series first teleologically and then genetically; walking up, I structured my mind for the walk back down. It meant that I started with the final black-and-gray canvases of a single horizontal division, on which the eye focuses as on an area of terrific tension, hardly a line but an aura on one side of a dark demarcation. Perhaps for this reason, as I walked backward in time my eyes focused toward the middle stripe or rectangle (or field between rectangles), and the paintings of the 1950s came to be about a borderline situation, a reconciliatory experience. I find it even now impossible to focus on one of the rectangles, but only on the relation between them. I tend to see the paintings as a development (rather like Mondrian's prolonged effort to reach the edge of the canvas) toward the narrowing and obliterating of the boundary or transitional area, leaving only confrontation, only contact along a line. When the two areas, by now of seemingly immense pressure directed toward each other, and always with black above gray, were nearly balanced (in the last painting in the show, dated 1970), Rothko had reached an end. He had not exhausted his forms, but he had taken those forms to an end point of exhaustion. If he had not committed

suicide, he could have just as easily started another series based on the same forms, and perhaps reached another ending.

But to read back into the early works the progression of the last paintings is to get a very different sort of progression from what you get starting at the beginning. The first tentative paintings seem to have been concerned with verticals—tall Giacometti-thin subway passengers—until, in the *Subway Scene* of 1938, the horizontal demarcations first appear. The compositional unit is now the rectangle, the walls and horizontal railings, divided vertically by the pillars that support the ceiling. These paintings are genuinely subterranean, with all their emphasis on the horizontality of the space in tension with thin vertical supports. One of the things that makes Waldman's Rothko catalogue for the Guggenheim so good is her astute demonstration of how, in relation to the work of other artists, the Rothko image got that way—from the soft, fuzzy contours of Milton Avery, the colors and textures of Matisse, and the shapes of Mondrian. But Waldman overlooks the obvious progression to be found in the Rothkos themselves by following the Guggenheim ramp from *Subway Scene* (a very Avery-like painting) to the Surrealist paintings that follow.

Surrealism enters by way of de Chirico's Greco-Roman sculptural fragments. It is in fact the form of the architectural entablature that Rothko takes as distinctively his own, with its strong horizontal divisions of cornice, frieze, and architrave. In *Antique* (1938), for example, the bands are respectively decorated with Chiricoesque heads, buttocks, and feet, in a downward order based on the Vitruvian architectural model of the human body. Next, the symbols change to Jun-

Mark Rothko, *Untitled,* oil on canvas. Pace Gallery, New York.
Copyright © 1982 by Christopher Rothko.

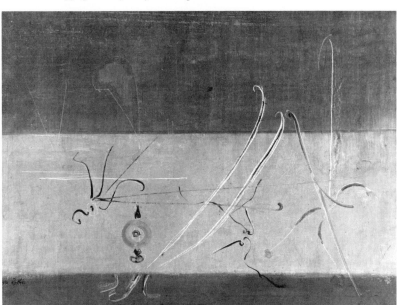

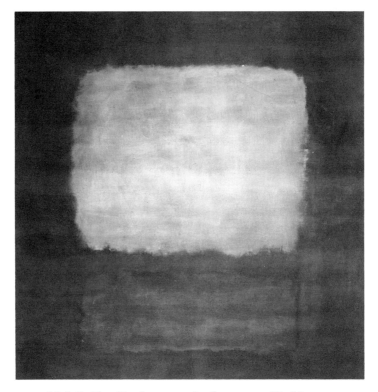

Mark Rothko, *Number 19*, 1958, oil on canvas. The Museum of Modern Art, New York.

gian archetypes, biomorphic shapes that recall Matta (or Paul Klee or Gorky), but the classical entablature remains intact in the background. The symbols are no longer contained but simply operate freely, as in *Hierarchical Birds* (1944–1945), against the tripartite horizontal divisions of the background. I would have to say in support of Hughes's opinion that those symbols hardly register as more than forms and leave one with no strong sense of what they resemble. The main impression is made by the delicate swirling lines of movement or force that surround them and define their space. (I wonder if this is the impression that remains in the fuzzy borders of the mature rectangles; at any rate, it might support the idea that they are *about* lines of force.)

What happens then, at the end of the 1940s (in the genetic terms I have adopted), is that Rothko simply wipes away the figures and lets the ground be the painting. He has not come up with a new, a different form; rather, he has purged the old one of its foreground excrescences, its conventional (Surrealist) symbols. If Pollock "veiled" his imagery, Rothko strips his away and leaves only the stage on which it played.

In this simple scheme I have skipped over the paintings of around 1948–1950 in which Rothko was working out the final form of the two or three rectangles. These paintings serve as an attempt to work out a compromise between

the horizontal and vertical forces of the earlier Surrealist phase—between the horizontal background pattern and the vertical activity of the foreground, which sometimes proved to be spinning or swirling horizontally. Some of these experiments avoid both horizontals and verticals, but they show various relationships of figures and ground that at length introduce the vertical stresses of the borders *beneath* the superimposed rectangles.

But the points I want to emphasize are these: Rothko's gesture, as well as Pollock's, is political. Of course, as Schapiro has distinguished them, Pollock paints with a "restless complexity," "a style of energy," while Rothko's paintings are "inert and bare," painted in "a style of passivity."[7] But as Schapiro realized, these are complementary expressions of the American situation of the 1930s: one an active, Orozco-like rebellion, a sexual discharge of energy; the other an expression of energy compressed, in terrific tension between the power held in check and ready to explode, a tension ultimately brought to bear on the horizontal line, as in the last paintings of no more than the line between two areas pressing inward. The process, as both painters show, is to subtract the subject matter (as de Kooning calls it at one point)—the social realism, social protest—and to retain the angry, independent gesture by itself. The vehicle has in this sense become the painting, and this per se makes of the painting an independent object in itself, in a far more meaningful sense than that of art for art's sake. This was certainly what characterized the best of American art in the first half of this century: Omit the content, as Edward Hopper omitted the illustration, the story; or as Rothko omitted the totemic figures before his luminous rectangles.

One form taken by all of these artists, as they developed into the artists of the late 1940s "breakthrough," was the return to primitive, totemic expression, which they carried back to (in Gary Snyder's words) "the fertility of the soil, the magic of animals, the power-vision in solitude, the terrifying initiation and rebirth, the love and ecstasy of the dance, the commonwork of the tribe." This involved an evocation of the America of "five hundred years ago [which] was clouds of birds, miles of bison, endless forests and grass and clear water. Today, it is the tired ground of the world's dominant culture." In other words, it was the social content of such primitivism that came to be emphasized, and both connected with the free American landscape, which was now being corrupted. And if one form this primitivism took was vaguely totemic forms, later reduced to even simpler, less representational shapes, another was the process of reduction itself.

The process continued with a gradual purging or simplifying of these totems or Moby Dick–like symbols until—as in Melville's famous chapter "The Whiteness of the Whale," or in Tom Sawyer's fence—only the whiteness, or the essential image, remained: the horizontal demarcations of Rothko, the large interlooping swaths of Pollock, the vertical lines of Still and Newman, the gigantic ideogram of Kline, and then the barely differentiated panels of Ad Reinhardt, Frank Stella, Jules Olitski, and others. This—extending, of course, beyond the

original group—represented a continuing search for the ultimate hieroglyph, which ended, as in Poe's *Narrative of Arthur Gordon Pym,* in utter whiteness or blackness, or in a glowing, powerfully evocative image like Rothko's.[8]

Marsden Hartley

If Rothko moves from figuration to abstraction, Hartley, a generation earlier, went from figuration to abstraction to figuration. Hartley's career can be read as an allegory of the American painter in search of his subject, which was also an attempt to replace, ultimately to confront and master, an absent, lost, or withdrawn object.[9]

Hartley's career began and ended in Maine, but he spent most of his adult life in Europe, taking in the phases of modern art at their sources. He started as a landscape painter of the Maine mountains, those flat ranges that are seen by the ordinary spectator as a panorama, hardly threatening, let alone Sublime. But painted by Hartley in vertical slices with a few farm buildings huddled at the bottom, the effect was of an oppressive yet protective shape bearing down on tiny traces of life. Having decided to be an artist, he went to France to absorb Analytic and Synthetic Cubism and to Germany to study the paintings of Kandinsky, Franz Marc, and others, and to develop his own brand of what he called "intuitive abstraction"—all apparently, as it turned out, in order to return finally to become the "Maine Artist" and paint the masterpieces of his final decade (he died in 1943).

This peregrination, which showed how badly Hartley wanted to be (and for a time was) part of the international art scene, reached its farthest point of alienation from the American subject, and from the American public, with the homages he paid to Cézanne in his synchronic paintings of Mont Sainte-Victoire—a very different shape from the blunt Maine mountain ranges. These paintings strained beyond recovery his relations with his most faithful supporter and dealer, Alfred Stieglitz, who believed in an American art independent of European influence. Ten years later Hartley ended his career with his absolutely personal (or American or Maine Artist) paintings of Maine's Mount Katahdin, which were also his own version of Mont Sainte-Victoire, and the end of his struggle to relate the art of Europe and America.

Hartley had very early on become aware of the paintings of Albert Pinkham Ryder, and in the last decade of his life he returned to the Ryder style—the only style, he said, on which an American tradition could be founded—and painted the remarkable portrait of Ryder in his stocking cap, with his long Ancient-of-Days beard tucked into his jacket. By paternalizing and internalizing him, Hartley returned to Ryder in the same way he returned at last to Maine and to Mount Katahdin.

As he moved from place to place he defined his art in terms of the polarities of inner feelings (or spiritual values) and formal values, with both of these terms

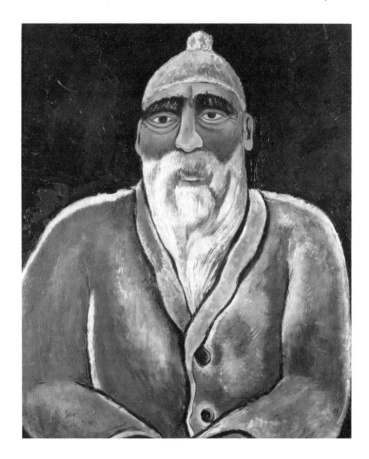

Marsden Hartley, *Portrait of Albert Pinkham Ryder,* 1938–1939, oil on board. Collection of Mrs. Milton Lowenthal, New York.

set up against observed nature. He learned from the Cubists, but he gravitated to the German Expressionists, whom he said he preferred to the intellectual French formalists because they "are more sturdy like ourselves." He referred to their mystical leanings, their "spiritual values" and "expression of inner feelings," which he felt were closer to his own aims, nurtured not only on Ryder but on the writings of Emerson, Henry David Thoreau, and the Transcendentalists. In practice this meant a certain sort of symbolism, but also an emphasis on the paint surface that linked him to Ludwig Kirchner and Max Beckmann, so that he remade Ryder in the angry idiom of Berlin in the 1920s. The "spiritual values" and "inner feelings" were also his way of referring to the feelings of a homosexual in anything-goes prewar Berlin.

The sidelong way Hartley came at being the Maine Artist included his being forced to return to America for financial reasons—literally in order to survive by becoming (probably following Stieglitz's advice) a regional painter; and his being psychically unable actually to return to Maine, living across the state line in New Hampshire, and then going to Dogtown in Massachusetts, to find yet another, a truer version of his Maine. The Dogtown pictures can also, of course, be seen as yet another homage to Cézanne, this time to the paintings of the rocks in the

Fontainebleau forest. Like the earlier versions of Maine in Germany and New Mexico, Dogtown was followed by others in Mexico, the Bavarian Alps, and a Nova Scotia island before Hartley finally settled into Maine with all of this complicated baggage.

Hartley found it difficult to return to—or face—Maine because of the childhood memories of abandonment he associated with the countryside. The biographical facts are that his mother died when he was eight, and his father remarried and then left his youngest son (christened Edmund) behind in Maine: "From the moment of my mother's death," Hartley wrote, "I became in psychology an orphan, in consciousness a lone left thing to make its way out for all time after that by itself."[10] This was a time so hard, so traumatic, that it was only with great effort, and much doubling back, that forty years later he could make himself resettle in Maine—even then spending as much time as possible in New York City. In between, he never stayed in the same house longer than ten months.

Hartley's relationship to his homeland vacillated between love and hate; but there is also the suggestive fact that he replaced the name Edmund, given him by his real father and mother, with Marsden, his stepmother's maiden name. Barbara Haskell, in the 1980 Hartley catalogue for the Whitney Museum of American Art, New York, surmises that he "perhaps wanted to reconcile himself with his father and to draw closer to his stepmother," but the insecure identification with his stepmother is presumably related to his vigorous, and ultimately unsuccessful, identification with Europe and European art, leading to his eventual acknowledgment of his father precisely in the paintings that merge Mounts Katahdin and Sainte-Victoire.

In the other symbolic version of Maine that Hartley found in Nova Scotia, he also recovered the family he had lost forty years before—in the Mason family, with which he lived for a short, idyllic time. But once again it was a family found and almost at once lost. He had made up for the loss of his father in the early European years by his attachment to young German officers, in particular Karl von Freyburg, whose image and whose death in the early months of World War I contributed to Hartley's major abstractions, the "War Motifs," as he called them. This love, though in the context of a family now rather than an officer corps (symbolized in the "War Motifs" by the regimental insignia, medals, and tents), ended as abruptly: Alty Mason and his brother and cousin drowned in a storm between the island and the mainland.

Hartley's motive was personal, and it could be argued that his greatest art (these two phases of 1914–1915 and the 1930s) came from a lost love. (He seems to have connected Mason's death with the watery death of Hart Crane, whom he had known in Mexico just before his suicide.) This time Hartley used the Ryder mode instead of Synthetic Cubism, finding objective correlatives in paintings like *Toilers of the Sea*. But he was also painting out of a social milieu seen in a particular political context, beginning with Germany before and after World War I, but also including America in the Great Depression. The stages can be

Above: Marsden Hartley, *Mount Katahdin, Maine,* 1942, oil on board. National Gallery of Art, Washington, D.C., gift of Mrs. Mellon Byers, 1970.

Below: Marsden Hartley, *Mont Sainte-Victoire,* oil on canvas. Private collection (Photo: Middendorf Gallery).

enumerated as 1) Stieglitz's belief that now "you have really no 'practical' contact in Europe and you are really without contact in your own country"; 2) Hartley's disillusion with Europe—"how barren Europe is—of ideas—of belief in art—or even of spiritual prospect. It is a country of forgotten ideas aesthetically speaking"; but 3) his further disillusionment with America itself, which on his return revealed itself as a place of spiritual and physical depression: "How chauvinistic and xenophobic America had become." It is not surprising that he found in the survival of the Ice Age moraine and primeval rocks of Dogtown Common a correlative to the situation he (and many other American artists) felt in the Depression years. The desolation, after all, included the foreclosure and dispersal of the last inhabitants of Dogtown; the holes where cellars had once been; the landscape that mingled rocks and ruins with undergrowth; and Roger W. Babson's jingoist inscriptions on the rocks ("Get a Job," "Never try never win," and "Help Mother"). Hartley's Dogtown was a graphic adumbration of Charles Olson's twenty years later in his *Maximus* poems—the end of all things, of America, and of the post office, equally of the ancient city of Tyre and of Massachusetts Highway 128.

Then, with the trip to Nova Scotia, Hartley translated Dogtown into the iconography of the rocky coast and stormy sea, the cause of Alty Mason's death (and the family's breakup). At the same time, in the convention of votive figures he had explored in New Mexico, he found a model for the "archaic portraits" of the Mason family, the *Last Supper* and *Pietà*, and finally the lone, isolated figure of a dead gull, plover, black duck, or white cod.

Even before the tragedy, Hartley saw the Masons as one aspect of the primitive or elemental nature he felt in the Nova Scotia landscape: "There is a touch of Christian martyrdom about the life anyhow, for they endure such hardships and hate any show of cheap affection." The extent of the transformation can be seen by juxtaposing photographs of the nattily dressed male Masons with the right-angled icons he constructed of them. The representation was based on German Expressionism and the political simplifications of the Orozco murals he had seen in Mexico in 1932. He was trying to express ideas of working-class art, and this meant that in his paintings of loggers and fishermen he conflated proletarian imagery (as in the murals of the WPA artists) with an early Renaissance iconography of Crucifixions, pietàs, and Last Suppers. The resulting figuration, however, joined the Christological figures with iron-pumping beach boys, their huge chests and biceps covered by checked lumberjack shirts.

The spectator is assigned a precarious position in relation to these strange allegories, somewhere between the patriot standing before the Renaissance Christian imagery of the Mexican muralists and a deeply anguished private lover asked to participate in the hermetic iconography of a gay subculture. *Fishermen's Last Supper* is painted on a tilt that suggests the viewer's—or the sitters'—rocking on a ship at sea, rocking and keening in grief, repeated in the tilt of the foundering ship on the wall, and made more eerie by the upright electric shocks

of hair on the heads of the drowned male members of the family. We have no choice but to view the picture through the grieving eyes of the artist, who is elevating his personal obsession by means of techniques that carry with them public and political associations of oppression and upheaval.

"One must destroy life," Hartley wrote, "and destroy it with images greater than itself." Looking back over his career, we see on his part an initial reliance on verbal allegories—reaching from the numerological symbolism in the "War Motifs" (for example, of eight) to the elaborately literary quality of *Eight Bells' Folly, Memorial for Hart Crane* and on up to the first version of *Fishermen's Last Supper*, with eight-pointed stars over the heads of the drowned brothers and "*Mene Mene . . .*" inscribed on the tablecloth. The second stage was to remove words, leaving only the symbol, stark and alone. The "War Motifs" had retained the concreteness of ideas Hartley associated with the German painters. As Porter puts it, "So in abstract German painting the details embody general ideas, and the painting as a whole is something that can be taught rather than experienced."[11] This perhaps explains why I find Hartley's landscapes and portraits surrounding the Masons so much more moving than the symbols with which he mourned Karl von Freyburg. His shapes now have primitive, animistic, and even Surrealist sources rather than the Cubist sources of the abstractions.

The landscape animates nature, not in the Transcendentalist sense but in that of Melville's *Moby-Dick* and its great white killer whale. In *Northern Seascape, Off the Banks*, the shore rocks have become sharks' teeth (recalling the shark mouth in the foreground of *Memorial for Hart Crane*), and in *Hurricane Island, Vinal Haven, Maine*, the row of rocks in the immediate foreground and the rocks opposite, separated by a savage line of surf, resemble an open whale's mouth. In both paintings the heavy clouds in the sky threaten a crushing force from above, as the rocks do from below; the tiny ships on the horizon appear to be ground between these opposing stones. (The ship in *Northern Seascape* is the same shown in the picture on the wall in *Fishermen's Last Supper*.)

In these landscapes, and in *Evening Storm, Schoodic, Maine*, there is a horizontal line that is being pressed from above and below, which in *Evening Storm* is broken, thrust through, by a giant wave. The wave has taken on the form of Mount Katahdin, a roughly phallic shape of the sort Paul Rosenberg pointed out in Hartley's paintings as early as 1922 (in *Port of New York*). Once he had turned away from the high horizontal line of the mountain range in the early Maine landscapes, Hartley developed a shape resembling a Gothic arch, which dominated his abstractions. This is the shape in the "War Motifs" of the pile or collection of medals or of regimental banners, topped with a plumed German officer's hat, and of the triangular soldiers' tents (or, in the American Indian paintings, of teepees). These conical shapes, which eventuate in the mountain peaks of the Garmisch-Partenkirchen and Mount Katahdin paintings, can be taken in the "War Motifs" as a kind of portrait of von Freyburg, in the manner of Marius de Zayas or (in words) of Gertrude Stein, and so an ambivalent representation of the

Marsden Hartley, *Hurricane Island, Vinal Haven, Maine,* 1942, oil on canvas.
Philadelphia Museum of Art, gift of Mrs. Herbert Cameron Morris.

thing about von Freyburg that Hartley both admired and now saw to be only a
heap of vanities—truly ambiguous, as they must have appeared to Americans
who looked dubiously at the pictures when they were exhibited just before Amer-
ica's entrance into the war. But the shape is essentially the totemic one of the
father and his surrogate the mountain, reappearing finally in both the archaic
votive portraits (themselves derived from the similar shapes of the Madonnas
that Hartley painted in New Mexico) of the Masons, Ryder, and other symbolic
"American" figures (including Abraham Lincoln; and even a funerary image of
John Donne wrapped in his shroud).

Mont Sainte-Victoire, then, becomes Mount Katahdin, the breaking wave
on the Maine shore assumes the shape of Katahdin, and both of these shapes—
so different from the flat range of mountains in the early landscapes—recapitu-
late the Gothic arches of the abstractions. And yet Hartley himself, before he
could paint his final images, felt he had to confirm these images-out-of-art by
climbing Mount Katahdin. He had read Thoreau, and he must have known *The
Maine Woods* (1864), in which Thoreau describes his agonizing climb of Ka-

tahdin.[12] Halfway up, Thoreau stops, looking around at the boulders and broken trees, and concludes that whereas in Europe nature is seen as having human meaning, in the New World it bears no kinship whatever with mankind. He sees his struggle up the mountain as "scarcely less arduous than Satan's anciently through Chaos," and he repeatedly quotes Milton's description of Satan struggling through the murky area between heaven and hell. For this association of the mountain with nature-as-chaos and of himself with Satan includes the notion that mountains are the high places where gods live, and, he writes,

> It is a slight insult to the gods to climb and pry into their secrets, and try their effect on our humanity. Only daring and insolent men [like Thoreau and Satan], perchance, go there. Simple races, as savages, do not climb mountains—their tops are sacred and mysterious tracts never visited by them.

As Hartley also knew, the Maine Indians had made a god of the mountain. The climber mythologized his climb in terms of these contradictions, and the painter carried them with him when he painted the distant peak—which, moreover, from a distance regained its resemblance to *the* symbol of art for a painter of Hartley's generation, Cézanne's Mont Sainte-Victoire. Hartley, like Thoreau, placed himself in the position of the satanic challenger scaling and controlling the Father through representation.

From the top, as Thoreau wrote, "we could overlook the country west and south for a hundred miles"—seeing the whole state of Maine—though it was nothing but "immeasurable forest" with "no clearing, no house." This is not the view Hartley paints; he returns to earth and paints the mountain as it stands, distant and unapproachable; and yet it is significant that he had to "climb" it first (in the sense that he approached and camped at its foot), before returning to the safe spot from which the Sublime could be represented without overwhelming the spectator with the threat of engulfment.

On the mountain—climbing the mountain—the experience was more like Dogtown. It was utterly alien to man:

> Man was not to be associated with it. It was matter, vast, terrific,—not his Mother Earth that we have heard of, not for him to tread on, or be buried in,— no, it was being too familiar even to let his bones lie there—the home this of Necessity and Fate. There was there felt the presence of a force not bound to be kind to man. It was a place for heathenism and superstitious rites,—to be inhabited by men nearer of kin to the rocks and to wild animals than we.

In Dogtown Hartley had been content to represent this experience of being-in, or of Satan slogging through chaos. But for Mount Katahdin he had to return to earth and look back, turning it into another totem, and incorporating the experience into the larger experience of the totem he associated with is earliest memories of Maine and its aesthetic equivalent in the landscapes of Cézanne.

Hartley's influence on the generation of artists that followed him is only be-

ginning to become apparent. Johns shares the imagery of Crane's death and the gay subculture. Avery's landscapes and seascapes certainly show the effect of contact with Hartley's late paintings, including the figure paintings of the Mason family and beach boys. It is difficult to image Philip Guston's last-phase paintings without Hartley's Dogtown. But in a less direct way the crucial case is Rothko.

Hartley's progress and his final hard-won image hauntingly evoke the image Rothko arrived at in his mature paintings. This began as a modular background against which Rothko placed totemic or archetypal figures, which he then removed to leave the stark rectangles with which we are familiar. The Rothko rectangles can be approached as a substitute for the monoliths that originally appeared in front of them, along the line of Hartley's votive Madonnas and "War Motifs." Alloway has described a Rothko as "presenting clouds with the weight of oceans or suns," which "vibrate, advance, and expand."[13] Indeed, Hartley's *Summer Sea, Window, Red Curtain* of 1942 has turned his usually palpable cloud into the anticipation of a Rothko rectangle, luminous and blurred. Or the rectangles can be read as a Hartley landscape in which the immense pressure of the rocks below and the rocklike clouds above come to bear on the horizon line (in which Hartley sometimes places doomed sailing ships). The pressure Hartley exerted on the horizon is much the same as that exerted by Rothko in his last paintings, where there is no more than the glowing line separating a light and a dark area of paint.

The devious path I have traced also, and primarily, connects Hartley with the central, perhaps informing tradition of "American" art—landscape painting. While the French followed their revolution with history paintings of heroic Roman subjects, the Americans (after the usual propaganda pieces) rejected the European tradition of figure painting for landscape. This tradition connects Washington Allston and Cole with Pollock and de Kooning and the total-field paintings of the Abstract Expressionists. Cole and de Kooning, however, have in common with Hartley the virtual interchangeability of human (Hartley's totemic or votive) and landscape images. Women and landscapes are de Kooning's primary images. Cole's landscape, as Bryan Wolf has shown, presents a threatening paternal mountain, before which is a small promontory from which we as spectators challenge the mountain but see no way across the abyss to make common cause with it.[14] Whereas, in the far distance, there is a small *locus amoenus*, the spot to which Tom Sawyer wants to escape, a beautiful sunlit meadow, which is *beautiful*, as opposed to the sublime threat of the mountain. One's eyes search the canvas for some access, but it is not there. Cole, according to Wolf, works out the solution by having slender fragments of mist connect the mountain with the meadow in the distance. The landscape became, I suspect, the way the American image-makers joined their endless plains, forests, and mountains with their original revolutionary images of themselves as sons rebelling against a father—England, George III, any authority figure—while at the same time repressing for themselves the distressing reality of revolution.

Marsden Hartley, *Summer Sea, Window, Red Curtain,* 1942, oil on canvas. Addison Gallery of American Art, Phillips Academy, Andover, Massachusetts.

Hartley's Katahdin rises from the gentle slopes of the middle-ground, which separates a lake in the foreground from the cloud-spotted sky. The hills beyond serve to blunt and soften the precedence of Katahdin. In one painting of 1941 the mountain is submerged in a range, returning to the roughly horizontal line of the earliest Maine scenes. The clouds above are the same color and texture as the mountain, and the formal relationships are less those of Cole's sublime landscape than the interplay between the mountain shape and the parallel lines through which it rises—remnants of the horizon and rocky shore in *Evening Storm* and the seascapes. Now, however, the area at the bottom is the open mouth of a lake, and the emphasis is on the rising mountain shape.

De Kooning's interchangeable women/landscapes are equally threatening, each a version of something as ambiguous as the great white whale. De Kooning's women, with (at least in some cases) the aura of the "love goddess" Marilyn Monroe, are in this sense in the tradition of Hartley's votive Madonnas, his "War Motifs" with their phallic shapes topped with plumed helmets and soldiers' tents, and his archaic portraits of Ryder and other "American" heroes—as Hartley shows, the alternative to the landscape tradition, in which a broad expanse of sea is devouring, or a mountain rises threatening in the distance.

All of these artists, painting during the same years, make the same search for the one summary symbol, the single all-expressive image, which for Hartley is the mountain- and seascape. Shared also is the need to see these final images as the culmination of a series of trials, or as revealing a sense of process and pilgrimage ending in conversion. In the years following Hartley's death, pilgrimage takes the form of palimpsest or of a series of layers in a limited space, the privileged dimension of the longer process in time in which one painting of a woman or a landscape follows another. A second change is enlargement to an often gigantic scale, and so monumentality, and a kind of painting that makes much larger claims for itself than Hartley's did. Nevertheless, these two modifications simply draw further attention to the importance of the physical pilgrimage of Hartley from Maine to Europe and back to Maine as represented in the series of paintings that registered his search.

De Kooning

De Kooning now remembers the great paintings of 1945–1955 as formalist acts: He added one form or color to balance another, in a sort of continuous seeking and rejecting of resolution or closure. Perhaps more successfully than Pollock, he suppressed his original choices and representations by moving and turning them arbitrarily about until they had lost, or at least skewed, their strictly representational or denotative origins, even for himself.

"Veiling," the word applied to Pollock's method of abstracting figuration, also describes de Kooning's essentially Surrealist mode, beginning with the immediate and unconscious movements of the artist's hand and mind. But de Kooning's talent for representational drawing had to be checked by arbitrary movements of the elements he drew or pasted on the paper. He once copied Bruegel's painting *The Blind Leading the Blind* and then turned it 90 degrees to get a less biased, more accidental composition. He also, more notoriously, turned one of his "Woman" paintings on its side and began his "Landscape" series. He took an image powerfully eccentric in itself, whether Bruegel's or his own, and distorted or estranged it.[15] (Krasner's similar strategy was to make abstractions out of fragments of her own earlier paintings; thereby making a statement *about* that earlier work and the relationship between it and the later.)

We could contrast these with the paintings of the contemporary German expressionist Georg Baselitz, whose compositions at first resemble Abstract Expressionist paintings. But on closer inspection we see that the paint represents figures who have been turned upside down. By painting figures this way, Baselitz tells us, he estranges them, forcing us to see elements of abstract form (which may recall a de Kooning). Thus he offers a double disorientation, of the painter's gesture and of the representation. But by simply reversing the canvas, and by including the human element, he has forced the spectator to ask: Did he paint it upright first? Does it affect the brushwork to paint a representation upside down? Does turning it upside down assist pattern or disorient figuration? Do I adjust my

eyes as to the rest of the visible world, and see it right side up? Or do I naturalize the image into a particular memory of Mussolini hanging head-down in a Milan gas station in 1945—or into a general symbol of our society as the world-turned-upside-down? These are quite different issues from those raised by a de Kooning, but they still indicate a kind of painting that focuses our questions about the relationship of the Sublime to incomprehensible (natural) shapes, to the human figure, and to the artist who participates in relation to these different forces.

Stuckey has described the process of de Kooning's paintings: they are developed "from drawings, cut, realigned and redrawn again and again," and in the final painting he includes "representations of these studies, or the studies themselves. . . . As a result [as his version of action painting], his pictures represent the stages of the artistic process itself, including its pauses, frustrations and marginalia. His method amounts to a special variety of painted collage in which the individual shapes of a finished picture are a record of the studies involved in the work's development." [16] This means that de Kooning's beginnings are as important as his "endings." As he said to Harold Rosenberg: "That's what fascinates me—to make something I can never be sure of, and no one else can either. I will never know and no one else will ever know." [17] That is, the rationale for his composition by palimpsest is what Rosenberg calls "metaphorical abstraction"—by rearrangement and abstraction from a representational object, perhaps an image in a film or a remembered dust jacket of a novel, perhaps only the words "HOPE" and "MAN" across the top and bottom of the canvas.

De Kooning disorients his figures to the point at which the viewer's task is divided between a visual pursuit of the changing shapes and combinations—and of the traces of the artist's revisions as he twists representational shapes until they are no longer representational. The process of de-figuration has perforce become the subject of his painting: the artist's shifting play of formal values or his change of mind, the drama of his artistic self-assertion and self-doubt, or of a confidence of his own power so great that he can afford to leave behind the signs of struggle, of trial and error. De Kooning, like Pollock, wants the viewer to see the figuration struggling against the de-figuration.

But for each painting there was a knowable point of departure, which contained a meaning, and there is the final result, perhaps years later, which has long since lost all touch with the original, perhaps arbitrary image, and to which de Kooning now attaches a title that probably applies to the final result—or may even be facetious. The title *Mailbox* supposedly appealed to him because there was no reason to select it. And yet the picture is full of toothy mouths that resemble mail slots. He found and designated something representational that had emerged in the process of painting. But in doing so he designated an aspect of the painting, when he was seeking only a series of interlocking or connecting forms, meanings, and representations—"something I can never be sure of, and no one else can either." And this was a *series in time*, whose sequential meanings were perforce lost by the time the painter had come to a stop.

What of these meanings (or the original, originating one)? His "break-

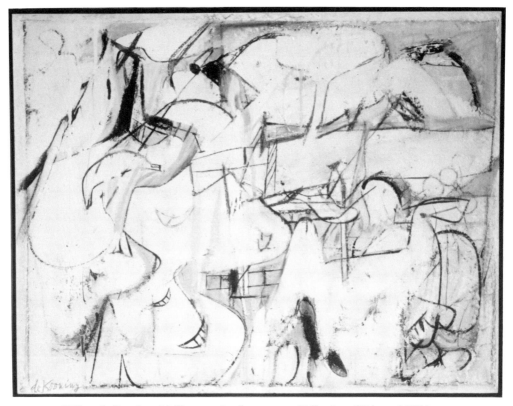

Willem de Kooning, *Mailbox,* 1948, oil on canvas. Collection of Edmund Pillsbury.

through" black-and-white paintings represented, of course, a turn toward the primitive, a reduction to the most basic essentials. They also, it has been suggested, imply communication, message-making, the "post-war desire to invest abstract art with a momentous message." The painting titled *Light in August* (as Stuckey has shown) may allude to the essential American problem of the black and the white, as evident in the writings of Faulkner in de Kooning's own time, but also notably in the ambiguity of black and white in Melville's *Benito Cereno* and *Moby-Dick.*[18] As I first pointed out to Stuckey, the New Directions dust jacket of Faulkner's *Light in August,* published in 1946, was a black-and-white semiabstract photograph that strongly resembles de Kooning's subsequent painting. De Kooning remarked to an interviewer that he would like to paint Joe Christmas "one of these days"—"that half-breed Joe Christmas dressed in what I imagined to be a kind of zoot suit." *Light in August* is the Faulkner novel about the man who cannot know whether he is part black—and so de Kooning painted a series of pictures that are neither black nor white, but so interlocked that neither color can be seen as figure or ground. He thereby solved a technical problem while making—or at least (in this case, I should think) beginning with—a statement that had a political dimension.

Titles like *Light in August* are not unusual for de Kooning. In his 1977 retro-

spective at the Guggenheim, paintings called *Untitled* were mixed with titles like *Man with Mustache, La Guardia with a Straw Hat,* and *Rosy Fingered Dawn,* which force us to look for a representation and draw our attention to certain elements that correspond to the title—and away from other equally prominent elements that do not. The de Kooning "Women," for example, might equally have been titled "Homage to Soutine" in order to draw our attention to *that* aspect, which appears prominently in some of them. The result can be taken as either a designation of representation or as itself a further estrangement from the representation. The title gives the figure a final turn *away from* its original meaning. As Porter remarked, the titles *Lizabeth's Painting* and *Ruth's Zowie* "do not tell what the painting may have come from (which it may be impossible to verbalize) so much as what the painting partly in each case *became*" (my italics).[19]

De Kooning's attitude toward titles indicates that he wishes to play off title and image as form and content. In a conversation with Herbert Ferber—who told him that Crucifixions, for example, had and needed no title—he responded: "I wonder about the subject matter of the Crucifixion scene—was the Crucifixion the subject matter?"[20] As de Kooning shows (and as Kline does with the titles and the humanizing of his paintings, or as Still does with his Whitmanesque, and Motherwell with his *symboliste,* rhetoric), there is a crisis of the visual and verbal, the graphic and literary, at the center of Abstract Expressionism. These artists were in one sense forgoing reference—or reference outside the painting itself—even when they remembered where one clung pertinaciously to their forms: in the forms' point of origin, whether in the newspapers or in old master paintings, in politics or in art history. The titles play against a new kind of literary reference, the formulation of what the artists are doing in relation to the tradition of art, by which we may mean the narrative of problem-solving, progress, revolution, or the agon with the precursor.

The critic too has entered the painting as a determiner of meaning. The title of Pollock's *Lavender Mist* was given the picture by Greenberg, presumably not because of any reference to Duke Ellington, but because that was what *he,* the critic, saw—a lavender mist; because *Lavender Mist* conformed to *his* theory of the flat surface to which the painting should aspire. Pollock himself may have thought the title appropriate because of the allusion to the improvisatory forms of jazz; but not Greenberg. One recalls the famous occasion, referred to repeatedly by de Kooning and Porter, when Greenberg said an artist could no longer paint human figures. In other words, de Kooning was painting during a time in which the critic could tell the artist what aspect of the work should be indicated, what the artist had done, and what this meant.

The important point may have been, as Porter argued, that the Abstract Expressionist painters preceded rather than followed the criticism that explained what they did and should do (as opposed to the next generation, brought up on Greenberg as well as on Pollock and de Kooning); but their work itself followed on other literary and political assumptions—of the American tradition, of anti-

American, antibourgeois politics, of the Depression, of Faulkner's novels, and of Surrealist doctrines of revolution.

Art can be dominated by the written word in at least two senses. First, it can illustrate literature or can easily be translated into—or project—a literary text. Surrealist art, for example, illustrated Freudian concepts, as well as using certain literary texts or even photographs and other evocative illustrations in collage. Second, art can be dominated by the written word through the criticism of art— the provision of aesthetic categories (Beautiful, Picturesque, Sublime) or, in our own time, of critical theories. Even while disparaging a literary content, art criticism like Greenberg's and Rosenberg's of the 1950s itself imposed verbal forms of a different sort on the painting. My suspicion, at least in the case of de Kooning, is that his titles were an attempt to estrange his image, turn it away from that sort of meaning, which was often all too visible within the canvas.

D. H. Lawrence summed up the issue of landscape and figure in the preface to his exhibition of nude paintings in 1929. His bias was toward the human figure; and thus "landscape is always waiting for something to occupy it. Landscape seems to be *meant* as a background to an intenser vision of life, so to my feeling painted landscape is background with the real subject left out."[21] This was the reverse of John Constable's view that landscape is created by *omitting* the human figures—the "history"—while retaining the emotion their actions generated, an idea closer to the opinions of Rothko (and of Hartley).

De Kooning is more clearly embedded than his colleagues in the European tradition of figural art, with allusions to paintings and photographs rather than to the totemic (the Mexican, American Indian, etc.) shapes with which Pollock and Rothko begin. But his interchangeable women/landscapes indicate not only a knowledge—or extension—of Rubens's thighs and Renaissance flesh color and Picasso's corporal dislocations, but also memories of dark earth mothers, focuses of the sexual content of his earlier biomorphic paintings; and, as well, contact with the tradition, best known in the *Dresden Venus*, of women-landscape homologies that signify fertility.

De Kooning's breakthrough, following his first series of essential or reductive images, is the female figure reduced to "two eyes, a nose and a mouth and neck," and it just happens that he connects this with the great painting tradition of the nude. He puts it this way, however: His women have "to do with the female painted through all the ages, all those *idols*" (my italics), both in the sense of art history and of atavism—"a thing in art that has been done over and over— the idol, Venus, the nude." ("Flesh was the reason why oil painting was invented. . . . For the Renaissance artist, flesh was the stuff people were made of. It was because of man, and not in spite of him, that painting was considered an art": in other words, Renaissance humanism.)[22] But this is also the "idol"—the elemental shape of eyes, nose, and mouth, to which he anchors himself (and

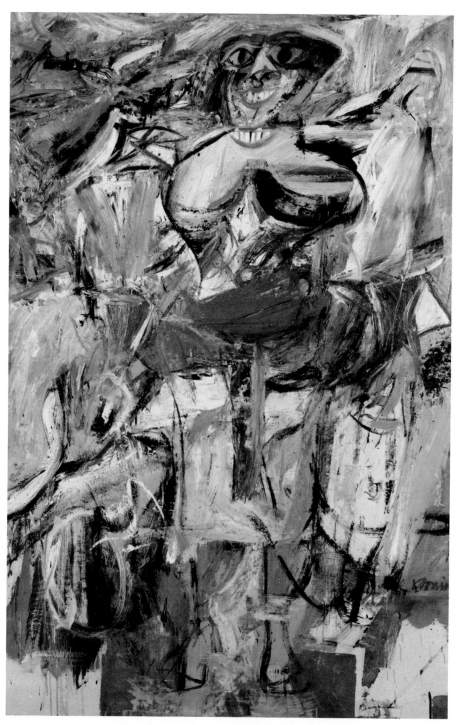

Willem de Kooning, *Woman and Bicycle,* 1952–1953, oil on canvas.
Whitney Museum of American Art, New York.

then worries about the "woman's knee"), the connecting links (like shoulders in the early paintings of men); and ultimately the face and the powerful V shape of the groin or loose W shape of the buttocks—where his women and his landscapes merge. For these landscapes are much the same, some of them beginning as women who are either turned on their sides or revised a few more steps into landscape: for example, the central V shape in *Suburb in Havana* (1958).

Like the paintings of women, the landscapes are concerned with highways and "the feeling of going to the city or coming from it"—as Hess says, "He had always been fascinated by connections—the shoulder, the planes of a collage, the jump from one shape to another. He saw the highway as an enormous connection, with an environment of its own" between the suburbs and the dump areas.[23] In the woman he has the fixed element around which all the rest can shift and metamorphose: the mouth, so fixed that de Kooning sometimes cut out a mouth from advertising photographs and at least once pasted one on his painting, a kind of omphalos. "I thought," he wrote, "everything ought to have a mouth. Maybe it was a pun. Maybe it's sexual." Or perhaps, he adds, it was a "grin" rather than a mouth: "It's rather like the Mesopotamian idols, they always stand up straight, looking to the sky with this smile, like they were just astonished about the forces of nature you feel, not about problems they had with one another. That I was very conscious of—the smile was something to hang onto." The "pun" is presumably on "mouth" of a river or a cave, on Portsmouth or Exmouth, even the suggestions of "mouths"—crescent moons with vertical lines for teeth, an important element in these mouths (in such paintings as *Mailbox*, another kind of mouth)—in short, to a vagina, possibly a vagina dentata (one remembers Richard Condon's novel *The Vertical Smile*).

When I look at de Kooning's women's toothy smiles I think of Reinhardt's remark about abstract painting: "The addition or retention of eyes, teeth, feet to abstract shapes may be unreasonable or dishonest, except as a form of wit." The woman, de Kooning said to David Sylvester, "did one thing for me: it eliminated composition, arrangement, relationship, light—all this silly talk about line, color and form—because that [i.e., the woman] was the thing I wanted to get hold of."[24]

Two inferences: The personal, action painting dimension remains in the reference to things "to hang onto" or "get hold of." De Kooning talks a lot about how "silly" or "absurd" it is to paint such things now as women, but how it is even more absurd not to. Second, the matter of composition: "I put it in the center of the canvas because there was no reason to put it a bit on the side. So I thought I might as well stick to the idea that it's got two eyes, a nose and mouth and neck." Thus as part of a problem-solving process the woman obviates questions of composition and relationship; but as the "thing I wanted to get hold of" she also carries with her all those other associations summoned up by references to a mouth. She is "the center of the canvas" in that she is iconic, the center

image, like Rothko's and Gottlieb's primitive, with overtones of church art and older icons. But as "something to get hold of" she is the idea of connection or joining, as Rothko works with the idea of division: the essential landscape motif of the pelvis, of the woman shape with the center of interest in the hills and valleys leading the eye into the pelvic area.

At bottom, what de Kooning foregrounds is the erotic content of art, already made explicit in Toulouse-Lautrec's paintings of whores and in much of Picasso, implicit in Pollock's Abstract Expressionism. Hess has distinguished Pollock from de Kooning as follows: "For Pollock, the big subject is the orgasm, which is to say he is concerned with release," whereas de Kooning "is involved with preludes, climaxes, and postludes—he wants release and control." [25] Pollock may have vaginal images like *The Deep*, but in general love-making and painting are equated in a way that is more literal, though less overt, than in de Kooning.

De Kooning's woman also brings us back to the sense we must have, looking at the paintings of de Kooning and his colleagues (and hearing of their conversation), of a shared sexism, unconscious and unquestioned, part of a male bonding that I will attempt to place in its proper 1930s–1940s context in the next section.

Peter Arno, James Thurber, and Charles Addams

The typical Peter Arno cartoon shows a man and a woman intimately intertwined on a sofa, and the caption reads, "Have you read any good books lately?" During my teens, albums of Arno cartoons were kept in a cupboard under the checkout desk of the neighborhood library, and I was privileged to see them only because the librarian was the aunt of a friend. Those baffling one-liners were part of my sex education: "You do too know how to bundle!" "Why Auntie—what big eyes you have!" "We want to report a stolen car." "Good God! I forgot to get favors for the men!"

Arno represented a sizable part of the ethos of *The New Yorker* cartoon. "Sophistication" was the word applied to that magazine in the 1930s and '40s, and this meant that the common denominator of their cartoons, whether by Arno or James Thurber or Whitney Darrow, Jr., was the woman. Now when I look at old *New Yorker* cartoons the first thing I notice—or have pointed out to me by female friends—is their misogyny. In the case of Arno, the point of view is that of the raunchy male on the prowl.

An Arno cartoon of 1949 shows a young woman and her date seated at a bar, the latter addressing the bartender. The one-line caption (a *New Yorker* trademark) is: "Fill 'er up." The words juxtaposed with the image illustrate the most basic structure of the comic, two self-contained logical chains intersecting in a single situation—making a *pun*, in this case a sexist pun that in the 1980s demands the response: "Why not 'Fill *him* up'?" (A recent cartoon showed a woman driving into a gas station and demanding, "Fill *him* up.") [26] In Arno's

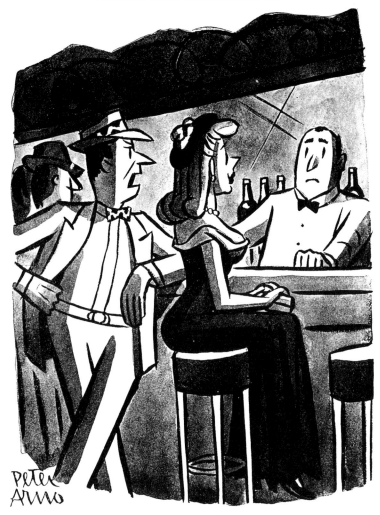

"Fill 'er up."

Peter Arno, cartoon.
The New Yorker, 1949.

cartoon the pun means: Fill up the (female-gendered) gas tank of the car; fill up this woman with alcohol, that is, get this attractive, demure young woman drunk; together with the inference (given the impatience we sense in the speaker of the words) that she is little more than a car.

There is a comedy of misogyny in the interplay between the beaming young woman and the bored young man: They are, as it were, made for each other and for the wide-eyed bartender—the bystander, the observer whose amazement is directed at the woman, not the man who is speaking for her. For there is a *sub*-text here, with two crucial points: first, the *sexual* sense of "Fill 'er up," i.e., with the nozzle of the hose from the gas pump; and, second, the link between the

man and the bartender: The man is in effect offering to share his date; he's offering to pass her around, making a gesture to the bartender in terms of a mediated, homosocial desire that now appears less a subtext than it did then. The connection is underlined by an optical illusion: The bartender's arm appears to extend into and merge with the other man's. The subtext underlying the expressions, verbal and facial, is the transformation of the woman into an object of penetration—given the gas-pump image, of crude sexual dominance. The cartoon is an act of aggression—on the part of the man; and on the part of the artist, Peter Arno. The woman's speechlessness, we would now say, reflects less on her intellectual capacities than on the fact that the cartoon and cartoonist render her only a speechless object. And, I should add, *New Yorker* lore includes stories of the collective efforts of the staff to brainstorm the one-liners for cartoons.

Not that this bias did not appear in other magazines as well—*Colliers, Liberty, The Saturday Evening Post*. A famous cartoon by Virgil Partch (who signed himself VIP) in *Colliers* showed a young man eating his way through the restaurant

Richard Taylor, cartoon.
The New Yorker, 1939.
Copyright © 1939, 1967,
by The New Yorker
Magazine, Inc.

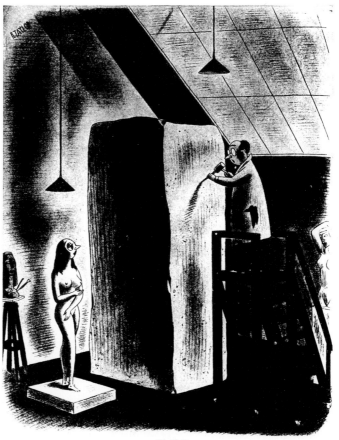

"Smile."

table toward his date, who sat on the other side. An image of pure male desire, this cartoon was too unsophisticated for *The New Yorker*. But *The New Yorker* mattered because it carried the work of the most original and accomplished of America's graphic humorists.

It is not surprising that one *New Yorker* genre was the self-reflexive cartoon about the artist, or that this genre pivoted on the female model. Richard Taylor is the artist outside the cartoon (distinguished by the round Little Orphan Annie eyes he gives all of his people); the cartoon is about a male artist, his model, and the intransigent medium in which he has to render her—and the artist's hubris. "Smile," he says, as he prepares to make his first chip in the huge block of marble. It is also significant that the model is a young woman and that the man is rendering her—physically, literally—an object in stone. But with this huge unwieldy block, it is seemingly to attempt to hold or contain her.

At the other end of the process, the perfectionist artist adds one more tap to bring the representation to perfection—and that is the tap that splits the block. (But now, Pygmalion might respond, he has *two* women.) The reverse of Arno's, the cartoon's comedy is focused primarily on the foolish man, secondarily on the vacuous-looking female. The discrepancy is weighted against the artist—a kind of visionary—in a way that tends to have been characteristic of *The New Yorker*, which paid very little attention to contemporary art (except for its comic possibilities) until it hired Rosenberg to write its art column in the 1960s.

But a quite different case was the *New Yorker* art of Thurber. For one thing, rather than the bold, elegant style of Arno (which seems to underline the aggression of the male figures), Thurber drew in a consciously atavistic style more like the scrawl of a child (in fact, of a man virtually blind). Thurber and Saul Steinberg were the two *advanced* artists of the *New Yorker* stable. But Steinberg's subject was representation itself, and Thurber's remained men and women. He was not, however, interested in the young woman as sex object; she has become a wife—or we might say a projection of the Arno woman after marriage. Thurber may have begun with something like the impatience of the young man in "Fill 'er up," but he shows the feeling intensified by marriage and years of togetherness.

In his cartoons, the woman is a huge, encompassing, terrifying threat to the husband. The comedy is not in the monstrosity of the wife, however, but in the juxtaposition of wife and husband from what is clearly the viewpoint of the husband, who feels threatened. The wife is nothing but a projection of his fearful fantasies. In one cartoon, the house to which he is returning—after a day at the office; after at most a mild flirtation (this is no Arno man)—turns in his imagination into a jinnilike female monster. (Ross Murfin has pointed out to me the illusion made by the brickwork of the house's basement, suggesting that the wife's body turns into a serpent's; in which case the tree also takes on Edenic significance.)

I am not sure this isn't Thurber's way of containing his real subject—the

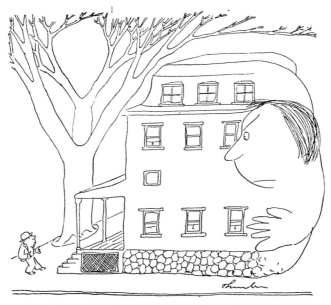

James Thurber, cartoon. *The New Yorker,* 1933.
Copyright © James Thurber, copyright © 1971 by
Helen Thurber and Rosemary A. Thurber.

Arno man's *fear* of the woman—by rendering it safe and domestic. While the milieu is domestic now, there are no children. The wife is in fact an independent Other. That might mean joining the other wives just like her in the prefeminist solidarity of the women's club or kaffeeklatsch. But in the case of *these* women of Thurber's it is their husband's bar that they have made their own. The little husband can only cringe outside the door (as he cringes before his wife-dominated house) and compensate for his weakness by muttering, "Gah dam pussy cats." The bartender's gaze in this case never meets his; the men are isolated in a losing power struggle.

But if the domestic scene has become—as Thurber names one of his books—"the war between men and women," what takes its place? A smaller number of cartoons show a warm human relationship between the little Thurber husband and his dog (and the Thurber dog is one that is said to believe he is a human and is sometimes deeply disturbed when confronted by a mirror). The safe, faithful dog, who brings his master his slippers every night, replaces the uncontrollable wife, or rather the husband's uncontrollable fears.

How do we explain this phenomenon in the 1930s and '40s, and why does it appear in *The New Yorker?* Partly because men had not yet had their "consciousness raised," and women still served as scapegoats for other, less easily expressed fears: for example, class and racial prejudices, which already were considered inexpressible, just as in the 1970s and onward misogyny became less expressible—except, of course, in the displacement by which feminism itself, or rather

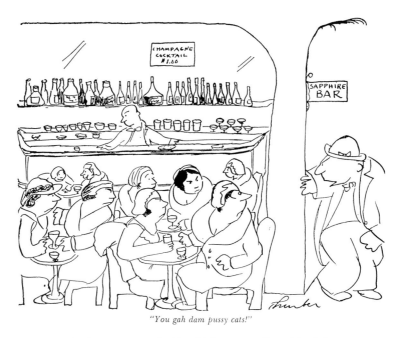

"You gah dam pussy cats!"

James Thurber, cartoon. *The New Yorker,* 1934. Copyright © James
Thurber, copyright © 1971 by Helen Thurber and Rosemary A. Thurber.

*anti*feminism, or male chauvinism, became the subject of graphic humor. But it
is equally possible that class and racial prejudice in jokes and cartoons were dis-
placements for the true fear, which involved sexual identity.

The "sophistication" that was the ethos of *The New Yorker* had a lot to do
with its antifeminism. In the years following the repeal of Prohibition, the years
of the "Lost Generation," of women recently having been given the vote, of re-
putedly hard-smoking and -drinking women increasingly going into men-
dominated jobs, and so on, *this* was the subject taken by sophistication: Woman
was the center of interest because she was threatening men in a new and pecu-
liarly intense way, but as yet without a powerful rhetoric of her own, and so she
was portrayed as either sexual object or threat to man's freedom, or both.

If we glance back to the birth of American graphic humor in the England of
the 18th century, we find none of this. Of the great comic artists of the century,
only Jonathan Swift has a reputation for misogyny, and he had behind him, as
authority, the probably pathological misogyny of the early Church Fathers, of
Jerome and Tertullian at any rate, ascetics and monastics. In graphic art,
Hogarth sees women as centers of vitality, forces of mediation between imprac-
tical poets and musicians and the contingencies—the disorganized, plebeian
sounds—of the real low world. Women carry almost a religious significance of
mediation for him. Rowlandson too, an artist whose drawings were very popular
with rakes and libertines (up to and including the prince of Wales, prince regent,
and king of England), invested his women with normative qualities he seldom

gave his men: They are active sexual beings, beautiful, and often having to deal with older men who are decrepit or worn out by work and not up to the demands of their sexuality. The caption of a typical drawing is spoken by the young woman: "Come to bed, you sot."

Younger men come to these women's aid, or *they* come to the aid of the younger men—but given the world projected by Rowlandson's many, many drawings and prints, we know that the younger men too will grow old and fall into the same relationship with their women, who will then need another younger man. The basic Rowlandson situation has a young woman mediating not between too much and too little order, as in Hogarth, but between a young and an old man, her young lover and her old husband or sometimes father. In these older men lies the fear of impotence, replacement, and death, a fear that presumably remains to motivate Arno's men as well as Thurber's.

The source of the Arno woman and at least one branch of the comic woman of our century was the 1900s "Gibson Girl," as she was called, the female figure in the cartoons of Charles Dana Gibson, ultimately reduced (or apotheosized) into just a question mark. I suppose it is significant in the mythology of woman that the question mark is really created by her loose flowing hair. ("Love in these Labyrinths his Slaves detains," Pope wrote in *The Rape of the Lock*, where Belinda's lock is apotheosized, "And mighty Hearts are held in slender Chains.") Another Gibson cartoon has the young woman sending messages under the table by foot to her boyfriend—"Wireless Telegraphy" is the punning caption: The wireless was new then, and Gibson was saying that it was just a new term for

C. D. Gibson, *The Eternal Question. Colliers,* 1903.

THE ETERNAL QUESTION

WIRELESS TELEGRAPHY

C. D. Gibson, *Wireless Telegraphy. Life,* 1901.

something we had always had. But the Gibson Girl is not sending the message to the man; they are communicating with each other. They are, the two of them, just talking around a large, heavy, formidable-looking older woman, who represents the older generation, the blocking Society, that is pitted against the young lovers as in Rowlandson's drawings (she will reappear as the wife herself in Thurber's drawings). Nevertheless, it should be noted that *his* foot is *on top of* hers—a slight edge of dominance and added sexual significance, part of Gibson's donnée. But Gibson, shortly before his death in 1944, defended a career spent depicting pretty women: He said, "If I had been an oyster, I'd have drawn girl oysters. Wherever I looked I saw those beautiful girls, and who was I to resist?"

Gibson was the creator and reproducer of an unmistakable feminine type: Long, thin, hard, with a square jaw and often carrying a tennis racket, she is fairly androgynous. Only secondarily was Gibson a comic artist, one who *used* these beautiful Gibson Girls to produce laughs. In fact, in this sense he was a precursor of Arno: his excuse for simply drawing all those "beautiful girls" was the comic picture, which was only made to show them off. Primarily he was a fantasizer. By drawing what he wanted to see as though it were real, Gibson made himself happy. He also, however, as we would say these days, acted as a spokesman for his society, and as such he successfully contained—and trapped—the American woman within the image of "girlish" allure, that image from which feminism was already attempting to liberate her.

Intervening between Gibson and *The New Yorker* were the suffragettes (unsurprisingly, Gibson made antisuffragette cartoons), the vote for women, and a great deal of talk about women's independence. By the precarious 1920s, when *The New Yorker* emerged, women appeared to be vacating the domestic sphere; birth control was a subject that was ceasing to be taboo; and mass-circulation

daily papers and commercial films were both aiming at and writing about women. These popularized an image of the newly liberated "flapper" as androgynous in appearance and sexually adventurous. *The New Yorker,* in this sense, simply made outrageous the underlying assumptions of the popular press.

The most famous of all Charles Addams's cartoons is of the lone woman skier who somehow gets—through, past, or around—that tree (1940). But this too is a cartoon *about* women: The skier is a woman, the tree is a male sexual shape, and it is a male skier who is watching the woman skier's plight (*he* has seen what we have not, that is *how she did it*)—as it is the male spectators of *The New Yorker* who watch both of them, with the male skier as their surrogate, and also with his slight sense of prurience. Because it wouldn't be as funny (though perhaps to a woman funnier) if it were a man straddling—or escaping, frustrating—that huge phallic tree. The question isn't just how the woman got around/through the tree, but what *happened* when it did somehow get between her legs. It's such a resonant, powerful cartoon because it is full of suggestions like these: The woman is less a sex object than a mystery; the cartoon embodies—the fears? yes; but mainly the mystery the man feels in the woman.

The 1930s was also the decade when Surrealism reached America, first in the popularization of Dali images and then in the more serious contact with André Breton, Louis Aragon, and other French versions of the movement. There is a story: "When Pierre Unik told Breton that he consulted, in lovemaking, his partner about what she enjoyed, Breton was amazed. Why not? asked Unik. Because, replied Breton, her likes and dislikes 'have nothing to do with it.'"[27]

What then did it mean for an artist—Surrealist or otherwise—to paint an abstraction of a woman? For Picasso, this act was plainly one of possession corresponding (woman by woman, model by model) to sexual possession. De Kooning

Charles Addams, cartoon. *The New Yorker,* 1940. Copyright © 1940, 1968 by The New Yorker Magazine, Inc.

sought to "abstract" by rendering a woman's body ugly; indeed, his primary representation was of the consciously *un*beautiful, which he accomplished by "caricaturing" the sexual attributes, the lips, breasts, buttocks, and vagina. And the act itself was associated with virility, active and aggressive. One recalls the American response in the 1920s to the Hollywood films of the German director F. W. Murnau: They were considered too beautiful, therefore effeminate, and not "box office" in so "male" a society.[28] De Kooning and his compatriots, by representing something other than the beautiful and graceful, were flaunting their American masculinity. It also follows that sexual identity was emphasized over social identity in de Kooning's works. His "revolution" in this sense was purely artistic; in content his work was as reactionary as Arno's cartoons. For he was simply drawing on expectations and conventions that we can see most easily (and for him appropriately) in the popular cartoons and comic strips of the time.

ABSTRACT FIGURATION II: HISTORY PAINTING, POLITICAL CARTOON, AND COMIC STRIP

Kline

Rivera's RCA Building mural of 1933, called *Man at the Crossroads Looking with Hope and High Vision to the Choosing of a New and Better Future*, was destroyed because of the threatening presence of Lenin's face. Lenin was in effect "iconoclasted" by Nelson Rockefeller. (Rivera's repainting of the mural can be seen in the Belles Artes palace in Mexico City.) Then Rivera's revolutionary image, in the style and iconography of Mexican revolutionary art, was replaced by painting in the tradition from which he had revolted—the 19th-century academic version of the Baroque. These murals are by José Maria Sert, and the Michelin Guide and the Rockefeller Center tour guides point to them as interesting examples of perspective. They are monochrome paintings in the style of Frank Brangwyn out of Tiepolo, with the dizzying harbor-work scale of Piranesi and a few specific echoes of Sert's countrymen Velázquez and Goya. Muscular but rather gnomish workers, in meager loincloths out of *Flash Gordon*, straddle pillars on the ceiling (airplanes fly over their heads), looking much the way Gulliver did to the Lilliputians when he served as their embarrassed triumphal arch.

The main panel opposite the entrance—corresponding to the Rivera panel—has two huge statues being lifted into place by workers (no sculptor is present). The statues reach toward each other over a chasm, one holding out a tree trunk and an axe, the other straining to receive it. Beneath this, Abe Lincoln in stovepipe hat (the foreign artist's symbol of American liberty) is helping a worker to complete a similar transaction. The panel is probably supposed to suggest the raising of Rockefeller Center itself. Around the corner, other workers try to hoist a statue of a nude male lifting a lightly clad female in roughly a Rape of the Sabines pose. Sert's workers, who always seem to be doing what the statues they hoist are doing, are lifting into place heroic, idealized images of their gnomish,

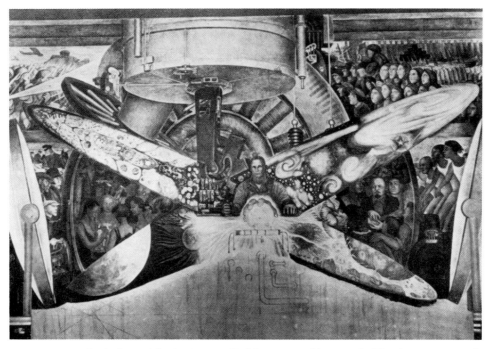

Diego Rivera, unfinished mural for the Great Hall of the RCA Building, Rockefeller Center, New York, 1933 (destroyed). (Photo: Matthew Baigell).

plebeian selves. Over the staircases of the entrance doors a number of these *ignudi* of different races engage in symbolic actions of brotherhood such as playing football with a globe.

I am attempting to suggest the ambiguous symbolism at work in Sert's murals. Four large panels run along each side of the elevator banks (behind the central panel I have described). On one side the scenes of humanity's struggles to survive and become civilized are accompanied by inscriptions in large Roman letters: Figures out of the first lines of Juvenal's sixth satire are explained by the words "Man labouring painfully with his own hands; living precariously with courage, fortitude and indomitable will to survive." The panels progress to the discovery of the grape and of farming; to industrialization ("Man the master and servant of the machine"), in a Brangwynish version of Velázquez's *Vulcan's Forge*; and to religion ("man's ultimate destiny depends not on whether he can learn new lessons or make new discoveries and conquests, but on his acceptance of the lesson taught him close upon two thousand years ago"), in a composition that combines a Sermon on the Mount, a Christ Healing the Sick, and a Suffer the Little Children. In the upper part of the panel, his face concealed by a hood, a mysterious figure emanates rays of light.

Upper and lower are the symbolic coordinates of the series. Along the other side of the elevator banks the lower part of the composition shows slaves pulling a huge contraption on wheels, and in the upper a train engine approaches amid

billows of steam. Below, the sick are untended, groveling, and dying, while above they are being inoculated, waiting in line along a tilted pillar that recalls the tree branch in Goya's third *disparate*. In the third panel slaves are erecting a building of some sort, with whips and chains much in evidence; some of them are bound to a post. It is just possible that the figures on the upper level are being freed rather than chained. In all of the panels the lower level seems to represent oppression and the past, the upper the freeing from slavery by some form of modern technology and the raising of humanity into its ideal state.

The last panel has more Goya figures and is the most curious of all. Two huge cannons converge and a mother straddles their mouths, holding up her baby: as a sacrifice? to cast it down? or to indicate that she and it have overcome the cannon and war? New York skyscrapers rise in the upper distance, and at the very bottom the struggling masses are once again reaching up, with others higher up reaching down to make contact with them—to lift them up to the higher level. A boy halfway out on the muzzle of the cannon is taken from one of Goya's tapestry cartoons.

The theme is civilization through progress, but, except possibly in the last enigmatic panel, civilization is being reached down to the "masses" from above, and they remain slaves and brutes (except in the idealized versions of themselves carved by some aristocratic sculptor, which they lift into place). This is, with a vengeance, an image of amelioration from the top, quite at odds with the assumptions of the Mexican artists, whose heroes were Zapata and Villa.

Sert's mural is, however, the sort of Baroque historical composition—with, one suspects, a similarly unimpeachable sentiment concerning American "liberty"—that Kline reflected in his breakthrough black-and-white paintings of 1950 onward. He reduced the representations to something like the sketch an art teacher (like Hofmann in the 1930s) or a formalist art historian would have taught a class to make of an old master painting. Pollock's compositions also derived to some extent from Benton's method of reducing old masters to abstract dynamic lines of "action"; as de Kooning can be said in his "Women" to abstract the human figure by way of art-class diagrams. There was the well-known example of Theo van Doesburg, who, in a series of drawings, gradually abstracted a cow into a grouping of rectangles; the series was reproduced in Alfred Barr's catalogue for his exhibition "Cubism and Abstract Art," at the Museum of Modern Art, New York, in 1936. (Picasso made a similar example of a bull.)

That Kline's pictorial compositions are based specifically on the monumental architectonic constructions of Baroque old masters seems to me a significant aspect of their impact. One happy result for the modernist was the omission of embarrassing particulars—the faces and human gestures—but the retention of the emotion (as Constable removed the history from a landscape but retained the pathetic fallacy).[1] Another result was that when he enlarged these drawings into monumental paintings, Kline produced images that were based on conventional forms, and so relatively easy for the gallery-goer to assimilate. What they saw

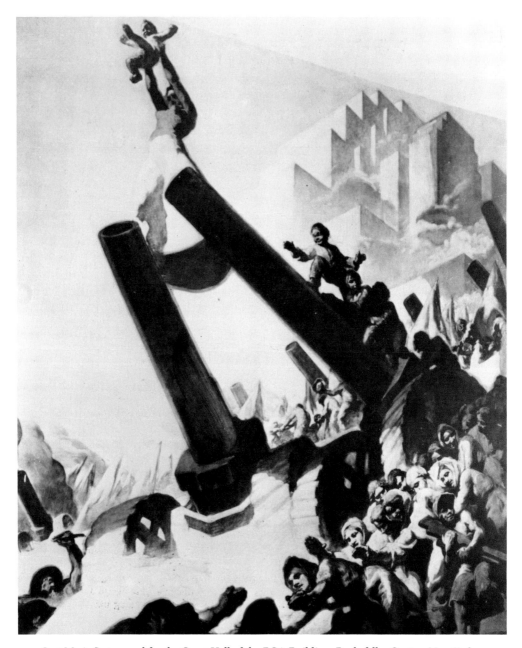

José Maria Sert, mural for the Great Hall of the RCA Building, Rockefeller Center, New York. Installed, 1933. Photo courtesy of Rockefeller Center. Copyright © by Rockefeller Group, Inc.

were the forms of a Rubens history painting, the *sfumato* of a Rembrandt Bible history (of the sort Kline himself painted earlier in his career), and the comforting, familiar forms of a conservative muralist like Sert.

We know that Kline, the only one of the Abstract Expressionists who was not interested in Surrealism, had a great "admiration for traditional art," his work being "permeated by recognition of such masters as Velázquez, Manet, Whistler,

Franz Kline, *Siegfried,* 1958, oil on canvas. Carnegie Museum of Art, Pittsburgh, gift of friends of the museum, 1959.

Albert Pinkham Ryder, and Albert Blakelock."[2] The last of these names should remind us of the sense of landscape conveyed by many of Kline's abstractions. But Kline began in the Phil May tradition of comic draftsmanship. He admired May "because with a single stroke, rather than cross-hatching, he could convey the shape and shadow of a form";[3] in short, he admired May's expressiveness.

This is not to overlook the jagged lines in Kline's work, which could have

Robert Minor, *Pittsburgh. The Masses,* August 1916.

derived equally from Sert's cannons and pillars or from Orozco's various symbols of man's inhumanity to man. It may have been an equally significant aspect of Orozco's "revolutionary" murals that he resorted to what was basically the old-hat Baroque of his predecessors, as opposed to Rivera's return to a version of pre-Columbian art. But Orozco was alluding not to Rubens (or producing a modern Rubens); he was blowing up the lithographic political cartoons of Robert Minor, Boardman Robinson, and others in *The Masses,* which were themselves small, intense images of antagonistic symbols (Capitalist and Worker) focused into vectors of power and energy. The Posada connection had led him to the realization that a political cartoon could be enlarged into a kind of history painting. And it is perhaps telling that Kline referred to his "breakthrough" by saying, "You know, like the Message to Garcia," alluding to the Cuban Revolution.

The phenomenon of the American political cartoon arose not out of the Gillray (and Hogarth) tradition, with its conservative, counterrevolutionary politics, its subtleties and ambivalences and ambiguities, and ultimately its damn-both-your-houses despair. It derived instead from the simpler, more formalized lithographs of Honoré Daumier in Paris (two or three figures with strong light and shadow) and the pen drawings of Thomas Nast in New York. These were vertical compositions, with strong contrasts of light and dark (symbolic, especially in the light of *Moby-Dick,* of white and black), and in most cases simplified to large confrontational figures. In the early years of the 20th century, Art Young and Robert Minor, "revolutionary" or at least socialist political cartoonists, established the style that lasted in the United States until the infiltration of the influence of the English caricaturists (from Gillray to David Low to Vicky) in the 1960s. This was a lithograph effect, a composition with two symbolic figures,

one good and the other bad, for example Big Business and little John Q. Public. An ur-form or ur-motif, the formal and symbolic relations of a *Masses* cartoon by Minor, led directly into the cartoons of D. R. Fitzpatrick, Tom Little, and the 1930s generation of political cartoonists.

Perhaps more accurately than as diagrammatic Sert, Kline's paintings can be regarded then as vast simplified versions of the lithographic political cartoon. This meant that his solution to the Abstract Expressionist figure-ground problem was to create an agon between the obvious figure of the black lines and the palpability of white paint (not just the color but the *paint*) that sought to define, cut back, and encroach upon the black: but still essentially the Orozco solution of the political cartoon.

The distinct aura of reference keeps surfacing in the critics' descriptions of the paintings. Leo Steinberg wrote of the 1956 exhibition that "in Kline's painting, not the *framing* blacks but the *keen, purposive* white is the *champion*," and then added, changing his (the painting's) metaphor from figural agon to cityscape, "and even though, at top, *dark rafters hold it down*, it made a splendid *flight*" (my italics). Kline himself, a great and reputedly comic talker, spoke of his paintings in the same referential terms:

> The first works in only black and white seemed related to figures, and I titled them as such. Later the results seemed to signify something—but difficult to give subject or name to, and at present I find it impossible to make a direct, verbal statement about the paintings in black and white.[4]

He also referred to painting "a happy picture after a sad one," and to "a kind of loneliness" in his paintings, "which I don't think about as the fact that I'm lonely and therefore I paint lonely pictures, but I like the kind of lonely things anyhow." The pair of black rectangular shapes paired in *Untitled* (1960) he referred to as "two wounded lovers."[5]

One can detect a kind of expressive sign system in, for example, the expressiveness of Kline's diagonals. In his many representational paintings of Vaslav Nijinsky (based on a photograph), the tilted head is emphasized; this happens too in self-portraits, and the strong diagonal remains prominent in the abstractions. As Harry F. Gaugh puts it, "He had recognized that melancholy could be expressed by turning a head down to one side"; in the Nijinskys the "telltale diagonal suggests a pulling back from the hostile world outside the paintings," while in the abstractions "the diagonal acquires more generalized significance, yet a connotation of physical and psychological restlessness persists."[6]

The sense we sometimes get of stick figures in Kline's "two wounded lovers" and figural titles confirms his need to make a connection with reference. For his first show he spent hours with Elaine and Willem de Kooning thinking up titles—"in a spirit of levity with a bottle of scotch on the table."[7] Yet again and again the title seems to have been significant to him, and to have functioned

much as the verbalizing he felt compelled sometimes to impose on his "abstract" images. Robert Hughes wrote as if the images were landscapes: "Those black strokes were the residue of a tough, specific place . . . a world of trestles and girders, piers and railbeds and X braces, of sooty industrial silhouettes and locomotives highballing through the lonesome American dark." Hughes is referring to the industrial landscapes from Kline's youth, which he had painted in his representational period, and to the cityscapes of the late 1940s. And *Wotan*, Hughes continues, "that extraordinarily forthright black rectangle, with a stub of the top 'girder' sticking out to the right, is an image whose *Wagnerian power* fits its title."[8]

As *Wotan* shows, the modern master whose presence informs the paintings was Mondrian. Hess referred to Kline's "melted Mondrians,"[9] but Kline's Mondrian is the painter not only of the squares and rectangles but of the paintings-in-white of trees and of plusses and minuses. But from these incursions of white pigment on black and vice versa, Kline shapes an agon between the (to paraphrase Steinberg) keenly purposive white champion and the "dark rafters" and "framing blacks." Since Kline dramatizes himself as another of the artists who define their painting by their own gestures, the agon takes on the appearance of one carried out by different (perhaps even Dr. Jekyll and Mr. Hyde) aspects of the painter.

If (to pick up again the old master tradition) Constable removed history from the picture so that only the responding landscape remained, then Kline removed the representation itself, leaving only the "composition"—the lines of force—and the tenebrous atmosphere. One does not *want* to know what it is, but it is clearly *something*, and that is the point as much as the comforting sense of graspable composition. De Kooning, on the other hand, turned his back on the architectonic tradition of Western art—and with it on power, beauty, conventional senses of form, balance, and harmony; he replaced them with the ugly, unbalanced, consciously clumsy, *un*meaningful images of his paintings. As Gaugh writes, "Unlike de Kooning, Kline moved toward abstraction by generalizing his subjects' appearance."[10] He means that whereas Kline simply blurs and distances, universalizes and "abstracts" in the sense of "generalizes," de Kooning rearranges and dislocates.

Gorky

Anyone who has looked at paintings by Miró and Matta, let alone Picasso, has seen that Gorky was in some sense continuing to be a figurative and a personal, even autobiographical painter—and that in one way or another (yet to be explained satisfactorily) *The Artist and His Mother* (in two versions, 1926–1936 and 1929–1942) was the generative work, though mediated by the aforementioned painters and by some of the Surrealists. Harry Rand, overreacting to Greenberg's assumption that all the Abstract Expressionists were in essence ab-

stract artists, asserts the thesis that Gorky was everywhere painting his family and his own personal experiences—where he lived, whom he lived with, especially the centrality to him of "family" (going back to that remarkable photograph and painting of himself and his mother).[11] Rand devotes much energy to identifying figures as Arshile Gorky, Agnes Gorky, their child, their dog (with a fireplace, a high chair, etc.). He would have been better employed seeking to establish the transformational mode Gorky employed in order to create this particular sort of figuration. I would have to add that much of the time I am simply unable to *see* the figures Rand identifies.

One of the identifications Rand makes in *The Calendars* (1946) that I am able to see is the dog sitting in the foreground. Two things that may be identified as floppy ears are certainly present. But Rand halts at that point. He has a dog, and so he can go on to identify Mr. and Mrs. Gorky and their child and its high chair. But at that point one has to ask: Why does Gorky use this peculiar form for a dog, one derived from the conventions of the animated cartoon, and in particular one in which those floppy ears are clearly the outer labia of a vulva? This question of formal transformation would seem to be primary, the identification of the sign "dog" secondary.

The chief limitation of the biographical approach is that it is concerned to find no more than the sign for a figure. It is engaged in a primitive iconographical research (as if Erwin Panofsky had never added the crucial term *iconology*) in which the signs are unrelated to forms, other graphic considerations, and the total composition.

The analysis of Rand's that gives me most trouble is that of *Agony*, the painting Gorky made after his colostomy and the burning of his studio in 1946. Rand makes a great deal of the assertion that the central figure in the picture is a man hanging by his neck from a rope, and that this is Gorky's proleptic image of his own suicide of two years later. I cannot even get as far as the second improbable assertion because I do not see—either in the painting or in the careful preparatory drawings—anything to corroborate Rand's identification: nothing either in the shape of the "figure"—the strange insectlike creature Gorky seems to use as his model for the human body—or in the loose network of straight lines that seem to anchor the upper part of the figure. The figure may be *caught* in some way, but it is not dangling; rather, it seems to be standing at or leaning against a lectern (as in *The Orators*). The fact that in one version this figure is replaced by "a seated figure" leads Rand to suggest that "Gorky was not utterly firm in his resolve about suicide."

Why does Rand dismiss so blandly the observation of Marny George (Gorky's first wife): "Very shortly after hearing of his death I found that I, too had cancer. I, too had a colostomy operation. . . . (How many personal symbols in his last paintings have an unbearable clarity for me!)"? In this picture made of shades of red (an overdetermined color, the color of the studio fire as well as of blood), the forms that in the earlier paintings were biomorphic with a strong sexual bias

(figuration consisting largely of male and female genitals) have become forms that resemble intestines hanging out and openings where they should not be. These are the forms that Hughes has summed up as "natural life, expressed always as the close-up or interior view rather than the landscape with figures."[12] Hughes, however, sees the "look inward to the body and not out from it" ("intestinal couplings and imbrications") already operative in *The Liver Is the Cock's Comb*, of 1944. He may be reading back from later pictures and I may be reading forward from earlier.

To approach the question of a transformational mode we might start with a demonstrable case. We know that Gorky's close friend and disciple de Kooning began with a representational image, then imposed both formal and aleatory considerations—including rotated and juggled cutouts—in order to dissociate or dislocate the recognizable image. The result is either an image so intense that it can only be confronted in slipping glimpses or an image that has simply, in Russian formalist terminology, been "made strange." Gorky's method was not the same, but *some* such model was at work.

One of the problems that occasionally arise in this kind of abstraction/representation can be seen in Rand's identification, in two sketches for *The Betrothal*, of an old man's head he is soon referring to as "the Admiral" (the father of Gorky's second wife, Agnes). I might add the equally plainly delineated breasts in the upper left of some of the finished versions of *The Betrothal*. The face and breast, however, seem to be accidental: freely abstract lines that have inadvertently become representations, but in a different representational mode from the governing one. Would Gorky have introduced a totally different convention from the ones employed in his other work of the time?

The one transformational mode Rand does identify is in the landscape forms Gorky painted while living in Connecticut. I too am able to recognize the natural shapes—waterfalls, hills, lakes—because these derive directly from Kandinsky's transformational mode of circa 1912. But in the same picture, Gorky does not seem to follow Kandinsky's mode from the transformation of landscape to the transformation of his human figures. The figures remain closer to slightly modified Matta or Miró figures.

Should we look at Gorky's "figures" as if they were expressionist humanoid forms like Francis Bacon's, mutant plant forms like Graham Sutherland's, merely biomorphic forms in the style of Matta and the Surrealists, or the suggestive shapes sought by de Kooning that are consciously neither this nor that? Is this a transformational mode analogous to either Analytic or Synthetic Cubism (or to both) as they operated on the human body, that is, as an unfolding of unseen inner forms, or as a replacement of human with biomorphic or inanimate parts?

Peter Conrad uses the biomorphic or genetic source of Gorky's forms as a stick with which to beat Picasso. Because Gorky's designs "have evolved on the analogy of organisms, his dissection of their structure isn't the engineer's tinker-

ing but the biologist's recourse to origins"; not "Picasso's brutal refraction" of the figure "but a reconciliatory expansion of these people is reproduced and unfolded into universality."[13] As he often does, Conrad has picked up Rand's inchoate notion and made it genuinely suggestive. There is, for example, Rand's idea (in Conrad's words) that in *The Artist and His Mother* Gorky "portrays his mother not so much by making a replica of her face as by animating the looping and protectively continuous lines which—on her shawl—wrap round her face. These circumambient lines eventually supplant the face by doing duty as a symbol for it."

In some cases it is easier to see the influence of the old master paintings cut out of art books and magazines that we know Gorky kept (sometimes for years) on his studio wall than the simple referential equations Rand supposes. For example, if you look squintingly (take "slipping glimpses") at the London segment of Uccello's *Battle of San Romano* (mentioned but dismissed by Rand), you see the layout of some of the mature Gorky paintings. I was particularly struck by Rand's words about Elaine de Kooning's observation that Gorky had a reproduction of David's *Mars Disarmed by Venus* on his studio wall and used this as the basis for his *Diary of a Seducer* (1945): her argument "for the similarity of the two works is highly tenuous and bears nothing like the congruence to describable situations that forms the criteria used in this study," says Rand.[14] Yet I can recognize the halo of the wreath in Venus's hands, and the general division of male and female symbols, which may be at one end of a transformational series that ends with the ironically titled painting. If so, it describes the mode of the whole composition, whereas Rand never gets beyond particular details, often in a caricatural or cartoon mode of representation (and then, one notices, only those he can identify biographically; the others are left unmentioned).

Two cases, however, merit examination: *The Orators* (1947) and *The Black Monk* (1948). The first represents a kind of figuration that is centrifugal, out of Miró and Matta, and presumably involves a fragmenting and rearranging of human bodies into largely biomorphic forms. But the second moves toward a bold, overall design, the most obvious aspect being the positive and negative images of the monk, who is flying straight at the viewer (as he did in the Anton Chekhov story Gorky was reading and rereading just before his suicide). The painting is a "last painting," a final personal statement, more apocalyptic than self-pitying, that reminds me of Motherwell's *Elegies to the Spanish Republic*.

The literary text and title may be as relevant to *Diary of a Seducer* as to *The Black Monk*. At the very end of Søren Kierkegaard's *Diary of a Seducer* (which concludes his *Either/Or*), the protagonist Johannes, having seduced Cordelia and thereupon abandoned her, remarks: "If I were a god, I would do for her what Neptune did for a nymph: I would change her into a man." Like Don Giovanni, he projects a repetition: the next time, a seduction of a girl who would imagine that *she* was the seducer—"that it was she who tired of the relationship."[15] Gorky may have seen that Kierkegaard's irony works against Johannes, the seducer: It is

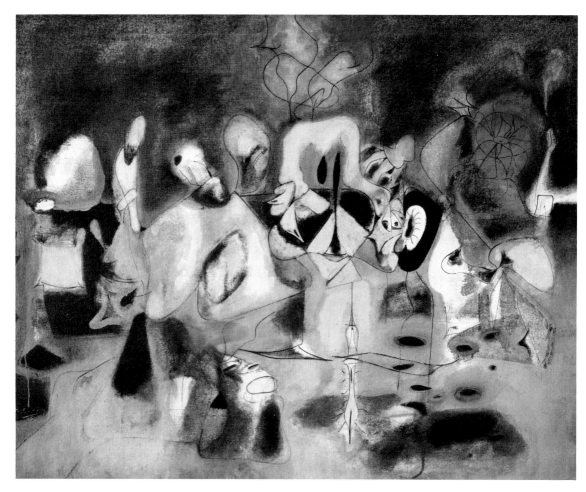

Arshile Gorky, *Diary of a Seducer,* 1945, oil on canvas. Museum of Modern Art, New York, gift of Mr. and Mrs. William A. M. Burden.

in fact always he who is seduced. In this context we might see why Gorky kept David's *Mars Disarmed by Venus* on his wall, and used it as a compositional origin (in Conrad's terms, genesis) for the design that became *Diary of a Seducer.*

There is no question of Gorky's intense desire to communicate in these paintings, but with whom? To judge by the inscriptions on various of the drawings for *The Calendar,* with his second wife, Agnes ("Mougouch"). This fact lends strength to the argument that these works show the family and reflect its breakdown. In the last great paintings, communication and breakdown coexist. It must have seemed to Gorky that his own life followed and repeated the destruction in his youth of both the Armenian people and their art (in particular the illuminated manuscripts he knew at Yarak). It is hard to imagine him at the end, in 1948, doing anything but hanging himself: The last pathos of the destruction of so many of his works (both before and after his death), the paralysis

of his painting arm, and the breakup of his marriage and family materialized his seeming failure to communicate.

Guston

The only painting by one of the original Abstract Expressionists to directly challenge first-generation Abstract Expressionism came in the later works of Philip Guston. In his case one wonders whether his motivation was the failure to communicate or the need to move on to another, a new, a "final" phase. The Whitney exhibition of 1980 was focused on that last phase, the paintings from 1969 to his death.[16] The 1940s appeared in one room, the Abstract Expressionist paintings of the 1950s in a second, and the transitional paintings leading up to 1969 in a third. To get to the first of these you had to walk through three rooms of the 1970s paintings. There were in all seven rooms devoted to the last phase.

One of the fictions with which artists now live is that they must always tackle yet another style, or, on the model of a Titian or Goya or Matisse, or in the heavy shadow of the restless Picasso, attempt a final phase. But in Guston's case, it can be argued, the final was only a return to an earlier phase, perhaps an attempt to say again more powerfully what he had attempted to say in that first, Depression, activist, WPA phase. Seen in the light of the last phase, all of his oeuvre is of a piece. The final brutality only draws attention to the latent brutality, the socially determined commentary, in the most apparently refined of his earlier works.

The three phases are ostensibly figuration, abstraction, and figuration. What this progression reminds us of is the other Abstract Expressionist painters who began as figurative artists and developed a distinctive abstract style that can be related in interesting ways to their figurative styles. Pollock and de Kooning returned to figuration, the latter spending the succeeding years painting women. Guston created a wholly, or apparently, new figural style, but the continuity is clear enough. Though represented in the soft harlequin patterns of the first phase, *The Tormentors* (1947–1948) has the stitched boots, and the early drawings show the Ku Klux Klan activities, that will reappear in the 1970s. In the "Porch" paintings (1947) there are signs of a softer, very stylish, muted—less powerful—version of the crowded, depthless Beckmann triptychs that were being shown in the 1940s. "Meaning" is insistent in these early canvases of Guston. They are essentially political cartoons, but drawn in the convention of semi-Cubist WPA murals, crossed with a strong memory of de Chirico and of Ernst (*Conspirators*, 1930).

Now consider a typical Abstract Expressionist painting of the 1950s. *For M* (1955) is made of soft pinks and reds, growing into impasto toward the center. While still wet, the impasto parts have been painted over with burnt umber, producing a peculiarly muddy, defacing, aggressive effect something like graffiti scribbled over the original image. This is the first sign of the smeared paint-

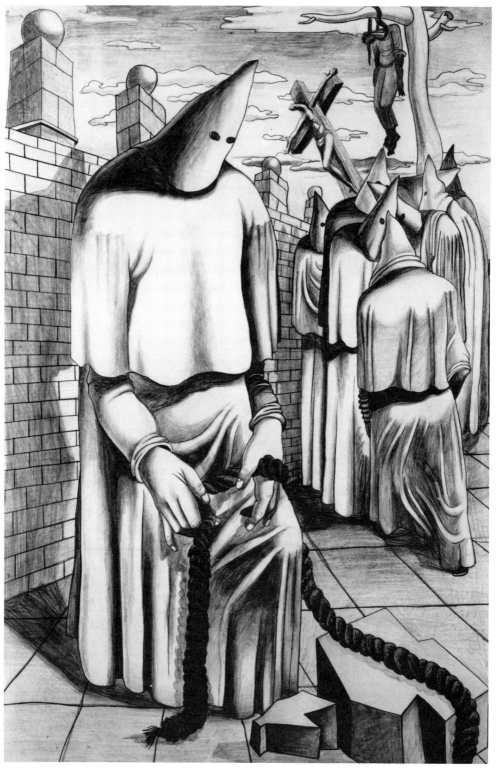

Philip Guston, drawing for *Conspirators,* 1930. Whitney Museum of American Art, New York, purchase, with funds from the Hearst Corporation and the Norman and Rosita Winston Foundation, Inc.

application of the last phase. In these paintings the strokes of paint—usually vertical and horizontal crisscrossing strokes, but sometimes squiggles and slashes—stand out from the soft pastel tones of the background; and, tending to concentrate around one area, they are centripetal in effect. In these strokes there is no effort at figuration—or even at hieroglyphics or ideographs. There is no attempt, as in de Kooning, to start from representational shapes and consciously render them nonrepresentational.

But in the 1960s this central part becomes denser and thicker, and rough head-shapes emerge that are reminiscent of the figure in Gorky's *Black Monk*. (It is possible that Guston's titles—*Painter, Inhabiter, Close-Up*—direct us to our interpretation of the shape.) Though there is a short period when the canvas

Philip Guston, *For M,* 1955, oil on canvas. San Francisco Museum of Art, gift of Mr. and Mrs. Stanley Freeman.

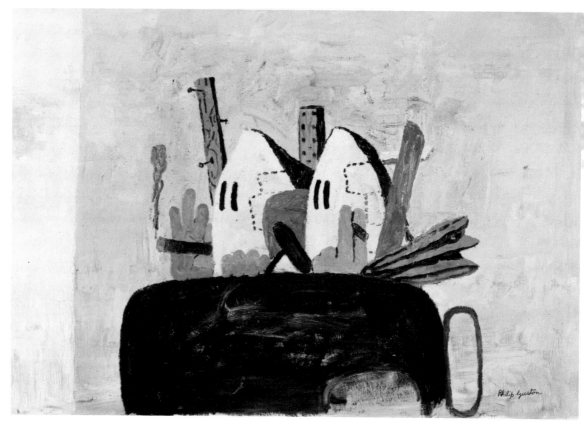

Philip Guston, *Edge of Town,* 1969, oil on canvas. David McKee Gallery, New York, The Edward R. Broida Trust (Photo: Douglas M. Parker).

becomes a large panel of a comic strip, very soon thereafter the paintings of boots, legs, hands holding cigars, and huge-eyed, eye-shaped heads look as if they were simply a further evolution in the direction of figuration from the abstractions of the 1960s.

The subjects of these final paintings are an artist in his studio, devoted to food, smoking, and sleep as well as to painting; a group of Klansmen in some sinister activity; or a pile of junk (see in particular the untitled drawings of 1980), something between a mass of jointed pipes and hairy legs, sometimes made to look like a monument (*Monument,* 1976, or *Tomb,* 1978), sometimes—best summed up in *The Web* (1975)—like a gigantic spider. The artist's eye and mouth come to be equated, especially in those paintings in which they are related to the swallowing or regurgitating of the forms—the pipes, legs, Klansmen, and other junk—of his art.

But insofar as these works grow out of Guston's Abstract Expressionist paintings, they may be as much about painting on wet paint—about the relation between the soft background and the aggressive, dirty, mixed (or soiled and garish) foreground. This "painting on wet paint," in an incredibly gross, childlike way,

is authenticated by the invariably small, neat script of the artist's signature, writ-ten with a delicate brush—the only vestige of that first phase of the 1940s. At the same time, the size of the canvases (all large—the size of a large Poussin, how-ever, not of a mural) asserts their importance and the importance of whatever they are depicting. The relationship of the scale, the gross paint application, and the careful script of the signature indicates a conscious intention, a willed act that does not admit to any loss of control in these apparently uncontrolled works. They are "history paintings" of the 1970s, precisely the contrary of Kline's huge black-and-white canvases, which were the contentless "history paintings" of the 1950s. Kline's breakthrough involved the conscious jettisoning of precisely the recognizable, referential content that Guston has now retrieved.

But instead of the Baroque forms of the political cartoon, Guston expanded the comic strip panel. One ponders, looking at the figuration of de Kooning and Gorky, let alone the more explicit work of Guston, the influence of comic strip style and iconography on the Abstract Expressionist generation. In *Untitled* (1949, private collection, Switzerland), for example, de Kooning has intro-duced, or "discovered," a figure in the cartoon or comic strip idiom and allowed it to remain in the midst of a typical de Kooning passage of "Abstract Expression-ism." *That* sort of figuration was a liberating way between abstraction and figura-tion that circumvented conventional, academic draftsmanship as representation.

It may also be significant that the source of Guston's style and iconography, if not of his form and color, is historical. It is a return to the comic strips *Mutt and Jeff* (the legs and striped pants in *Cellar* of 1970 are Mutt's), *The Gumps*, and *Krazy Kat* of the 1920s and '30s—as well as to the Ku Klux Klan, with its sugar-sack hoods and jackboots, of the same time. This is Pop art, but how different from the slick, decorative version of Roy Lichtenstein, who used the anony-mous, styleless comic strips of the 1950s and '60s—strips that cannot be identi-fied with either a character or an artist. With a kind of sublime laughter as accompaniment, Guston expanded the Abstract Expressionist mode to the gro-tesque, the idiom of 1930s comic strips. But he had begun in the 1930s with representational protest paintings, then interiorized these into explosive patterns of abstraction, and finally externalized them once again in these huge simplified comic strip shapes of Ku Klux Klan lynchers and of Depression dump heaps that recall Hartley's Dogtown.

Nor was Guston an artist like Johns, who took a well-known image and aes-theticized it, or filled it with a private, personal significance. Guston produced public imagery, pop imagery at its most elemental and unslick. If the smoking, boozing, and sleeping artist was in some sense a personal reference, it was as general and clichéd as the comic strip forms in which it was registered. And in this sense Guston's last phase was a direct continuation of the public art he (and Pollock and others) produced in the 1930s.

It must be added that the image sought by the Abstract Expressionists *was* in itself a final, "last phase" image. The result was a powerfully reductionist image

that recalled the great final masterpieces of Western art: Rembrandt's last self-portraits, Hals's *Governors of the Alms House,* Van Gogh's cornfields, Matisse's cutouts. Here we know we are at the absolute end of a tradition. In the case of artists like Rothko and Kline, the artist's final phase, then, coincided with the eschatology of his "breakthrough" image. Pollock attempted a further "final phase image," de Kooning has produced "final phase" paintings (simple, colorful, minimalist, recalling nothing more than Matisse's final experiments in pure color and form), and Guston, perhaps feeling that he had *not* himself produced that final form, went on to make a genuine "breakthrough" in the huge comic strip fragments. For Guston, the others' "breakthrough" phase was only a way station. He was the only one of the group—and perhaps this is why he said that one felt that everyone else leaves the room until only the artist is left—who moved on to an absolutely individual style. His Abstract Expressionist style was lovely, slightly derivative, and on the way to something else, which was his real breakthrough.

Popeye, Krazy Kat, and Superman

Addams's cartoons, beginning to appear in *The New Yorker* around 1940 and peaking in the 1940s and '50s, projected an alternative (or perhaps emblematic, truer-than-true) American family. Their fame was responsible for at least two television sitcoms in the 1960s, *The Addams Family* and *The Munsters.* But the family and antifamily had been established as the primary subject of the American comic strip by the 1920s: *The Katzenjammer Kids* (alternatively, *The Captain and the Kids*), *The Gumps, Skippy, Gasoline Alley,* and many more. Strips like *Mutt and Jeff* represented the male bonding that elided the fact of the family; and by the 1930s the alternative plot of a *Dick Tracy* or *Flash Gordon* had opened the way to the "breakthrough" into the world of *Superman* and *Batman* in 1938–1939.

George McMannus's *Bringing Up Father,* better known as *Maggie and Jiggs,* was about the rich man who keeps returning to his origins, escaping from his social-climbing wife and pretentious daughter to eat corned beef and cabbage with his former friends at Dinty Moore's tavern, or on a dangerously dangling girder on one of the new skyscrapers high above New York City. What he leaves behind or escapes are luxurious Art Deco interiors and his wife Maggie's vase or rolling pin, the other prominent symbol, flying after him. A typical strip finds Maggie trying to get Jiggs into his tuxedo for one of her soirees and ends with a panel of Jiggs safely ensconced on a girder dangling precariously from a crane, eating corned beef and cabbage. The comedy involves breaking out of the house or room dominated by his wife, a stifling confinement for the earthy and plebeian (for there is also a class dimension here) Jiggs, and a refuge with his male friends. The ideology represented by McMannus was so transparent in the 1930s

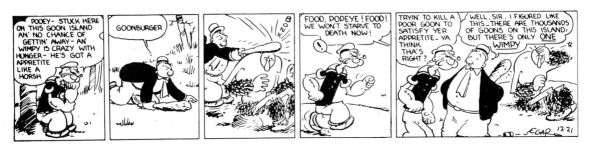

Elie Segar, *Popeye,* King Features Syndicate, Inc.

as to go unnoticed, and it is operative in different way in Thurber's *New Yorker* cartoons, de Kooning's "Women," and Hopper's interiors.

Another comic strip, Elie Segar's *Popeye,* was built on a trio of the hardworking sailor, driven by spinach; his "girl"-friend, the rail-thin Olive Oyl; and his male friend, the fat, indolent eater-of-hamburgers J. Wellington Wimpy. A typical strip is about the male-bonding, interloping Wimpy—and it includes Alice the Goon, who gave her name to "goons," *men* hired to terrorize or eliminate opponents, subhuman types with none of Alice's benevolent charm. (Segar also invented the Jeep, the *androgynous* little creature who could *do anything*—after which the U.S. army vehicle was named. The word survives today as a generic name for a kind of tough practical car that can do anything.[17]) The point of this episode is that Wimpy is *not* interested in women—either Olive Oyl or Alice the Goon. He is *obsessed* with his desire for hamburgers, and he sees Alice the Goon as nothing more than meat for a *Goon*burger. The punch line is Wimpy's savagely imperialist sentiment: "Well, sir, I figured like this: There are thousands of goons on this island, but there's only *one Wimpy.*" And the goon here is Alice. The *female* goon.

In retrospect, the *Popeye* comic strip was another social commentary on the America of the 1930s. The name J. Wellington Wimpy—or J. Pierpont Morgan—and the character's capitalist derby and his enormous appetite (*and* for hamburgers) are a subversive image of 1930s American capitalism by a Depression cartoonist. Wimpy's appetite is not for roast beef or steak but for hamburgers, meat that is ground up into something else: *Anything* can be burgerized (there are now chickenburgers, fishburgers, and so on). The word "burger" itself, from the German, means merchant, bourgeois; and it's significant that Wimpy eats nothing but hamburgers. One of the virtues of the Jeep is that it can create mounds of hamburgers for the insatiable Wimpy. Arno's male objectifying the female is displaced to the figure of the capitalist and recoded from gender difference to sociopolitial exploitation—objectifying *everything,* including the female goon.

Popeye, by contrast, eats nothing but spinach, and not fresh spinach but al-

ways canned spinach. A famous *New Yorker* cartoon of 1928, by Carl Rose, showed a little girl being forced by her mother to eat spinach. Her mother says, "It's broccoli, dear," and the little girl says, "I say it's *spinach* and I say the hell with it." Canned spinach was always something that children hated, and this was what fueled Popeye: Its reputation, with its high iron content, was for being healthy, and there was an attempt to promote spinach as a source of cheap protein during the Depression. The point is that Popeye eats this undesirable food in order to give himself the strength to save Olive—usually from abduction and rape; whereas Wimpy eats his hamburger for no other reason than to satisfy his hunger. The political subtext is clear, and the sexual sub-subtext no less: nothing but male bonding keeps the woman revered, objectified, or in her place, the symbol of normal heterosexual desire validating the more important business of being a sailor man. Olive oil is, after all, a lubricant.

Popeye should remind us that from *Little Orphan Annie* to *Pogo* and *Doonesbury*, the American comic strip has carried a political subtext, sometimes of the right and sometimes of the left, and that with Jules Feiffer and Garry Trudeau in the 1960s and '70s, the comic strip became an adjunct to the political cartoon on the editorial page—often influencing its form, turning it into a political comic strip.

A few years ago I picked up in a bookstore a Dover Press facsimile of Harold Gray's *Little Orphan Annie* strips from the Depression. *Annie*, together with *Dick Tracy, Terry and the Pirates*, and for a while *Flash Gordon*, I had followed with an intensity that is unfortunately lost with childhood. Partly, perhaps, it was the distance from which I read them. I grew up in the northernmost tip of North Dakota, but every week—about a week late—the *New York Sunday News* reached us with *Dick Tracy* on the front page and *Orphan Annie* on the back. (When I was five I visited New York City for the first time, and my most vivid memory is of acquiring a copy of the *Sunday News* on the street as soon as it came out.)

Looking at the Depression *Orphan Annie* strips, what I saw was Daddy War-bucks losing his fortune. The sign of this was the disappearance of his tuxedo and the stud in the middle of his dress shirt (he never appeared without these). We see him in a shabby outfit getting a laborer's job as a truck driver. Then, to avoid hitting a child who runs in front of his truck, he drives it into a pier of the Third Avenue El (or was it the Chicago Loop?). Then we see him in a hospital bed with a huge bandage following the contours of his domed head. He is now blind and has lost the last symbols of his former state: both the bald dome and the bright button eyes. When he sheds the bandages, he wears dark glasses and carries a cane. Eventually he regains his fortune and his sight, but the strip moves to this conclusion with glacial slowness, and the images of Warbucks in shabby clothes, with a bandaged head, and with a blind man's dark glasses—accruing to

the shabby clothes—register as indelible alterations of the familiar, secure image. For me, this series of images epitomized the Depression, which I was fortunate enough to feel in no other way; it projected a horrid possibility of loss of money, of house (his mansion burns down), and of sight—of the helpless parent, that contingency most dreaded by a child.

In another sequence, union organizers invade Warbucks's factories, corrupt the workers, and are indeed gangsters and racketeers; and when things look very bad, a deus ex machina appears—an elephant, I remember, whom they have mistreated. The union leaders climb into one of those high-backed early-1930s cars, and the elephant, who never forgets, brings down its foot on the top, crushing the car like an accordion. The *Orphan Annie* solution is a significant one: The feeling of frustration with government and society can only be dealt with in the way of Warbucks's friend Punjab, who simply drops his cloak over unmanageable elements of evil and when he raises it they are gone, eliminated, as one's fantasy of the time wished were the case with the forces of society that could not be controlled. (The Asp was another such force that Daddy Warbucks could summon to settle evil forces when needed.)

Gilbert Seldes's thesis in *The 7 Lively Arts* (1924) was "that entertainment of a high order existed in places not usually associated with Art," for example, "that a comic strip printed on newspulp which would tatter and rumple in a day might be as worthy of a second look as a considerable number of canvasses at most of our museums."[18] I would stress not only Seldes's raising of the issue of "pop" art in this context, available and well-known in the 1930s, but also his emphasis on the transience of the material and the contrast with museum art. Above all, Seldes was protesting "the grading of the arts and placing some of them forever at the lower table," and the villain of his book was the *faux bon*, as he called it, of the art world of Paris.

The comic strip Seldes singled out was George Herriman's *Krazy Kat*, which had emerged as a separate strip in 1913 and continued until Herriman's death in 1944. This was a remarkably seminal fiction. Its language play allowed intellectuals to connect it with *Ulysses* (as, more recently, its bare existential situation has been associated with *Waiting for Godot*), and its scratchy elemental draftsmanship with Guston's final phase. *Krazy Kat* was part of the 1930s zeitgeist, for example in the Algonquin Circle, that also took up the Marx Brothers, especially Harpo, and of the intellectual's love of the absolutely silent gesture—in Ignatz's case the throwing of a brick, in Harpo's the cutting off of every necktie, the clutching of every female thing—that drew on Marcel Duchamp and Dada but anticipated the sort of gesture Rauschenberg would make with bedding and male and female apparel in the 1950s.

The gesture of Ignatz Mouse (or, more properly, Mice) was continued by that of Herriman the artist, who broke the series of closed boxes that traditionally

constituted the comic strip. The characters break out of the boxes; the boxes themselves are jumbled, their lines dissolved, and characters float free in space; or the boxes become circles or irregular figures. In short, the diachronic structure of a comic strip narrative is fractured. (Herriman was forced to return to closed series of boxes in the late 1920s because of the exigencies of syndication, but he opened up the boxes again in the 1930s—and in 1935, for the first time, he added color to the Sunday pages, needless to say hallucinatory colors.)

The cult popularity of *Krazy Kat* is illustrated by E. E. Cummings's introduction to the book *Krazy Kat* of 1946. The strip was also admired by such artists as Picasso and de Kooning, Guston and Richard Diebenkorn. "Diebenkorn was keen about Krazy Kat cartoons, cultivating a deliberate awkwardness," Elmer Bischoff commented.[19] Cummings's essay refers (significantly for at least Diebenkorn) to the "strictly irrational landscape in perpetual metamorphosis," that Southwestern American landscape that looks at times like the surface of the moon. (One wonders if the color of Diebenkorn's Albuquerque paintings did not derive from the Sunday color pages' rendering of the New Mexico landscape of *Krazy Kat*.) The Surrealists admired Herriman for his use of landscape: Settings continually change while Krazy and Ignatz stand still in front of them—a shrub becomes a redwood, a hut a church, a tree a potted plant. Painters found here a particular relationship of figure to ground based on Surrealist landscape assumptions.

The situation was elemental—yet for 30 years the strip went on weaving variations on it. *Krazy Kat*'s popularity with artists has been due at least in part to this endless theme-and-variations, which by the 1940s had tired its popular audience (except for sentimental diehards like William Randolph Hearst, who continued to publish the strip in his newspapers). The first and original situation involves a mouse named Ignatz, who obsessively throws bricks at the head of a simpleminded cat named Krazy. In a most uncatlike way, Krazy is in love with Ignatz. Krazy pursues Ignatz, who hits Krazy with the brick—and this only makes Krazy love Ignatz the more.

In the late 1920s a third character, Offissa Pupp, who upholds the law in this strange, Surrealistic, Arizona world, falls in love with Krazy.[20] He is the proprietor of a jail, with one cell up over the door, in which he puts Ignatz Mouse whenever Ignatz hits Krazy Kat with a brick (we always see Ignatz's face through the bars). Pupp spends all of his life warding off these blows and imprisoning Ignatz, either as punishment for his success or as protective custody.

As cummings summed it up, the cartoon is about love, passion, anarchy, and police order—a comic version of the things that seemed most important in the radical politics of the 1920s and '30s. Ignatz's brick-throwing gesture cummings sees as either the radical or the conservative (libertarian) position, but certainly a political action. In relation to Pupp as policeman and Krazy as a predatory cat, this is correct; of course Krazy *loves* the mouse, but this is not surprising, for mice are good to eat, to consume. The cat who has "caught" the

mouse likes to prolong the pleasure by playing with it before eating it, but remains in a strong sense a consumer. In fact, Herriman dramatizes a complex sequence of master-slave interdependencies.

It is instructive to trace the line of descent from *Krazy Kat* to *Mickey Mouse* to *Tom and Jerry*. For *Krazy Kat* began as a one-line strip at the bottom of Herriman's comic strip of the moment, *The Dingbat Family*, itself about a family. The "family" plot narrows to the Dingbats' obsessive paranoia about the invisible family who have moved in upstairs. Below the Dingbats live the cat and mouse, and while the Dingbats are away they take over the whole strip in order to tell the story of how it came about that Ignatz Mouse throws bricks at Krazy. The story is of a paradise of mice that is invaded by an ancestor of Krazy's who eats them, one by one, until an ancestor of Ignatz hits him with a brick. (A later strip, playing on the word "atavism," shows Krazy returning to his ancient hunter's instinct and once again pursuing Ignatz.)

The story-in-the-present is about a cat who *loves* the mouse and a mouse that has to keep beaning the cat. But from these seminal narrative and dramatic personae came the Disney menagerie and the reversals of predator and prey in the animated cartoons *Tom and Jerry, Bugs Bunny,* and *Roadrunner.* For one thing, the drawing of *Krazy Kat*, originating in the bottom-line strip, is quite different from the conventional comic strip style of *The Dingbat Family.* Herriman's style in all of his other comic strips resembles the "comic strip" style of Frederick Burr Opper, R. F. Outcault, "Tad," Bud Fisher, Sidney Smith, and the rest. The exception is the style of his cat and mouse, who develop into wonderfully scratchy-thin, almost stick figures, fleshed out somewhat in Offissa Pupp and Kelly the brick-maker. *This* was the style (more economical, perfect for animation) that Disney picked up when he began drawing Mickey and Minnie Mouse.

But it is probably more important to notice that Herriman's whimsical reversal of predator and prey leads to all of the cat figures who (returning to the originating story as Herriman tells it) start out pursuing the diminutive mouse but find the tables turned and are treated even more roughly themselves. The cat is never shown loving the mouse, but the relationship is clearly a symbiotic one. The animated cartoons play much more on (or with) the audience's feelings. After so long, our sympathy turns in a strange way to the predator, who is always being mistreated in violent, often Surrealistically violent ways: He is crushed like an accordion or blown into fragments that somehow come together again. Herriman's concern, by contrast, is with the psychology of the cat and mouse, and then the triangle of the cat, mouse, and "police" dog.

A third point: It is obvious that Charlie Chaplin and Buster Keaton comedies of the 1910s—and the Keystone Kops—were among the models for Herriman's strips, in particular for *Krazy Kat*; and so, in art-historical terms, the comic strip—and then in a different way the animated cartoon—may be regarded by practitioners like Guston as the art that replaced the representational high art that was (as Danto argues) put out of business by moving pictures. Art is a major

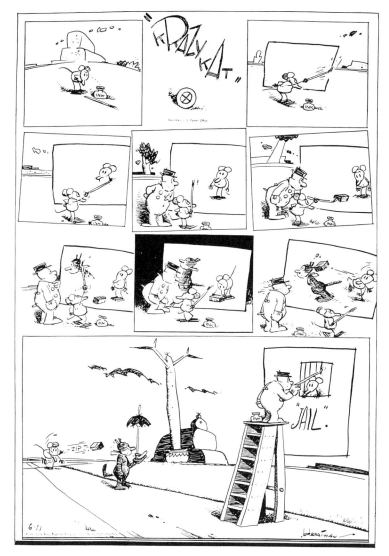

George Herriman, *Krazy Kat,* 11 June 1939. King Features Syndicate, Inc.

theme of *Krazy Kat*. Herriman frequently emphasizes the material nature of his comic strip and the ambiguities of representation. Out of many examples, I choose one in which Ignatz finds, at the outset of the strip, not the brick he usually takes up at this point in the story but instead a pen and a bottle of ink. And so he starts to draw a piece of paper on which he then draws himself. The moment Offissa Pupp walks up, Ignatz draws in the brick that he knows will alert the policeman—and then he draws in Krazy; and then he changes his own image so that he is bending over to pick up the brick—and in the next panel of the strip, in which Ignatz has redrawn the scene once again, the mouse artist is hit-

ting the cat with the brick. There is only one possible solution, in terms of Ignatz's particular offense in this strip, and that is for Pupp to draw on his own sheet of drawing paper the familiar jail window, with Ignatz Mouse inside it, to which he adds the label "Jail." But back in the real world (you might say, having diverted Pupp's attention from the real world with the world of "art"), Ignatz sends a real brick sailing—"zip"—at the head of the *real* Krazy, who is carrying a parasol to protect her head from the comparatively benign force of the overhead Arizona sun.

Herriman—like many comic strip artists of the time (and as he had done in *The Dingbat Family*)—included a small one-panel strip across the bottom, under the main cartoon story: A bird is regarding a typical Herriman landscape of the sort we see in the comic strip. Krazy says, "But he's a 'Ott [Art] Krittik,' aint he?"—to which the practical man of law Offissa Pupp replies: "Yes, but he's also a woodpecker"—i.e., he is going to go after the *painted* tree and peck it *as if* it were a real one. Thus the theme of the strip itself is underlined and given a final period. And the little mouse adds, simply, "ahh," to this modernization of Pliny's story of Zeuxis and the grapes. As this strip suggests, Herriman's drawing as well as his plotting constantly put in question assumptions of high art and ordinary representations of reality.

Accompanying the comic strips in the 1930s was the most mass of the mass media, the animated cartoon. In Disney's domestic fantasy, Minnie and Mickey Mouse get along just fine, if with occasional misunderstandings. But there is no Maggie and Jiggs or Popeye and Olive Oyl, not much of a *relationship* implied here, and nothing is made of the coupling. There are separate stories based on Mickey characteristics or Pluto or Goofy characteristics, or, increasingly as he caught the public fancy, on Donald Duck characteristics; these are simply human actions in animal garb, Aesopian fables. In the emergent narrative, Donald's choleric nature is juxtaposed with his role as parent (single male parent) of the nephew ducklings, which amounts to the hornet's nest, raging bull, or collapsing tent of the contingent world.

The memorable Disney images began with the Three Little Pigs versus the Big Bad Wolf and went on to Snow White and the Seven Dwarves versus the Witch, Pinocchio versus the Cat and Fox, and Bambi versus the hunters. *The Three Little Pigs*, created in 1933, has always been interpreted as a fable of the Depression: "Who's afraid of the Big Bad Wolf" refers to hard times and the "wolf at the door," and the wolf is pitted against three little pigs, round, well-fed symbols of capitalism, who are also vulnerable to big bad wolves who would like to *eat* fat, succulent porkers (*ham*burgers). The message is simple: build your house of brick and the wolf can't get you. But the story that grips is about the threat at the door, who if you won't let him in at the door is able to "huff and puff and blow your house down"—or is able to climb down your chimney. But

then, when the wolf climbs down the chimney, the pigs have a boiling pot waiting and *they* now turn the wolf into food. In typical Depression terms, the message becomes: Eat or be eaten.

The comic effect, however, comes from the turning of tables: The predator becomes the prey, the eater the eaten. This aspect of the Disney fiction, deriving, I have suggested, from *Krazy Kat* (a source Disney acknowledged), was endlessly elaborated in the narratives of Bugs Bunny, Roadrunner, and the rest versus their various prey. Their story of pursuit involves the intimate *interdependency* of predator and prey, with the foreordained conclusion (that the wolf will get the pig, the cat will get the rabbit or canary, the coyote a small, apparently defenseless roadrunner) subverted. The wolf is always coming down the chimney, expecting to take the pigs by surprise, and is himself surprised by the pot of boiling water that turns the feeder into food. It need hardly be added that predator and prey are of the same sex, recalling the primary importance of the man and the bartender in Arno's "Fill 'er up."

Even *Popeye*, when turned into an animated cartoon, becomes an agon between the tiny sailor (dependent on spinach) and the huge, muscular Bluto. They resemble in some ways the discrepant figures of Capitalism and John Q. Public in political cartoons. Bluto's crime, however, is invariably focused on Olive, whom he courts or abducts, and whom Popeye rescues. And the point of view is Popeye's, not (as it would be in the *Tom and Jerry* type of cartoon) at least partially the cat's.

Complementing these comic images were the melodramatic plots of the comic *books*—the collection of past comic strips, published separately, that began to appear in the mid 1930s, and then the original comic book heroes that appeared in *Action* and *Detective Comics* in 1938. Straddling the modes of comic strip and animated cartoon, the second-generation hero Superman, like the God of *Little Orphan Annie*, does what the ordinary forces of law and order cannot. Superman's appearance coincided with the great fear (that displaced the Depression) of Nazi Germany's intentions in Europe and the world; and his greatest fame came during and following World War II, in the animated cartoons of the 1940s, a TV serial of the 1950s, and a series of very successful films in the 1970s and '80s. Superman presumably corresponded to some sense of self-identity in many Americans of those years (and right up to the present, though the movies are self-parodies and Superman is now a comic figure). The narratives of Superman and his epigones coincided with the emergence of the United States from isolationism into nationalism and patriotism, and this was followed by the similarly aggressive ethos of Abstract Expressionism, of the heroic male artist figure of Pollock or Kline or de Kooning. Pollock was the Superman figure who, in his paint-spattered overalls, striding over a prone canvas onto which he dripped paint to make what appeared to be totally nonrepresentational shapes, served as the local champion of liberty against the coerced Russians, who produced timid social realist pictures of workers in overalls.

Superman in *Action Comics* was followed the next year by Batman (in a villainous and corrupt city called Gotham, modeled on New York) in *Detective Comics*, and then by separate *Superman* and *Batman* comics, and then by a proliferation of comic book heroes—Captain Marvel, Captain America, the Submariner—during World War II. All are schizophrenic figures with a private and a public persona. But as another dimension of the context we have been filling in for the Abstract Expressionists, this schizophrenia, we may note, is presented as a tremendous breakthrough from the small to the large, from passivity to energetic action. A mild-mannered reporter or millionaire transforms himself in a single gesture, and Clark Kent becomes Superman or Bruce Wayne becomes Batman. Billy Batson simply says "Shazam!" and turns into Captain Marvel.

One final feature that set off *Batman* (as it had earlier comic strips like *Dick Tracy*) was the villain who outshone the hero in symbolic, perhaps even human interest: the Penguin and Joker in *Batman*, the Mole, Pruneface (and Mrs. Pruneface), the Blank, and many more in *Dick Tracy*. I see this perhaps natural enthusiasm for lurid villains as a reflection of the table-turning we see in the animated cartoons: The villain (read the predator) has to be at least as interesting as the hero; and for "hero" we can read the figure who throws bricks at the cat, the figure outside the "law" of Offissa Pupp.

The spectrum of comic invention in America from the 1930s into the 1940s produced two basic fictions: one domestic, of a mismatched couple, or, on a more sophisticated level, of premarital courtship, with both models really about the superior fellow feeling of male and male; and the other public, of an extralegal hero who punishes criminals unreachable by the law, or of the wolf or cat who finds the tables turned on him—another extralegal situation—by the pigs or the mouse. One figure is the hero (anticipating Charles Bronson or Clint Eastwood–Harry Callahan figures of the 1970s and '80s) who overturns the assumptions of society: whether Harpo Marx, Ignatz Mouse, Jerry the mouse, or Roadrunner; or Punjab, Superman, or Batman. We might see this figure connected to, or picked up by, the political dissident and painterly avant-garde as another aspect of its overdetermined context for the figure of the American artist. And as Batman had his Robin (Dick Tracy his Pat Patton), the Abstract Expressionists clubbed in bars and painted male-bonded fantasies of women. And yet it is essential to place these fantasies, and the ideology they reflect, within a solidly "heterosexual" (if homosocial) myth. The homosexual or gay myth (as we shall see when we turn to Bacon and Johns) is a different one.

ABSTRACT FIGURATION III:
THE CLOSED ROOM

Hopper

Edward Hopper was the one illustrator, exactly contemporary with Norman Rockwell and the rise of the *Saturday Evening Post* cover, who also became, without radically disowning either subject matter or style, a major artist. At first the difference would seem to be a matter of subtraction: certainly of the psychological particularity, the overtly illustrational element of the designs. But Hopper dispenses with style itself, with the elegant brushwork and draftsmanship that distinguished J. C. Leyendecker, for instance (with whom Gail Levin, in her catalogue of Hopper's illustrations, associates his brushwork in some of his magazine covers).[1] The same principles of form remain, which Hopper (like Rockwell, N. C. Wyeth, and others) learned from the posters and paintings of Toulouse-Lautrec and Edgar Degas as well as from the illustrations of E. A. Abbey. In Hopper's case, he never abandoned the emphatic Golden Section used by Abbey, but whereas Abbey divided his figure groups in this way, Hopper applied the division to architecture, to the large rectangle of storefront or some other form of essentially empty (or blank) space, with a wisp of humanity somewhere present. The wisp takes various forms, by no means neutral, such as making the one prominent sign in the window of a pharmacy read "EX-LAX" (*Drug Store*, 1927). Eventually there is the plain, absolutely empty rectangle representing a room in *Sun in an Empty Room* (1963).

What carried over from commercial illustration, along with the "EX-LAX," were the subjects. "I was always interested in architecture," Hopper remembered, and the largely nonfiction topics he illustrated for trade publications (the *Wells Fargo Messenger*, *Hotel Management*, and *Tavern Topics*) involved the representation of offices, ships, railroads, hotels, and restaurants. In later years he was irritated by a critic who wrote that his painting *Summer Evening* (1947), which shows lovers standing on a lighted porch at night, would serve as an illus-

tration in "any woman's magazine." The conception itself, he replied, had no figures in it. "The figures were not what interested me: it was the light streaming down, and the night all around." It is not, however, light versus dark (let alone the illumination of figures one finds in a painting by Maxfield Parrish) that Hopper is stressing but "light streaming down" and "night all around." The submerged metaphors sum up the characteristic Hopper situation. (Although he also wrote, "The loneliness thing is overdone. It formulates something you don't want formulated.")

Some sense of our feeling about a painting like *Summer Evening* can be taken from the letter Hopper wrote commending *Scribner's Magazine* for publishing Ernest Hemingway's short story "The Killers": "Such an honest piece of work" in "the vast sea of sugar coated muck that makes up most of our fiction." Hopper's remark suggests that he was trying to do in art something similar to what Hemingway was trying to do at the same time in the short story, and that an analogy between the works of the writer and the artist has validity. (Compare, for example, "The Killers" and Hopper's *The Nighthawks* of some 20 years later.) Such an analogy might help us to understand Hopper's process of subtracting stylistic flourishes, story, even incident, which he followed by adding the enigmatic couples or single figures. These figures function the way Hemingway's people do, in similarly stripped settings, in "Hills like White Elephants" or "A Clean Well-Lighted Place." Hopper's formal justification for his fictions ("it was the light streaming down") also recalls Hemingway's description of his writing in formal, sometimes painterly terms in the dialogues of *The Green Hills of Africa* and *Death in the Afternoon*.

But it was the etchings, not the commercial illustrations (parallel in time), that served as the proving ground for Hopper's major oil paintings. The definitive Hopper etching is probably *Evening Wind* (1921)—the naked woman on an unmade bed near an open rectangle of window with a curtain blowing inward. A number of etchings explore the subject of the open window and the nude in the window, seen from inside looking out. But Hopper writes of *East Side Interior*, one of these versions (1922), that it "was entirely improvised from the memories of glimpses of rooms seen from the streets in the eastside in my walks in that part of the city."

In other words, while Hopper shows the scene from the inside looking out, the inspiration came from his experience of walking along a street, undoubtedly at night (the only time the effect is possible), and looking in. Hopper's interiors convey (or "illustrate") precisely the commonplace urban experience, the loneliness of the outsider looking in and yearning for the security of insideness. He represents the actual view of what was *seen* only in a painting like *Night Windows* (1928)—or in different form, with the Hopper spectator himself materialized, in three of his most evocative etchings: *House on a Hill* (1920) shows a couple in a buggy looking at a Victorian Gothic house, with its one double window open and the curtains blowing, suggesting the whole of an alien, occupied

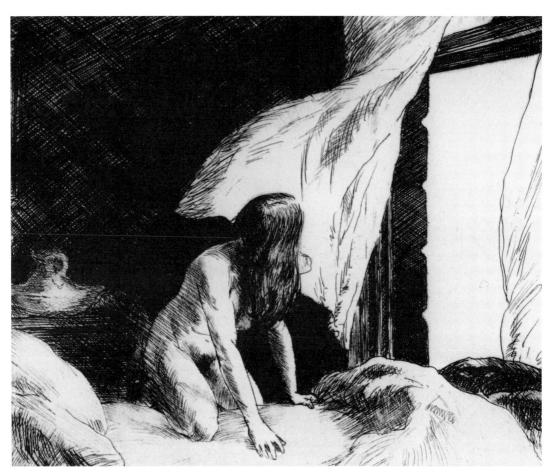

Edward Hopper, *Evening Wind,* 1921, etching. Whitney Museum of American Art, New York, Josephine N. Hopper Bequest.

interior not shown; in *House Tops* (1921) a woman looks out the windows of an elevated train at rooftops, with only the tops of their windows showing; and *Girl on a Bridge* (1923) shows a woman looking at the upper stories of an apartment house, juxtaposed with treetops, but every window is hooded by an awning, and the strange sucking shapes give the print its mystery. These are metamorphic images—their reverberations partly of the sort we associate with Pieter de Hooch interiors, but also of course Edouard Vuillard's and Pierre Bonnard's. Stripped bare of everything except the essential shapes of things, except light and darkness, inside and outside, architectural structures and the natural shapes of trees, these paintings suggest the haunting sense of one represented scene merging with another, simpler, more primal one.

Hopper found his personal manner, as Levin reminds us in *Edward Hopper: The Art and the Artist,* when he left behind direct observation of nature and moved indoors. But there is also abundant evidence of his reuse, revision, and

simplification of an observed image over the years, most obviously culminating in the late paintings of sunlight in totally empty rooms. A generation before Kline, Hopper was—in the terms available to him at the time—seeking "to pare down naturalistic subjects to a few quasi-geometric shapes" in the manner of Cubist "abstraction."[2] Retaining representation while reducing shapes to minimal rectangles and trapezoids (with minimal figures) was his version of what Kline carried out with the additional models of Mondrian and the blowups of the Bell Opticon projector.

The critics liked Hopper because his subject was "American," but Hopper kept insisting his subject was "myself." He went to Paris as Hartley went to Germany (at about the same time), to find what he felt about the American landscape, which in his case meant about "myself." The Hopper landscape structure is already implicit in some of his works of the time, for example *Canal at Charenton* (also *Après-midi de juin, Gateway and Fence, Saint Cloud, Le Parc du Saint Cloud,* and *Louvre and Boat Landing,* all of 1907): A long horizontal line cuts across the lower part of the composition, representing a road or river line below some buildings or trees. But not until the 1920s would the Impressionist brushwork disappear, the color and shadow contrasts be intensified, and the horizontality extended to increase the suggestion of empty space. *Canal at Charenton* is 23 by 28 inches, while a late summation like *Road and Trees* (1963) is 34 by 60. As the interiors end in empty rooms, the landscapes end in a stark shape not unlike those of Rothko's last paintings, in which a single line horizontally bisects the canvas.

Hopper found this pattern—a foreground pressing on but cut off from the middle distance; an intense interest in the line of unbroken horizon, even when it is repressed as horizon—in Paris in the Seine embankment, and in virtually every locale he painted in France. My impression is that he carried this shape with him to Paris, where his eyes were suddenly unblinkered. Having "found" it in Paris he carried it back with him, painting New York as if trying to recover the bank of the Seine or the memory of Saint Cloud. The nostalgia was for America by way of French forms, topographical and painterly.

I have little doubt that the years of earning a living as an illustrator forced Hopper into his sharp contrasts of light and shade, which he did not have in his Impressionist landscapes of France (or America). They forced him to deepen his colors, and introduced him to the use of light in a situation of outer and inner spaces. They also, of course, afforded him a kind of subject that involved offices, domestic rooms, urban streets, and their interrelations. And the illustrations gave him a paint surface that can best be described as nondescript or utilitarian, unlike the showy Impressionist surface of the early landscapes. I used to feel disappointment whenever I went up close to a Hopper canvas to find an undistinguished paint surface that is sometimes, especially in the painting of figures, awkward and labored. But this playing down of the handling allows a total attention to the bold simplifications needed for a magazine illustration or cover to

Above: Edward Hopper, *House on a Hill,* 1920, etching. The Philadelphia Museum of Art, Harrison Fund Purchase.

Below: Edward Hopper, *House Tops,* 1921, etching. Philadelphia Museum of Art, Harrison Fund purchase.

Edward Hopper, *Girl on a Bridge,* 1923, etching. Whitney Museum of American Art, New York, Josephine N. Hopper Bequest.

catch and hold the eye. It is as if Hopper had decided to worry only about the impression the painting made at a certain distance from the eye (as in reduction for reproduction). Except in its rendering of architecture, his paint is not in any interesting way descriptive of the object it defines. In fact, the paint surface is largely independent of the representation. His trees are strange, stereotyped, shaggy shapes that can only be called "Hopper trees." The effect is odd when he does attempt something more, as in *Summertime* (1943), where seen through the woman's light summer dress is her right thigh and (a little less evident) her left breast. This draws our attention to what Hopper usually is not interested in—and so to what he *is*: simple spatial relations, firmly established by strong contrasts of light and shade and color, and relatively large empty spaces.

Two watercolors can be juxtaposed: In *Skyline, near Washington Square* (1925) a long horizontal of roofline crosses the whole lower part of the canvas, cutting off the lower stories of the tenement that would appear to be the subject of the painting. This watercolor stands out from Hopper's many merely descriptive

scenes; next to it in the Whitney exhibition of 1980 was a watercolor, of as late as 1933, that simply showed a house and could have been painted by almost any talented Sunday painter. Many such paintings show how nondescript Hopper could be when he was simply sitting in front of a scene and recording. But he *named* this one *Mansard Roof*, and the title reframes the picture to resemble a typical Hopper structure consisting of a roofline, a long horizontal line with variables above it. Other versions of the *Skyline* composition are *Hodgkins House, Cape Ann* (1928); *White House with Telephone Pole* (1930), where the horizontal is a road; and *Blackwell's Island* (1928), which uses a river shoreline instead. Sometimes the long horizontal is slightly curved, a road over a hill, as in *The Camel's Hump* (1931).

By the mid-1920s the composition is established and its evocations made explicit in *House by the Railroad* (1925), an oil that was closely anticipated by the etching *American Landscape* (1920). *House by the Railroad* is impressive (as Levin suggests) because of the effect of the horizontal line of railroad track cutting across the whole lower part of the house, and because of the sense conveyed by the juxtaposition of house and railroad tracks of rootedness and rootlessness. I would add: The rootedness of the closed, mysterious "house" (as he calls it); the rootlessness of the spectator we associate with the railroad tracks; and the fact that in the etching he can call this an "American" landscape.

At one extreme Hopper paints a hall stairway leading down to an empty door, beyond which is nothing but darkness and some vague indication of foliage (*Small Stairway*, ca. 1925); or he paints a room with the door open onto nothing but sea (*Room by the Sea*, 1951). The effect of *House by the Railroad* is based on a similarly Surrealist juxtaposition. But Hopper is not toying with Surrealism so much as juxtaposing culture and nature at their outer limits, as in the country store up against sheer wilderness in *Seven A.M.* (1948).[3]

This flat horizontal plane at the bottom of the landscape is, on the one hand, the train track that cuts across, indeed cuts *off* the bottom several stories of the tenement beyond it. This is also the flat stretch of raised ground on which the "Man with a Hoe" is raking in *Pennsylvania Coal Town*. Here it cuts off nothing, but the man standing on it is looking at the sun, at something between the two houses that we cannot see but he can.

The suppression or omission has ordinarily taken place in the earliest sketch. An exception is the *Small Stairway* to which I have referred, the sketch for which must have been from nature and shows a normal porch and street lamp beyond the front door. In the painting there is nothing out there. A woman was apparently looking out a window in *Sunday Morning* (1930) before Hopper painted her out in order to leave the façade unrelievedly blank. But in general the absence is part of Hopper's original conception. As he tells us, and as his careful sketches show, he was not an improviser on the canvas.

Sometimes his titles draw attention to the absence. As with *Mansard Roof*, the titles are often a significant framing device. *Circle Theater* (1936) is the title

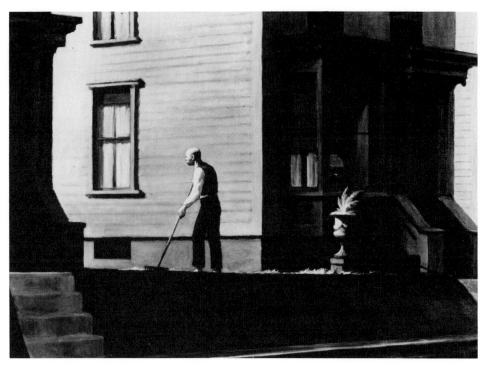

Edward Hopper, *Pennsylvania Coal Town,* 1947, oil on canvas. Butler Institute of American Art, Youngstown, Ohio.

of a picture in which that name in lights is precisely what is blocked out by an intervening subway entrance; the same happens in *Chop Suey* (1929). In *Shakespeare at Dusk* (1935) the statue of Shakespeare in the park has its back turned to us. Shakespeare is just what we cannot see. The woman looking out a window on an upper floor of a tenement front (cut off as usual at its second or third story) in *Home at Dusk* (1935) is looking to her right—looking for somebody, as the title tells us, to return home. The painting is about what is not there.

If the exteriors are usually empty, the interiors, whether seen from inside or outside, have one or occasionally two figures, seldom more. The point of departure is again in one of the French paintings, a largish one (*Summer Interior,* 1909) of a half-nude woman slumped on the floor with one arm on the bed, the sheet pulled off and under her body; she seems to be looking at a rectangle of sunlight cast on the floor. This painting leads to the splendid *Hotel Room* (1931), which, together with *The Barber Shop* (1931) and *Tables for Ladies* (1930), was an experiment in the direction of the monumentalized interior that was picked up and explored in the 1960s by Diebenkorn. But Hopper returned to the smaller format, a smaller figure subordinated to a larger room, and the relationship of inner and outer (the window in *Hotel Room* shows only night outside).

The interiors, like the landscapes, are constructed almost entirely of right angles, and they emphasize long horizontal lines even when they are not on long

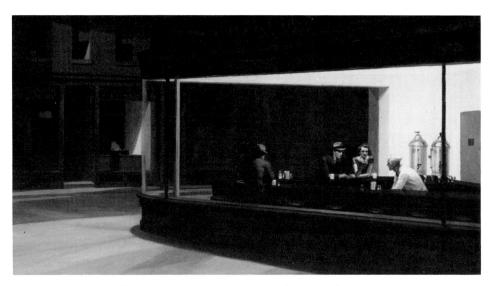

Edward Hopper, *Nighthawks,* 1942, oil on canvas. Copyright © 1989 by the Art Institute of Chicago.

rectangular canvases. But there is also a curved feminine shape that sets these off—within a room, a circular lampshade, round glowing lights, an overstuffed chair (outside, the shaggy Hopper trees)—and there is the human being herself, for the protagonist is always a woman, though she is sometimes accompanied by a thin, cold, remote man. The interiors could all be titled "Alone in the City."

The Hopper painting I always return to is *Nighthawks* (1942), in which a couple sits within the brightly lit interior of a diner, a dark empty street outside. I was about 10 or 12 when I first saw this picture, in the Chicago Art Institute. It terrified me. Or rather, to be more precise, it made me afraid in the way I feel afraid sometimes descending by airplane into a completely unfamiliar city. This is not empathy with the two figures (he self-engrossed, she looking at a greenish object about the size of a ticket in her hand) seated at their lonely counter, nor with the counterman, let alone the other man whose back is turned. It is fear of this couple, who are—or seem to be—knowledgeable of, self-sufficient in, a world that is completely and unalterably self-sufficient. I am by no stretch of the imagination in their life. But on closer inspection, there is one striking detail: The same street appears outside the all-night diner that was shown head-on in *Sunday Morning* (1930), the most famous of all Hopper paintings.

Levin brings forth the interesting fact that Hopper (a great theatergoer, as should be evident from the paintings) had seen Elmer Rice's *Street Scene* just before undertaking *Sunday Morning*. She reproduces a photograph of Jo Mielziner's set: True, there is a slight sense of an empty stage set in this and other Hopper landscapes. The analogy with *Street Scene* reminds one of the absence of "actors" and the straight-on horizontality, with the bottom line even more emphatic than usual. But do we feel we are looking at an empty stage or merely an empty street? Which is the common term, theater or emptiness?

Theatergoing was one activity of Hopper the man, and the other two chief ones seem to have been traveling, especially train-riding, and walking. *Sunday Morning* is a view that a spectator is ordinarily more aware of on a stage than on a street. But as recreated in *Nighthawks* the street is seen not by reconstructing it on a stage, or by walking along it and adjusting a kinetic into a static image, but by seeing it through a long rectangle of window. If this insight is valid, we can see that in most cases Hopper's paintings are of scenes that a spectator catches through similar rectangular windows—of a train, a car, or a motel. In the case of a train, I refer not only to the emphatic horizontality but to the degree of focus (a perceiver's view in transit, not in lengthy meditation), to the part of the house seen and the parts not seen (rooftops from an elevated train), and even to the vantage of the house or building (old enough, for example, to have been built facing the train tracks before they were put in).

These are all frames that make very plain one's status as spectator and out-sider. The feeling is of something seen only once—in passing, from a train, completely cut off from all knowledge of what went on before or after, but held indelibly in the memory in a way that the familiar never is. The image of the girl in a loose kimono standing in the doorway of her house in the midst of a field, in *High Noon* (1949), is the view of the transient—the man in the speeding car or train, who carries with him the poignance of never knowing who she was or what she meant.

In this context it is easy to understand the game that the Hoppers played in an interview with Brian O'Doherty in 1964. Hopper told O'Doherty that the young woman perched on the porch of *Second-Story Sunlight* (1960) was named Toots, the woman in the theater in *Intermission* (1963) Norah. "Why Norah?" "Maybe she's Irish," said Hopper. "She's a maid or something on her night out," said Jo Hopper. "She's a coming egghead," Hopper added. All you can do about such people and such a scene is to make a game of inventing their names and histo-ries. This sounds at first like no more than a domestic in-joke, and it also sug-gests something of the uneasiness we feel about such charged images, and the need of the artist himself to domesticate them. But it is not without significance that Norah is Irish and a maid—even a coming egghead: She is both Other and transient.

Is it an irony that in *Nighthawks* the eyes of the spectators within the restau-rant are turned away from the window through which *Sunday Morning* is to be seen? No, only that every such scene contains two possibilities: one looking in and the other looking out. In a larger sense we can see Hopper's practice as paint-ing what he sees and then at another time the situation from which he sees it—the street of *Sunday Morning* as well as the restaurant through whose window he sees that view of it; the rooftops as well as the man sitting in an upper story, looking out, in *Office in a Small City* (1953); the view of rooftops and coun-tryside as well as the woman sitting on a train *not* looking out (*Compartment C, Car 293* of 1938, or *Chair Car* of 1965). This situation can also be related to the

Hopper view both from outside a room looking in through the window—often with the intensification of night—and from inside the room looking out, with the occupant (we might say the actor) either looking out or turned inward.

Transience is the common theme in all of these. Hopper's is a modernization of the ancient topos of transience into images of literal transients, informed (I presume) by at least some sense of the Depression. The point of intersection between *House by the Railroad* and the interiors is *Room for Tourists* (the words on the sign in this painting of 1945). The bottom horizontal is the street, reinforced by the horizontal of the clipped hedge that separates the house from the street; through the windows we see brightly lit but empty rooms in which both others, equally transient, and we ourselves will pass the night.

The stage and the train or car window have in common the framing of an action or a scene and the complete removal of the spectator from contact with the experience. Perhaps Hopper's plainest model is, as Levin suggests with her example of *Street Scene*, the theater. In the theater paintings there is an audience and an empty stage, or actors and no visible audience to speak of—audience waiting for actors to appear, curtain to rise, and actor waiting for applause; or the sense of the way the audience looks to actors and the way the actors look to the audience—remote, and never at the same time. The utterly unbridgeable line that separates audience and actors is a recreation of the one that separates the spectator on a train from the landscape.

At this point we reach the fact that the figures in Hopper's mature paintings are often awkwardly painted. In the drawings, illustrations, and etchings they are professionally drawn and quite adequate. (Indeed, in the early French paintings people are entirely absent, whereas they swarm about in the drawings of the same time.) But something happened to the figures when he sought a convention for painting them. The painters whose figures he seems to have used as models were his friends Guy Pène du Bois early on, for figures that, I suspect, he came to recognize as too close to the stereotypes of his illustrations (*Two on the Aisle*, 1927, for example, which also evokes *The New Yorker*'s Wallace Morgan), and then Leon Kroll's women for the rest of his career (*Summertime*, 1943, *High Noon*, 1949, and *Carolina Morning*, 1955). His most effective women owe something to Reginald Marsh's streetwalkers (the flesh showing through the dress in *Summertime* is a Marsh touch), but to Marsh's diaphanously thin paint he preferred the clear modeling Kroll used on his more brassy, assured, and threatening women.

According to Levin, the model for all of Hopper's women was his wife, Jo. As Levin puts it, Jo insisted shortly after they were married that she model for all of his women. Certainly many of his women *are* Jo, in that they have Jo's face, and the others, even those with different faces, have the same body. This places the interiors in one sense in the genre of "Artist's Studio" scenes (in theatrical terms, backstage), with Jo the model as much a fixture as Vuillard's mother sitting in his rooms sewing. But the model as the person seen looking out of the room raises

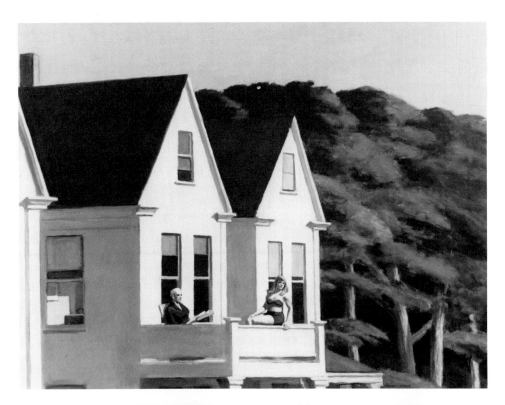

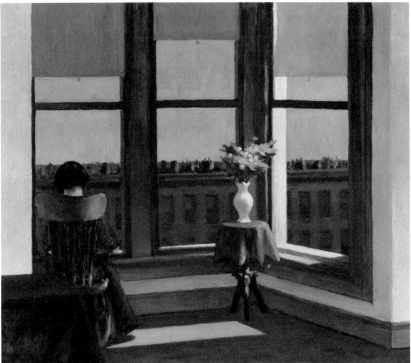

Above: Edward Hopper, *Second-Story Sunlight,* 1960, oil on canvas. Whitney Museum of American Art, New York, purchase with funds from the Friends of the Museum.

Below: Edward Hopper, *Room in Brooklyn,* 1932, oil on canvas. Museum of Fine Arts, Boston, Charles Henry Hayden Fund.

the question: Whenever this woman appears, is it she who is the protagonist, alone in her room, or is it Hopper who sees her as the impenetrable, unreachable Other? What does he make of the fact that Jo poses, insists on posing, for all of his women? Bonnard's wife, Marthe, posed for his women over a period of 40 years. But they were all Marthe; with Hopper they are the same person but painted in different roles and different costumes, as a person who is not Jo, as she is clearly not Hopper himself—in a situation in which he is looking in as from a passing train or automobile.

When (only occasionally) she is accompanied, it is by some man—austere, thin faced—who is obviously not Hopper. Inevitably, with Levin's catalogue before us, we place this information in relation to the stories of Jo's assertive garrulity, which dominated every social scene, and of Hopper's taciturnity; to those pencil drawings he presented to Jo, his joking pleas to her for food and sex. We know she refused to cook for him, thus introducing him to many greasy-spoon restaurants. The rest is conjecture. But I also wonder whether the cold gray-haired woman who is not Jo—the one in *Hotel Window* and *Hotel Lobby*, for example—is based on memories of Hopper's mother (a conjecture supported by Hopper's paintings of her). On whom, then, are those thin gray men based? The only portrait he made of his father is from 1900, while the ones of his mother are from 1916, of a woman the age of the woman in *Hotel Window*.

In the picture called *Excursion into Philosophy* (1959), another of Hopper's significant titles, it is pretty obvious that the text lying on the bed behind the gloomy-looking man, sitting this side of a bare-bottomed sleeping woman, has under the circumstances to be Aristotle's *Omne animale post coitum triste* (which appears in a similar situation, written out, in Hogarth's engraving *After*). The man's left foot is cut across by the rectangle of light from the open window, like the one in *Summer Interior* of 1909, and light also cuts across the bare legs of the woman and makes a rectangle on the wall behind her. Through the window all we see is a sand dune and the sky Hopper associates with Cape Ann or Cape Cod.

Another, a female version of this picture is *Summer in the City* (1949), of ten years earlier—a far finer painting, with a less tendentious title. The woman sitting in the same position as the man on the bed in the later painting seems only to be thinking: What else? She is not looking out of the room. When Hopper's woman does look out the window (more often she is outside, on the street or in the doorway) it is to bask in the sun abstractedly, not to show longing. The jokey titles are attached, as a rule, to reinforce the male desire to escape into "*Omne animale. . . .*" The title of *Four Lane Road* (1956) forces us to see the highway as an escape route for the patient man listening to his wife's harangue (her head sticking out a window like a figure in a Punch and Judy show). It is a situation that is also true of the harried-looking man gazing away from his haggard wife out the window in the painting titled *Hotel by the Railroad*—the window and railroad indicating his desire, once again, for something that is not present.

Hopper's last painting, *Two Comedians* (1965), is of a curtain call of two masked clowns, one male and the other female, bowing along the long horizontal of the stage to an invisible audience. The only other painting of the stage in action is *Girlie Show* of 1941, which shows a stripper making her last pass. We can follow in the sketches the transformation of Jo's face and body into this masked woman's. For me, *Two Comedians* raises the question, what is to be made of the very early, very large painting called *Soir Bleu*—which Hopper kept and never exhibited again after its first unsuccessful trial in 1914, and to which he returned in a literal way in his last painting, but which bears little resemblance to his characteristic compositions (except for the extremely long horizontal shape of the canvas, with its vertical marking of the Golden Section)? *Soir Bleu* commemorates Hopper's French period with the outside, probably the terrace, of a Parisian café, and little indication of architecture. The café consists of a pimp alone at a table, and a heavily painted woman—probably a prostitute— standing facing us, almost taunting us, beyond a table at which are sitting an artist, a clown, and (his back turned) an admiral; at the third table, on the right,

Edward Hopper, *Seven A. M.*, 1948, oil on canvas. Whitney Museum of American Art, New York.

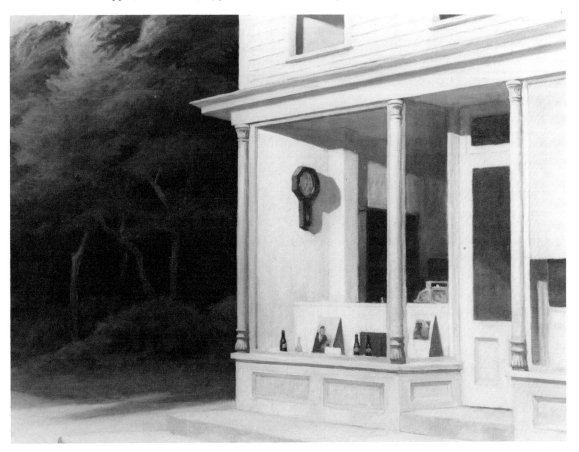

are a couple in evening dress. All appear to be in costume. The two prominent figures, however, are the whore and the clown, and the former has the face of the stripper in *Girlie Show* but with black (not red) hair. *Soir Bleu* owes more than a hint to Marsh's paintings and etchings of striptease shows. There may, despite all the complex interwoven strands that would overdetermine any painting, be a sense in which Hopper simply mined this painting for the characters who appear within his architectural settings for the rest of his life.

Magritte

A Canaletto or Bellotto capriccio of the dome of Saint Peter's rising from behind the Piazza San Marco has one of the qualities of Surrealism: incongruous juxtaposition. So also the urinal exhibited in a picture gallery and signed "R. Mutt" (1917); but Duchamp used the incongruity to make a comment on the relativity of art itself. A Dali of Shirley Temple's head on the body of the sphinx (with the skeleton of the Good Ship *Lollipop* abandoned in the desert nearby), or of Mae West's face opening into a lush pink boudoir, makes incongruous juxtaposition a vehicle for satire.

In such company Magritte's painting of a room completely filled by an apple appears to be rock-bottom Surrealism. The objects are "styleless" and neutral in that they are not transformed by artistic personality, as they would be by Dali, Ernst, or Yves Tanguy. Yet they are not the objects themselves but the objects portrayed in the stiff manner of advertising posters or illustrations. They are closer to the Victorian wood-engraved illustrations that Ernst juxtaposed in his collages than to his frottages. At Magritte's less than rock-bottom, he relates to Duchamp and the question of what is art: a dinner table painted on a stone wall, with doors cut into the wall, will reconstruct Leonardo's *Last Supper*; coffins bent to resemble people will simulate the compositions of paintings by David and Manet. Behind most all of his designs is a general allusion to graphic designs that have in common only the fact that they are well-known to the point of popular cliché—as well known as Saint Peter's, or a urinal in a public toilet, or the sphinx. With the incongruity reduced, Magritte's paintings fall into the school of Pop art. This is not, of course, to deny his freedom of choice and arrangement of these popular images of rosy apples or clothes dummies; there are signs of his own Cubist and primitivist origins in the paint's smooth surface and the front-face compositions, and he can go off into a very good imitation of de Chirico in any of his periods.

His acknowledgment that de Chirico was his master is misleading: de Chirico's scenes of massively symbolic conglomerates, viewed from dramatic angles, in late afternoon light, are those of a Piranesi to Magritte's Canaletto. Magritte's homage to de Chirico tells more about himself than about his master, who, he says, is "the greatest painter of our time in the sense that [his painting] deals with

poetry's ascendancy over painting and the various manners of painting. Chirico was the first to dream of *what must be painted* and *not how to paint*."[4] The style of popular art, Magritte realized, is the signifier of anonymity and cliché, but it is also the only way to avoid the problem of "how to paint." The objects he juxtaposes or metamorphoses are never in any sense real objects; they are representations of the representations of things, and that room-filling apple is brother to the gigantic orange being squeezed (where it should be squeezed) on a billboard; not in order to allude to a billboard or the page of a magazine, however, but to supply a readily accepted sign system for "apple" or "room."

Magritte does not place a Saint Peter's next to a Piazza San Marco (or patently picture-postcard images of them) but rather a bird-sized egg in a bird cage, a substitute for the bird. An apple or a rose in a room is not strange because of the object, or even because of its size, but because it completely fills the room, adding disorientation to incongruity. One then speculates on the continuum or the relationship, as on how the coffins came to replace people in the Manet and David imitations.

In his book on Magritte, A. M. Hammacher traces the painter's development back to his early interest in Fantômas, the French translations of Poe, and the Symbolist poets, and so defines "mystery" as the aim of his paintings.[5] He pushes "mystery" back to one of Poe's own sources, Samuel Taylor Coleridge, and argues that we must see Magritte's painting as the Coleridgean imagination, the creative faculty, rather than the fancy (or the merely juxtapositional). But he also (following Suzi Gablik's book *Magritte*, 1970) discusses the Magritte of the word-sign-thing discontinuities (akin to Ludwig Wittgenstein and to Jorge Luis Borges and the artist's concern with the root problem of representation itself. Both Magrittes exist, but a third is the Freudian, who connects the two. The paintings, like dreams, have more than one meaning—indeed call for the supplying of dream thoughts and analysis to explain the condensation and displacement involved in the coffins for human bodies, the bird cage for a torso (via the rib cage?), or the egg for a bird.

"Mystery" should not be confused with the "fantastic," which we can take, with Tzvetan Todorov (and Freud), to be a phenomenon about whose reality or unreality we are made to be in doubt. There is never such doubt in a Magritte painting. The Freudian *unheimlich* or uncanny is the category that covers the effect of Magritte as well as of Poe: *Todestrieb* (the death drive), *Wiederholungszwang* (the repetition compulsion), and castration anxiety are the primary forces set in motion by Magritte's imagination.[6] The representation itself is appropriately that of an intermediate image, a nearly forgotten magazine illustration or a picture in a children's book. At the heart of Magritte's scene is the relationship of castration to ocular anxiety: The eye is both the surrogate for the sexual organ and the organ with which the crucial discovery of difference is made; the Magritte scene rehearses the act of seeing the missing, the altered, the transposed.

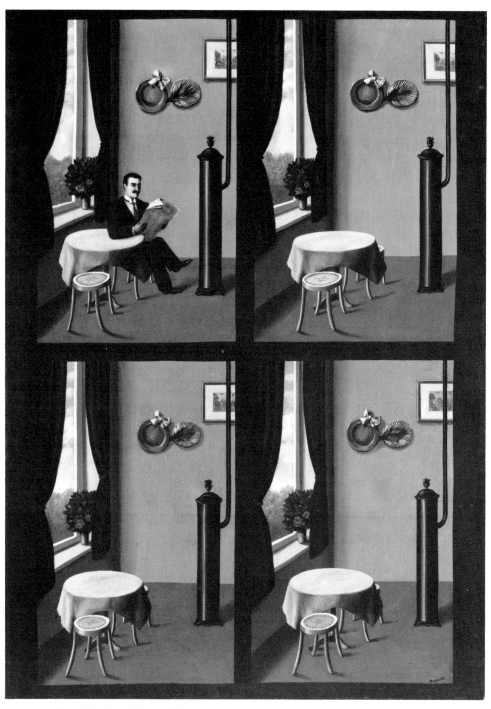

René Magritte, *Man with Newspaper,* 1927, oil on canvas. Tate Gallery, London
(Photo: Copyright © 1990 by C. Herscovici, ARS, New York).

The threat is to the totality of one's own body as well as to one's knowledge of the difference of the world.

Our feeling before a Magritte is of something missing. We see a truncated woman (perhaps covered by a cloth), a woman whose head is lost under her frantic hands, a body truncated and framed in discrete segments, and a building, part of which is gone. A boot ends in human toes, but it is also an amputated foot; there is no body. Among the more evocative pictures are the reversed mermaids with phallic fish-heads, which become the peg-legged merman with his love in *The Old Gunner,* or both lovers turned to stone in *The Song of Love.* We feel the mortal danger to the subject, which can dissolve into a wall or into the sky or turn into stone; its integrity, its very identity, is at stake, and already rendered suspect by the posterlike representation.

There are four exactly repeated views of a middle-class room: In the first, a man is sitting at the table reading the newspaper; his absence in the three replicas sums up the effect I have tried to describe. But what of the room itself? For Magritte the room is the closed chamber in the rue Morgue, or the one into which Fantômas mysteriously penetrates, or in which crimes are committed in the whodunits of John Dickson Carr, with the question, How could a murder have taken place in this locked room? It is also the room of tabloid murders and squalid assignations, explaining the centrality in this oeuvre of the early *Assassin Menaced,* which is unique in its collection and rehearsal of Magritte motifs in a single picture.

The closed room is shared with artists as different as Vuillard, Balthus, Bacon (and, adapting him, Bernardo Bertolucci in *Last Tango in Paris*), and Hopper. Vuillard is precisely what Magritte was not, a "painter" more interested in "how to paint" than in "what must be painted." Balthus, Bacon, and Hopper, though also interested in "how to paint," use their paint to further the expression of anxiety. Hopper's is the case that seems to me most relevant: He claimed his paintings were only studies in form and the effects of light; he had no Surrealist in his background, indeed deriving straight out of the Impressionists. He takes his wife Jo or Captain Ed Staples and places them in an empty room or against a blank wall, looking like an overexposed photograph. He paints his self-portrait in an empty room with a closed door, his head against a blank wall. The ultimate Hopper is a painting of a completely empty room with the late afternoon sun slanting in from the right making abstract patterns on the floor: in design almost a Mondrian, in atmosphere a Magritte.

In the context of Magritte's painting, Hopper's empty room with ocean showing beyond the open door would be Surrealist. In the context of Hopper's, it is a house on the beach seen from the inside. But the effect, without any of Magritte's conceptualism or precise denotation, is the one Magritte said he strove for: strangeness, and to a greater degree and with a greater economy of means.

Hopper's basic structure is the rectangle of living space cut off at top and bottom, as in a chain of boxcars, or a street of storefronts with sidewalk under and sky above, disappearing off the picture space to right and left. A container of some kind is defined, whether storefront, all-night diner, house, train, or bedroom; the canvas itself is very long and rectangular (as opposed to the rather squarish shape of a Magritte). Light comes from almost directly to the right or left, indicating late afternoon as the sun is going down, but quite different from twilight in the paintings of Bellotto or de Chirico: Hopper's light and sky are usually New England, near the open sea. If there is a house, under it is tall, uncut grass, and around it bushy trees painted in a free manner distinctly at odds with the hard-edge lines of the house. So, too, the boxcars are in the middle of wild, wide-open countryside; or the filling station is on the edge of a wood, with a lonely highway going past.

But all of this is frame. The basic image is the impersonal room, and the transient looking in or out of it. But one picture shows a woman in a motel room, with the huge picture window filled with the incongruous shape of an automobile's nose, and low purple hills beyond. It is the same effect David Sylvester describes, writing of Magritte: The car outside his study window seemed to be "thrusting itself through the window into the room. What was happening outside seemed to be happening in my head. I felt the car was stuffed inside my brain."[7] Inside or outside Hopper's rooms, and often in the relationship of inside to outside, of voyeur to what he sees, there is something slightly *wrong* that cannot quite be pinned down. In the lone undressed woman in her room, standing by the bed or lying or sitting on it, and looking out a window at the outer world, there is no longer any sense of Poe's claustrophobic chamber, let alone Plato's cave or John Locke's small room, but rather of O. Henry's "The Furnished Room." The literature Magritte and Hopper allude to tells the difference between an artist who constructs syntactically a series of Poe fables and the painter who repeats endlessly his (our) memory of something between the vivid, enclosed shock of the primal scene and the frozen boredom of those "lonely nights in one-night cheap hotels" (lines from another of the texts informing Hopper's weltanschauung).

In Hopper's sunlit rooms the light is secularized. Hughes, writing in *Time* of Hopper's *Woman in the Sun* (1961; equally applicable to *Morning Sun* of 1952), says: "Jo facing the August light of Truro recalls any number of quattrocento Annunciations." Perhaps the traces of an Annunciation are inevitable in any room with sunlight intruding that is not a *Danae*. But Hopper's rooms are always hotel rooms or offices or someone else's, and the sun reaches someone else (even if she is Jo). Hopper's own experience, which is presumably what he communicates in his paintings, is of someone outside the room yearning to get in or inside yearning to get out, and so only a spectator to the contented figure of Vermeer's interiors (the Dresden *Woman Reading*, for example). *Morning Sun* achieves a Vermeer-like intensity: Jo sits in a sort of chemise on her empty bed facing the open window, breathing in the sunlight.

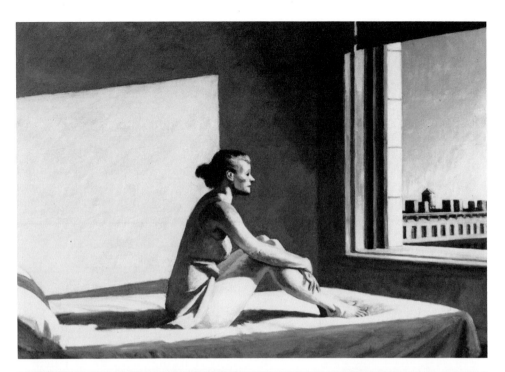

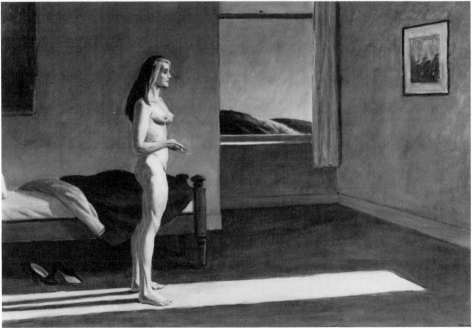

Above: Edward Hopper, *Morning Sun,* 1952, oil on canvas. Columbus Museum of Art, Ohio, Howard Fund Purchase.

Below: Edward Hopper, *A Woman in the Sun,* 1961, oil on canvas. Whitney Museum of American Art, New York, 50th Anniversary Gift of Mr. & Mrs. Albert Hackett in honor of Edith and Lloyd Goodrich.

In that strange painting *Pennsylvania Coal Town* (1947), the "Man with a Hoe" (taken from an early pen-and-ink sketch of ca. 1900, after Jean François Millet's painting) is placed in the same situation in the narrow space between the walls of houses, bending toward the sinking afternoon sun. Hopper's paintings, especially the later ones, are heliotropic, but they leave one wondering whether it is the light or the heat of the sun that is sought.

One Hopper genre I have not mentioned is the porch. In the 1950s he begins to show people emerging from the house and basking in the unmediated sunlight (*Seawatchers* of 1952, *Caroline Morning* of 1955, *Four Lane Road* and *Sunlight on Brownstones* of 1956, and *People in the Sun* and *Second Story Sunlight* of 1960). In this his final phase, they have come out of their closed rooms and offices (which Hopper is also painting by this time as empty rooms), to sit simply looking into the sun.

Stieglitz

Sun Rays—Paula—Berlin (1889), a very early Stieglitz photograph, shows the effect of sun rays through blinds cast on a wall; as every photograph must ultimately be, it is about light.[8] "Paula," the human subject, sits writing at a table framed by four photographs of herself, one of a young man, three Valentine hearts, two landscapes, and, as if these homely details were not enough, a pair of lovebirds in a cage.

Sunlight, the pictures on the walls, and the composition itself evoke Vermeer's sunlit interiors. Vermeer presides over the photograph, but the decor is "Berlin" 1889, not 17th-century Delft. And the photograph tells a story. Besides writing a love letter, Paula's turned-away, self-absorbed face and the artful panoply of pictures suggest a relationship between lover and beloved in which the woman is more interested in her own photographic image than in her lover's— or a relationship between the photographer and his subject, a relationship to which Stieglitz will always return. For those other photographs attached to the wall within the photograph (including a duplication and almost a reversal) make the photograph's theme photography itself. If so, then the demurely bonneted woman and the photographs of her dressed and undressed can be seen as an anticipation of a principle of photography that Stieglitz was to explore more profoundly than any photographer before him: I refer to the 300 photographs of Georgia O'Keeffe, as well as to very personal photographs of other women with whom he was emotionally involved. *Sun Rays* also looks ahead to those portraits in which O'Keeffe is framed or flanked by her own works of art.

It is easy, a century later, to overlook the ground-breaking effect of Stieglitz's early photographs: his exploitation of the hand camera, his walks through New York, and the pictures taken at night, in the rain, in snow, or in a downpour or blizzard, again at night. He was reacting in both photographs and polemics "against the mainstream" of the posed, composite "academic" realism he associated with Henry Peach Robinson's pseudo-paintings. But of course, as in *Sun*

Alfred Stieglitz, *Sun Rays—Paula—Berlin*. 1889, photograph. National Gallery, Washington, D.C., Stieglitz Collection.

Rays—Paula—Berlin, we see not a snapshot but an eternal moment, the Flatiron Building or Fifth Avenue as "art." Stieglitz has simply substituted one type of painting for another. Artistry is writ large on these photographs, which in many cases served as illustrations for his written arguments in *Camera Notes* and *Camera Work*. In these essays, the word he applies most often to photography is "artistic" ("truly artistic photograph," "artistic instinct"). His accomplishment was to keep abreast of the times, substituting Impressionism for the realistic academic painting he ridiculed, and then moving on to the advanced art of his day, to various forms of Analytic Cubism and finally, in his cloud "equilavents," to organic abstractions of the Kandinksy sort. The little stable of five or six painters regularly hung in his galleries (Hartley, Arthur Dove, Charles Demuth, O'Keeffe, John Marin) corresponds to the modes or styles of art he felt photography's affinities to be with. These found their equivalents in the phases of his own work and were passed on to at least two generations of American photographers. In other words, he fixed photography within a kinetic, not a static, tradition of *ut pictura poesis*, more flexible and au courant but not different in kind from Robinson's.

It is not that painting is like photography but that one tends to become in practice the model for the other. It was Stieglitz's limitation to use contemporary

paintings, however advanced, as his model for the photograph rather than realizing that the situation might, to the benefit of photography, be reversed. What the notion of the "artistic photographer" kept him from realizing in his theory and most of his practice was that the photographer can also (in the snapshot as well as the time exposure) *upset* our notions of academic or conventional form and genre, and so produce a model for painters to follow (as with Manet and Degas in the 19th century). That model can base its formal principles on the quotidian use of the camera—on documentary, medical, or official photographs—or on the sheer accident of the snapshot.

As to Stieglitz's own photographs: I distrust prize-winners, and Stieglitz won 150 prizes for his photographs. This tells us that technically and synthetically he was a superb craftsman. It also suggests that he remained in some sense academic at each stage of his career; or at least that he exerted more control over his camera and his object than other photographers. If he was one of photography's great masters, he was its Raphael, not its Michelangelo or Rembrandt. *The Flatiron Building* and *Spring Showers* are beautiful and unexceptionable; by "unexceptionable" I mean that nothing is wrong with them. Such works are often awarded prizes after the exceptionable photographs have been eliminated. My thesis is that the great photographs (like the great paintings) are the exceptionable ones.

There are two basic critical positions on photography: One is that of the photographers P. H. Emerson and Stieglitz, essentially *ut pictura poesis*, and the other is that of the nonphotographers Charles Baudelaire, Walter Benjamin, Roland Barthes, John Berger, and Susan Sontag. The latter group, perhaps with greater detachment, sees most photography as merely "reproductive," either literally of paintings and other objects (replacing engravings) or figuratively of painterly styles. What makes photography interesting for these critics is its potential for discovery through accident—what Barthes calls the "punctum," or the irrelevant eye-catching (or heart-stopping) detail—and through the knowledge we always carry with us when we look at a photograph that this *has happened*: that photography is the one art that is doggedly referential, that always holds *something* beyond the reach of the painter who "represents" nature. Whenever we look at a photograph (magnificently so in early Jacques-Henri Lartigue), we also know that the photographer has had little control over the image beyond choosing a time and place and then choosing whether or not to develop (and how long expose) and preserve the image. (Even Lartigue's spontaneous images presumably affect us as they do because they correspond to a capability of photography by this time recognized by Degas and developed in his paintings.)

Stieglitz only partly if at all grasped the fact that photography of his sort—the "artistic photograph" he advocated in all of his writing—is always parasitic on painting, or at least secondary to it, perhaps even a form of reproduction and dissemination of the insights of the painter, whether as reproduction or as imitation. Photography's true ground, as Benjamin recognized in his seminal essay of

1931, "The Work of Art in the Age of Mechanical Reproduction," is instead found in its least aesthetic or literary counterparts—the snapshot, the medical or scientific illustration, the police photograph, the album portrait, and the aerial photograph: precisely the forms taken up by the Surrealist photographers and collagists in the 1920s and '30s.

An analogy is worth pursuing between photography and the novel, which in the 18th century departed from the consciously elevated genres of romance, epic, and tragedy. Though often retaining the formal qualities of these genres for purposes of respectability (or contrast), the novel developed the popular forms of the spiritual or criminal biography, the periodical essay, news journalism, the diary, the personal letter, and other forms that were as oriented toward the truth-to-fact or to nature as the photograph (as it was touted by its originators).

It is telling that Barthes and Berger should single out only two of Stieglitz's photographs for admiration, and these eccentric ones: the steam from the horses in *The Terminal* and the close-up of a gelding's underside (with the draw-straps attaching it to the load it pulls) in the photograph Stieglitz characteristically entitled *Spiritual America*.

The great photographer is simply the great image-maker (or image-breaker): The image is all. Stieglitz's Impressionist *Flatiron Building* should be compared with his disciple Alvin Langdon Coburn's Expressionist one, in which the building has lost all spatial articulation and appears to be on the same plane as the strange figures jutting up like spears of grass from the street. Perhaps Stieglitz's *Flatiron Building* suggests something between a Monet and a J.A.M. Whistler, while Coburn's recalls the street scenes of Kirchner and the German Expressionists of *Die Brücke*. When painting styles are evoked, the choice is a matter of taste—Coburn only being the more avant-garde. But his photograph also pulses with life and energy, and the pair of globes of a street lamp hovering like twin suns or a pair of eyes above the people on the street, just this side of the tall dark monolith, is unforgettable. Stieglitz, seeking repose, makes sure there are no people about, no chancy or obtrusive objects that might break his mood.

Most of Stieglitz's portraits seem official, a little dull, when compared with Coburn's, whose Mark Twain is off center, as askew as his Washington Square; and whose Henry James is only a great bald skull in profile. But Coburn's portraits are images as definitive as a Titian Charles V, a Holbein Henry VIII, or a Van Dyck Charles I. For one thing, many of Stieglitz's portraits are of his official "family," the artists he sponsored and the writers whose views he regarded as in line with his own: They are *his* artists and writers, and share a homogeneous quality, all merging into respectable dignity (Dove and Demuth, at least, are almost interchangeable). With the large exception of the O'Keeffe portraits, the one Stieglitz portrait that stands up against Coburn's is of Hartley, Stieglitz's most recalcitrant painter, with his dandyish twisted scarf, swathed in a greatcoat, and peering out from under his fedora with his haunted and/or scared eyes.

In the case of Stieglitz, from the early days the personal pronoun "my" fig-

ures largely in his photographs. Between the early *Sunday Afternoon—From My Window*, or *From My Window, New York*, 1912, and the series "From the Back Window—291," the "my" becomes "the," but it still designates what is essentially a Stieglitz-eye view. The focus generally becomes sharper, more reportorial, as he weans himself from the pictorial tradition to this more precise sense of what the photograph is: a particular thing chosen to be seen and recorded by a particular person for a personal reason. So also the ironic and pompous titles—such as *Spiritual America* (on a harnessed gelding), and *The City of Ambition* (New York skyline)—disappear, and dark lines like the one drawn around *The Steerage* (as close to a textbook photograph as I can recall, accompanied by Stieglitz's brilliant formal analysis) are dropped, and what Stieglitz shows is what *he* sees. These are not just the views from his New York windows but his Lake George estate, the artists he showed at his galleries, the writers with whom he associated himself—and finally the young women on whom he had crushes.

The tension in Lartigue's photographs between the artist and his wonderfully recalcitrant, uncontrollable subject seems to me the photographic paradigm. But for Stieglitz, the "artistic" photograph means the controlled photograph. He experiences the occasional serendipity, as in the double exposure of Dorothy True, her high-heeled leg showing over a faint ghost of her face, the nose, left eye, and mouth showing through the dark calf of her leg. He chose to preserve this negative and develop it, but he did not turn the accident into practice; other photographers made careers out of such superimpositions and called them Surrealism or fashion photography. For Stieglitz an accident was interesting, worth preserving, but not worth submitting to. Reality was fine when (as in *The Steerage*) it conformed to the formal principles of painting. For Stieglitz, reality did not involve very much contingency.

What Stieglitz did grasp was the necessity of the photographic series, and his assumptions about "artistic photography" stood him in good stead when he arranged variations on a theme. One realizes that the series on a wall or the moving picture is the end toward which photography—or one important aspect of it—tends: Eadweard Muybridge was the transitional figure, but Stieglitz was the artist who made the choice to show his photographs as series. Stieglitz photographed not only the series of views of the same building rising in construction, and the series of cloud studies he called "Equivalents," but also those most cathected of objects, the women he loved. His biographer, Sue Davidson Lowe, tells us that he had considered "making a motion picture to reveal the whole emotional range of a woman's life through alternating close-ups of her nude body with footage of clouds in motions." As in the "Equivalents," Stieglitz often talked about photographs as "equivalents" to states of mind—presumably he meant the photographer's, but there is inevitably a tug-of-war between the artist who wants (slightly ridiculously, we may think) to see his states of mind in those clouds and the clouds imposing upon the artist arbitrary states of mind determined only by themselves.

As to the cathected quality of the image: Lowe gives many examples of the

importance of women in Stieglitz's life. It seems that he was "a spellbinding ra-
conteur of his exploits with 'women,'" and told all his descendants, especially
the female, the story of his first sexual experience—with a prostitute. He and
O'Keeffe flaunted uninhibited sexuality before the young Sue and the rest of
Stieglitz's extended family in the summers on Lake George. Lowe mentions his
youthful discovery in Vienna of the most sensuous of Rubens's nudes, his young
wife Hélène Fourment enfolded in furs.

One of his most striking images is *Georgia Engelhard* of 1922, a nude
perched in an uncomfortable position on a window holding a bunch of apples
near her breasts. In another *Georgia Engelhard*, of 1920, the girl, Stieglitz's
niece, appears in a sailor suit, a pudgy child of 12. She was 14 in the 1922 pic-
ture, one of those young girls with whom he established a Lewis Carroll relation-
ship. The photograph also asks to be seen in the context of Engelhard's own
account, in which she tells (without mentioning that she was nude) how Stieglitz
posed her

> sitting on the very edge of a cottage window, bending over with an armful of
> apples clutched to my bosom as if I were just about to leap up. At best a difficult
> pose to hold even for a few minutes, but . . . for more than an hour [I had] no

Alfred Stieglitz, *Georgia
Engelhard,* 1922,
photograph. National
Gallery, Washington,
D.C., Stieglitz Collection.

respite. . . . When I became cramped and tried to shift my position, or when I wriggled because a fly was slowly parading down my face, he would roar at me until I was ready to weep with rage and discomfort. The result of all this agony, however, was a perfect picture.

Precisely not a "perfect" picture, Stieglitz's goal. The photograph has caught the tension: she is as tightly wound up as a spring, but the only credit we can give Stieglitz as "artistic photographer" is if he intended to produce an incongruous variation on Edvard Munch's *Puberty*. Whether Engelhard is posing as Harvest Plenty or Ceres (Why nude? we ask, why the apples? Why held—not to her breast as Engelhard remembered—but to her womb?), the sense of a particular girl cramped into this "artistic" pose, possibly by the prurience of the photographer, is the "photographic" center—the punctum—of the image.

The duration of the sitting and the "roar" of the photographer when the sitter moved tell us something about Stieglitz and his relation to his sitter. O'Keeffe's complaints of the endless time taken sitting for Stieglitz are even more eloquent. Sometimes (as in no. 39 of his series of her) her fingers have moved slightly, a sign of her impatience or failure that the photographer has retained. Stieglitz rejected the sitter's traditional headrest (which he called the "Iron Virgin") but added to the control involved in taking any photograph the further, more purely physical and psychological control of the sitter while he took the photograph. The drama of these photographs lies in the remarkable tension between the reciprocal powers of subject and object in the photographic agon. In a painting, the sitter or the landscape has no power of its own and is simply represented— can be made totally the occasion for a painting. In a photograph, the intractable object is full of surprises, and the photographer can either elide the surprise or accept the accident and let it reveal new formal and psychological possibilities; he can (if, for example, he is in love with it) let the object master him.

What distinguishes a nude made by Manet or Courbet from a Stieglitz nude is the painter's medium. The photographer's medium is the human element, the model, lover, woman, who resists and has to be worked in the same way as the painter's pigment.

Stieglitz's masterpiece, it is generally accepted (and was from the time they were first exhibited), remains the series of photographs, taken at all hours of the day and night, of O'Keeffe. These photographs still derive from painting and sculpture: He fragments her, now isolating her head or face, or part of her face, now her nude torso or pelvis or breasts, most strikingly and lovingly (and formally) her hands. The mode is Auguste Rodin's, and like Rodin's small plaster body parts, O'Keeffe's isolated hands could be turned whichever way the viewer desired. As part of a series, these fragments did not exist separately without the common element of Georgia O'Keeffe—as she was at a certain time on a certain day, clothed or unclothed, posing or not posing, happy or sad, or aging. O'Keeffe tells the story of the men who came up to Stieglitz after his first exhibition of the O'Keeffe photographs and asked him to do the same with their wives and girl

Alfred Stieglitz, *Breast and Hands (Georgia O'Keeffe)*, 1919, photograph. Metropolitan Museum of Art, New York, gift of Mrs. Alma Wertheim, 1928.

friends. "If they had known what a close relationship he would have needed to have to photograph their wives or girl friends the way he photographed me—I think they wouldn't have been interested."

One has the same feeling with Edward Weston's nudes, who, as formal pattern, tend to be boring and secondary to the work of painters, but who, when seen as part of a series that includes the women's passionate or angry or wryly cool faces, become powerful precisely because of the artist's futile attempt to abstract and empty what is so full.

If what Stieglitz signally lacked was the native anthropologist's eye of August Sander, or the innocent-nine-year-old eye of Lartigue, he came closest to having an eye of his own when he looked day after day at O'Keeffe. What distinguishes the O'Keeffe photographs is both the eye of the lover, the photographer who has a personal stake and exposes himself vis-à-vis his sitter, and the woman who is remarkable and allowed to be so. At least half of the impact is due to O'Keeffe's presence: her face, ranging from serene to joyous to (in the most marvelous of all, *A Portrait I*, 1918) complete vulnerability in early-morning dishevelment; her poise, gestures, and earthy grace, all embodying restrained passion; and her own artistry, which in almost every photograph holds the other con-

tingent qualities in check. For not only lover faces lover but artist faces artist. She is nude as a model and as a lover are nude, but she herself painted nude during the summers, sometimes chasing off the peeping Tom nieces and nephews. And while Stieglitz was photographing the erotic centers of her body, she was herself painting flowers and New Mexico rock formations as body symbols and sometimes standing in front of them for her photographer.

O'Keeffe chose the "key set" of Stieglitz's photographs, the "best" print of each negative in his possession at the time of his death, and donated them to the National Gallery (Washington, D.C.), where an impressive selection was shown in 1982.[9] In some cases Stieglitz cut different compositions out of the same negative, as in versions of *The Terminal* and *Winter—Fifth Avenue*. He wrote a great deal about the variations the "artistic" photographer can bring out of a single negative, including the most minute shades of tonality, and the most significant work of his career was devoted to photographic theme-and-variations. This was the particular form "artistry" took for this extremely self-conscious and artful man. The notion of a "key set" chosen by his foremost sitter (and wife) therefore raises the question, *key for whom?* I cannot imagine that Stieglitz himself made these choices before his death; if not, were O'Keeffe's the correct ones? How did her choices affect the photographs of *herself?* Are choices desirable where the essential Stieglitz principle of difference depends on more than one version? What should be the range of the variants of a particular negative? If an exhibition of Rembrandt's or Goya's prints would have included variant states, why not an exhibition of Stieglitz's photographs? What is needed, 40 years after his death, is not sanctification and the establishment of a canon but a thorough catalogue with the states of the photographs and a sober appraisal of their significance.

Now the relationship between artist and subject has come full circle. The cover of the National Gallery catalogue shows O'Keeffe's hands, which chose the "key set" in the first place and undoubtedly (though this is denied by the coauthor of the catalogue) exerted some influence on the selection of the photographs and texts for the exhibition. (She included no photograph of her beautiful rival Dorothy Norman.) The appearance of O'Keeffe herself at the opening of the exhibition was the final act in the drama of the photographer and his sitter, or, in larger terms, of the photographer and his material, showing how the object seen will always, despite Stieglitz's claim to the contrary, dominate him in a way it does not the painter or sculptor—not just outlive him but have the last word.

A final note on O'Keeffe herself. In the 1920s and '30s, while Stieglitz was photographing her, she was painting flowers and mountain ranges that resemble women's vulvas, thighs, and other body parts. That she painted natural forms to resemble female genitalia was an interpretation accepted by Stieglitz but firmly denied by O'Keeffe, who saw herself as simply turning naturalistic compositions into abstractions in order to disprove the Cubist thesis that there is no such thing as abstraction outside purely geometric forms. (Her censorship of the sexual dimension, so obvious in her paintings, recalls the censorship she was later to exert on Stieglitz's photographs.)

But O'Keeffe's flowers and desert landscapes that are tropes for generative body parts—and always female, never male—raise interesting issues: One could say that Stieglitz photographed her body *as if* it were a landscape, and O'Keeffe painted landscapes *as if* they were a female (possibly her own) body. O'Keeffe demonstrated—in a way related to the Surrealists, but ostensibly independent of them—that abstraction does indeed lie outside Cubist grids, in organic forms. One could also note that she used representation to convey images very similar to the ones Pollock and de Kooning later concealed by veils of abstract and accidental patterns. The latter images are equivalents of Stieglitz's O'Keeffes; they are female bodies controlled—or violated—by a plainly male hand, arm, and gesture. O'Keeffe's are equally plainly presented as nothing more than landscapes that suggest unashamedly positive generative forces uncurbed by male hands and intentions.

Diebenkorn

Guston's career, from figuration to abstraction to abstract figuration, had the beauty of a sonata form. The contrary of Guston, Diebenkorn began as an Abstract Expressionist (1948–1955), then turned to figuration (1955–1967), and returned to a modified abstraction, the open-ended "Ocean Park" series, that owes much to the subjects and forms of the period of figuration. Eight years older than Johns, Diebenkorn connects the two generations as a younger contemporary of the Abstract Expressionists.

A few apprentice works survive, however, that preceded his contact with the New York School. They are cityscapes in the manner of Hopper; I would guess he had seen one of the paintings with railroad tracks cutting across the foreground. The tracks make a natural frame, joining form and representation in a particular way that would inform Diebenkorn's mature paintings, both figurative and abstract. This "Hopper" is reflected in his very early *Palo Alto Circle* of 1943. In the figurative paintings of 1955–1967 he simply subtracted and abstracted from Hopper's interiors until the most minimal reference (or representation) remained; but the images are still powerfully suggestive, utilizing a significant characteristic of Hopper's own paintings, abstracted as they were from his "illustrations."

Yet Hopper did not offer Diebenkorn the authority needed in the 1950s for representational painting. That he found in two paintings of the French School, which he saw in the Phillips Collection in Washington, D.C.: Matisse's *Studio, Quai St. Michel* (1916) and Bonnard's *Open Window* (1921). Although he saw them as he was self-consciously entering upon Abstract Expressionist painting, they served as the models for his figurative painting of the 1950s–1960s, and they remained as a primary armature for the "Ocean Park" abstractions. Near the end of the figurative period, he saw Matisse's *Open Window, Collioure* (1914) and *View of Notre Dame* (1914) on their first exhibition in the United States, in a

Richard Diebenkorn, *Palo Alto Circle,* 1943, oil on canvas. Santa Cruz Island Foundation, Santa Barbara, California.

Henri Matisse, *Studio,*
Quai St. Michel, 1916, oil
on canvas. The Phillips
Collection, Washington,
D.C.

traveling Matisse retrospective. These were again enabling paintings. His last,
abstract phase follows directly from the figurative paintings he had just made
(nos. 102–109 in Gerald Nordland's invaluable monograph),[10] but the Matisse
paintings served to validate for him the particular kind of subtractive abstraction
he embodied in the "Ocean Park" paintings.

Diebenkorn's career, structured by his "profession" as an academic, can be
defined in terms of a series of paintings he encountered in galleries or exhibi-
tions, which validated for him works being produced by colleagues in the univer-
sity. He supported himself during his formative years by taking classes under the
G.I. Bill and teaching studio art at the college level, living in academic commu-
nities in New Mexico, central Illinois, and northern as well as southern Califor-
nia—and only briefly in New York. Between these viewings of Matisse,
Diebenkorn saw, in the context of his university teaching, the work of David
Park, Bischoff, and, above all, his senior colleague at San Francisco State, Still.
Still's canvases informed his particular experiments—which he attacked with the
analytic intensity of an academic study—in the Abstract Expressionist problem
of how to break the figure-ground convention.

Diebenkorn in effect conflates the opened-up room of Still's (or Turner's, or

Henri Matisse, *View of Notre Dame,* 1914, oil on canvas. The Museum of
Modern Art, New York, acquired through the Lillie P. Bliss Bequest, and the
Henry Ittleson, A. Conger Goodyear, Mr. and Mrs. Robert Sinclair Funds,
and the Anna Erickson Levene Bequest given in memory of her husband,
Dr. Phoebus Aaron Theodor Levene.

Whitman's) Sublime and the Matisse artist's studio. His objective throughout his
career has been to keep his picture space from falling into a figure-ground rela-
tionship, generally following Still's solution of making rents in the surface
(where Pollock interwove skeins of paint at just the surface level so that they can-
not be pried apart into figure and ground). As John Elderfield notes in his study

of Diebenkorn's drawings, this involved rejecting linear Cubist geometry for an arrangement of "intuitively discovered zones or areas reaching to each other across the surface."[11] The corollary problem was his personal need, beginning as he did with Hopper, to accommodate the Abstract Expressionist unity of the picture plane with the figurative painter's perspective box.

Diebenkorn did not, however, accept the Abstract Expressionist rhetoric against French painting. Still had consciously employed a heavy-handed paint texture, clumsily applied blacks, and dark, muddy colors as a reaction against the brilliant coloring, the finesse and delicacy, of French painting. He had used an aggressive rhetoric of art as a breaking through the walls of the European past, of art as a liberating, emotional force *produced by social outsiders*, employed to "counter the influence of Matisse and of European modernism." Still's message (like Rothko's) was "that art must avoid traditional sources and procedures in order to be vital and new."[12]

Richard Diebenkorn, *Girl Looking at Landscape,* 1957, oil on canvas. Whitney Museum of American Art, New York, gift of Mr. and Mrs. Alan H. Temple.

Diebenkorn retained the colors of Miró and much of Matisse's elegance in his abstractions. His reliance on cityscape, interiors, and a landscape *seen through* a window or door (that is, a representation of a room) sets his paintings off from the Abstract Expressionists and their "landscapes." When in 1955 he turned to the sort of figuration practiced by Park and Bischoff (the "San Francisco School"), his solution was characteristically based on the Matisse *Studio*: An open space is framed by lines and indeterminate shapes that refuse to stand out as figures. This solution also gives some sense of the importance of Diebenkorn's later contact with Matisse's *Open Window* and *View of Notre Dame* at just the moment when he needed a way back from representation to abstraction, but not back to the Abstract Expressionism he had abandoned.

From the Matisse paintings, especially the *Studio*, Diebenkorn took the basic ingredient that held together the works of all three, ostensibly contradictory phases: the architectural frame of the room (closed, but with an open door or window, already available to him in more mundane circumstances in Hopper's paintings); in particular, the painter's studio, the room in which he paints, and indeed the process of his painting. The figure, however, is a woman, sometimes accompanied by a man, and the setting usually invokes the domestic interiors, as well as the scale, of Hopper's interiors: The figures bear the same relationship to the picture space, carry out the same gestures and functions.

The Hopper element, however, only draws attention to what his interiors have in common with Matisse's. Diebenkorn continues to use the Matisse structure in his "Ocean Park" paintings without losing the basis of the abstraction in a landscape enclosed as if by a horizon, seashore, framing windows, curtains, shutters, inner and outer walls of a room—but now completely cleansed of psychological content of the sort found in a Hopper, or even in a Diebenkorn of the 1960s. He does this by reaching back to the Matisse studio, in which the architecture serves for the generic artist as a symbol of the essentially abstract quality of pictorial composition.

Even the artist's female model is recalled by the small area of circular or irregular shape, the complex element placed somewhere within the area defined by the lines of the framing composition, beginning in the abstractions of the 1940s. (This ambiguous figure derives as well from the shapes of Matisse's violin cases and bowls of flowers, which serve as substitutes for the model.) But in Diebenkorn's case one can almost say that this framing composition is *about* framing: As a framer, Diebenkorn is always working around the edges, never reaching the magic interior; or, perhaps better put, leaving it magically empty with a space that in the early "Ocean Park" paintings, by its general blueness, seems to indicate ocean.

Nigel Gosling's opinion in *The Observer* of Diebenkorn's London exhibition of 1964 is instructive: "the hard facts of painting—a square white canvas, a supply of pigment and the utensils of the craft, whether brush or spray or scraper—are openly deployed and then overlaid with hints of place and atmosphere. . . .

Richard Diebenkorn,
Ocean Park No. 29, 1970,
oil on canvas. Dallas
Museum of Art, Dallas,
Gift of the Meadows
Foundation, Inc. (Photo:
David Wharton).

They are variations on a theme labelled Ocean Park and are visibly based on some light and airy California beachscape."[13] Only they are, as we have seen, emptied of, gradually reduced from, the "hints of place and atmosphere." Yet whether or not Ocean Park itself bears any resemblance to the paintings, they do carry or suggest a *former* atmosphere (something past and veiled) of "light and airy California" beaches. In fact, as often in Diebenkorn's work, the title is simply a designation of *where* the series was painted, and in this case "ocean" carries the additional weight.

It is interesting, by the way, that Gosling sees these paintings "as a Californian tribute to Turner." They do recall Turner's (and, closer to the moment, Still's) emphasis on the periphery around an empty interior—though in Turner's case always centered on the presence of a sun. Diebenkorn's "Ocean Park" paintings frame the empty interior space of ocean and/or sky.

Like so many contemporary painters, Diebenkorn is eloquent on his own art. Here are his words explaining his turn to figuration in the 1950s: "To call this expression [i.e., his Abstract Expressionist paintings] abstract seems to me often to confuse the issue. Abstract means literally to draw from or separate. In this sense every artist is abstract . . . a realistic or non-objective approach makes no

difference."[14] Diebenkorn's form of abstraction, receiving its sanction from Matisse's *Studio*, depended on the retention of the signs of representation, both as vestigial lines of framing (recalling the horizon, seashore, windows, and so on) and of pentimenti within the frame.

For the Matisse *Studio* includes the trials, errors, and corrections of the artist's own handiwork. The surface of Diebenkorn's paintings, abstract and figurative, is based on this assumption. Matisse focused and legitimated for him the Abstract Expressionist practice (in particular de Kooning's) of retaining the explicit signs of the process of painting itself, including modifications; or perhaps the Abstract Expressionists legitimated, as they raised to a principle, this practice of Matisse's. I wonder, however, whether between Matisse or Diebenkorn and the Abstract Expressionists there is not a distinction to be made between *the process of the painting* and *the process of painting*: the first emphasizing the product as the result of process, the second emphasizing the process itself, that is, the human gestures. Diebenkorn's paintings are, in that sense, product oriented, one might say more classical, less romantic (or "revolutionary"). An unsympathetic critic might say safer.

The pentimenti, according to Elderfield, are not themselves symbols or archetypes or signs of the unconscious in the Surrealist mode, but merely "vestiges of formal steps in the development of the canvas."[15] I doubt this. One exception is the cross, spade, club, or quatrefoil shape that appears, sometimes whole and often broken, throughout his career (and becomes a figure for a while in the 1980s), which I take to be simply another surrogate for the model's body (or violin case) in Matisse's *Studio*. But my suspicion is that a close perusal of the understructures would reveal signs enough, though not, presumably (given what we know of Diebenkorn), with a Surrealist pedigree, that Diebenkorn is (again in Elderfield's words) "a diaristic artist."

Diebenkorn's own rationale for the pentimenti is diaristic in the Puritan sense of soul-reflecting. Speaking to Wayne Thiebaud, he referred to these as "crudities," presumably invoking Still's call for crude American painting: "This is something like 'ineptitudes' or 'awkwardnesses' which are retained in one's work in order to avoid the slick, the ingratiating. It is a redirection to avoid getting easy."[16] If the first part of the explanation invokes Still, the last sentence introduces a characteristic Diebenkorn concern, which we might call *resistance*. And with resistance comes a moral, perhaps puritanical concern about the sin of easiness.

His friend and mentor Park's statements frequently carry this heavy moral freight. For example, as Diebenkorn remembered, Park "encouraged heavy pigment as a proper use of oil paint. He was devoted to impasto and identified it with the morality of the artist. He didn't like thin paint, saying it 'reminded him of piss,' meaning it was trivial and showed a lack of commitment."[17] And as Bischoff recalled, "Park painted thickly and Diebenkorn, leanly." Of course thin paint allowed Diebenkorn to make a painting based on corrections and revisions,

one that caught and preserved the "moral" decisions, the palimpsest of choices, as in a Puritan diary. This was a painting not unlike Johns's, except that the palimpsest was *meaningful* (in Diebenkorn's particular sense of this word, indicating the artist's intentionality or responsibility; whereas for Johns it is merely something that designates the painting as a layered, archaeological construct). What Park in his own way was assuming was the moral position that there *is* a final, certain choice, and that thin paint allows the artist to fudge this point, to hedge the bet. On the other hand, Diebenkorn agreed with both Park and Bischoff that hard-edge formalism is sterile and intellectualizing, and he can write, "When I arrive at the idea, the picture is done. There seems something a little immoral about touching up an idea."[18] Aside from the interesting fact that his pentimenti are mostly lines—suggesting the linear aspect of the painting, the essence of Poussiniste Idea—Diebenkorn is only saying: The essence of art is knowing when the picture is finished. But he thinks of it as "immoral" to touch up an idea, as Park thought it immoral to use thin pigment or hard edges.

What Diebenkorn has painted over is as essential to the sense of the painting as *how* he has painted it out and what has replaced it. But his emphasis, at least when he tries to put the act of painting into words, falls on the artist's covenant: "I can remember that when I stopped abstract painting and started figure painting it was as though *a kind of constraint* came in that was welcomed because I had felt that in the last of the abstract paintings around '55, it was almost as though I could do *too much, too easily.* There was nothing *hard to come up against*" (my italics).[19] He needed, he said, "an art that was more contemplative and possibly even in the nature of problem solving. . . . One of the reasons I got into figurative painting or representational painting . . . was that I wanted my ideas to be 'worked on,' changed, altered, by what was 'out there.'"

His intention in the first abstract phase was "to explore the picture and supercharge it in some way." Diebenkorn makes it clear that he struggled with the problem of avoiding *any* "representational fragment" and therefore intruding any figure on the ground: "It was impossible to imagine doing a picture without it being a landscape, to try to make a painting space, a pure painting space, but always end up with a figure against a ground." John Canaday records Diebenkorn as saying "that a normal traditional development for a painter is through still life, primarily the painting of objects, into landscape and then the figure. Beyond that is the area of space, mood and light that, he felt, the figure blocked him from."[20] One presumes that "the area of space, mood and light" is the same as the "pure painting space," or at least in the "Ocean Park" paintings has become so.

But in his second, figurative phase, he says: "I think what is more important is the feeling of strength in reserve."[21] Representation then comes to mean *something hard to come up against* or *strength in reserve*, a discipline not found within the liberties of abstraction. And so he answers the question, "Does it *matter* if it is a woman in a striped dress or a vertical?" with the reply, "Absolutely

yes." (He does not ask the prior question: Does it matter that it's a woman? And is it a "Hopper woman"? Certainly not a "Matisse woman.") At times, he says, critics have said "I was really only *using* representational material as a peg on which to hang my conception of painting. That offended me *mightily* because it was *absolutely not true!*" The interviewer draws the conclusion that *if* the woman wears a striped dress, Diebenkorn is "forced to deal with *her* reality"; to which Diebenkorn replies again, even more emphatically, "Absolutely! Yes. . . . It isn't as *easy* as 'painting what you see' with a figure. A figure *exerts* a continuing and unspecified *influence* on the painting as the canvas develops. The represented forms are *loaded with psychological feeling*. It can't even *just be painting*. That kind of feeling *can be enriching* to the total work, but it can also be *continuously troublesome*, setting up overtones and *talking back* [i.e., to the painter]" (my italics).[22] These criteria are very different from the *ease* of painting—the sheer *accident*—invoked by Pollock and de Kooning, and from the notion of *just painting*. Insofar as Diebenkorn is resisting *just painting*, he paints a striped dress; but insofar as he also, as pure painter (as someone ultimately concerned with a "pure painting space"), wants to avoid the *trouble* of *psychological feeling*, he turns the figure's—the woman's—face away from the viewer or simplifies it or leaves it blank.

And yet, of course, as Hopper's canvases showed him, the turned-away face carries its own psychological feeling: It seems averted, projects self-absorption, possibly melancholy. Moreover, as his remarks indicate, there is a sense in which Diebenkorn the artist has good reason, technical if not personal, for not wanting "to make psychological contact with the face." In Elderfield's words, "He wants us to grasp the meaning of a work from the whole composition and not have it filtered through the personality of the model."[23] Yes, but, as the example of Matisse proved, there is a difference between blurring or abstracting a face and averting it.

The desire for a "pure painting space" seems an avoidance of such a face, especially in light of the fact that those interiors, with or without figures, are as suggestively empty as any of Hopper's. *Empty*, we see, refers to an existential quality as well as one of the artist's problem-solving devices. It remains to be asked whether the existential angst of the Hopper and Diebenkorn room carries over into the "Ocean Park" paintings, where the form is retained with a bare memory of the representation: that is, of a seascape seen from the window of a room, or—shall we say?—of the prospect seen from the vantage of a refuge, from enclosure pushed to the periphery.

In these terms, Diebenkorn's final gesture becomes extremely significant: In his "Ocean Park" phase he removes the figure entirely (the constraint, the resistance), invoking the assumption (or rationalization) that now he wants to paint with greater freedom. Diebenkorn sums up the problem of figuration as constraint:

> I would start out with brave, bold color and a kind of spatiality that comes
> through in terms of the color. Then I would find gradually I'd have to be *knock-*

ing down this stuff that *I liked* in order to *make it right* with *this figure, this environment, this representation.* It was a kind of compromise—that on one hand can be marvelous, and *what painting seems all about,* and the other becomes *inhibiting constraint.* (My italics.)[24]

"I wanted it both ways," he says. "A figure with a credible face—but also a painting wherein the shapes, including the face shape, worked with the all-over power that I'd come to feel was a requisite of a total work." So there had to be a compromise. "The face had to *lose* a measure of its personality. The first response in taking it had to be relational. . . . This compromise with the completeness of the face . . . was a large one . . . one that perhaps undermined my figurative resolve in the long run."

His sense of *meaning* involves not the significance or connotations of his figure's face or gesture; it involves his own working on the painting, revising it, adjusting it, until the relationships "stay put" and "look as though they were *meant* to be there. That's my idea of 'meaning.'"[25] Until they seem *meant,* that is, by the artist, Diebenkorn. What this Abstract Expressionist sense of meaning (as the artist's "gesture," the "event" of the painting) amounts to is the conflict of product and process; for the latter presumes that "a premeditated scheme or system is out of the question" for one who paints with the assumption that the personal exploration of the canvas is a projection of personality as well as craft, and that it records the pursuit not only of aesthetic possibilities but also of moral and *meaningful* choices. It is easy to see how the figure can aid this process, but also—as Diebenkorn came to see—inhibit it.

Diebenkorn is, for a number of reasons, a paradigmatic artist with whom to conclude this chapter. He illustrates by his career in an almost academically schematic way that abstraction and representation are inseparable. His own painting is saved from being dry academic by the practice itself, the lines, the colors, and the trial-and-error palimpsest of the paint texture. His practice of using thin sheaths of paint to wipe away the lines serves to simplify and abstract while at the same time suggesting an original, now abstracted (or rethought) representation. Idea and execution (or practice) seem to be in tension over the status of figuration and abstraction.

Diebenkorn's work (and his words as well) tirelessly demonstrate that art must be a construction of both forms *and* images; that an iconography of one sort or another is inevitable.[26] For art is both a construction of forms and—especially in the post–Abstract Expressionist period—a recreation or reimaging of other artists' forms, fictions, and metaphors from the history of art; both a construction of images in the world and a recreation of the iconography of Matisse and the "moderns."

FRANCE AND ENGLAND: BALTHUS AND FRANCIS BACON

Balthus's Sunlit Room

La Chambre is a large canvas, ten feet across, painted between 1952 and 1954. It shows an adolescent girl, nude except for stockings and pumps, stretched out on a chaise longue in a darkened room, her legs open toward the window. A curtain is being held back from this window by a small gnomish creature so that a strong golden light covers the girl's body, in particular her thighs and torso. What looks like a towel is under her, as if she has come from the bath. There are three pieces of furniture in the room, a huge armoire, a solid chest with a bowl and pitcher on it, and a spindly table. On the last lies a book, and seated on the book, its face turned toward the light, is a cat.

The painting could be a parody of Titian's *Danaë*, with the flood of gold pouring into the princess's lap (and in the Prado version her grotesque servant trying to intercept the downpour in her apron before it impregnates Danaë). Balthus himself painted variations on the subject both before and after *La Chambre*. In *Nu jouant avec un chat* (1949) the girl is semiawake, leaning back to touch the now smiling cat; another girl, dressed, has just opened the window. The room has the same furniture but lacks the heavy atmospherics of *La Chambre*; the André Derain–like forms and colors, the more uniform distribution of light, imbue the scene with an even greater unease but less symbolism. In a recent painting, *Le Peintre et son modèle* (1980–1981), the girl is clothed, engrossed in a book, and it is the painter (his back to us) who pushes the curtain from the window. In one of many other variants (*Les Beaux Jours*, 1944–1949) the girl is dressed and there is no window, but her body is in the same relation to the light of a blazing fire being stoked by a boy who is stripped to the waist.

The French artist who painted these scenes, though his mature paintings date as early as the 1930s and '40s, is about de Kooning's age, and needs to be seen in the company of the much younger Johns and their common concern

with the sexual dimension of Surrealism. Balthus is, as he cabled the cataloguer of the London Tate exhibition of 1968, "a painter of whom nothing is known. Now let us look at the pictures." He does, however, make it known that he is called Count Balthazar Klossowski de Rola, though the title is apparently without substance.[1] The two major selections of reproductions of his work before the retrospective exhibitions of 1983 at the Beaubourg in Paris and the Metropolitan Museum in New York were "authorized": one carried out by a close friend, Jean Leymarie, the other by his son Stanislas.[2] The latter seems to be spokesman for the hauteur of "nothing is known" ("*on ne sait rien*"). He tells us nothing in his preface to the Met catalogue, but he urges admirers, instead of seeking biography, to "contemplate" the paintings:

> By 'contemplation' I mean the elevation from mere perusal and observation to vision, from the empirical to the ideal—a state wherein the act of seeing, the seen and the seer become one. . . . Any other way is doomed to failure, for Balthus' art pertains to a mysterious tradition whose secret and sacred tenets he is constantly in the process of rediscovering.

However fatuous it may sound, this statement from the son of Balthus carries some authority. He tells us that "the fabled theme of the young adolescent girl"

> has nothing whatsoever to do with sexual obsession except perhaps in the eye of the beholder. These girls are in fact emblematic archetypes belonging to another, higher realm. Their very youth is the symbol of an ageless body of glory, as adolescence (from the Latin *adolescere*: to grow toward) aptly symbolizes that heavenward state of growth which Plato refers to in the *Timaeus*. Eroticism is nowadays confused with libidinousness, thus obscuring the true intelligence of esoteric works ultimately pertaining to the divine cosmic mystery of love and desire.

These words may to some extent be the result either of a paternal leg-pull or a filial misunderstanding; they could even be a filial send-up of the Father. But they do reflect, in however dim a way, one aspect of Balthus's paintings. His figures, including those suggestive adolescent girls, are not only behaving very strangely; they are represented in an extremely hieratic, even hieroglyphic stylization. Their bodies are often mannequinlike; the diagonal line favored by Balthus influences the shape of their shoulders seen from the back, the brittle inclination of their heads, and often their whole bodies; the girl he sometimes paints leaning over a table to read a book seems to have been cut from a pattern book.

Balthus is important to contemporary artists because he is one of the exemplary figurative painters of our time. It is possible that a figurative painter, struggling in the wake of the great modern tradition of abstraction, has to adopt a "mystery" or a myth; indeed, if his work is genuinely "figurative" (as in "figura-

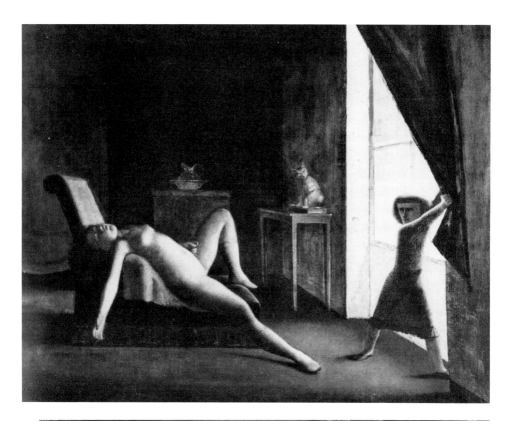

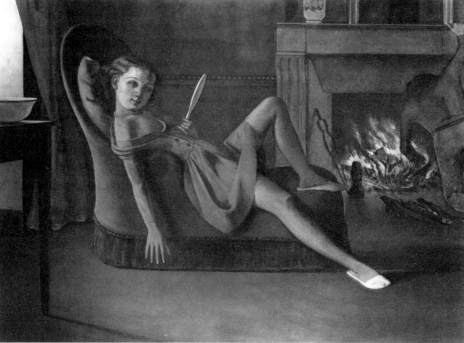

Above: Balthus, *La Chambre,* 1952–1954, oil on canvas. Private collection (Photo: Copyright © 1990 by ARS, New York/Spadem).

Below: Balthus, *Les Beaux Jours,* 1944–1946, oil on canvas. Hirschhorn Museum and Sculpture Garden, Smithsonian Institution, gift of Joseph H. Hirschhorn Foundation, 1966.

tive" speech), it is metaphoric rather than literal in its depiction of the objective world. The two continuing art movements of this century, both contending for place in Balthus's work, are Cubism and Surrealism. His figures often assume Cubist forms, and in some of his later works his whole canvas dissolves into Cubist patterns, often resembling the still lifes of Analytic Cubism. What is known of Balthus the painter, however, is that he emerged in the wake of the Surrealist movement in 1930s Paris (bearing strong traces of Derain's "classical" phase), and signs of the movement can be detected in the incongruity of the grotesque attendant, the cat, and the cavernous chamber itself.

Balthus's largest compositions, like *La Chambre*, may be in the tradition of Degas's *baigneuses*, but come on a scale and with an imagery to recall "history paintings" such as Titian's *Venus of Urbino* or *Danaë*. In the same way, he has painted panoramic landscapes carrying a pedigree from Poussin ("The Seasons") to Courbet and Camille Corot; still lifes from Chardin to Cézanne; cardplayers from the Le Nain brothers to Courbet and Cézanne; views through windows onto landscapes from the frescoes of the Villa d'Este to the scenes of Caspar David Friedrich, Bonnard, and Matisse; and cityscapes that recall the frescoes of Lorenzetti and Piero della Francesca. The viewer looking at a Balthus is aware of all these matters in much the same way we are aware that he calls himself *Count Balthazar Klossowski de Rola*, but also in the positive sense of an academic tradition carried into the present—and with the growing awareness of odd discrepancies and Surrealist dislocations.

We can place the advent of the Surrealist influence around 1932–1933, the date of the second version of *La Rue*. The first version is still in the post-Impressionist style of *Le Pont Neuf* and the other cityscapes of the 1920s. But the later version, expanded to the huge size he was to affect for his major works, has abandoned Impressionism for the smooth texture and odd juxtapositions of Surrealism. Balthus has added the molestation of the little girl, the strange roundish child bouncing her ball, and the diagonal-leaning boy in his mother's arms. These additions turn the central figure, the one odd element in the earlier version, into something more bizarre, resembling Lewis Carroll's Tweedledum or Tweedledee.

In the cityscape *Le Passage du Commerce Saint André*, of 1952–1954, Balthus paints a Paris street with (characteristically) its exit closed off by a cross street. The colors, texture, space, and composition are of a Piero fresco, but there are two strange figures painted in a grotesque convention, and these draw our attention to the irrationalities in the architecture—the sidewalks that disappear where they should close, and the formal but implausible variations of the window spaces, including blocked windows.

This is the Surrealist method of Magritte, but Balthus's canvases become interesting at precisely the point where Magritte's stop, with the flat, absolutely unexpressive paint that produces the effect of mechanical reproduction and focuses undivided attention on the content of Magritte's images (often illustrative of a verbal paradox). Balthus painted such bland surfaces in the early 1930s, but

in his characteristic pictures these passages are enlivened by charged areas of paint that involve the viewer emotionally in a way quite foreign to Magritte. One's attention is drawn to some passage of rich buttery paint, usually a high-light; or to some unfinished detail or emendation—or a face or body that is drawn in a different convention of representation or style, such as the grotesque hairdresser in *Toilette de Cathy* (1933), who appears earlier in *Pont Neuf* and later in *Le Passage du Commerce* and many other pictures as well. I wish to em-phasize the different textures, conventions, genres, and shapes, as well as the insistence on retaining the signs of his painting as process—the incongruity of formal means Balthus employs. All of these break the solid Magritte surface by acknowledgment of the painter's presence, and introduce chance and the uncon-scious into the very paint texture. It is at this point that Balthus also evokes Mas-son, Ernst, and the Surrealists, who draw attention to the act of metamorphosis both within the image and in the gestural performance of the painter.

Balthus's paintings are influential among younger painters today partly be-cause of the rich working of the paint surface: The sun *and* the bold play of the paint brilliantly illuminate the crucial parts of the female body. It is a genuine

Balthus, *Toilette de Cathy,* 1933, oil on canvas. Musée national d'art moderne, Centre Georges Pompidou, Paris (Photo: Pierre Matisse Gallery).

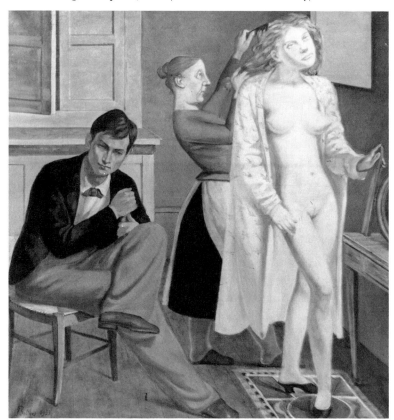

female body. Magritte paints not a nude but a truncated sculpture of a nude, a headless torso on a coat hanger, or a pair of amputated feet. Balthus simply paints a nude, but the genre of the nude is juxtaposed with the very particularized face of a little girl's portrait, and with the clearly focal intersection of the relaxed legs (sometimes in the manner of brothel photographs, wearing only stockings) that designates the genre of erotic art. Magritte's rooms and apples, before being composed, are taken from posters and magazine illustrations; Balthus's are from old master paintings. All of this he juxtaposes with his elegant forms and paint surface. It is this divided focus, this odd set of juxtapositions, that creates the Balthusian incongruity.

In his *Nu allongé* of 1950 Balthus represents a girl stretched out on a bed; he has painted the white of the bedding subsequent to painting the girl's body, so that the white of his pigment, an active defining agent, penetrates noticeably between her legs to the very intersection, impinging physically upon her body. In the earlier version, *La Victime* of 1938, the knife lying near the outstretched nude assigns the aggression to an outsider rather than to the artist, but it is equally aggressive and sexual.

Magritte's truncated objects are evocations of male anxiety; Balthus's girls hold the attention because the aesthetic experience—the paint and the almost Cubist formality of his pattern—is so erotically charged, not without some menace. His rooms are distant cousins of Magritte's anxiety-ridden rooms because we expect from the composition and the style Titian's Venus, but we are confronted instead with an adolescent girl. The shock value Balthus seeks is clarified when we recognize that although he begins with Titian's *Venus of Urbino*, he pivots on Manet's *Olympia*, the real graphic prototype of all his girls. He has picked up Olympia's particularity, her antithetical attendant (black to her white), her youth, and her unselfconscious indifference in the presence of the viewer, along with the brilliant clarity with which the body is painted, the emphasis on the bedding, and above all the sense of the outrageous, of the break with tradition in a picture so strongly affirming the tradition, that has been associated with *Olympia* ever since its first showing. Balthus makes the nude a girl just on the edge of womanhood, embodying a metamorphosis that seems to be taking place in terms of both the sunlight flooding in from the window and the artist's own play of pigment.

The Surrealist-related writers of the 1930s one immediately connects with Balthus are Antonin Artaud, the theorist of the "theater of cruelty," and Georges Bataille, the center of a group, much concerned with eroticism and death, that included Balthus's brother Pierre Klossowski.

Balthus designed the sets for Artaud's play *The Cenci* in 1935, and drew his portrait; Artaud had already reviewed Balthus's first exhibition in 1934, commenting, "If he uses 'reality,' it is the better to crucify it." Crucifixion was a central formula in Artaud's *Le Théâtre et son double* (1938), one of the more

influential books on theater published in this century. Painting is one of Artaud's two master similes for theater, the other being plague: "Like the plague, the theater has been created to drain abscesses collectively"; it is "a crisis which is resolved by death or cure."[3] Like the painter's *tableau* (the French word means both picture and dramatic scene), Artaud calls for a theater that replaces the spoken word with the visual gesture, the text with a foregrounding of the mise-en-scène. The "concrete physical language" Artaud advocates, which "is truly theatrical only to the degree that the thoughts it expresses are beyond the reach of the spoken word," could be used to describe a Balthus scene. By "cruelty" Artaud means an "extreme action" or situation like the plague—"everything that is in crime, love, war, or madness," but that comes down to a ritual of pain and exorcism.

The painting Artaud refers to is Lucas van Leyden's Mannerist extravaganza *Daughters of Lot* in the Louvre, which happens to deal with the taboo theme of incest, and he also adduces the "extreme" tableaux by Bosch and Grünewald of temptation, damnation, and crucifixion. From the dramatic repertoire he invokes Jacobean tragedy, built "around famous personages, atrocious crimes, superhuman devotions," and in particular John Ford's *'Tis Pity She's a Whore*, in which a brother and sister flamboyantly commit incest. Artaud is most interested in the young heroine, Anabella: "If we desire an example of absolute freedom in revolt, Ford's Anabella provides this poetic example bound up with the image of absolute danger." The theatrical elements here are youth, vigor, obsession, the narcissistic mirror image of brother-sister-lovers, and the suicidal sacrifice of Anabella to her obsession.

Jacobean tragedies may not at first seem relevant to Balthus's quiet domestic interiors. But almost everyone who has written on Balthus notices the threat exuded by his extraordinarily theatrical (in Artaud's sense) spaces. And youth, of course, is the locus of Balthus's world. His figures are either children or adults who have the bodily proportions of children. The pseudonym itself, Balthus, is derived from "Baltusz," the Polish diminutive of "Balthazar," Latinized. Balthus's official commentators (his friends and son) connect his juvenile world with the golden age; Leymarie refers to his use of "the child's world": "To see as he saw when a child," Leymarie says, was Balthus's aim. Certainly Balthus often employs the mantelpiece, hearth, and mirror complex of Sir John Tenniel's illustrations for *Through the Looking Glass*—and the threat of violence and murderous retribution of *Struwwelpeter* (both of which we learn Balthus loved). Yet the "room" is seen not from the child's point of view but from the point of view of the regressive, nostalgic adult who includes the desirable prepubescent girl in his fantasy, and may at times be connected with her dwarfish keeper or exhibitor.

Less purity than the free play of instinct is to be seen in Balthus's images. His children only make sense in the context of Artaud's theater of cruelty, and also in the context of Balthus's own set of illustrations for Emily Brontë's *Wuthering Heights*, 14 pen-and-ink drawings made in 1933 on which a number of his later

paintings were based. In this series, which is in fact the nucleus for his later work as a whole, Balthus renders Heathcliff a self-portrait.[4]

Cathy and Heathcliff are a disguised version of the brother and sister in *'Tis Pity She's a Whore*: Their love is not specifically incestuous, but it is forbidden. (Heathcliff, moreover, was given by the Earnshaws the name of Cathy's dead brother, and slept in the same bed with her as a child.) Spiritual siblings, they are children passionately driven to pursue each other despite the world of adult taboos. The large heads and small bodies that distinguish Balthus's work first appear in these illustrations. The younger generation stifled by the elder (a state of nature compromised by society) is summed up in the illustration that shows Cathy being dressed up into respectability while Heathcliff sits nearby expostulating with her: "Why have you put that silk frock on then?" When Balthus made a painting based on this scene (*Toilette de Cathy*), he reversed the roles: Balthus/Heathcliff is fully, formally dressed and Cathy is outrageously undressed, her head thrown back and her breasts impudently pointing their nipples in different directions; but despite the developed breasts her pubic area is that of a child. The boy has donned the veneer of adulthood that so annoyed Heathcliff. The girl, as in all of Balthus's later work, remains a girl, that is a free and—as in her unfastened robe—accessible spirit.

Bataille wrote an essay on *Wuthering Heights* in a book called *Littérature et le mal* (1957), which sets out to prove "that literature is a return to childhood" and therefore to a natural evil. "The fundamental theme of *Wuthering Heights*," he writes, is "childhood when the love between Catherine and Heathcliff originated"—and his image of the "two children [who] spent their time racing wildly on the health," who "abandoned themselves, untrammelled by any restraint or convention," sounds rather like Artaud's description of the brother and sister in *'Tis Pity*. "There is no character in romantic literature who comes across more convincingly or more simply than Heathcliff," Bataille writes, "although he represents a very basic state—that of the child in revolt against the world of Good, against the adult world, and committed, in his revolt, to the side of Evil." Although Heathcliff appears only infrequently in Balthus's scenes (perhaps as the boy stoking the fire in *Les Beaux Jours*), Cathy, either a pre-Linton Cathy or a Cathy who retains the wild Heathcliff in her, is the subject of a great many paintings. The grotesque old woman who was dressing her hair also recurs, recalling one of the old crones in Hans Baldung Grien's paintings who mock the beautiful young girl as Death mocks life; or possibly one of the duennas/bawds of Goya's *Caprichos*.

Bataille continues the theme in the other essays in *Littérature et le mal*—on Blake, Baudelaire, and the Marquis de Sade. Thus Baudelaire "deliberately refused to behave like a real man, that is to say, like a prosaic man"—rather he "chose to be wrong, like a child." This is the ethos Balthus chose with his name and his personal iconography, but embodied in the girl Cathy (Anabella). Although it is hard, without more biographical information, to establish prece-

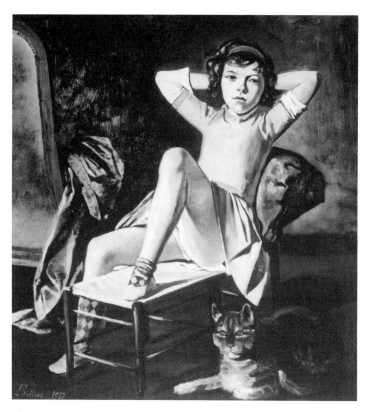

Balthus, *Jeune Fille au chat,* 1937, oil on board. Mrs. Edwin A. Bergman Collection (Photo: The Metropolitan Museum of Art, New York).

dence between the interpretations of *Wuthering Heights* by Balthus and Bataille (a third, related interpretation appeared in Luis Buñuel's film *Abismos de Pasión* of 1954), Bataille's ideas were already set out in his pornographic novel of 1928, *Histoire de l'oeil.* It opens, for example, with a chapter called "The Cat's Eye" that seems to herald the ubiquitous Balthusian cat: A boy and girl, both 16 years old, are involved in some sexual play with a cat's saucer of milk. It is no secret what *that* cat means, and therefore what in demotic French the feline signifies positioned near the girl's legs in Balthus's pictures. The cat may also, as some critics have suggested, be a self-reference to Balthus (in a painting of 1935 he refers to himself as "king of the cats," a deeply ambiguous phrase). But in the 1920 series of blockprints called "Mitsou," Balthus's earliest surviving work (he was 12), the cat is found, cherished, and lost by a little boy modeled, I suppose, on Balthus. This is not a *louche* cat à la Bataille, but it is worth noticing that if the little boy in this series parallels Heathcliff in the later one, the cat, ultimately lost, parallels Cathy. Certainly in the paintings of girls in the 1930s the cat is primarily a sexual index to the concealed (or not concealed) center of the painting, the flash of underpants or flesh. In *Thérèse revant* (1938), to take another case, the cat is in fact drinking milk from a saucer just below the girl's exposed crotch. (As in *Jeune Fille au chat* of 1937, the cat, in the same position, is alertly *couchant.*) The saucer in *Histoire de l'oeil,* and the girl's anatomical part that

rests in it, activate a series of round shapes that include eyes, eggs, testicles, and above all, the sun.

For the sun, so important a presence in Balthus's paintings, embodies Bataille's central doctrine of *dépense*—a general, wasteful expenditure, like the child's "sin" of squandering time, which increases the intensity of life by drifting carelessly toward death. "Eroticism," in Bataille's famous definition, "is assenting to life to [virtually beyond] the very point of death" (*"L'érotisme est l'approbation de la vie jusque dans la mort,"* not *jusqu'à la mort*). At its most elemental natural level, the effect of the Balthus girl is heliotropic: She is stretching and opening like a flower in the warmth of the sun. But the ambiguous pose (heads inclining as if on broken stems, bodies bending like discarded puppets) and the presence of the old crone keep this wholly positive and banal moment in check.

Bataille associates *dépense* and the sun with self-immolation, not only with Jupiter immolating Semele but with the Aztec deity to which human sacrifices were offered.[5] Indeed, the Bataille philosophy of *dépense* (formulated in *La Part maudite*, 1949, and *L'Erotisme*, 1957, but in circulation earlier) may be that secret/sacred mystery to which Stanislas Klossowski alludes. Bataille writes that for eroticism to be erotic it has to be a sin, a transgression of a taboo (it "has been hard put to survive in a world of freedom whence sin has vanished"). First, then, there must be the taboo subject, for example a prepubescent girl; and second, a threat or danger of death. Bataille quotes de Sade, "There is no better way to know death than to link it with some licentious image," and adds: "The sight or thought of murder can give rise to a desire for sexual enjoyment."

From both Artaud and Bataille, then, derive the centrality to theater and art of ritual human sacrifice, the voluntary offering of the innocent, as also the evocation of the Black Mass—a taboo version of Christ's Passion—laid out on a prone female body. In Balthus's *La Victime* the nude is stretched out on a crumpled bedsheet, prepared for love-making or—we see the knife on the floor— for murder or sacrifice. As Albert Camus wrote of Balthus, *"Ce n'est pas le crime qui l'intéresse, mais la pureté."*[6] In *L'Erotisme*, Bataille remarks on how sacrifice, like the act of love, involves an unclothing to "reveal the flesh," and (in the manner of Artaud) he compares these actions to "a rudimentary form of stage drama reduced to the final episode where the human or animal victim acts it out alone until his death."

Bataille sees the ceremony of his scene as an iconographic alternative to the Crucifixion, but it is obviously also a suggestive ritual that draws on older myths, of Greek origin in Danaë or Semele (young women who are "given" or who give themselves to a lustful god), or of pre-Columbian origin in the sacrifice to the sun god. Behind Bataille and his group was a general interest in latter-day Gnostic ideas and Rosicrucian doctrines, all centered on the opposition of light to dark, good to evil, or, in Bataille's terms, *dépense* to in-turned adult prudence: the young girl to the old hag. But the girl herself, with her particularized and inscrutable, perhaps somnolent face, denotes a turning inward, a kind of frigid-

ity, at odds with the open body. There is a withholding that is in tension with the acceptance of the body to the sunlight pouring over it. This returns us to the conflicting centers of interest in individualized face and exposed underpants, to which we can now add closed, self-contained face and open body, as well as the two aspects of time externalized in a watchful *dépense*-ful cat and an old crone. This attendant can open or close curtains to introduce or exclude the sun—can emblematize adult prudence or some subrational desire, whether Old Age/Death or the Goya duenna/bawd.

I conclude with a brief confirmatory survey of Balthus's painting in chronology. After beginning to paint in various modes in the 1920s, from Rousseau-primitive groups of figures in park settings to copies of Piero frescoes and Bonnard-like landscapes, in 1932 Balthus painted *Jeune Fille assise*, a portrait of a clothed girl throwing back her arms and reclining into a position of relaxed openness. By the next year he had transformed this figure into the absolutely characteristic girl of *La Leçon de guitare*, a composition that combines in one image the acts of guitar-playing, sexual arousal, and sacrificial display carried out on a prone body exposed in its lower parts, with emphasis on the prepubescently bald genitals. The composition takes off from (and alludes to) Ernst's equally notorious painting *The Blessed Virgin Chastises the Infant Jesus* (1926); Balthus has transformed the Christ Child's backside (distinctly feminine as Ernst paints it), being spanked by the Virgin, into the girl's frontside being played upon by the older woman as if she were the guitar that lies abandoned on the floor. Both Balthus and Ernst are mockingly alluding to pietàs (Balthus specifically to the Villeneuve Pietà in the Louvre). The woman's face bears a disquieting resemblance to Heathcliff's (and so to Balthus's) face in *Toilette de Cathy*, just as her exposed upturned breast is precisely Cathy's.

The nudes in sacrificial positions take two forms. One is the recumbent figure, most blatant in *La Victime* and its later version, *Nu allongé*, where the knife is absent and the artist himself has taken the role of the officiant. In the pictures of the later 1930s, where the paint texture begins to appear in all its richness, the light also makes itself felt in a more powerful and direct way. In *Nu adossé* (1939) the girl's thighs and belly are picked out by a ray of light, the rest remaining in shadow. There are many other pictures of this general sort, the girl sometimes clothed, more often unclothed, including the girls in *Le Salon* (1940–1943) and the wonderfully painted *Jeune Fille endormie* of 1943. There are, of course, gaps during which Balthus painted in other modes, and when we look at the whole series of paintings of the war years we see other preoccupations. But in 1945–1946, with the large *Les Beaux Jours*, he made the first of a series of summations of the subject, with the mythological overtones emphasized. Here the girl is open not to sunlight but to firelight; the fire, being stoked by a boy, is borrowed from an engraving of Vulcan stoking his furnace while Venus lies stretched out behind him.

While painting a second version of *La Victime* and other languid girls stretched out on beds, Balthus also painted a clothed girl lying on a hillside (but skirt hitched up to retain her receptivity to the sexual dimension of nature) in a landscape that echoes the curves of her body (1942–1945). She recalls Claude's *Echo* and, ultimately, Giorgione's *Sleeping Venus* (Dresden). This and *Le Cerisier* (1940) are two of the three landscapes that directly connect the female figure with nature. The third is the monumental *La Montagne* (1937), which combines the horizontal sleeping or dead girl with the vertical upstretched girl, later developed in *Le Cerisier*. They reflect respectively the horizontal and vertical aspects of the natural setting, the hillside and the mountain. Balthus's other landscapes, while omitting the human presence, are extended panoramas analogous to the close-ups of the female torso he painted in *Nu adossé* and *Jeune Fille endormie*. Where girls appear in the later landscapes, they are within a room looking out through a window at the landscape.

As the summation of the recumbent nudes, and a response to the fire of *Les Beaux Jours*, Balthus painted a series of nudes stretching backward in a flood of sunlight and playing with a cat (1948–1954). These led up to the huge *La Chambre*, with which we began, in which the sacrificial element is emphasized by having the gnomish creature introduce the sun, acting as officiant. (In a drawing for one of the *Chambre*-like paintings a bird is flying in the window toward the girl.) The girl in *La Chambre*, as we have noticed, lies on a towel. The idea of a bath, once introduced, leads to the standing girls of the 1950s who have just risen from a bath.

This second series of nudes—standing—began, however, much earlier, with the Surrealist *La Fenêtre* of 1933. Here the girl, an upright version of the girl in *La Leçon de guitare* or *La Victime*, perches on the sill of an open window overlooking a townscape of rooftops. She appears threatened; she holds up one hand as if to ward off an intruder, one breast is exposed, and with the other hand she braces herself against the sill, apprehension in her eyes. This figure, however, is related to the two standing nudes of the same years, Cathy of *Toilette de Cathy* and the large figure, straight out of Otto Dix's work of the 1920s, in *Alice*, with its raised, exposing leg that was to become a signature of Balthus's female "portraits." Both of these are cases of proud self-presentation, hardly involving victimage. The exposed breast of *La Fenêtre*, also present in the instructress of the guitar, may indicate the fading distinction between the victim and the attacker.

This upright figure has to be seen also in the context of the strange frontal portrait groups, primarily one parent and his or her offspring posed in a cross between a formal photograph for a family album and a Holy Family. One parent is always missing. The physical resemblance between parent and child is emphasized to an odd extreme. In the best-known of these, *Joan Miró et sa fille Dolores* (1933–1938), there is a marked tension between father and daughter, both so nearly the same size: He seems to be both holding her back and displaying her; she seems to be clinging to him with one hand while her left arm and leg thrust her out toward the spectator—her eyes combining anticipation and apprehen-

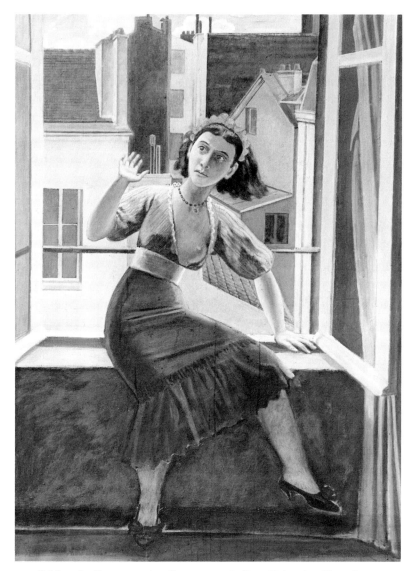

Balthus, *La Fenêtre*, 1933, oil on canvas. Indiana University, Bloomington
(Photo: Pierre Matisse Gallery).

sion. The association with a Madonna-and-Child painting is fruitful, for it is the
girl who fits the position of the sacrificial component; moreover, to complete the
Balthusian irony, her father is an artist.[7] In this context, another portrait of an
artist, *André Derain*, shows him dominating the foreground, left hand pressed
against his torso, presenting himself in the way the nudes later present them-
selves. In the background sits his young model, fitting into the pattern of a father
and daughter, or even in some perverse way (given his prominence in the fore-
ground and dresslike robe), a Mother and Child, as in *La Leçon de guitare*.

The offshoot of the Derain figure, and the alternative to the threatened girl of

La Fenêtre, is the self-contained *Jeune Fille en vert et rouge* (1939), a direct frontal image, monumental and reminiscent of Rembrandt's *Juno* (Metropolitan) but with the figure of a child, with budding breasts, a bland mysterious face, and a beret on her head, her dress divided vertically into red and green. She stands behind a table covered with a cloth whose folds are clean and sharp, a eucharistic altar on which are placed a candlestick and a piece of bread (or breakfast roll) impaled by an upright knife. Given the knife, a closer Rembrandt allusion might be his *Lucretia* in Washington or *Non Dolet* in Minneapolis, where

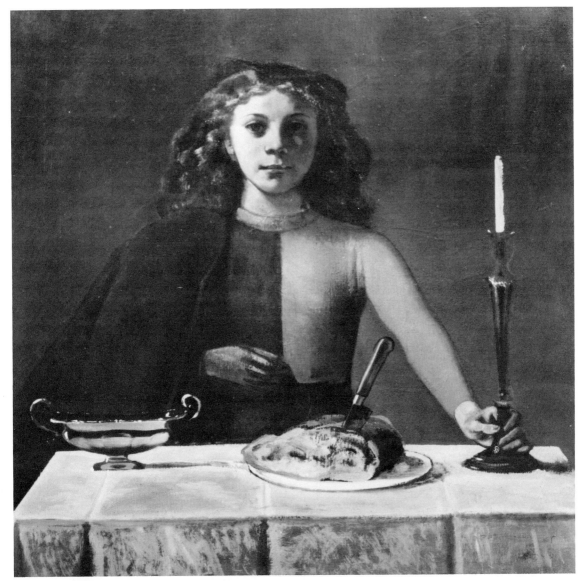

Balthus, *Jeune Fille en vert et rouge,* 1939, oil on canvas. The Museum of Modern Art, New York, Helen Acheson Bequest (Photo: Pierre Matisse Gallery).

rape and self-immolation join. But the girl's left hand is around the candlestick, not the knife; her right hand, incompletely finished, is pressed (or held) against her middle. The effect of this extremely classical composition is disturbing rather than restful. The tension is not only between the painterly directness and the centered planar composition but between the monumental figure-painting and the representation of an adolescent girl—and between the domestic and sacrificial associations of the still life. In this context the viewer suppresses a suspicion that the girl is holding her hand to her abdomen in the same gesture as the Arnolfini wife or the Virgin Mary. And in this context the unfinished hand jars against the assured brushwork of the rest of the canvas, in a way we have become accustomed to with Balthus. The girl seems to be a dressed, indeed costumed version of Cathy, apparently an officiant of some vaguely eucharistic ritual involving altar, bread, knife, ewer, and candle—and yet still with the possibility that she may herself be the sacrifice.

Finally, in 1948–1949, as the series of recumbent nudes in sunlit rooms was approaching its fulfillment in *La Chambre*, Balthus painted the series of frontal nudes emerging from the bath. Their pose combines the Christ of an *Ecce Homo* with a Baptism and a *Salvator Mundi* (as well as, in its later forms, the heavy female figure of Rembrandt's *Juno*). These figures, who in later versions become pure *baigneuses* drying themselves, or disturbingly violent figures leaping from the tub (a *Christus Victor* or a pagan Athena?), nevertheless continue to be accompanied by the old crone who goes all the way back to *Toilette de Cathy* (and may now recall the crone in Caravaggio's *Judith and Holofernes*).

Balthus also undertook a series of nudes in profile in the 1950s. These lead in one way to the *Nu devant la cheminée* (1955), the nude whose back is turned to the light, engrossed in looking at her own reflection in the mirror above the fireplace, and in another way to the *Nu de profil* (1973–1977), in which she does face the light, standing before a window in a room with only a table and washbasin. Suggesting a pose both offertory and receptive, she recalls more strongly than any of the previous paintings in this series one of Vermeer's naturalized Annunciations, a Dutch matron (sometimes reading a letter, sometimes pregnant) facing the window in a sun-drenched interior. (But then one also wonders whether Balthus had seen Hopper's *Woman in the Sun*, of 1961.)

The majority of the pictures, however, are of the bather turned away from the light. In *Katia lisant* (1968–1976), though her thighs are still open to the light, she is holding a book up to her face, between her and the light. In *Le Peintre et son modèle* the girl is engrossed in a book, oblivious to the painter, who (replacing the dwarf of *La Chambre*) himself opens the blind to let in the light. Another girl holds the mirror between herself and the light, looking into it rather than at the light; or she holds the mirror between herself and the figure of a cat, who has now become an admonitory emblem. In one picture the girl plays with a toy bird that is eyed by the cat, whom Balthus has borrowed from Hogarth's *Graham Children*, where he is hungrily watching a caged bird and emblem-

atically showing the children to be on the brink of experience in the adult world. The nudes engrossed in mirrors also recall the pose of the lady in *vanitas* emblems.

In 1955, pictures of one girl combing another's hair, and then of one awake and the other sleeping, are mythologized into an Annunciation or a Cupid and Psyche. Balthus replaces the sun with an intruder bearing flowers, fruit, or a light to the recumbent girl. The flower connects with the Annunciation, the blazing sunlit lemon (or orange) with the story of Psyche curiously approaching her sleeping lover *Cupid* to see his face by the illumination of a candle. Because he is revealed in his proper person (and burnt by the wax), Cupid disappears and leaves her literally loveless and lightless. The story, used by mystics from the Middle Ages onward as an allegory of the progress of the soul, is also a final echo of Balthus's story of the lost cat Mitsou. The girl, the Cupid figure, is not only asleep; her face is turned away and her body shrouded in clothes. The ambivalent receptiveness of the earlier girls is denied; only closure and voyeurism remain in these darkening interiors. Even the oriental girls Balthus paints, though nude, are crawling belly downward across a floor and engrossed in a mirror.

What one notices in these recent paintings is how the women are subsumed to decorative pattern. Compared with the heavy Junoesque figures of the frontal *baigneuses*, they are becoming younger and thinner, almost Giacometti-like in their attenuation. Their faces have lost the particularity of the early girls, whose piquancy to some extent derived from the blunt, tomboyish, altogether unconcerned features above the smooth body and open legs. These are now the sweet faces of angels painted by followers of Piero or Leonardo. They are painted in an increasingly fresco treatment of chalky, gravelly, rather monotonous pigment. The tension between *dépense* and self-absorption, embodied in the contrast of face and body, is now externalized and emblematized in the mirror and the story of Cupid and Psyche. We can follow Balthus from the 1930s to the present as he supports his strange portraits with an increasingly heavy mythological freight— progressing from a disguised Danae to a not-so-disguised Annunciation and an overt Cupid and Psyche. Myth, pattern, style, and sentiment: All become more emphatic until the paintings sometimes resemble blown-up Hallmark greeting cards.

The recent mythological paintings most easily confirm Stanislas's talk of esoteric mysteries about the ascent of the soul through love. The interest of the earlier paintings survives in other genres that Balthus has continued to explore: his very suggestive still lifes and the landscapes seen through a window, observed from the inside by a girl whose back is to us. His paintings of card games, undertaken in the late 1940s, began with two girls and then, in their most finished form, included boy and girl (1948–1950 and 1966–1973), and from time to time a single girl playing solitaire. The image, a modern amalgam of Pope's *Rape of the Lock* (in the intense expressions of the players) and Cézanne's *Cardplayers*, makes plain the restrained tensions of a game not unlike the one implied

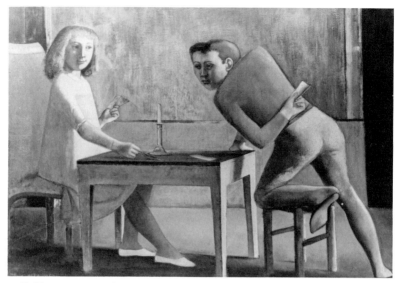

Balthus, *La Partie de cartes,* 1948–1950, oil on canvas. Thyssen-Bornemisza Collection, Lugano.

in the outstretchings and withdrawings of the sun-drenched girls. The card game sums up the ritualizing of desire that is Balthus's central concern. The Balthus doctrine, which may have begun as Surrealist incongruity, can be seen as the situating of erotic energy (*dépense*) within various sedate orders that restrain or withhold desire: the prepubescent female, for example, or the tradition of old master painting, or the portrait genre (or the convention of the angel's face); or, above all, the elaborate formal pattern of the composition (some paintings can be said to be as much about the Golden Section as about the girl). At an extreme, in *Nu devant la cheminée*, precise geometric lines are incised into the paint surface but blurred by the freedom of brushwork, the incongruence of lines and paint contours, and the use of rough charcoal smudges where the fireplace calls for clean lines. The withholding or restraining of desire, the sense of representing the moment just before or *at* violence ("*jusque dans la mort*")—this Balthus embodies in his tensions of classical form, autonomous paint, and provocative image.

Lautrec's Backs and Bedclothes

As a summation of (or model for) the figuration of a modern who wishes to be postmodern, like Balthus, I am going to offer the painting of Toulouse-Lautrec, aware that one could use Ingres as well, and perhaps other 19th-century French painters. But Lautrec shows how figuration and abstraction can be combined: He tells a story or makes an observation, but he displaces the interest onto some feature that has both formal (even abstract) possibilities and a special interest in itself.

One recalls how Balthus positions an apricot or peach, stem end toward us, so that its sexual as well as its formal qualities predominate over its descriptive ones—or he paints a portrait of a girl in which the visual center is divided between the individualized face ("Thérèse") and the white linen at the intersection of her crossed legs. These are still within the metamorphic realm of Magritte's famous *Le Viol*, in which a woman's face becomes a nude female torso and vice versa; they are mild versions of Duchamp's *Étant Donnés* . . . , the spread-legged nude viewed through a peephole. Yet they draw upon Lautrec's "illustration" of a feature that is a *chosen* area, a cathected subject, but that at the same time allows the artist scope for something else—whether abstraction, pure form, or exploration of an obsessive form.

More than one critic has proposed that Lautrec's talent for observation, human psychology, and the comic was so highly developed that he had to find ways to circumvent or censor it—for example, by turning his figures' backs and obscuring their faces. This phenomenon was made very clear in the 1979 exhibition at the Art Institute of Chicago and in Charles Stuckey's catalogue essay.[8] The painting used for the exhibition poster, *Repos pendant le bal masqué* (ca. 1899), shows a man in a red-nosed turkeylike mask ogling a hefty woman whose back is turned to us as she looks into a mirror. He may be regarding her profile, but her large buttocks are the most prominent feature of the body we the viewers see, and she is looking in the mirror at him ogling her (her eyes are indicated as turned rightward toward him).

This painting schematically sums up the effect of many of Lautrec's works, from the most elaborate in which people are watching each other down to the single portraits. In the stunning *L'Abandon* (1895) one prostitute looks down at what the second is doing to her, and the second, seen from the back, is observing the expression, the response, on her face. Her presence seems to reduce, or to control by contextualizing it, the pure expressiveness of the first prostitute's face.

Stuckey's thesis amounts to a fin de siècle extension of what Fried has called the subject's self-absorption (and so unselfconsciousness).[9] Fried has educed the principle and the strategies to make the actors themselves either spectators or self-engrossed (at one extreme, blind men) from Denis Diderot, who was himself seeking to revive the academic tradition of *l'expression des passions*. Although in the background of Fried's essay are the studies of eye direction and eye movements in Renaissance painting by Jean Paris and the very different spectator-object relations in the English painters Hogarth, Wright of Derby, and Rowlandson, Fried has defined a principle that also helped to form French neo-classicism and still held a firm grip on the generations of both Lautrec and Balthus.

Lautrec's aversion to the academic is the subject of his parody of Puvis de Chavanne's *Bois sacré* (1884), a conventional allegory of Parnassus full of muses and Apollos. Lautrec repaints it and inhabits it with contemporaries—his friends and patrons, who sought a new way of art not in Parnassus but in cabarets and

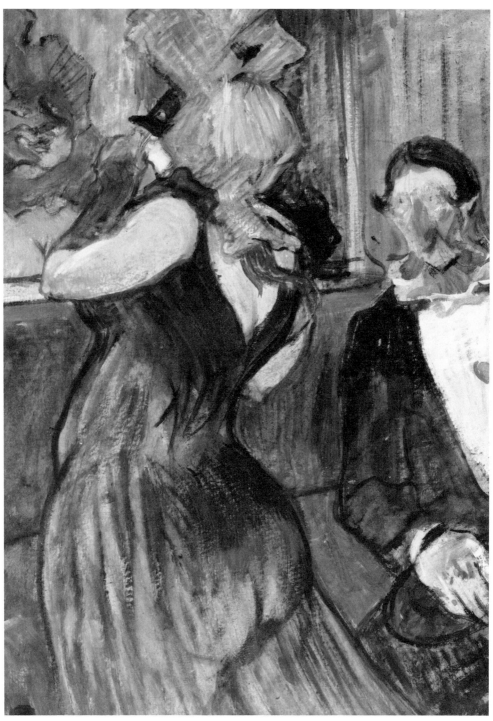

Henri de Toulouse-Lautrec, *Repos pendant le bal masqué,* ca. 1899, *peinture à l'essence* on board. Denver Art Museum.

brothels. Prominent in the group is the tiny but jaunty figure of Lautrec himself, his back turned, self-absorbedly relieving himself on the sacred grass. In Lautrec's case at least, absorption remained either a shred of academic convention or a leap back to a former vigor now lost in the friezelike rigidities of Puvis's allegory. The principle remained an academic one, however reduced in circumstances from an Apollo to a clown (Cardieux), a bon vivant (Céyleran), or a Bohemian artist (Lautrec himself).

It is true that Lautrec, in his earliest paintings, already likes to show sitters whittling on a piece of wood or reading a book or otherwise oblivious to the viewer—part also of the candid-camera principle invoked by contemporaries like Degas. More often, however, his figure is just putting down the book. For Lautrec seems to be much more concerned than Fried's artists with transitional states in which the sitter is only in the process of preparing to pose or to relax out of the pose. In *Monsieur Samary, de la Comédie Française* (1889), the actor is taking a curtain call, holding up his eyeglass to look back at the audience.

Stuckey makes much of Lautrec's use of profiles, connecting them with Renaissance profile portraits, medallions, even the heraldic designs of coach doors. He argues that these are less psychologically expressive than frontal views and are therefore used by Lautrec to place "the burden of emotional characterization entirely upon his organization of the abstract visual details he chose for costumes and settings." There is truth in this view, but it seems to me not only that some of the "profiles" Stuckey cites are not medallion profiles, but that Lautrec's more personal or characteristic "pose" is the two-thirds profile from the back. For example, *The Passenger in Chair 54* (1896) is a lithograph showing a woman in two-thirds back profile, in her hand a book she has just abandoned in order to watch impassively another ship—sinking?—on the horizon.

Starting with the early portraits, *M. Etienne Devisme* of 1881 and *Vieille femme assise sur un banc* of 1882, the back is turned and the profile is slightly blunted. Famous portraits of later years, like the full-length *Tristan Bernard au vélodrome Buffalo*, are of this type, and sometimes, as in *Moulin de la Galette*, Lautrec uses three or four variations of profile in the same picture. The two-thirds back profile is a way to draw a face that cannot see the viewer, and so is unselfconscious. It is one way to portray a person looking at someone else, whose face is visible to the viewer of the painting. As a single figure it implies self-absorption, and as one of two or more it becomes a spectator absorbed in a second person, as in *L'Abandon*. It is also undeniable, I believe, that the back turned to us becomes a barrier between us and what is seen.

Compare with *L'Abandon* Courbet's *Sleeping Women* in the Petit Palais. Although his lesbians are asleep, Courbet manages to eliminate all barriers between viewer and object. The face-on unselfconsciousness of his figures, almost merging with (in effect canceling) the viewer, is an image of total presence. In Lautrec we see a back, or we see around a back; we are looking through a keyhole or a camera lens, but in some way are distanced from the figures, the sight of

whom takes on an air of secrecy. When Courbet uses backs it is to put us (or originally, Fried believes, the artist) in the place of the sitter; Lautrec uses backs to distance the sitter, making him or her inaccessible.

In *La Blanchisseuse* (1887), a laundress is turning her shoulder, cutting us off from communication with her as she looks out a window. She has incidentally put down her work and is for the moment totally engrossed in thoughts of the world outside. Lautrec's women—his most interesting subjects—are characteristically engrossed in something other than what would have been considered their labor, their *métier propre*. They are prostitutes looking in a mirror (perhaps dressing) or into another prostitute's eyes for the love their profession does not give them; they are dancers—often parodies of Degas's ballerinas—involved in a process that Lautrec considers no more labor than painting his pictures; or, as laborers or even artist's models, they are somewhere between posing and the freedom of self-engrossment. Laturec shows a woman with a rice-powder box on a table, in the artist's studio but not yet made up for a pose, or he shows the deaf-mute Berthe holding an umbrella and hat, neither seated in a garden nor standing on a street corner but resting in the artist's studio. Stuckey sees such pictures as representing a conscious dislocation of pictorial signs, a contradiction of pictorial evidence. But this sort of picture can also imply a complete story or a psychological situation of a particular person who has not yet reached the point of beginning to work at modeling, whose thoughts are caught elsewhere. It can be regarded, in short, either as a statement of the artist or as a phenomenological study, grounded in time and place (without the mystery of, say, Degas's so-called *Rape* or *Interior*).

Lautrec's paintings raise the whole question of "posing" as an element in the transition or break from academic to "modern art." The abandonment of the model was a symbolic gesture denying the habitual use of classical models or of poses from earlier art. Lautrec's student copy of a Renaissance bust is complemented by his copy not of the classical statue of the marble-polisher but of a model posing as the statue; and this, of course, is followed by the parody of Puvis's *Bois sacré* and the various conscious attempts to find poses that are not poses. The model who is *not* posing is Lautrec's epitome of the situation.

The two-thirds back profile and the self-absorption of the subject draw attention to Lautrec's obsessive representation of backs, especially (clothed or unclothed) women's. I have mentioned as one explanation that this is a way to play down his precocious ability to catch expression, and so to elicit more character or comedy than he knew he should. Another explanation is the sheer difficulty of delineating backs, or at least of making them interesting. Perhaps more important is Lautrec's affinity to Watteau, the great depicter of backs. Watteau with his *fêtes galantes*, his reaction against the pompous academic art of Louis XIV, was in many ways Lautrec's spiritual father among French artists. Like Watteau, Lautrec habitually gravitates to this part of the anatomy, even when (as in the illustrations for Jules Renard's *Histoire naturelle*) he draws animals. But whereas

Watteau's backs always convey a sense of recession into the spatial and temporal distance, and so an overpowering sense of nostalgia, Lautrec's, as I have suggested, seem to block and become landscapes in their own right. The contours of the human back plus the complementary shapes of the drapery allow for formal as well as psychological (buried, repressed) patterns to develop out of the artist's imaginative impulses.

A reading of Victor Joze's *Babylone d'Allemagne,* a book for which Lautrec made an advertising poster, shows why he chose the huge, looming shapes of a sentry in his box (a repoussoir figure) and soldiers seen from the rear, some on the backs of large-flanked horses. Joze's novel contrasts the German militaristic abasement of prostitutes with the more chivalrous French treatment. These same expressionless, arrogant shapes appear at the end of Lautrec's career in the repoussoir figures of the Praetorian Guard intervening between us and the Empress Messalina (foreshadowing their servicing of her).

The portrait of a back is also, however, as the poster *Repos pendant le bal masqué* shows, a backside that intensely interests someone, perhaps the viewer or the artist. Yet another poster summing up the evidence of Lautrec's work could have been made from *The Photographer Sescau* (1896): the woman in the left foreground is in this case front-face to us, but the photographer who is the subject of the poster is catching her back, and he shows his reaction by means of the long phallic dangle of his cloth and by the prominent erection of his camera lens. The photographer facing her backside is made to appear one gigantic phallus—much as the brothel's laundryman in *Le Blanchisseur de la maison* (1894) indicates, by means of his bulging laundry-bag as well as his popping eyes, his observation of the open front of the madam's gown.

The photographer is one of Lautrec's images of the artist—an appropriate one given the assumption he shared with Degas and others that an artist, like a photographer, catches unguarded, fragmentary, unposed, accidental back-views of his subject. But Lautrec's connection is more specifically between the artist and a form of sexual behavior. At the beginning of his career, in his teens, he painted his first teacher of painting, René Princeteau, showing the artist's left hand in his pants pocket, with the masturbatory action displaced to the paint tube from which his other hand is squeezing brown pigment. No sexual object is present; art is equated with masturbation rather than with participatory sex. This may have been the apprentice's joke, but in the mature paintings (as in *The Photographer Sescau*) the paint and brush have become active sexual implements, which go beyond voyeurism to a sort of rape of the object on a sensitized glass plate or on canvas.

Lawrence Gowing has made the point that Lautrec's is a sexual (versus, say, a visionary) art, in which sexual and artistic potency are equated.[10] He did not ask whether there is a connection (perhaps an inverse ratio) between the potency of the artist and of the man residing in the brothel whose inmates he portrayed. But the artist, with his intense colors and textures, his heightened expressions, is

Henri de Toulouse-
Lautrec, *Le Blanchisseur
de la maison*, 1894,
peinture à l'essence on
board. Musée d'Albi.

demonstrating in every brushstroke a sexual contact with his object. It remains significant, however, that the object is almost never *faced*. The portrait of La Goulue seen head-on flanked by two friends is exceptional. Ordinarily the woman is glimpsed from the side, seen from below, or through a keyhole. This distance and detachment are evident, and yet the extremely sensuous, even sexual nature of the experience of viewing and presumably painting is also unmistakable. The painting serves as the sexual discharge; it hardly matters whether Lautrec proved himself with the prostitutes, since from childhood onward his physical condition would have led him to seek a substitute for his sexual drives in his painting.

There is a self-portrait in which Lautrec, at 16, looking at himself in a mirror, catches himself in the act of pausing between roles of painter and model. The mirror is exposed as mirror by the reflection of a candle as phallic as the paint tube he gives to Princeteau—one of the many displaced phallic shapes he later introduces, such as canes jutting between legs. This is the one picture in which the artist-voyeur is himself shown, in which the canvas itself becomes a mirror rather than an image of the outside world (though people are often looking into mirrors). Occasionally Lautrec appears himself, as in the back view of

the Puvis parody, or in the profile in *Au Moulin Rouge* (1891) where he shows himself as part of a spectrum of spectators; but ordinarily, and especially in the brothel scenes, he is the camera's eye only, and the picture is what he sees.

The magnificent series of lithographs called *Elles* (1896) sums up the problem of the brothel scenes. The cast of characters consists of a hefty Messalina-type prostitute, a delicate younger woman, and the bawd. Only once does a man appear, and he, resembling a weak version of Lautrec's portrait of Oscar Wilde, merely sits and looks at the prostitute dressing. The frontispiece, with *"Elles"* written at the top, shows the large prostitute with her back to us dressing before a mirror. The man (the corresponding *il*) is implied only by a hat and a pile of clothes in the foreground. In the other scenes of the series the man is displaced to a picture on the wall of a satyr with a nymph, or even of a swan with Leda (or a male bust on a mantel), that leaves the viewer as the implied man. The picture complements the mirror, and is one of a series of displacements of unacceptable (that is, unrepresentable) shapes: A woman's pubic hair, for example, is a triangle of black stocking on her leg.

The emphasis remains on the turned, blocking back and backside. The Leda-and-swan picture, in which the swan seems about to goose Leda, is on the wall above a woman bending over a basin in the same position vis-à-vis the

Henri de Toulouse-Lautrec, *Femme couchée-reveil,* 1896, lithograph. Harvard University Art Museums, Fogg Art Museum, Cambridge, Massachusetts.

viewer. The equivalent portrait is of a crouching woman who is taken from a Degas monotype in which the woman is crouched looking at a dog. Lautrec omits the dog, leaving the woman the object of the spectator's interest—obviously posing for him, or preparing for rear entry. The emphasis on the derrière can of course be given a personal application to Lautrec (who more than once materializes a dog's anus with a little *x*), or a sociological one with the evidence of the chorus line of the Moulin Rouge, or perhaps even of the popularity of the notorious entertainment offered by the "Petomane." One of the shapes that emerges from the mussed linen of the prostitutes' beds that Lautrec loves to draw is of buttocks.

All of this relates to the question of the virtual absence of men within the brothel scenes and to Lautrec's own position as number-one spectator, as he must have regarded himself. Only in a handful of paintings and drawings does Lautrec show any figures who might (given their short hair) be male in bed with the women, and there are enough short-haired females in other paintings to make it at least fairly likely that most of these are also women. The great majority of the brothel scenes show women sitting with, embracing, or in bed with other women.

I doubt if Lautrec was obsessed with lesbianism per se. Of course, he could more easily and discreetly have sketched the bedrooms during the daytime, when the men (who would not have relished portraits) were not there. But he could also have sketched the prostitutes alone with the implied male, that is, with himself, and he did not (unless in the crouching woman). Rather, the women are shown in active sexual postures with each other. In *Elles* it is clear that the man is considered a spectator, in various senses outside the action (usually off to the side or behind). For one thing, the prostitute is not working but playing (or sitting, waiting between tricks, or dressing or undressing); for another, there is the truth that Lautrec, at least as artist, is a voyeur rather than an active participant in the world around him—another version of the laundryman who can only stare at the madam's open gown.

Two quotations attributed to Lautrec sum up the emphasis on voyeurism and women making love. One is the story of his showing a friend (the engraver Charles Maurin) a snapshot of two girls together: "That beats everything. Nothing can match something so simple as that." Second, his remark that "a woman's body is not made for love. It's too stunning for that!"

One of the things Lautrec does best is the drawing of the woman or of women in bed; but this is because he is the painter of backs and bedclothes (*Femme rousse assise, Femme rousse vue de dos*)—of a landscape of bedclothes defined by the slight emergence of a human face, arm, back, perhaps leg, which are a minimal suggestion of highlights in an undifferentiated expanse. What is characteristic is the slight indication of the object, perhaps recalling other shapes (buttocks, pudenda), emerging from largely bare canvas or cardboard or from the white paper of a drawing or lithograph. It was a mannerism of Lautrec's speech, described by his friends, that he seldom finished a phrase, letting his voice trail off into inau-

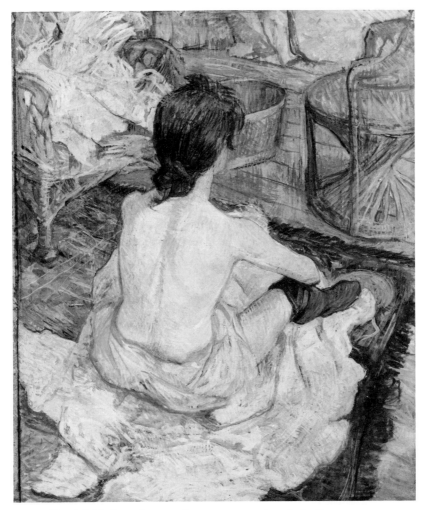

Henri de Toulouse-Lautrec, *Femme rousse assise*, 1896, oil on canvas.
Musée d'Orsay, Paris.

dibility and leaving his listener to fill it in. He also seems habitually to have seen the suppressed shape in the ordinary. As he said to Tristan Bernard, "So-and-so looks like a sole, with both eyes on the same side of his nose"; or of a rugby player, "He looks like a man coming up from a wine cellar with a full stock of bottles." Like so much figure and landscape painting, Lautrec's was an art of metamorphosis: One shape is always becoming another, as one time or pose becomes another.

Lautrec's subject in these pictures is the beautiful horizontal stretch of a rolling landscape, with faces picked out as one would houses along a hillside, or genital shapes in ravines and clumps of trees, but on the bed of a brothel: a version of what he does with backs as well. He turns women around to make them unselfconscious but also to see them from the rear, his own viewpoint becoming that of the tiny, crippled, fantasizing aristocrat, perceptive of formal elegance but

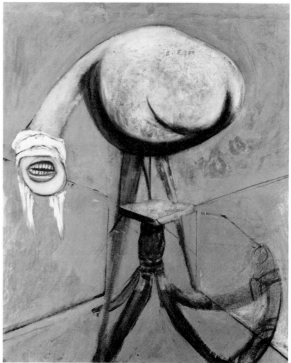

seeing from behind and down under—a backside view of the world. That view is the required one (he believes) for modern art, because of its detachment, its freedom from cant and from the reliance on pose, its ability to make subconscious connections if necessary, and its assurance of one's being spectator only—in either a total separation between, or equation of, art and sexual act.

As a model for artists escaping from academic abstraction, Lautrec represents a figure but turns its back, or paints the model *out of* her role; he focuses on an isolated, cathected body part (sometimes the naked back), or the pattern of rumpled, used bedding; and thereby he creates a personal myth, by preference a sexual one, of a brothel life, or of a cabaret life on the verge of the brothel. As Picasso showed in his earliest paintings in Paris (when he painted Lautrec pastiches), and continued to show throughout his various periods of abstraction and modified figuration, the artist's sexuality serves effectively as a personal substitute for "official" iconography. In "revolutionary" art male sexuality in the private world had long served as a metaphor for public, political actions, and for the actions of the (male) painter himself. Picasso felt that his images of his own sexuality worked in this way, and so did Pollock and some of his colleagues as well. Picasso, however, like Lautrec, sometimes reserved a separate place for himself—off to the side, small and dwarfish, an observer only of the woman, or even (in his later years) of the act itself carried out by younger men.

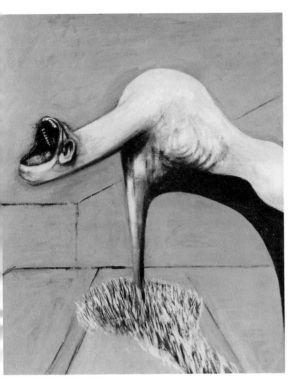

Francis Bacon, *Three Studies for Figures at the Base of a Crucifixion,* 1944, oil on canvas. Tate Gallery, London (Photo: Art Resource).

Bacon's Crucifixion

In his interviews with David Sylvester, Francis Bacon tells us that there is "paint which conveys directly and paint which conveys through illustration": "some paint comes across directly on to the nervous system and the other paint tells you the story in a long diatribe through the brain." And "illustrational form tells you through the intelligence . . . what the form is about, whereas a non-illustrational form works first upon sensation and then slowly leaks back into the fact." These two kinds of painting Bacon contrasts with abstract painting—"an entirely aesthetic thing. It always remains on one level. It is only really interested in the beauty of its patterns or its shapes."[11]

At first sight, Bacon seems to be placing himself outside the illustrational tradition of British painting, certainly outside its sadly literal-minded dead end in Holman Hunt, J. W. Waterhouse, and the Victorian history painters. But in fact all he is saying is that one kind of painting appeals to the brain and is merely rationalistic and illustrational, the other appeals to (or touches) the nervous system—the very nerve endings. One leads the viewer from the object out into a process of intellection, while the other produces a powerful sensation that then slowly draws him or her back into the painting to understand why.

Like Sutherland and Henry Moore, Bacon began by adapting the bulbous

forms of Picasso in his "Surrealist" phase, but he calls them, in his first major painting (1944), *Three Studies for Figures at the Base of a Crucifixion*. The three paintings are presented as a parodic triptych, each with a vaguely zoomorphic shape standing out against a shocking orange background roughly marked to indicate a receding, closed interior space. Bacon's title suggests that they are either different parts of a single situation, three "spectators" at a Crucifixion that is itself absent (a sort of predella for an altarpiece by Grünewald), or they are different views of the same person or action seen differently but not necessarily consecutively. Although it emerged later, Bacon's personal definition of a Crucifixion was some act of violence, a moment of physical pain, which he usually paints as a triptych, but with the violence (often, he says, imagery "of the butcher's shop") portrayed—as opposed to merely observed, as the title of the 1944 paintings indicates. In later triptychs the Crucifixion itself is repeated, first in a bloody bed scene, and then in a literal butcher shop.

But Bacon wishes to think of his Crucifixion as an "armature," as he calls it, rather than as iconography. He wishes us to forget that the word brings to mind Christ and the Cross and to regard it simply as a structure or "armature on which you can hang all types of feeling and sensation": "I haven't found another subject so far that has been as helpful for covering certain areas of human feeling and behavior." A Crucifixion, he argues, is really a way of setting off a subject, allowing us to see the object better, as "the central figure of Christ is raised into a very pronounced and isolated position, which gives it, from a formal point of view, greater possibilities." He makes the same claim for the "framing" of his Screaming Popes with thin white lines, which, however, may create boxes that enclose and trap, rather than show off the figures.

But Bacon insists that he wishes to employ the formal to stimulate a response more nervous than aesthetic. And all one need do is compare one of his butchered carcasses with Rembrandt's or Soutine's to see that Bacon's is made to recall the Crucifixion in a very literal way. (In one case the carcass directly imitates a Cimabue Crucifixion.) If the painter Francis Bacon is aware of the doubleness of his name—the father of English empiricism and a product of the butcher shop—it is a doubleness that existed in the first Francis Bacon as well, and in Shakespeare and Hogarth. First there is a plain piece of meat, second there is the awareness of the observation and the recording, the punning on it, even the moralizing of it.[12]

As Bacon admits, we have to *understand* the nervous response. John Russell has described the strange left-hand figure: it has, he says, the "hairstyle of a female jailbird (or jailer)," and at its shoulders we see

what might have been mutilated wing-stumps. An inch or two below these there was drawn tight what might have been either a shower-curtain or a pair of outsized pajama trousers. Set down on what looked like a metal stool, the figure was thrashing round as if to savage whatever came within biting distance.[13]

I quote these lines not just because they are perceptive observation but because they are words that seem called for by the enigmatic image—by its enigma—in a way that is seldom true of, say, a Picasso, even in his Surrealist period (which in some ways connects with these paintings by Bacon). Also I want to stress that once these words have been read, it is impossible to look at Bacon's image again without coming to terms with them, if only to force them under the table. Other verbal formulations are possible. John Berger, for example, notices that "the necks end in mouths. The top half of the face does not exist. The skull is missing"—and he concludes that what is absent (mind) rather than what is present (pain) is important—that what is implied is mindlessness.[14] This would, of course, apply as well to the missing (implied) Crucifixion: There is no Christ, only pain expressed by the spectators, in this very "existentialist" image.

Bacon himself tells us that he intended the figures to be Eumenides, those avenging forces from Aeschylus's *Oresteia*, though his title applies Christian terminology. The Eumenides' passion of unrelenting revenge merges with the horrible faces of the mockers in traditional *Ecce Homo* paintings and some Crucifixions. The Eumenides, as the title tells us, are witnesses to an offstage crucifixion. And what we see is, first, the witnesses themselves raised onto platforms like the crucified, and second, a collage of visual echoes, beginning with the stooped, bowed left-hand figure's resemblance to the grieving Mary the Mother or the Magdalen at the foot of a traditional Crucifixion.

We know another fact about Bacon's procedure as painter: He was much influenced by the images of photography. These were not, however, anonymous photographs in general. They were, for example, Muybridge's series of bodies in movement, and stills from films (the best-known example being the screaming governess in the Odessa Steps sequence of Sergei Eisenstein's *The Battleship Potemkin*, who reappears as a Screaming Pope); they were subject photographs with what can only be called "literary" associations.[15] They also relate to Bacon's emphasis on painting as accident, on the aleatory marks out of which his paintings often emerge. A verbal trait he may have derived from his interest in Surrealist poetry, this interest also applies to the use of photographs, those records of a fleeting moment, another sort of accident absorbed into a larger one.

The photographic image recalled in *Three Studies* is a still of Charles Laughton as Quasimodo in the 1939 film version of *The Hunchback of Notre Dame*, with his disfigured back bound to the pillory, whipped, and slowly rotated as spectacle before the crowd. In other words, although Bacon takes his strange organic shapes from Picasso, he has activated a set of allusions to raging Eumenides (as Quasimodo's subsequent revenge shows), to sorrowful Mary (in Quasimodo himself, but also implied in his association with Esmeralda, who offers him water and whom he in turn later rescues from the same scaffold), and to crucified Christ.

The figures in *Three Studies* and the Eumenides merge in the image of Christ's mockers, most familiar in the paintings of Bosch, Massys, and Grü-

newald. There is a Crucifixion by the Master of Delft, a triptych Bacon could have seen in London's National Gallery, that shows both mockers and the Magdalen at the foot of the cross: The left panel shows an *Ecce Homo* and the right Mary the Mother. But more specifically, we know that one of the photographs Bacon kept around his studio was of Grünewald's *Christ Carrying the Cross* (Karlsruhe). To combine the hideous grin on the face of Christ in this painting with the bandage around the head of Christ in Grünewald's *Mocking of Christ* in the Alte Pinakothek in Munich is to conflate brilliantly the victim and victimizer.

The coherence of these three panels depends on a kind of disunity—not only because they hang side by side as three paintings whose total composition is relatively incoherent, but because the emotional response Bacon speaks of is based on contradictory readings: We sense a Christ and at the same time a mocker of Christ, a Mary the Mother and the Eumenides, a sufferer and a spectator. There is a metaphoric layering that contributes to psychological depth at the expense of purely aesthetic unity. Though the formal, architectonic force is greater than, say, in a Hogarth painting, where the details lead one on a cognitive chase rather than a formal one—a chase less concerned with nerve endings—the general effect of paradox, that is of regarding an image in two ways, remains essential.

Compare this doubling with the Eve on Michelangelo's Sistine Chapel ceiling, who is typologically also Mary and Judith and Esther. Eve's foreshadowing of Mary is a very different matter from the echo of Mary, Hercules, and others in Hogarth's Harlot, who is a parodic intercessor for men, their victim as well as the exploiter, both agent and patient whose suffering exposes the cruelty of others—an image of "harlot" that Hogarth developed into a powerful image of his society's ambivalence.

There is a also doubleness of intention in Picasso's Surrealist figures: They were representations of his feelings about Marie-Thérèse Walter, and John Richardson has referred to them as the reflections of a love affair—"the frenzied sexuality and voluptuous forms" of "mammoth women, asleep or reading, by the sea or in a garden"—"monsters of sex appeal!"[16] These figures also have violently open mouths, full of teeth, with the triangular tongue that was to reappear in a different context in *Guernica* a few years later. At the same time, Picasso was painting Crucifixions that show gaping mouths surrounding a diminutive, almost sticklike Christ: Mary herself as well as the mockers has one of these devouring mouths, which Picasso may have remembered from Goya's paintings (where the open mouths are appallingly emphatic). But in Picasso's representations of the Crucifixion they are still kept in their traditional places, and one suspects the conflation to be of the predatory and the eucharistic aspects of the mouth (of the female, in Picasso's case). One could even argue that they are called for by the ins and outs of his balanced composition, a primary consideration even in a painting like *Guernica*, but not in a painting by Bacon. (They reappear in the works of Pollock and de Kooning, as well as of Bacon, in the 1940s and '50s.)

I am suggesting that the main tradition of painting from the Renaissance onward, which has its apotheosis in French painting, is constructed on an architectonic—literally architectural—principle of unity, of all elements contributing to one end in a centripetal movement. Whereas what we call British painting—a kind of painting nurtured on the model of Shakespeare and great national writers rather than great (foreign) painters—is based on the principle of the pun, the multilayered reference that joins (to use Samuel Johnson's words for Metaphysical poetry) heterogeneous materials in a violent yoking.

The Bacon figures—pope, businessman (or politician), ape, sphinx, Blake, Van Gogh, and pairs of figures wrestling or copulating—are all in the plural, painted serially. Nearby are sides of beef, umbrellas, banks of microphones, but also guard railings and monkey bars, window shades, electric light bulbs, beds. Like the "Figures at the Base of a Crucifixion," they are portrayed in a closed interior space (or, if exterior, a clearly demarcated plot of grass or a field). The background is dark but alive with lines of force, sometimes boxlike, sometimes with vertical slashes resembling a curtain. Thus the Bacon repertoire between 1945 and 1960, painted in richly textured purples, mauves, midnight blues, grays, and grayish greens, with touches of pink, red, white, and ocher (the color of the unprimed canvas).

Immediately upon returning from the Bacon retrospective in London (Tate Gallery, 1984), I saw a photograph of President P. W. Botha of South Africa on the front page of the *New York Times*, which confirmed, if nothing else, the predication of Bacon's early paintings on the model of the photograph.[17] The totally dark background, the businessman's suit, the gaping mouth, the microphones that imply a speech, the atmosphere of crisis, the abstracted (in the painting, absent) eyes, the prim spectacles, the sense of blue gray monochrome: All support the photographic allusion, as the white boxing lines suggest the editor's marks for cropping before turning the photograph over to the printer. The pane of glass with which Bacon insists his canvases be covered is necessary because he paints on the reverse of primed canvas, without varnishing, and so the slightest touch would mar the surface. But the glass also serves (as he explains in his interviews with Sylvester) to unify the disparate parts of the canvas, some areas raw canvas, other stained, and others impasto. And as a uniformly glossy surface, the glass contributes to the photographic illusion/allusion.

Bacon insists that he is a "portraitist" and "a maker of images," that he has to paint from photographs rather than from the sitter in person, and that he seeks (though never achieves) the "one perfect image." The photograph, both prior to and within the painting, with the pane of glass and the spectacles, distances the figure, who is not (at least before *Study for a Portrait*, 1953) an identifiable portrait but rather a composite, primarily of Velázquez's portrait of Pope Innocent X and a photographic still of the woman in the Odessa Steps sequence of Eisenstein's *Battleship Potemkin*. Although Bacon also mentions a painting, Poussin's

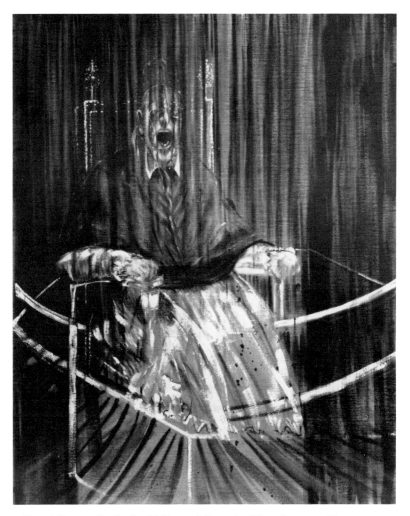

Francis Bacon, *Study after Velázquez's Portrait of Pope Innocent X,* 1953, oil on canvas. Nathan Emory Coffin Collection of the Des Moines Art Center, Coffin Fine Arts Trust Fund, 1980.

Massacre of the Innocents, it is the photograph that is directly evoked, of Eisenstein's woman *and* of Velázquez's painting. The conflation depends on the immediacy and secondariness of a newspaper photograph/halftone raised to an altogether higher plane by the rich colors and textures, the monumental size and composition of a Titian or Velázquez painting. (Bacon had, characteristically, seen other Velázquez portraits, but not the *Innocent X* in Rome: He collected color reproductions of it. When he did have an opportunity in Rome to see the original he refused, feeling that seeing it would only increase his sense of failure in his attempts to evoke it. The distance from the original must be added to the other senses of distance Bacon employs.)

The face itself is blurred, as if rubbed with a cloth or hand. The effect is to

recall the surface of a photograph at the heart of the canvas, which extends out into more conventionally painterly areas and at the periphery into the uniform darkness of stained canvas. But the blurring, in the photographic idiom, also implies movement, representing, as only a snapshot can, the moment of transition from one state of being to another. Some Renaissance theorists felt that the greatness of the canonical sculptures—the Dying Gladiator, Niobe turning to stone, and Laocoön and his sons being crushed by the serpent—depended on, derived from, this moment. The metamorphosis in Laocoön was centered on his open mouth, the authority of prophetic speech becoming the victim's scream as power and pain exchange places. In Bacon's painting the closed face of Velázquez's pope opens into the cry of the helpless woman of *The Battleship Potemkin*, a conflation of power and pain already established, though not in the photographic idiom, in *Three Studies for Figures at the Base of a Crucifixion*.

By yet another transformation the pope on his throne becomes the businessman on his bed in a private (hotellike) room. The open mouth, the public speech turned in private to a howl of release or pain, and the drawn-up legs evoke photographs (and Bacon's own contemporary photographic paintings) of apes perched in zoo cages.

The doubleness appears also in the term "Crucifixion" as both punishment and "armature," both pain and spectacle, offering a poignant point of intersection between the Passion and the dais of the court painter whose aim was to elevate his already elevated sitter. In short, the Crucifixion is for Bacon a structure that conveys the drama of both suffering and self-display, of what is inward or felt (and incommunicable) and what is external and presented, combining the pain of the victim with the aesthetic or political concern of the painter who must celebrate a national figure, perhaps a monster. (The original model for the screaming face seems to have been a photograph of Goebbels delivering a speech: the propagandist turned into his own object of display.)

For Bacon also connects the Crucifixion with a butcher shop, which means for him (he tells Sylvester) both the "great beauty of the colour of meat" and thoughts that "we are potential carcasses"—"it's surprising that I wasn't there instead of the animal," he adds, concluding that it contains "the whole horror of life—of one thing living off another." Though the best-known precursors are the flayed oxen of Rembrandt and Soutine, the raw colors come from Goya's still lifes of meat and fish. The mouth itself, as so often in Goya's works, is both the scream of the slaughtered beast and the spectator's mouth open in the act of devouring it. But Bacon also claims he painted the open mouth from a photograph of a pathological mouth in a medical text, and that he painted it simply because it was so beautiful—he had wished to do a series of mouths like Monet's sunsets. Sylvester gently points out to him that his mouths always end up black and blank, to which Bacon replies ruefully that he just didn't succeed (any more than with his other ambition, to paint a smile).

At this point in the Bacon-Sylvester dialogue we cannot tell whether Bacon

shares the joke. We have to infer either that he begins to paint with an aesthetic intention that in the act of painting (by a series of accidents and improvisations to which we will return) develops into something quite different; or that in the 1960s, when he talked to Sylvester, he was seeing the early painting from the perspective of his later work; or that he carelessly slips back and forth between the aesthetic talk of beautiful mouths and the moral or metaphysical talk of "the whole horror of life." He explains the swastika armband he has given one figure of the 1960s and the hypodermic syringe he has stuck in the arm of another as formal necessities, the spot of red required at one point and the device for attaching the figure to the armature (that is, to the Cross) at another. By this time, he admits, these additions are "mistakes." (He may have forgotten the similar use of the swastika by Eugène Ionesco in *La Leçon* of 1951.) But the chronological difference between his explanation and the effect the earlier paintings have on viewers is not unlike (a case he cites) Giacometti's explanation that his figures have that attenuated, edge-of-the-abyss look only because the problem of "being true to what he saw" was so difficult for him as a sculptor, and not because he retained traces of (or had taken to an ultimate conclusion) his earlier Surrealist experiments.

Because it institutionalized Bacon's self-image, I found the Tate retrospective of 1985 misleading and disappointing. It reduced the paintings of the period 1944–1960 to the barest sampling, while filling gallery after gallery with the repetitious and I think misguided works that Bacon has produced since then. Up to the two great Crucifixion triptychs of 1962 and 1965, which in many ways sum up the outer reaches of Bacon's explorations, I see constant progress, invention, and experimentation. The sheer variety of forms and figures, of color and texture, is remarkable, and places Bacon in the front rank of contemporary painters. But this was all evident in the last Tate retrospective of 1962. The new exhibition revealed the stasis in Bacon's art of the last 20 years.

Much of the responsibility must rest with the marvelous Sylvester interviews. In 1962, when the first took place, Bacon had just changed to the style he has followed ever since, and he was at pains to rewrite his career, with the enthusiasm of a convert, denigrating the earlier paintings as failed experiments, a prologue to the great paintings upon which he was embarked. The interviews were rightly acclaimed, but they should be understood as special pleading and a conscious distortion of the Bacon canon. The forcefulness of his words may also, I fear, have permitted Bacon a complacence unearned by the paintings themselves.

The Crucifixion triptychs of 1962 and 1965 are final simplifications and extensions of the earlier work, in the same sense that Franz Hals's two great canvases of the governors of the almshouse say the last word about his earlier group portraits. Bacon has reached back to the triptych form and the orange background of the 1944 triptych, now with the attendant figures on the left panel and two versions of a Crucifixion in the second and third panels. Crucifixion and

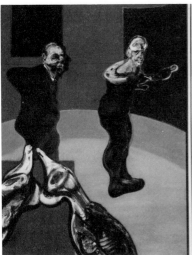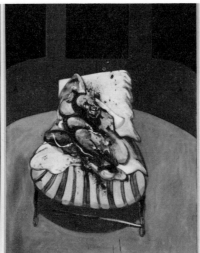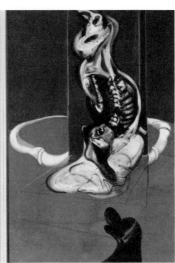

Francis Bacon, *Three Studies for a Crucifixion,* 1962, oil on canvas. Solomon R. Guggenheim Museum, New York (Photo: David Heald).

butcher shop join with the Muybridge serial photographs of athletes wrestling on a bed (as in *Two Figures,* 1953) to extend the associations of power and pain to sexual embrace to crime of passion. But the triptychs also contain elements of the new phase that had begun around 1960: While the right panel of the 1962 triptych still alludes to the outside world of Western culture, in this case (as Bacon reminds Sylvester) to a Cimabue Crucifixion, self-allusion is beginning to predominate. Both right and left panels are reworkings of the carcasses in *Painting 1945:* The face on the right carcass derives from the mouth of *Head I* or *II* (1947–1948) or one of the ape paintings; and the central panel is a violent extension of the embracing couples in grass or on a bed. The conflation of Cimabue and these motifs from Bacon's own paintings seems appropriate here, as a final and dramatic statement of extremity.

But these two triptychs are islands in a stream of paintings that carry cumulative self-reference to mere cannibalism. They repudiate the allusive structure I have described, the haunting mergers of figure and ground, and the overall energy of paint texture. A public association of ideas (not unlike the one Thomas Hobbes described when he showed how a Roman coin would remind a mid-17th-century Englishman of the 30 pieces of silver, therefore of the betrayal of Christ, and so of Charles I) is replaced by a private and personal one, in portraits of close friends, no longer poignant composites, that are said to capture the "fact" of the sitter in a more "positive" light. The overall energy of brushwork that drew us to and around the figure, relating figure to ground, is now confined entirely to the figure, sometimes to the box or circle in which it is isolated. The background is reduced to an inert area of usually bright, pastelish color, as if applied with an airbrush. (In the more recent paintings, the figure, too, looks airbrushed in.)

The change can be dated between 1959 and 1960, when Bacon abandoned

Francis Bacon, *Study for a Portrait of Van Gogh III,* 1957, oil and sand on linen. Hirschhorn Museum and Sculpture Garden, Smithsonian Institution, Gift of the Joseph H. Hirschhorn Foundation, 1966.

the mimetic quality of paint as the illusion of the surface and image of a photo-
graph, or of an old master painting, for the accountability of paint as only itself.
The variations on Van Gogh's *Painter on His Way to Work* document the transi-
tion, which (despite Bacon's denials) appears to have been a response to the
painting of the New York School. Bacon forces the strong horizontals of Van
Gogh's background into correspondence with the downward diagonal of the art-
ist's body and shadow, making his figure determine the ground. In his subse-
quent paintings he retains the downward twist of the human form but loses all
interest in the ground.

As Andrew Forge reminds us in his essay in the Tate catalogue, figure paint-
ing always had primary interest for Bacon. He habitually painted the figure first,
then filled in the remainder of the canvas in a figure-oriented pattern. The pale
white lines, regarded in this way, do sometimes recall the perfunctory flourishes
a lazy art student might execute to fill out a study of a head without coming to
grips with the problem of a setting. It is possible to see the later paintings as an
honest acknowledgment of this problem by totally separating figure from ground,
emphasizing the figure and reducing the ground to the barest minimum. From
Bacon's point of view, he has produced a painting *about* the human figure, a
sculptural painting in the tradition of Michelangelo's prophets and ancestors in
the Sistine ceiling, down to the plinths, pediments, and framing devices. He has
said that in the early 1960s he wanted to produce sculptures but never got be-
yond the painting of them. The result, however, without Michelangelo's power-
ful architectonic structure, is disjointed.

The size of these panels no longer evokes the monumentality of tragic im-
ages, as it did in the 1950s: With the elegantly twisted uniformity of the figures,
the flat backgrounds, and the light color register, these panels are now large in
the 1960s sense of "decorative." They evoke the chic contemporaneous paintings
of David Hockney in England (*Man Taking a Shower in Beverly Hills*, 1964, and
A *Bigger Splash*, 1967, both hanging nearby in the Tate) and Andy Warhol in
the United States. The gnarled figures seated on toilets or vomiting in sinks offer
the same frisson as Warhol panels of auto accidents and electric chairs. They
would not disturb walls hung with paintings by Ellsworth Kelly, Brice Marden,
and Cy Twombly. By contrast, try to imagine *Study for a Portrait* (1953) or the
1962–1965 triptychs on those domestic or corporate walls.

A partial exception is the series of smaller portrait heads, which isolate the
most interesting vestige of the figure paintings and, at least sometimes, retain the
less decorative dark ground. But the portrait heads were already well under way
in 1959–1960 with the heads of Muriel Belcher, a logical extension of the Blake
heads of 1955, painted in the manner of the Van Gogh figures of 1957. At that
time something of the conflated allusions of Blake's life mask and Van Gogh's
final trips to the fields near Arles, of mad artists and approaching death, of their
arbitrary colors and textures, remained in the isolated heads of Henrietta Mor-
aes, Isabel Rawsthorne, George Dyer, and (above all) Bacon himself. Yet isolated

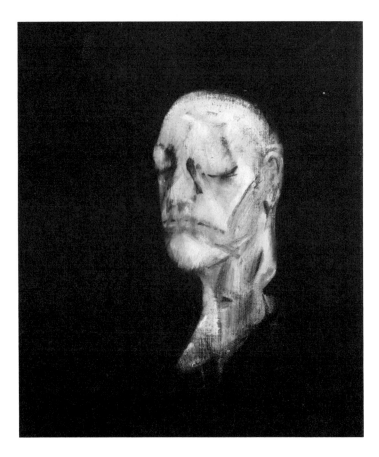

Francis Bacon, *Study for Portrait II (after the Life Mask of William Blake)*, 1955, oil on canvas. Tate Gallery, London (Photo: Art Resource).

as these heads are, with features so twisted that the conflation becomes an agon between the observed grimace of the sitter and the intrusive hand of the artist, the question still, for a while at least, remains: Is this the hand of Van Gogh? Or are these paintings recollections of Theódore Géricault's heads of the insane or of the severed heads of criminals, or of the photographs of pathological cases Bacon acknowledges as one of his sources? Bacon's self-portraits often derive from penny-arcade photographs in which he appears to be—or is—in an advanced stage of inebriation or abstraction: a fact he confirms in his remarks to Sylvester about the artist's need consciously to derange his senses.

In short, I see Bacon's situation as analogous not to the final phase of a Rembrandt or Titian (as Bacon, Sylvester, and many critics seem to suggest) but to the long second phase of Samuel Palmer or de Chirico. Bacon's brilliant earlier paintings are his equivalent of de Chirico's metaphysical paintings, produced during a short period (hardly a decade) and then repudiated with a great deal of fanfare in favor of his subsequent "correct" paintings. Indeed, the lightening of the palette, the repudiation of meaning, and the turning to the Italian Renaissance for inspiration are also interesting parallels: De Chirico returned to a weirdly personal version of Botticelli, and Bacon to a version of Michelangelo's

sculptures and sculptural paintings of figures. Both also corrected their earlier works by repainting them in the new approved style. *Second Version of "Painting 1946"* is a travesty of that great work as de Chirico's soft feathery repaintings betray the hard intense masterpieces that preceded them. In Bacon's most recent paintings the powerfully evocative figures of the 1944 triptych, on the same orange ground, have come embarrassingly to resemble thalidomide babies with cricket knee guards, flippers, and small but prominent sexual organs.

I want to suggest some ways in which we might attempt to explain (if not justify) Bacon's change of direction. I begin with an acknowledged literary source, the poetry of T. S. Eliot. Bacon has said more about Aeschylus's *Oresteia*, but if we remember Eliot's Sweeney poems (to which Bacon alludes in the title of a 1967 triptych), we notice that Bacon's Aeschylus is subsumed under Eliot's: Eliot conflates the murder of Agamemnon with a contemporary Sweeney, his blood with the nightingale's song and excrement ("And let their liquid siftings fall / To stain the stiff dishonoured shroud"). Bacon, like many of his generation, has never lost Eliot's way of seeing and describing, but I think he has simplified, perhaps intensified, his reading of him.

"Sweeney Erect" is an instruction-to-a-painter poem. "Slitted below and gashed with eyes, / This oval O cropped out with teeth," with a "Gesture of orang-outang," is offered as a subject for a painter: Thus Sweeney "Rises from the sheets in steam." In "Sweeney among the Nightingales," "Apeneck Sweeney . . . spreads his knees / Letting his arms hang down to laugh" (later, showing a "golden grin"). Bacon fulfills these instructions in his male figure crouched on a bed or perched on a bar, his pope or his ape, his *Study for a Portrait* or *Study of a Baboon* (1953). The simple domestic articles that fill his background furnish the background of Eliot's poems as well, and even his strange targeted dogs (of 1953) may be visualizations of "Gloomy Orion and the dog" (that is, the Dog Star, with its associations of heat and madness). The point Bacon takes from Eliot is that Sweeney, placed in the context of Aeschylus's *Oresteia*, becomes a mock-heroic comment on contemporary life. He is equally interested in the atavism of Sweeney's reversion (cultural for Eliot, physical for Bacon) to ape.

Bacon takes from the description of Sweeney in "Sweeney Erect" the blurring of the ape's rising to an erect posture with an ambiguous act of love, an epileptic seizure, and a murder. The scene shifts between those two Bacon locales, bedroom and bathroom, as Sweeney arises "full length to shave," "tests the razor on his leg," and we hear a shriek from "The epileptic on the bed / [Who] Curves backward, clutching at her sides." The gaping mouth (which in the prose poem "Hysteria" is expressed, "lost finally in the dark caverns of her throat") contains many of the associations Bacon explores, but it is fastened to the carnal bed, the amorous-murderous struggle that Bacon first introduces in his double figures of 1953–1954. In "Sweeney among the Nightingales" the

murder is Sweeney-Agamemnon's, and in Eliot's "Fragment of an Agon, Sweeney Agonistes" (with its mock-heroic echo of Milton's *Samson Agonistes* and its epigram from Aeschylus's *Choephoroi*), it is Sweeney's fantasy murder of a sweetheart. In Bacon's evocation of "Sweeney Agonistes" in his triptych of 1967, but in many of his other works as well, he represents the telephone, the window, the mundane detritus (the motorcar appears in his landscapes, and even the "desert isle" begins to appear in his sand dunes of the 1970s), but above all the eucharistic cannibalism of the open mouth and the bloody bed (Sweeney wants to "convert" missionaries "into a stew") and the ordinary bedroom in which (to use Bacon's words, quoting Wilde) each man kills the thing he loves.

Shared by Bacon and Eliot, I presume, is the English obsession with murder stories, especially crimes of passion, in the medium of newspaper headlines and halftone photographs. (Bacon did not know that the murder referred to in "Sweeney Agonistes" was not perpetrated on a bloody bed but in a bathtub, by drowning.) But in terms of a graphic tradition Bacon approaches the Eliot situation through Muybridge's serial photographs of athletes wrestling, which he turns into a pair of lovers almost ghostlike and hardly distinguishable from the bedding or grass in which alternatively they grapple.

If the first aspect of the Eliot poem reflected by Bacon is allusion (to Shakespeare and Dante, to contemporary argot and newspapers), the second is the atavistic aspect summed up in *The Waste Land* and Eliot's acknowledgment of Jesse Weston's *From Ritual to Romance*, which goes beneath allusion to what Eliot calls myth and ritual. Eliot himself, especially in the poems that followed *The Waste Land*, subordinates witty mock-heroic play to an evocation of archetypes. I am, of course, purposely describing Eliot's development in terms I have applied to Bacon's visual isolation of the central, mythic figure because this takes us to the heart of what happened to his painting in the 1960s. The earlier paintings had still rendered "a painting" of a conventional sort, as Eliot had related himself to Shakespeare, Webster, and Middleton. But as Eliot comes to focus on his own personal salvation, so Bacon also narrows his attention to simpler things, his own and his friends' "facts." The bed (or the grass plot) is set on a platform, and as it comes to be associated with the Sweeney-Agamemnon murder, it loses its mysterious indeterminate background and becomes a kind of altar.

It seems that the confused singleness-doubleness of these copulating figures—who could be interpreted as one person in two postures—owes something to the ambiguity of Sweeney "pushing the framework of the bed / And clawing at the pillow slip," but also to the Eliot figures of "Ash Wednesday" who struggle on the winding stair: the "same shape twisted on the bannister / . . . Struggling with the devil of the stairs": "At the second turning of the second stair / I left them twisting, turning below." The single twisted shape who appears in the later panels simply implies or shows the traces of his double in this symplegma (to use Fuseli's term in a similarly sexual context). Thus he is framed, focused, and celebrated by circles (including bullrings or circus rings or race tracks) and even on

one occasion literally represented at the turning of a stair. I suspect that some version of Eliot's "still point of the turning world" is what Bacon is trying to evoke at the center of his bare and boring emptiness, which he may have intended to be as negative as Eliot's.

Bacon was very much a man of 1930. Like others of his generation he has outgrown neither Eliot the poet nor the art movements of that moment, Art Deco and Surrealism. Art Deco continues to appear in the tubular furniture of his rooms (which he himself designed around 1930) and in a general way in the composition of his backgrounds. As to Surrealism, Bacon acknowledged Picasso's huge organically bulbous female shapes on the beach as a source for *Three Studies for Figures at the Base of a Crucifixion*. Like Bacon's early canvases, they are conventionally Surrealist images in their conflation of religious and secular (eucharist as sacrifice and gourmandizing), desire and fear, passivity and aggression, focused on woman as both object and threat.

The psychosexual dimension of Surrealism, apparent in these Picasso paintings, would not have escaped Bacon. His language in the interviews with Sylvester evokes the Surrealist vocabulary, and his paintings exploit images that in many cases Eliot shared with the Surrealists. Both the flat original background (his shade of orange appears in works by Ernst) and the rich painterly surface have Surrealist origins, as does the collage of old master paintings and newspaper photographs. Of especial importance to Bacon was the Surrealist concern with clinical photographs from medical books, for example Jean Martin Charcot's photographs of hysterical cases (reproduced in *Révolution Surréaliste* in 1938).

But if Surrealism in one of its aspects imitated the conventions of old master and popular art, in another it sought to reflect the immediate subconscious movements of the artist's mind, and its overriding aim, given these methodological assumptions, was the "one perfect image." Bacon's aim, he told Sylvester, was to "paint the one picture which will *annihilate* all the other ones, to concentrate everything into one painting." If we combine this desideratum with the reliance on accident, we have the powerful, haunting, mysterious image emerging from paint, which was in one way the end product of Bacon's 1950s art and, in a different way, of his paintings after 1960.

It is not unreasonable to see this search as parallel to that of the Abstract Expressionists in New York for the totemic image, a secularized version of what an image of God-in-Glory meant to a medieval Christian. Bacon's earliest reproduced painting was another Crucifixion, singled out by Herbert Read, doyen of the English apologists for Surrealism. And as Bacon remained focused on the Crucifixion and gradually simplified his composition to the Christ figure alone, twisting in empty space, perhaps literally an imitation of a Cimabue Christ, the New York School took off from the Jungian archetypes of primitive art, African or pre-Columbian, and ended with the hieroglyphic shapes of de Kooning and

Pollock and the numinous rectangles or single vertical lines of Rothko and New-man. What Bacon seems to have absorbed from the Americans around 1957 was the belief in the autonomy of paint, but his isolation of the figure—the cancella-tion of all else involved in the conventional notion of a painting—also parallels their reduction of art to a single essential.

Bacon is correct, however, to distinguish himself from the Americans. If they sifted their Surrealism through Jung and social activism, Bacon seems to have been less interested in the revolutionary Surrealism of Breton than in the anar-chic self-referential doctrines of Artaud and Bataille. Dawn Ades has brilliantly established the connection with Bataille in the Tate catalogue, but Artaud, with his invocation of a "theater of cruelty," seems equally relevant. Crucifixion, for example, is a term Bacon could have found in Artaud's *Le Théâtre et son double*.[18] The two interpretations of Bacon's mise-en-scène, which also connect it with Balthus's, fit Artaud's call for the closed room in which a crime takes place and the armature on which to display an object of desire. The preference for desire, pain, and spectacle over meaning (which Bacon refers to as "illustra-tion") connects the actor-director and the painter.

The violence of Bacon's attack upon his subject or image is reflected in the vocabulary he uses to describe the act of painting. He acknowledges "the injury that I do [my sitters] in my work" and asks Sylvester, "Who today has been able to record anything that comes across as a fact without causing deep injury to the image?" He wants his distortions to "bring the image over more violently," but he also explains the hypodermic needle in a figure's arm by the artist's need to "nail" the "flesh onto the bed," invoking once again both the Crucifixion and the artist's complicity with the executioner. He needs to "trap the fact" or "catch the fact at its most living point" (whether the "fact" is the hypodermic or the nailing to the bed).

These sadomasochist metaphors are related to his concern with photography and with "positioning" the body—as in the book *Positioning in Radiography*, which he recalls as an early influence. The body he paints is acted upon, x-rayed, its inner structure revealed; but to do this the artist has to "nail" it down in various ways, seeing, placing, and painting it as if it were a patient (his example also, to explain his interest in open mouths), something like Eliot's "patient eth-erized upon a table," with its later echo in Prufrock's seeing himself as "pinned and wriggling on the wall." It is, of course, Bacon himself almost as often as his friend Dyer who is thus nailed down. But this violence must also be presumed to connect the agency of the artist with the sort of sadomasochistic sex play implied in the figures themselves, who upon occasion may call for comparison with the photographs of Joel-Peter Witkin and Robert Mapplethorpe.

His skill at representational painting, he tells us, must constantly be counter-acted—by wiping away outlines with a rag, by dashing paint randomly on the image, by turning the canvas. Accident, another Surrealist inheritance, began for Bacon as a point of departure or a way to explode what was becoming too

"illustrational" into a new picture. In his account of how *Painting 1946* emerged from an attempt to paint a bird, he suggests something very like de Kooning's turning a "Woman" on her side in order to begin a landscape. The seeming accident is, on a more profound Surrealist level, no accident but the perception of a resemblance. If he rejected an accident, it nevertheless remained, and was blended and blurred into the background as part of its mystery—as the candid camera's blur of a rapid movement in the subject, for example.

In the later works, however, accident has moved to the center; painting has become "a game by which man distracts himself," specifically a game of roulette. Bacon now lets his arm determine certain supposedly involuntary shapes, sometimes throwing at the image unrelated, quite independent blobs of paint. The gesture recalls Pollock's notion of painting as an extension of the artist's own body, but unlike Pollock, Bacon limits the movement to the isolated figure. The accident is seldom integrated but remains an overt trace—of painterly power, certainly, perhaps also of painterly process or accident. It is an open question whether Bacon is thereby attacking or worshiping his image; whether the paint splash is homage, or whim, or a painterly discharge of sperm.

Bacon's aim in a given canvas, he says, was to "paint the one picture which will *annihilate* all the other ones, to concentrate everything into one painting. . . . [But] unfortunately," he adds, "I've never yet been able to make the one image that sums up all the others. So one image *against* the other seems to be able to say the thing more" (my italics). The aggressive verb joins the composite, coupled image to create the Bacon series in which "one picture reflects on the other continuously and sometimes they're better than they are separately." His model, Bacon tells us, was Muybridge's series of photographs of the human body in action. His popes are not to be confused with Warhol's 15 or 50 Marilyn Monroes, identical except for differences of inking, which only indicate something about the age of mechanical reproduction. The popes and businessmen, the wrestlers (on the bed, in the grass), are all different, contributing to the idea of a single stable image that no longer exists. These early paintings with their old master echoes signify the end of an art tradition, the loss of confidence in the one definitive picture.

We knew that in his earliest paintings Bacon did proceed with the assumption that he would paint one "which will annihilate all the others" and destroyed all but the final image. Thus only *Three Studies for Figures at the Base of a Crucifixion* survives from the 1940s. Then, when he was under pressure from a dealer to fill out a show of his work, accident intervened to preserve the "failed" canvases and so produce serial composition. In the post-1960s paintings, however, Bacon returns to the "annihilation" of the others, first by bad-mouthing the earlier series in the Sylvester interviews and then by replacing the series as a set of variations, a metaphysical exploration of incompleteness and doubleness, by mere accumulation. Repetition now seems predominantly therapeutic or incantatory, another aspect of worship or exorcism of what has come to be an idol set

on a shrine. The powerful iconoclasm of the earlier paintings has receded into something close to idolatry—not of the early works themselves, which he now repudiates, but of the subjects painted and the consequent repaintings.

Two contemporary Surrealist-derived artists who shed some light on Bacon's intentions are Balthus and Giacometti. In the 1930s and '40s, Balthus was painting closed rooms with outstretched figures in scenes strongly suggestive of both worship and sacrifice. These paintings, on a scale and in compositions as monumental as Bacon's, hold the attention because the aesthetic experience is so emphatic and yet erotically and menacingly charged. The open, outstretched, sun-drenched little girls on the bed are heliotropic, and in their particular settings they evoke old master subjects in a way not unlike Bacon's canvases. Although Bacon's popes and the wrestling couples are androgynous, they are essentially male (Innocent X and Muybridge wrestlers) and only incidentally female (the Odessa Steps woman's scream, a man and woman embracing), and they become specifically male in the later Bacon paintings. As I shall suggest, these figures probably began as a male studio model, but Bacon has first to deal with the doubleness not only of Surrealist collage but of homosexual desire: as disguise or displacement, as active-passive difference in gender sameness. We can virtually see the popes and businessmen splitting apart into the wrestlers (there are separate paintings of Innocent and the Odessa Steps woman in 1957) and then returning, reintegrated, in the later men.

An enigmatic but pivotal series was the "Sphinxes" of 1953 (returned to, or repeated, in 1983). A woman-lion figure, the sphinx must have originated conceptually in the oedipal reference of the broken glasses of the Odessa Steps woman and the eyeless male faces painted around 1950. As a Surrealist image, the eyes and mouth were interchangeable, the woman's bloody face displaced to a man, and the mouth employed as both threat (of devouring or severing) and scream (of agony or pleasure). By leaping from the *Oresteia* to the nexus of *Oedipus*, Bacon replaced the wife-husband murder with the one man ritually sacrificed by self-blinding (or castration), and his elevation in *Oedipus at Colonus* to the status of a local deity. From Oedipus's interlocutor, the sphinx, Bacon moves to Oedipus himself in the portraits of Blake and Van Gogh, of Bacon himself and his male friends.

The Giacometti sculpture that most reminds one of Bacon is *Head of a Man on a Rod* (1947), a head canted back with its mouth open in a scream, impaled on a long rod. This recalls the destroyed painting Bacon described to Sylvester as a wound on a pedestal, as well as the dark floating heads of Blake's life mask; but it can also stand as a paradigm for the crucified popes and businessmen. Giacometti's obsessive linear framing in his painting, in which the sitter's face amounts to the sum of trials and errors, the approximations and framing lines, recalls the abbreviated framing lines of Bacon's early paintings and the blurring vestigial

paint of the more recent ones. Both artists isolate the head in order in some sense to impale and exhibit it, which in the light of their common Surrealist background is to make it an object of desire.

Giacometti began a Surrealist and ended (as Bacon said he would like to be) both a sculptor and a painter of portrait images. Bacon's brush imitates the gestures of Giacometti's hand in clay, the fingers shaping and molding the plastic substance, leaving marks of power in the ravaged flesh. His distortions are unlike de Kooning's, he explains, because he is not seeking aesthetic relationships only; the process of the artist's defiguration is not his subject, but rather the tension between his own power and the figure, which must retain in some form its recognizable actuality. Otherwise, the "seeing" of the image will have failed—as of course he admits it usually does—and the image will have lost its potency for him.

Both Giacometti and Bacon followed their Surrealist phase with a repudiation of it. Giacometti's Surrealist sculptures of the 1920s and '30s are as various and inventive as his more famous sculptures of the 1940s are obsessively similar. In the latter works he consciously turned his back on conceptual and allusive shapes (phallic cradles, aggressive and nursing; androgynous composites) and "returned to nature" and problems of "seeing." This elemental need is embodied in elemental shapes (though if the earlier sculptures can be said to "allude" to African sculpture, the later relate as strongly to Etruscan or primitive Greek). But though Giacometti claimed to be exerting all of his energy on being true to what he saw, in fact he had evolved—like Rothko, Newman, and some of the Americans, indeed like Bacon—the one "perfect image" out of his earlier experiments and thereafter produced variations on it, being totally identified with it. His revisionist aim, like Bacon's, was to put behind him the conceptualizing of the Surrealist work and build those externally described tensions into the artistic process itself—like Pollock, regarding the art object as an extension of the artist's body.

There is, however, one clear difference between Giacometti and Bacon. While they shared an insistence on the failure of their efforts specifically to convey what they saw, we can at least recognize the faces, however distorted, of Bacon's little group of friends and of himself. Whereas Giacometti insisted on the primacy of representing what he saw, our senses tell us that his heads (or noses or feet) all look at least as alike as cousins. In fact, Bacon is essentially still painting within the tradition of English portraiture, where a likeness has always been of primary importance. For if his early use of allusion has its roots in Surrealism, it is also conditioned by the English tradition, being "literary" in a sense that may have contributed to his fear (derived, I suspect, from the formalist criticism of Roger Fry and later Adrian Stokes) of being "illustrational." His merging of Innocent X and the woman of the Odessa Steps, especially in its starting point in a highly validated old master portrait, invokes Reynolds's painting of the courtesan Nelly O'Brien in the pose of a Raphael Madonna, or of young Master

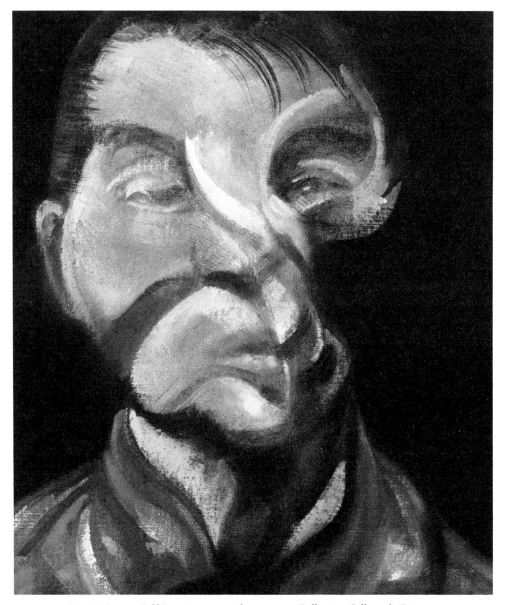

Francis Bacon, *Self-Portrait,* 1972, oil on canvas. Collection Gilbert de Botton.

Crew in the pose of Holbein's Henry VIII—or of the actress Sarah Siddons in the pose of a Michelangelo Prophet. In a later painting, long after Bacon had abandoned this method, one still notices a pair of figures (in *Triptych—Studies of the Human Body* of 1979) who echo Michelangelo's Adam and his sculptures of Day and Night in the Medici Chapel. Significantly, Bacon posed before this painting for publicity photographs for the Tate exhibition. What he has repudiated is Reynolds's mordant wit (or Hogarth's when he showed a prostitute in the pose of the Virgin Mary, or a rake in the pose of Christ), which remains only in

the photograph of himself and his paintings of the Michelangelo men. Otherwise his echo recalls instead Reynolds's more official portrait of Commodore Keppel in the pose of the Apollo Belvedere, painted at least as much to elevate the role of the English artist, in particular Reynolds, as to elevate the sitter—and, moreover, unambiguously to *elevate*. Elevation, we have seen, is put in question in the early paintings; much less so in the later, where "attention must be paid" is constantly asserted.

Bacon calls his paintings portraits and argues for placing portraiture above history painting at the top of the generic hierarchy. In this he was following the practice, if not the preaching, of Reynolds; by retaining the monumental composition, the structure of his Crucifixions, he was, like Reynolds, attempting to raise portraiture to the highest status by marrying it to history painting. Indeed, his attention to likeness, to the "portrait," holds him within the English tradition of Sir Godfrey Kneller, Hogarth, Reynolds, Thomas Gainsborough, and Sir Thomas Lawrence.

But the general effect of his "portraits," it must be admitted, is of caricature. Caricature, we saw in chapter 1, was an inherent part of the English tradition of art, along with its strong literary affiliations. The English model for Bacon would be an enlargement of one of the figures in Reynolds's Roman caricature groups (of around 1750) into one of his monumental single portraits. Bacon's evident model, however, can only be the Goya portraits that derive from Velázquez's dwarfs and idiots, for which his *Innocent X* can stand as a displacement—in which he reads the pope as a malevolent version of a dwarf or idiot.

Coldstream's Life Class

There is a more immediately contemporary school of painting in London with which it is difficult not to associate Bacon. This is the figural art of Sir William Coldstream and a number of other artists roughly associated with the Slade School, supported by the formalist criticism of Fry and its extension into psychosexual categories by Stokes. Stokes in particular hovers behind many of the utterances in Bacon's interviews. In an essay on Coldstream, Stokes refers to him as "a great modern master, as 'extreme' and isolated as Rothko."[19] Stokes, whose basic distinction is between art that is modeled and art that is carved (offering a sculptural model for all art), describes Coldstream's paintings as "carved shapes uncovered from a stone," embodying an "attentiveness to the commanding wholeness of the model. . . . [Coldstream] upholds in the nudes, creates from the sitters, a massive unadorned solemnity on which the artist's own dignity *qua* artist, we feel, entirely depends." Although these sentences sound inflated applied to the timid work of Coldstream, they could serve as a rationale for Bacon's later views of his own painting.

Adapting Melanie Klein's version of Freud, Stokes saw the pivotal moment of representation as that when the artist comes to regard the sitter no longer as a

"part-object," as the breast that the child still feels to be part of him- or herself, but as an independent "whole-object" that does not force or distort the "stone," emerging by a process of carving rather than modeling. I think this moment has been of central concern for Bacon, but he has reversed Stokes's developmental pattern, regressing from the whole-objects—pain and power internalized and externalized—to the part-objects of which the artist's body will not let go.

The Coldstream School's emphasis on the life class, on the mise-en-scène of the academy, with the dais on which a model poses, has left its mark on Bacon's scene, however much he has concealed it with Eliot's trappings. If we accept Bacon as primarily a figure painter who has been forced, in order to produce finished paintings, to deal with backgrounds and settings, we can see him as someone who has never lost his nostalgia for the life class and the male model (as opposed to the portrait sitter or the figure in a subject painting). We can see his "armature" as that setting of the life-class model. It was also life-class practice that led Coldstream and his followers to retain the splashes and spills of paint, the ticks for measurement and the pentimenti, the signs of composition and revision and error, to remind the viewer that this is an academy study, not a finished "machine"—an extension of the artist's body, not the sitter's.

One way out of Victorian painting was to follow Walter Sickert back into the studio and paint the artist's model as model. Sickert wrote of the model Tilly Pullen that she was far more interesting when she had removed her heroic costumes and was just Tilly Pullen in her own surroundings. This assumption had been laid out in the 1730s by Hogarth in terms of actors and roles rather than artist's models (in *Strolling Actresses Dressing in a Barn* and other works). Like the costumes of Hogarth's actresses, Pullen's "lendings" were essential to the effect, even when she was seen without them in her own flat. But Coldstream does away with the theatrical aspect, and so with the last traces of the literary: He paints the model in the studio only, without trappings *or* her own dress. The human body is his subject, but seen in the particular context of a studio in an art school.

As William Bailey has remarked, American artists usually go back to their youth or some earlier time for their subjects, perhaps for their forms as well; whereas the Coldstream artists—extending in fact to their more recent experiments in "body art"—go back only as far as their training at the academy, in this case the Slade.[20] They have somehow chosen to be retarded at this level of experience, composition, and technique. The lack of finish, even the incompleteness, is that of a studio work. The subject is a studio sitter, not a portrait subject, and the picture space is essentially the space of artist-model, not of spectator-portrait. Moreover, these paintings are ostensibly painted *for* a studio of students: Why else retain those red (sometimes black) marks of measurement? Coldstream is, as his paintings show (indeed proclaim), essentially a teacher of painting. His paintings retain this emphasis, and the paintings of his students retain his lesson in their repetition of his mannerisms, which tend to make them, thematically at least, a part of the paternal oeuvre.

Other mannerisms such as an added strip of canvas—even the simulation of an added strip where there isn't one—suggest that the painting is trying to be about the act of painting: trying to catch and hold itself at that point when it is still being painted, but always in an academy, on an easel; it has not (with Pullen in or out of costume) yet gone into the street, let alone into salons or the purviews of the literary imagination.

Stokes suggests the rationale for the Coldstream kind of painting: It is based on an absolute reliance on the physical presence of the object; and if this is a human, in order to obtain such patience it would have to be a paid model. Its exact position is chalked out, and one has heard jokes about the model's aging— hair graying, face wrinkling—over the period of time that also has to be recorded somewhere on the canvas surface. Unfortunately, the only evidence in the painting is the measure marks or the retained signs of trial and error of the drawing. But the latter could as well be taken as homage to Cézanne, as we might also argue that the obsession with the studio represents in fact a homage to Matisse.

What strikes me most is the complete conventionality—in a studio or academic sense—of the paint application. To see how conventional it is (even in Lucien Freud's nudes), one need not contrast a painting by de Kooning but only look at a Bacon; or, better, follow the progress of Michael Andrews. *Digswell Man II* (1959) is the transitional work: It breaks the Coldstream pattern (still present in his nude portrait of his wife Julie in bed) by turning to Bacon's Van Gogh paintings of 1956–1957. All the elegance and studio style of Coldstream is gone; for Bacon this is the precise point of pivot between the thin chalky and allusive paintings and the meaty, scarified, impasto swirls. But in *Digswell Man II* the paint application goes beyond even Bacon's vortical distortions to an un-English freedom (or sloppiness) that suggests some contact with the work of Diebenkorn, Park, and the San Francisco School of around 1956.

In his second period, Andrews used Bacon's portraits as a way into heads and bodies distorted as in funhouse mirrors. The actual effect of his Las Vegas paintings (*Good and Bad at Games*, 1964–1968, for example) is not so much that of Bacon's smudged faces becoming twisted dissections of inner/outer flesh, or of the waxing-waning motion of a Giacometti figure, as of Jack Levine's generals and industrialists, who appear to be caught in distorted, unfocused action photographs. Very close to the technical sense of caricature, Andrews's figures have a satiric social content that is quite alien to the work of either Coldstream or Bacon.

Andrews is a various, experimental, talented, and risk-taking artist. From portraying jet-set parties he went restlessly on to staining unprimed canvas, depicting elegant architectural structures (piers and pavilions) followed by tropical fish, floating balloons (which he tells us he associates with the human self), and hunters stalking stags, always using his subjects to make emphatic formal patterns. But he does raise a question about contemporary British art: However interesting, does his development remain "provincial" when compared with an American artist of his own age, Johns, who had, rather than the tradition of

Coldstream and the Slade School (even the work of a maverick like Bacon), the tradition of Abstract Expressionism, which evolved as he was coming of age? English painting has tended to be elegant and somewhat nerveless, and certainly secondary. Andrews's parties, which recall Cecil Beaton and even Hockney, are to the groups painted by Bischoff, Park, and Diebenkorn as Gainsborough's portrait groups were to Goya's.

I further wonder about the particular kind of secondariness apparent in Patrick George and Ewan Uglow. They are Coldstream clones down to their red measure marks. Bailey has argued that there *are* differences: George is more concerned than the others with light, Uglow with decorative pattern and the purely theoretical dimensions of Coldstream's art.[21] Uglow is only the more self-conscious, carrying his finish (except in the fine early painting of the sun-tanned nude lying across a bed, a horizontal near the bottom of the canvas, that looks more like the work of George) to the enameled anonymity of manikins. There is a little of the sense of early de Chirico in some of these strange, diagrammatic versions of Coldstream. If Uglow is an intellectualized and stylized epigone, George draws out what is most immediate and personal in the Coldstream style and produces some—to me at least—evocative versions of the typical English (Constable) landscape.

Frank Auerbach, though a very different artist in terms of style, fits into the school as an obsessive searcher for the right image—again a body or a face—with all the traces of the search showing. He employs a body art in the sense that the motions of his arms and hands are so repeated and emphatic as either (with brush) to heap up inches of pigment or (with charcoal) to wear holes in the paper that correspond to the body he is representing, roughly as the signs of measurements do on a Coldstream canvas. But of course these are only Auerbach's equivalent of the body movements of de Kooning and Bacon.

Freud, beginning as a Berlin artist very close to Dix, Beckmann, and George Grosz, in the 1970s began to adapt Bacon's body shapes into close-ups of twisted models' bodies—in one case a frontal view of the pelvic area only, the remainder left unfinished, which relates the Bacon "wound" or "smile" to Courbet's *Origine du monde* (but without a nod in the direction of Duchamp or de Kooning). These occasionally extend beyond the immediate model to relationships of a mysterious conversation-picture sort, with another figure in the same room. But the actual painting is as academic as the Coldstream epigones; though in a richer Baconesque impasto, the brushstrokes are regular, and there is none of Bacon's aleatory movement.

These remain remarkably secondary works. In the practice of Coldstream and his closest followers the figure and ground are dominated by principles of form and paint derived from Cézanne but now conventional "studio" work. Following from the example of Bacon, Freud and Auerbach have opened up these rather conventional Cézanne-like studio studies into the possibilities of a "body art," a kinesthetic painting shading off into happenings centered on the artist's

own body. Lawrence Gowing's life-size projections of his own body are related to Bacon's extreme treatments of himself and his friends. I could imagine Bacon, in a future dialogue with Sylvester, defending the artist who, at six o'clock on a cold London evening, appeared on the roof of the Hayward Gallery, stripped, and, as he hung in various Baconian postures from a scaffold, had coat after coat of paint poured over his shivering body.

The English School: Lord Leighton's Toes

Victorian art is the obvious place from which to chart the high threshold of repression in contemporary British art. The "Victorian High Renaissance" (the title of the Brooklyn Museum exhibition of 1979) refers to Frederic Lord Leighton, George Frederic Watts, Albert Moore, and Alfred Gilbert, whose names are almost as interchangeable as their assumptions and who all flourished in the last quarter of the 19th century.[22] To these I add the name of Sir Lawrence Alma-Tadema.

With English art one has to begin with the historian's question: What will a painting by Leighton or Moore tell a student of history or of art history? I suppose it will tell how the drapery folds of the Elgin Marbles looked to artists at this time. It will show the adoption of the many-folded version of Greek drapery in paintings that are essentially (certainly in Moore's case) *about* the drapery pattern, and, according to all of Gombrich's criteria in *The Sense of Order*, are more design than sign, more decoration than representation.[23]

Leighton at least may also show the historian something about contemporary attitudes toward sexuality. As the Brooklyn Museum's exhibition label to *Actaea, the Nymph of the Shore* (1868) tells us, nudes were frowned upon by the Victorians, but Leighton's nudes (he rose to the presidency of the Royal Academy) were so determinedly unerotic that nobody complained. Not only the petrifying visage of Actaea but her strangely unreal body, the painful twist of the torso and the deformed hips, may tell us that something more than clumsy painting (let alone the distortion-for-effect of Bacon) is at work here. Leighton's uneasiness with the female figure shows us personal as well as social repression. He allows— at what level of consciousness is not certain—sexuality itself to slip in through the phallic dolphins plunging into the sea, toward whom Actaea's disapproving glance is directed. Presumably being "nymph of the shore," she literally turns her back upon all those goings on out there beyond her control.

There is, however, one part of Actaea's body that is *not* conventionalized from the Parthenon frieze or distorted by some painterly anxiety, and therefore individual and interesting: her twisted toes, especially the big one, expressing, one might suspect, the discomfort her frozen face only suggests at what is taking place out in the ocean. All that is repressed in the face and body is let out in the toes. The interest in toes in *Actaea* is confirmed by Leighton's other poetic history paintings in which all the character in his smooth, anonymous figures—his

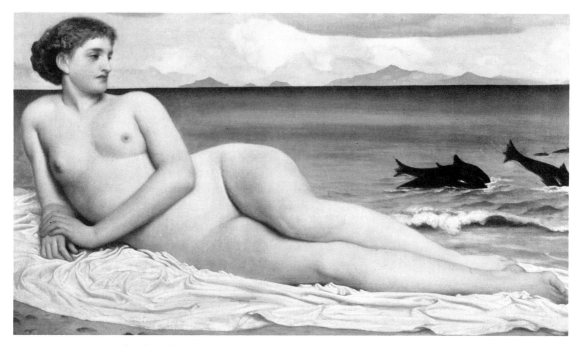

Frederick Lord Leighton, *Actaea, the Nymph of the Shore,* 1868, oil on canvas.
National Gallery of Canada, Ottawa.

attempts to bring to life antique sculpture—is lodged in the lovingly done feet, in the complexly excited, energetic, wriggling toes.

If one feature of these Victorian paintings is a relationship between what Freud would call symbolization (the conventional, stereotypic images, related to Gombrich's schemata) and representation (a return toward the figuration of primal materials), another has to be the criterion of harmony in the construction of a painting, especially one with as high a quotient of design and pattern as these. *Flaming June* (1895) is by all odds Leighton's most striking conception. The toes of June's left foot are twisted but glimpsed under the veil of her skirt, and the wiggliness is for once translated into the whole twisted shape and into the flaming colors. In this particular painting the effect is broken not by obtrusive toes but by the totally variant texture of the glittering stretch of sea behind the figure, painted in an impasto that makes it seem a piece of medieval gilding from another picture.

Alma-Tadema may still be of interest—though not because he was the world's foremost painter of marble, and able (said Sir Edward Burne-Jones) to render better than anyone "the incidence of sunlight on metal and marble," although his textures now often make his pictures seem to be on the verge of Surrealism. Certainly not because we are interested in the life of ancient Rome as he depicted it: Vern Swanson, in his book on Alma-Tadema, sounds as if he thinks the Victorians invented the idea of the Roman role model.[24] In fact, something needs to be written about how the culture that found its model in imperial Rome

in Alma-Tadema's paintings differs from the 18th-century English gentry that saw itself in the republican and early Augustan Rome embodied in John Michael Rysbrack's busts and in Palladian villas. Most of our memory of Alma-Tadema paintings is from old history and Latin textbooks where we saw his Claudius or Cleopatra, and from the school hallways where inevitably a reproduction of *A Reading of Homer* looked down. I have examined original Alma-Tademas (and pondered the fact that their most assiduous contemporary collector has been *Candid Camera*'s Alan Funt), and all I can say is that they reproduce well. Like the paintings of Maxfield Parrish and Norman Rockwell—to take two quite different cases—these were made for good photographic reproduction. They are not as gemlike as the paintings of Gérôme, who handed on to Alma-Tadema the secret of his medium, and they certainly lack the bravura of Bouguereau, whose satyrs and nymphs have an almost hallucinatory effect in the original. But all of this admitted, these images fascinate—and to my mind far more than those of Leighton, the artist's main competitor. The reasons are not hard to find. A few, the views of the Tepidarium and the collapse of "exhausted maenads" after a dance, are frankly erotic in a way carefully avoided by Leighton and his contemporaries. *In the Tepidarium* (1870) is a small triumph of its genre, with its feathery fan that covers/replaces the woman's pubis, and with the strigil or body scraper in her other hand, which has a distinctly dildoesque aspect.

In the second place, well-wishers were always urging Alma-Tadema to paint contemporary genre, and it is true that what his processions of partying Romans coming at us down some long narrow street or stairway recall is a Tissot (he took over James Tissot's Saint John's Wood house, as well as learning from his compositions). By reproducing stills from the films *Intolerance* and *Cleopatra*, Swanson not only makes his point that Alma-Tadema's influence was mainly on the D. W. Griffiths and Cecil B. de Milles, but accidentally that his Romans are clearly contemporary Englishmen. Even the women are not especially idealized. I am sure that Victorians felt that this was the way Romans actually moved about— as opposed to the figures in the classical friezes of David and Ingres. On the one hand, the most erotic art, of course, never elides individuality. On the other, I suspect that Alma-Tadema is covertly representing the Victorian house, with its architectural peculiarities, *as if* it were Roman.

For the real source as far as the picture's interest is concerned must be Alma-Tadema's Netherlandish forebears, especially de Hooch and his elaborate imitators of the 18th and early 19th centuries (including the German Friedrich). I refer to the art of interior relationships. Alma-Tadema's pictures are far more pictorial, less metaphysical, than de Hooch's; they are mysterious and suggestive glimpses into another dimension. (I recall a wooden sculpture of a ranch-style house, or a floor of an apartment building, on exhibition at the Whitney. It was placed against the museum wall so that you could see in only through two openings, catching glimpses into parts of rooms, and could see nothing of the *other* side. This is the sculptural version of the effect I am describing in the paintings of

de Hooch and Alma-Tadema.) A well-known example is Cleopatra in her cur-tained enclosure (her barge) with Antony glimpsed in another "inner room" that is in fact, as we see past her canopy, a stretch of the Nile. Another example of the "glimpse through a doorway to a second set of images beyond" (Swanson's phrase) is the Frigidarium, from which we look back into the Tepidarium. The exedra—the curved bench made famous by *A Reading of Homer*—appears in a great many Alma-Tadema paintings, serving invariably as a division between this and something out there beyond. So the bench works especially well for a lovers' meeting, where it cradles them, cutting them off in a hiding place from the out-side world. The "improvement" of one of his paintings made by cutting it into three distinct panels tells a great deal about Alma-Tadema's talent: They *are* three distinct compartments, and cutting them apart only emphasizes their inde-pendence, while depriving them of their problematic relationships.

Alma-Tadema's contemporaries thought him best at painterly technique and at rendering still life, worst at figures; but what caused people to feel this way? Was it the unclassical images, clearest when he juxtaposes a Roman or Greek sculptor with his statue? There is always something a little uneasy—perhaps jokey, to judge by what we hear of Alma-Tadema's sense of humor—about these juxtapositions. Swanson's best comments are throwaways in his captions, where he draws our attention to the decentering and cutting off of figures, and to the violent juxtapositions of different planes or different levels. "The obtrusive crop-ping usually infringed upon the dignity and ideality of the human figure." That is what bothered people; but the effect was the very Dutch one of the figure-rendered-in-its-setting, emphasized by the "split level" compositions. Or perhaps the contemporary effect of the snapshot still made people feel uneasy when em-ployed in an academy piece. It seemed necessary for Alma-Tadema to use the Roman setting (or earlier the Egyptian); whenever he tried to paint his own con-temporary setting he lost these terms, these orthogonals that suggest another life or relationship beyond the edge of the subject or of the canvas itself, as in the filigree of the Victorian house.

Moore's case is closer to Leighton's. In even the best Moore paintings there is some jarring element, usually the heads. Taken from Greek statues, they fail to relate to the elaborately painted drapery, bearing much the same incongruity Anne Hollander notices between the manikin in a store window and the clothes she wears.[25] Moore's blank sculptural faces should be compared with Alma-Tad-ema's, which belong to contemporary English men and women who just happen to be in Roman dress. But we also have to ask how Bonnard or Vuillard—two other artists who come to mind in the presence of Moore's rooms—would have painted these interiors. About all Moore does do is remind us of how he has missed the point or lacked the boldness (or the precedent) to replace the face altogether with a blob or smear, or simply failed to create a harmonious com-position, one in which all the elements are subordinated to an overall unity.

In an even grosser form, the same fault is to be seen in all G. F. Watts's

paintings except the portraits. I grew up admiring reproductions of *Hope*, *Gala-had*, and *The Minotaur* (but had never noticed until recently, in the Tate Gallery, that the Minotaur is crushing beneath its hoof, which rests on the parapet over which he is gazing, a canary). I remember wondering why in his own day these were ridiculed and his portraits praised. His subject paintings—again employing the same drapery convention as Moore's—are poor attempts at the starkness Millet achieved effortlessly in France. Only the portraits capture this quality, a single one of which (*Cardinal Manning*) expresses Watts's Hardyan pessimism far more powerfully than *The Sower of the Systems* or *Hope*.

Like Watts, Leighton too is capable of a good portrait (the sinister smiling *La Nanna* and the remarkable *Richard Burton*, with a fierce red scar running down the cheek). But then portraiture, along with landscape, is something the English have always had a talent for—by which I mean they worked at portrait painting, building up a tradition and certain expectations of their own, from which a Watts could effectively deviate.

I must not omit one example of sculpture, Gilbert's *Mors Janua Vitae* (1909). This bronze-and-marble structure is topped by portrait busts of Eliza and Edward Macloughlin holding a casket in which Edward's ashes were deposited (the purpose of the sculpture). But since during the process of sculpting Eliza and Gilbert had an affair, Gilbert gave Eliza's head a trapdoor for the deposit of his own ashes (which, however, never reached their intended destination).

These emphatic toes, drapery folds, odd faces, crushed canaries, and trapdoors for ashes are all, I believe, epitomes of English art. We might conclude (glancing back to chapter one) that Victorian painting reflects a last gasp of the "revolution" of counterrevolutionary caricature—of the representation of revolution separated from the brutality and terror (and truth) of the revolution itself. Whatever the explanation, there is a jerry-built quality about English art, which finds one manifestation in the lack of unity or harmony I have mentioned and another in the dependence on extraaesthetic dimensions such as the whole ambience of Gilbert's trapdoor. It is hard to think of an English painter except Gainsborough or Constable who does not allow this clearly disharmonious quality or is not merely pleasant and decorative (the hostile view of some Gainsboroughs). Even Turner, in all but his private paintings, feels he must include jarring elements that just would not be found in French or Italian paintings, or even American paintings: the crudely drawn figures (though Claude, it must be admitted, is capable of equally odd human shapes) and of course the silly little emblems, verbal puns, and personal references (to mallard ducks and "turning"), which, however, he considered an integral part of his effect.

Ben Nicholson, for example, was largely a wasted landscape artist. If he had had Reynolds's sense to stick to what he did really well, he would have taken the lower genre instead of the higher, more fashionable one of School of Paris

Cubism. He would have painted more scenes like the Mousehole and Saint Ives landscapes, or the variations on the Siena cathedral. The white abstractions, which are very handsome, seem to me less touching than the layers of Nicholson's pale whitish gray paint incised with the lines of farmhouses and cottages, resembling, in a marvelous (and again, probably English) way, early Florentine architectural backgrounds.

A kind of uneasy truce is arranged in some of the landscape drawings and paintings by having semiabstractions of huge teacups or coffee mugs fill the foregrounds. In a later drawing, the foreground is occupied by the steering wheel and dashboard of a car, through the windshield of which we see the distant landscape. The foreground is the Picasso or Braque still life seen by a sophisticated English artist in front of what he really loved, the English landscape. The School of Paris serves as a way to locate the artist, to place the viewpoint (in time more than in space, as an English contemporary of the great French artists) from which he sees the landscape.

Nicholson's oeuvre tilts either way—toward the landscape or toward the foreground Braquish still life. In the constructs of layered and carved wood, Masonite, and canvas (with the elegant pencil lines incised in the whitish Nicholson colors), he produces large objects that would look very good on the wall of a boardroom. These are genuinely attractive pictures, comparable to the work of the second-string School of Paris artists of the same period, but they do not disturb. To see what an English artist can do to disturb, one must return to Bacon's paintings of the 1940s and '50s.

Sutherland had seemed to be the British painter of the 1940s, but in the 1950s he was abandoned by native critics either because he was eclipsed by Bacon or because he exiled himself in southern France. (Bacon was in some ways an imitator who diverged: His *Fragment of a Crucifixion* of 1950 shows clearly his debt to Sutherland's Crucifixions of the late 1940s, down to the "lines" that frame the figure.) Regarded unsympathetically, Sutherland did not seem to have grown beyond the early organic, biomorphic shapes except in his portraiture, which, however, now appeared timid alongside the powerful, disturbing images Bacon was producing. One need only compare Sutherland's *Winston Churchill* (disturbing enough for the sitter's widow to have destroyed it) with Bacon's *Screaming Pope, Man in Blue,* or *William Blake.*

In a way it was proper for Sutherland, who never lost the traces of Picasso, to move to France. At his best, he took Picasso's spiky horticultural forms, turned them into thorns, and painted suggestive metonymies of the Crucifixion. At his less than best he produced images of Christ (Northampton) which derive directly from Grünewald via Picasso's Crucifixions, or introduce the enclosures and expansions of the decorations in the Irish Book of Kells (as in the altarpiece, Coventry Cathedral). He was "English" in that his work derived to some extent from the organic forms of Palmer's landscapes—that is, from local horticultural, even herbal details of the English landscape (as opposed to the panoramas Constable

painted, which subsumed the Palmer sort of detail). But by the end of the 1930s, these forms, having assimilated Picasso forms of the 1920s, were losing touch with the indigenous. At the end, Sutherland's paintings were British in the sense that they resembled huge exfoliations of a page in the Book of Kells, illuminated initial letters that often recall Palmer's isolated *locus amoenus* (seen as through Alice's keyhole into the garden) surrounded by green tendrils that reach to the edges of the canvas. Sutherland and Nicholson, and even Henry Moore and Barbara Hepworth, are artists who in international terms represent a very British development of one or two phases in Picasso's career.

Sutherland and Moore came together in their wartime drawings of bomb shelters and mines. Priority presumably goes to Moore for those tunnels and mummylike figures, but according to Roberto Tassi in his *Sutherland: The Wartime Drawings*, both artists fitted perfectly into the world of Charles Dickens's and Gustave Doré's spectral London.[26] Tassi's book, which was first published in Italy and shows where Sutherland's reputation now resides, sees London as a hell; I cannot help seeing, at least in Sutherland's case, the cozy animal burrows of Beatrix Potter and Kenneth Graham. The spaces revealed by uprooted plants and other garden excavations are what Sutherland drew and painted. The most original of his war drawings were the various versions of fallen elevator shafts, which bend over to look like his *Green Tree Form: Interior of Woods*. These works raise the question, which Tassi briefly touches upon in his poetic essay, of the effect experience has on the painter: The English war artist tended to paint gutted buildings, underground stations, and curious bomb effects, remaining a Palmer painter of haunted landscape.

English landscape painting is immediately distinguishable by its love of a particular English place, its nostalgia for the English past, and its need to evoke literary associations (one form of which was Nicholson's Cubist associations). In the "Landscape in Britain 1850–1950" exhibition at the Hayward Gallery (1983) there was, of course, much variety, including modern evocations of Constable, Turner, Gainsborough, and Palmer (as well as of Cézanne and others).[27] But two paintings will sum up. One was a wonderfully moody stretch of oceanfront at a seaside resort (1889, by Norman Garstin), rain falling and a few scattered people with umbrellas; the title should be simply the name of the place so vividly depicted, but it is the poetic jingle, "The Rain It Raineth Every Day." The other landscape was Carel Weight's long bleak panorama of a South London street (1955)—one I would immediately recognize if I passed by—which has in the foreground, half cut off, a small child (a diminutive version of Munch's *Scream*) with its hand held out, presumably about to be hit by a car. The quiet landscape is forever altered by that event (*The Moment* is the title). A friend of mine who studied with Weight at the Royal College of Art said it was his habit to look at a landscape the student had painted and say, "My boy, always put in a fairy somewhere." The advice is even relevant to Turner, who added quaint emblems to correct or explain his form design. Even Constable by the end of his career was

adding emblematic rabbits and statues of Raphael and Michelangelo where there were none. The British insist on putting a fairy in almost every picture.

Spencer's Baggy Dresses

In *Feminine Beauty,* Kenneth Clark distinguished faces that have classical and characteristic beauty—terms borrowed from Reynolds.[28] Classical beauty is regular, symmetrical forms; characteristic beauty is the more irregular kind that signifies primarily to the lover. In paintings, Reynolds meant by "characteristic" the eccentric works of Salvator Rosa or the Venetians, as opposed to the stereotype-seeking tradition of the High Renaissance, which supposedly led from ancient Greece to Raphael, the Carracci, and Reynolds himself. It is no surprise that Clark, like Reynolds (and Leighton and other English artists), privileges classical beauty.

Clark's inclusion of Raphael's nude *Three Graces* points up one issue: face or body. The nude body subordinates the face, and this tends to mean classical beauty for Clark. Thus he gives us the familiar Venuses, from Dresden to Urbino to Rokeby, from faces that cannot draw our attention away from the body to backsides that preclude the face (or reflect it in a mirror).

Stanley Spencer's Patricia Preece is not included in *Feminine Beauty.* In 1980, the same year Clark's book was published, the major exhibition in London was a retrospective of Spencer's work at the Royal Academy, the institution from which he once resigned because they refused to hang his *Beatitudes of Love.*[29] Spencer was a contemporary of the German artists usually assembled under the name *Die Brücke,* who are also noticeably absent from the pages of *Feminine Beauty.* Like them, he often painted symbolic pictures, which in his hands come out reminding us of something between Blake's "frescoes" and J. R. R. Tolkien's Third Age of Middle Earth. These are full of large shapeless cylinders of cloth defining figures whose heads appear to be made of the same material and who never quite touch the earth (though sometimes they climb up out of it, as in the great Resurrection pictures in the Tate).

What is first noticeable about Spencer is how crudely he ordinarily painted. Like the German Expressionists, though without their savage attack on the canvas, he paints as if he were a simple craftsman (or an amateur, the English version of the simple craftsman). The lack of depth and intricacy of pattern combine to make difficult the deciphering of forms. The dustman's strange Uccello-like hat (in *The Dustman,* 1934) turns out, on close examination, to be a topiary tree behind his head. I can see no significance in this double gestalt, only confusion.

One might conclude that Spencer learned draftsmanship from Henry Tonks at the Slade, but not painting (like Fuseli and other English artists, he was not always able to make the transition from drawing to painting). His preliminary drawings, and indeed the draftsmanship of the paintings, are effective, but he simply squared off the drawing, transferred it to the canvas, and proceeded to fill

in the paint from the upper left corner. This is art based on the old concept of Idea: Draw a cartoon and leave the execution to your assistants. It is not the way to produce a painterly canvas. He may have thought he was duplicating the effect of a trecento fresco, as he seems to have thought he was approximating the forms and content of Giotto. But there is also the fact—to which I have been coming around—that he could upon occasion paint beautifully, as in many of his portraits, all of his self-portraits, and the nudes of the 1930s.

These nudes are emotionally the center of his work, partly because the rest is by comparison so ascetic. They are examples of "characteristic beauty": Neither body nor face is anything Clark would recognize as classical. But Spencer never painted better than in the intensely felt portraits of Preece and Hilda Spencer: his whole life converged in the 1930s on this appalling triangle, full of self-deception and misunderstanding, and (it appears) of exploitation on the part of his "Fornarina" Patricia, who made off with much of his money, his house, and many paintings. He claimed, when his dealer would not show these portraits, that they were essential to the understanding of his other (allegorical) works.

Spencer's remark says that his sedate paintings of men and women in the "Resurrections" and the "Beatitudes of Love" imply the figures that he had found himself actually painting in the mid-1930s. He is saying that the love he portrays fully clothed (indeed in the baggiest dresses and suits) as a warm, slightly whimsical thing is actually physical—and not involving beauty and idealization but love of precisely what is there, whether the bald dustman or the slack-breasted Preece (her very particularized face flattened to fit the canvas, which is really only about her body) or the gawky, slack-membered Stanley Spencer himself.

He paints the compliant, apparently unbothered Preece in some of the frankest life painting on record, and then he produces a similar portrait—though only to the waist—of his by then ex-wife Hilda. He plans to make chapels of these in the great Blakean structure he called his Church House, which seems to have been intended to spread out over all the village of Cookham. What comes across is the contrast of faces and of breasts. The frustration in the physicality of the Preece painting (she refused him the final favors until after marriage, and then proved to be a lesbian) has been noted by all the writers on Spencer. The contrast is between the quite beautiful face of Hilda and Patricia's plain, moonish one, and between the small breasts of Hilda and the quite remarkably pendulous ones of Patricia, whose main quality—conveyed with every trick of the painter's craft—is their slackness. They are fallen, flabby, without body. Their great size together with their deflation seems to have intrigued Spencer (one is tempted to add, as active toes intrigued Leighton). Hilda is in Clark's terms relatively classical, though Spencer emphasizes the rolls of flesh around her middle, caused by the way he has seated her. Her face is still Pre-Raphaelite, close to photographs of Jane Morris, a glance toward Spencer's past, while Preece's is round and flapperish, of the 1930s. He loved her stylishness, spent £1500 on Bond Street

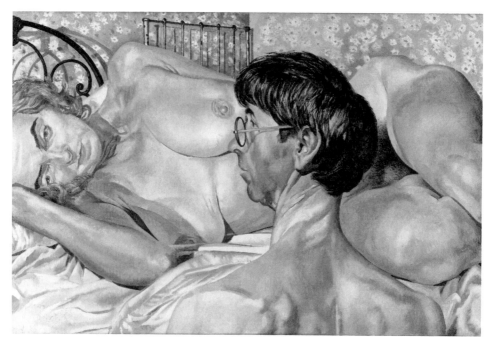

Stanley Spencer, *Self-Portrait with Patricia,* 1936, oil on canvas. Fitzwilliam Museum, Cambridge.

clothes for her, and filled his paintings with stylish dresses while courting her. The body he painted so concretely was under those dresses, which he rendered in the "Giotto" style of the allegories in the "Beatitudes of Love" and (with his own body) in the "Christ in the Wilderness" series. Above the deflated breasts in one version he hangs his own limp sexual organ, and places beneath her—recalling in a way Giorgione's *Sleeping Venus,* with its landscape above and drapery below—a leg of mutton. What combination of love, frustration, sexual fantasy, and hatred (or of the mixed genres of nude, still life, and landscape) produced these images it is hard to say, but the result is decidedly beyond the categories of Clark's *Feminine Beauty.*

Spencer painted in three modes. First, the self-portraits, portraits (the beautiful double portrait of Hilda and their daughter), and the nudes are as closely observed and obsessively represented as can be imagined. The landscapes, though often painted in his flat, textureless style, and sometimes Palmerish in their luxuriance (he liked to paint May trees), are often as evocative in their way as the nudes—as close to Spencer's own experience. Finally, the religious paintings translate his native Cookham into something as luminous and strange as Blake's Felpham and Palmer's Shoreham, and with the old Blakean sense of a completely created world based on the personal experience of a cranky autodidact who studies books (Shakespeare, Milton, the Bible) more than other works of art.

These roughly allegorical paintings, however, are really about cloth, in par-

ticular garments, and other synthetic materials. It was in these objects that Spencer sought his freedom of formal play. Wyndham Lewis, though admiring Spencer, complained that formally his larger canvases were repetitive. The crowds or people do repeat single figures endlessly, but each major canvas is conceived on a formal unfolding of some synthetic material—something loose, unfolding, and encompassing, even entrapping. Dresses and hats take over for a while during the Preece affair in the 1930s, but in the great Burghclere Chapel decorations of the 1920s it is some common material: mosquito netting that comes to encompass the soldiers like Vulcan's golden net, or duffle bags, garbage cans, bedding, a map dangerously unfolding to fill a whole panel, and tents, ultimately the white crosses that are carried by each dead man in the altarpiece. I think, in this context, we can see his interest in Preece's breasts as his discovery, in the naked body at the core of the pretty clothes, of the same quality he loved in the loose, baggy dresses, the mosquito netting, and the unfolding maps.

Before I read Spencer's own comments on his work I had interpreted the Burghclere panels as showing men mastered by these commonplace materials. This seemed particularly appropriate in the time of World War I, and still more so in Spencer's panels of shipbuilding on the Clyde (Imperial War Museum), painted during World War II and showing the interiors of ships. These twist men upside down (the contrary of the resurrection pictures) and immure them in small compartments where each is working with an acetylene torch—and within the long horizontal tube of the canvases, which are also predellas to an altarpiece for an imaginary chapel.

What we learn from Spencer's own remarks, however, is that he regards the exfoliation of man-made things as representations of human activity, and these, he says, are a way to sublimate the war. As the Royal Academy catalogue puts it, instead of the action of war, "Spencer celebrates the intervals between action when the soldiers busy themselves with the life-enhancing business of washing, eating and relaxation." The painting called *Soap-Suds: A Scrubbed Floor* (which was a preparatory painting for the 1927 Burghclere panel *Scrubbing the Floor*) is the typical Spencer image: The swirls of soap suds, the traces of human endeavor, are work in action. In the small painting, he shows only the patterns of the soap suds, while in the Burghclere panel he adds the soldier applying the brush. I suspect that these shapes of combined material substance and human effort meant more to Spencer than sublimation or escape from the horrors of war. He seems unaware of the implicit irony that this exfoliation, at least from the perspective of the 1920s, reveals men's works getting out of control, showing themselves as the cause as well as the manifestation of the Great War.

One of the Burghclere panels, *Convoy of Wounded Soldiers Arriving at Beaufort Hospital Gates* (1927), is dominated by the huge pair of gates that are being opened across the front of the panel to let in a truck piled high (or so it seems) with bandaged soldiers, most of their arms in slings, which make a

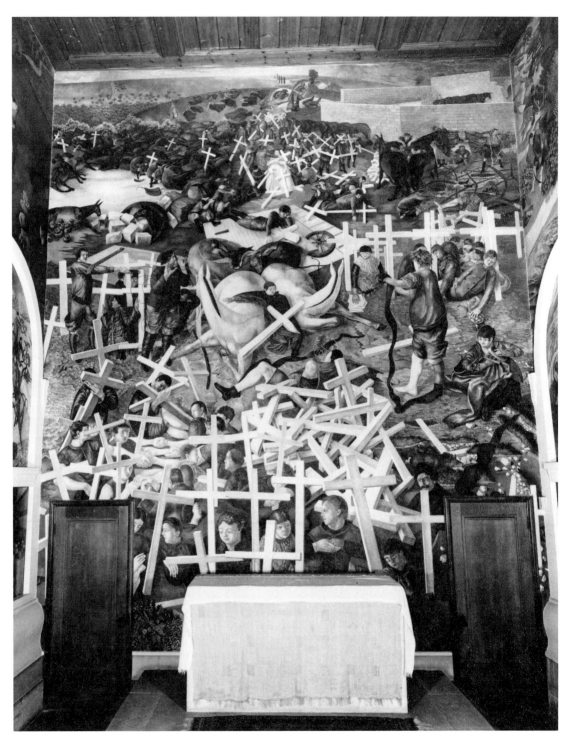

Stanley Spencer, *East Wall of Burghclere,* 1928, oil on canvas. National Trust, Sandham Memorial Chapel.

counter pattern of short diagonals to the verticals of the gate. At the time he experienced this gate, in Macedonia in 1918, Spencer wrote that

> The gate was as massive and as high as the gate of hell. It was a vile cast-iron structure. Its keeper, though unlike that lean son of a hag who kept the gates of hell [Death in *Paradise Lost*], being tall and thicker was nevertheless absolutely associated with that capricious . . . being who had charge of all the "deaduns" and did all the cutting up in all the post-mortem operations.

He used precisely the same gate, open in the same way, in a Yorkshire landscape of a year later; in this case the gate opens onto a prospect of enclosed fields.

The gates introduce us to the equivalents Spencer found everywhere for resurrection, probably going back to pictures he saw in books of the Piso Campo Santo *Judgment*, which included the lifting up of sidewalk squares or the opening of grass pods. The general conception of resurrection seems to have been the equivalent for him of conversion in this life. The two Spencer situations in his religious canvases are of resurrection and sudden access of love. Love of the dustman shows him being given broken crockery and old vegetables, things a dustman collects and so "loves," but also (as Spencer noted himself) what the donors love as part of themselves ("these things were bits of the lives of people to whom they belonged and express their characters"). This was resurrection within historical time.

Both explanations—exfoliation of materials as "life-enhancing business" and as civilization out of control—find support in the fact that Spencer paints the soldiers in the Burghclere panels as little children. They are unable to cope with adult materials, objects that are as huge and inflated as they appear to children. This is a strand of Spencer's work that connects with the Hilda and Patricia paintings. *Love Letters* is filled by an enormous sofalike object, which proves to be an ordinary armchair in which Stanley and Hilda Spencer sit, the size of children, almost lost in its embrace. Hilda is returning to Stanley his love letters, which she had kept in her bosom. He was a very small, birdlike man (a fact he emphasizes in many paintings), but Hilda was also by this time dead, and his painting is commemorating the fact that he has been trying to recover her love— and her past—ever since his break with Preece, and that he has written her an unending series of letters uninterrupted by her death. This painting, in other words, shows another kind of resurrection, in either sense of the word, carried out in terms of unfolding letters. But the chair and the cascading pattern of letters also satisfy these children, making life bearable, in the same way that the routine of eating and washing made bearable the Great War to its soldiers.

In this sense, Spencer—though in many ways different—is an English painter of precisely the subject pursued by Constable in all his paintings. Both were concerned with English life as everyday routine, and in particular in a childhood, now lost, which in all sorts of ways the artist tries to recover.

Constable tried to retrieve it through landscapes reflecting his adult love for Maria Bicknell, as Spencer did through his various transformations of Hilda, and then of Patricia, and then again of Hilda.

Years ago, when I first saw Spencer's huge resurrection pictures in the Tate, I was overwhelmed by their imaginative boldness, their curious but interesting patterns, and their deep folk echoes. Only later (probably influenced by the School of Paris and its assumptions) was I bothered by their lack of concentration, their avoidance of painterly qualities. Just before the Spencer retrospective opened I took a last look at the Spencer room as it then was in the Tate. I walked around, becoming increasingly uneasy about Spencer's unconcern for paint, and then, passing into the next room—confronted by a Modigliani and several Bonnards—I found myself thinking: *This* is painting. Now I look back and wonder whether there isn't room for Spencer's art too, at least until it becomes too whimsical (as it does sometimes, as in *Love among the Natives*), in the manner of Roland Emett.

The comparison should be with German contemporaries: Emile Nolde, whose Christ altarpiece, which has a certain importance as a 20th-century Grünewald without Grünewald's finesse, and his other religious paintings (*Golden Calf*, for example, with its maenads dancing), are German equivalents of Spencer's mythical paintings of about the same time. Beckmann's triptychs of the 1930s and '40s (brought together at the Whitechapel Gallery, London, in 1980) do with greater assurance everything that Nolde was attempting in his altarpiece to bring Gothic altarpieces into the 20th century.[30] They find an idiom in which the grotesque world of Grünewald and Dürer and Cranach can be married to the southern tradition of classical art.

The mediator Beckmann found—undoubtedly because it was at hand in Berlin during the years he conceived and painted his first triptychs—was Luca Signorelli's *Pan* (destroyed in World War II), which joined heroic High Renaissance figures to strange allegorical concepts about poetry and philosophy and included figures (Pan himself) that were just on the edge of Gothic inwardness. *Pan* is reflected most obviously in the two borrowed male nudes of *Argonauts*, but also in the prone foreground figure of *The Temptation*, *Blindman's Buff*, and *The Beginning*, and in the crowded allegorical groupings of monumental figures in all of the triptychs.

The iconography is—or is made to sound in the Whitechapel catalogue, by Gert Schiff and others—both simpleminded and heavily pedantic. The triptychs themselves transcend pedantry by Beckmann's forms (from Picasso and Matisse) and his mastery of paint, and also by the nightmare observations that make the conventional imagery of Diana, Sheba, and Saint Anthony seem attempts at repression by secondary revision. The hallucinatory power is the same as Grünewald's decomposing, maggoty Christ on the Cross. For example, what Schiff identifies, in *The Departure*, as Eurydice carrying Orpheus out of the underworld (and she *is* holding a candle to light the way—though surely Orpheus

should be carrying her) conveys the more horrible memories of the ancient punishment of tying the victim to the body of a corpse and leaving him to die slowly. *The Departure*'s visual power depends on its evoking some of the most basic atrocity stories: the man with hands cut off, posed to recall the notorious Chinese photographs of extended torture (meditated on by Bataille and Julio Cortazar, among others); the torturer's raised weapon suggesting that castration is next, and the bound woman in a position to be sodomized. The central panel, in this context, is the myth that escapes from the reality of the side panels, literally in the boat and the figure whose head is crowned (for whatever reason—rather suggestive of an auto-da-fé, or a feast of fools).

Spencer was a contemporary of these artists, and he painted English versions of Nolde's and Beckmann's religious paintings, in his case going back to Giotto and primitive fresco painting, but with perhaps a dash of Paul Gauguin. I prefer Beckmann's painting, but when I read Schiff's (and sometimes Beckmann's own) account of what he is doing—and Beckmann's invocation of Blake in his 1938 lecture in London—I yearn for the poetic humility and intelligence of the English painter. But Spencer has no Grünewald behind him from whom to draw frightening images of the unconscious; he has only Dante Gabriel Rossetti and, farther back, Hogarth and Blake, tame and civilized figures by comparison. Bacon, in this respect, stands out as a European figure tapping the whole tradition from Grünewald to Goya to Beckmann.

JASPER JOHNS AND THE SECOND GENERATION OF "AMERICAN" PAINTING

Johns's Target

Unlike Claes Oldenburg, who, once he had found his manner, turned himself into a factory, Jasper Johns bravely went after a second manner and then a third. The context for Johns's phases was the memory of the Abstract Expressionists who only achieved a viable manner—or found an image or a form—in their 40s and, by suicide, accident, or natural causes, went no further (with the notable exception of Guston). And yet their suicides, accidents, and natural causes seemed the result of the insoluble dilemma of what to do next. To rest secure, artists in this century have been taught, is artistic suicide.

Johns was 28 when fame and fortune came with the notoriously successful exhibition of 1958. Though canny in matters pertaining to his reputation, he was also an extremely intelligent artist, and in the 1960s he cast himself adrift from the early inventions (while holding onto their iconography in his printmaking).

What he revealed in the paintings of his middle period, evidenced in the Whitney retrospective of 1977, was introspection, or, rather, an outward turning of the introspection one sensed in those tightly controlled early canvases.[1] The layers of newsprint and encaustic that made the targets and flags and number series into something like Freud's "mystic writing-pad" were replaced by an opposite openness, an overflowing of the canvas into added panels, dangling cups and wires, and other utensils; this, together with an attempt at monumentality, we associate less with Johns at his most individual than with his friend Rauschenberg. The canvases are literally projected outward, in a progression from the closed boxes containing casts of various body parts in the early target pictures to the later polyester body molds clamped to crisscrossed boards attached in turn to the canvas. They are personal and confessional, these objects and marks. And their heroes are the poet Hart Crane, with his death by water, and

the critic and poet Frank O'Hara, with his death near the water. The myth of *Out the Window Number 2* (1962), the "Diver" paintings (1962–1963), and *Periscope (Hart Crane)* (1963) is Narcissus looking at his own double in the water and diving after it. We are not surprised to find Johns's own face (as well as copies of his earlier works) attached to some canvases, and his handprints pressed into the wet paint of others.

The question of what Johns was up to was somewhat blurred by the attention to the narrow question of his reputation. Hilton Kramer, in the Sunday *New York Times* (18 December 1977), merely dismissed Johns as a creation of the critics; but Hughes in *Time* and Rosenberg in *The New Yorker,* in more sensitive critical appreciations, registered their reservations. The Whitney show, whose occasion was probably Johns's new departure in the crosshatching paintings (as he calls them), may have been premature. The viewer was left clutching at the hints and recapitulations of the most recent work, as if on the brink of the unknown (which eventually, a decade later, turned out to be the "Seasons" series). But there was also too much recapitulation of his own earlier work, too much making art of art (or personal reminiscence), when he had once made art out of everyday subjects: a suggestion of inward-turning exhaustion. Kramer's article was all the more irritating because its intemperance accreted around a kernel of truth. The fact manifest at the Whitney retrospective was an apparent falling off, an uncertainty and groping that followed those first amazing years—Johns's classical period—of the flags, alphabets, number series, and maps.[2]

The big Rauschenberg-like canvases culminated in a series of flagstone patterns. These have, inevitably, been connected to the flag paintings by a verbal pun on "flag." They carry metaphoric titles (*Wall Piece*—in three versions, 1968–1969—and *Harlem Light,* 1967); though since they seem to represent panels of linoleum, I suppose the word "wall" is doubly metaphoric—surrealistically dissociated from the object. But they are patterns that if executed by Rauschenberg would have been real flagstone linoleum attached to the canvas (as Rauschenberg would have attached a real flag); if by Lichtenstein or Warhol, reproduced by silkscreen or halftone (the difference lying in the size of the screen). Since they are by Johns, we expect them to be built up as a sculptural effect, made by himself with cut paper, and then freely painted over within this structure. But in the flagstone paintings he is reproducing the flagstones as if they were linoleum (as in the same years he took impressions from window screens and even his own hand and face, producing other Rauschenberg-like images). Only in the painted-out areas that sometimes appear does he indicate any more. Perhaps the flagstones were a continuation of the *objets trouvés* that run parallel to his painted surfaces. But he sacrificed the sense of palimpsest that is so important in his early paintings.

With *End Paper* (1972) he returned to this earlier mode, treating the flagstones as simply a structure in which to paint freely and atmospherically. But with a difference: The canvas is again intact, but the system is arbitrarily brought

to a close by the edge of the canvas and related in various ways to one or more panels (sometimes as a mirror). In effect, Johns moves from canvases that unify figure and ground in a single object (flag or target or window shade) to canvases that are *all* field, beginning with his alphabets and numbers but going on to more open patterns like flagstones. Beginning with the most ingenious solutions to the figure-ground problem, he moves on to the literal "ground" of flagstones. He might as well, however, have painted zebras or giraffes. But he wanted not something alive or moving but something dead, an inanimate sign.

The third distinct phase then employed modules of hatched lines, as if a single number or letter, instead of whole alphabets, had been repeated to cover the canvas. Some of these achieve a painterly richness at least equal to the flags and targets. I am sure this is because they return to the completely arbitrary and known sign that serves as an armature for the free play of Johns's paint. The issue is not the form but the intensity with which the artist invests it without sacrificing its recognizable and banal identity as sign. The hatchings have been compared by critics to everything from the stripes of the American flag paintings and the fingers of *Diver* (but there are usually only four) to a homage to Cézanne's brushwork or Picasso's shading of one of the faces in *Les Demoiselles d'Avignon*. Unlike the cascading paint in the works that preceded them, these patterns are no longer formless and self-revelatory. But unlike the flags and alphabets, they have no name or reference; they are only pattern.

In his natural casting about for a new manner, Johns proceeded in a way distinctly his own. The paintings of the 1960s and '70s contained bits of the old ones; they were more personal than the old partly because their alphabets and beer cans were no longer the public objects they were when he first used them but were by this time Johns objects, and his own recollections. If Johns was engaging in a "revolutionary art," there was a "revolutionary" gesture of painting a target or an American flag, followed by an "art of the revolution," that is, the recollection and celebration of the act. Or, put differently: Once successful and himself in the public domain, Johns became his own subject.

Initially, in the targets and flags, he was painting a representation of, in effect aestheticizing, the art (or, if you will, "revolution") of Pollock, de Kooning, and the rest. He was recalling their action painting within conventional armatures that disposed of the question of representation or of the personal gesture (whether it reflects the political activism of Orozco or of Picasso). In his more "classical" encaustic flags and targets of the late 1950s, he was recalling as well the preceding generation's use of superimpositions and palimpsest, of sexual imagery, of found and embedded objects, and of tripartite horizontal demarcations.

Some tentative conclusions: Johns's flags, alphabets, and numbers served as closed systems (the parameters of conventional signs) for the Abstract Expressionist disposition of field painting. As in the contemporary works of Rauschenberg, Johns carried on the Abstract Expressionists' privileging of the carpenter's construct. But, putting their emphasis back onto the Surrealist *objet trouvé*,

Jasper Johns, *Diver,* 1962, charcoal and pastel on paper. Collection of
Mr. and Mrs. Victor W. Ganz.

Johns, Rauschenberg, Warhol, and others of their generation replaced the
Jungian archetype (or totem) with the commonplace sign systems of American
culture. And in this sense they consciously contradicted—in effect counter-
revolutionized—the most basic assumption of the first generation, which was
dramatizing in its painting an assertion of freedom, whether public ("American")
or personal, from all such constructs. Instead, this second generation demon-
strated both the stultifying forms of American culture and their inherent beauty.
And the artist's freedom became the completely personal (idiosyncratic, coterie,
even coded) freedom in the use and metamorphosis of these stereotypes.[3]

Johns's work is a dialogue with itself and with Johns's career as an artist, and so
with his critics—above all with his critics. One reason for his reputation—the
feeling that he is a major American artist—is undoubtedly the excellent critical

writing that his work has elicited (by Leo Steinberg, Max Kozloff, Barbara Rose, Michael Crichton, and others). The reason for this attraction is the high level of intellectual content in Johns's paintings and sculptures, combined with his rich Abstract Expressionist handling of paint. The intellectual content is, moreover, *in* the paintings, not external to them, an addition of the critics. Nevertheless, Johns has been sufficiently the creation of his critics to raise questions about the relationship of the art object to the critic who writes about it. Almost every page of Crichton's Whitney catalogue is a reminder of the way Johns's own penchant for wordplay carries over into the criticism, which blurs the area where Johns's puns and metaphors end and the critic's begin.

Johns says, "My work feeds upon itself," and the critic passes beyond the obvious truth of the tenor of the remark to the intriguing vehicle, which he now sees materialized in the inclusion of eating utensils in the paintings. In 1964, Johns molds a pair of glasses with mouths for eyes (but with real glass for lenses) and casts it in metal. Then he adds (the word "adds" describes his own explanation of his process of composition) an inscription, "The Critic Sees." The critic, knowing Johns or knowing that he is from South Carolina, hears the inscription pronounced "The critic *Says*." The critic—thus verbally alerted, or carrying on in the spirit of the jest—then writes that the sculpture suggests a further verbalization: "Oh say can you see," which links it with the earlier flag paintings, and so with the critic's puzzled response to those paintings at their first showing in 1958, making it in effect an adjunct to the flags. Regarded in the perspective of "The Critic Sees," the flags become part of a continuum of perception. As, contrariwise, the bronze version of the flag elicits the verbalization: "The Stars and Stripes forever."

When you say that the road in Meindert Hobbema's *Avenue at Middelharnis* (National Gallery, London) "plunges" into the distance, you are merely trying to explain the sense of steep recession by a metaphor that imagines you "plunging" down that road. But to say of *Target with Four Faces* (1955) that these are "dismembered" faces, "multiplied" and "blinded," is to seek a verbal equivalent to the sense of four faces, their eyes "absent" or "cut off" by the upper edge of a row of boxes. Steinberg relates their "blindness" to the "bull's-eye" of the target below, discovering a possible metaphor explaining Johns's juxtaposition of faces and target. David Sylvester says the "absent eyes . . . give them the look of men blindfolded before a firing squad."[4]

I take my example from Steinberg because his essay is so perceptive and because he uses these metaphors heuristically, to test rather than argue an interpretation.[5] He sees "an uncanny inversion of values. With mindless inhumanity or indifference, the organic and the inorganic had been levelled." Notice the loaded relative clause, and the emphasis of the main clause on a *leveling*, not on a relationship or a parallel, of organic and inorganic. "Bull's-eye and blind faces—but juxtaposed as if by habit or accident, without any expressive intent." This sentence allows for both a disturbing human document and an exercise in

problem-solving by a "modern" artist who reduces all iconography to formal ar-
mature. But in fact the placement "without any expressive intent" is also part of
the sense of aggression in the words "blinded" and "multiplied," which are to be
taken as either the critic's power play with the painter or (more likely I think) the
critic's intuition of the painter's power play with his spectator.

We have to begin by asking whether the painting that elicited this commen-
tary is to be verbalized as a "target" (as its title would indicate) or as a "bull's-
eye," an unstated secondary sense. Are those casts in the compartments atop the
target to be called "faces," or—as I find after reading Steinberg—does one have
to see them as "eyeless" or "blinded faces"? "Blinded" suggests a much stronger
metaphor than "eyeless," with overtones of Cornwall and Gloucester in *King
Lear* rather than of mere omission, which is the observable fact (or one observ-
able fact). The act of aggression implied in "blinded" then carries over to the
other paintings also involving body fragments, verbalizing them as "dismem-
bered." Perhaps from the start we should have verbalized those faces more posi-
tively as "mouths" or "noses and mouths," were it not for the fact that the body
in the middle-period works *is* dismembered.

We are dealing with what Wittgenstein called drawing attention to an aspect
of a picture, which makes us see a particular configuration without denying the
existence of others. The aggressiveness of the artist is one such aspect, and the
subject of seeing or not seeing is another. For perception is the aspect Johns him-
self draws attention to in his sculptures of spectacles, light bulbs, and flashlights,
which are effectively glosses on the paintings. These images of illumination and
other aids to seeing are sculpted as if to help the critic or viewer with the paint-
ings they have not understood. But in the serial context of these sculptures, we
may see the paintings themselves as about perception, about the focusing of eyes
on a target or, in a different way, on a flag; or the focusing of ears on a music box
(in *Tango*, 1955).

In this case the critic has drawn our attention to an aspect the existence of
which is confirmed by the artist himself. But the critic may also find confirma-
tion for the feeling of the artist's aggression in the utensils Johns is offering the
myopic viewer. The critic may point to the accompanying passivity of the object
represented. Steinberg says of *Book* (1957), a book painted red with yellow edges,
that it is "a paralyzed book on a boxed frame." "Paralyzed" is a metaphor that is
not internal to that picture: "Inert" or "open" book perhaps, but "paralyzed" has
to be extrapolated from other paintings in a series that conveys "a sense of deso-
late waiting." "The face-to-the-wall canvas waits to be turned; the drawer waits to
be opened. The rigid flag—does it wait to be hoisted or recognized? Certainly
the targets wait to be shot at." The window shade "waits" to be raised. The
hanger waits to have clothes hung on it, letters to spell a word, numbers to make
a sum, and the book to have its page turned or to be read.[6]

The book could equally be described as having been pried open and covered
with paint (an aggressive act); as having been reduced (leveled) to the mere object

"book," with all its humanistic connotations eradicated. The artist could be said to have stripped it of all but its formal quality as parallel rectangles (or a compartmentalized rectangle). But not quite: because the bookishness of the object is still too insistent, as is the faceness of the casts in *Target with Four Faces*. One aspect, in short, is its *de*facement, and another may be its "waiting" for some kind of recovery or use.

No one, I think, has remarked that the window shade has no cord. The drawer cannot be opened or the canvas pried off (Kozloff's metaphor), which draws attention to the artist's act of fastening them down. Or they cannot be *used*, books and newspapers cannot be read or drawers opened (Rose's metaphor), which draws attention to the fact that they have been removed from an area of use to one purely aesthetic. But also involved is a sense of frustration in the viewer, who sees them as a book or window shade that, in the world he or she still occupies, is *meant* to be read or opened.

"Waiting" in these cases must be said to describe the viewer as well as the painting: the way you feel after standing in front of it waiting for its purpose or meaning to emerge. You wait, reading the paint (like the stains on a wall beloved of Leonardo and the Surrealists), and assisted by the presence of certain elementary peripheral signs. The indication of drawers or the outline of a window shade, the shape of a target and a row of heads or body parts, the word "THE," "TENNYSON," or "NOW" leads the viewer to search the paint surface.

When Johns employs oils, as in one of the target paintings of 1958 (or in *Painting with Ruler and "Gray"* of 1960), the surface is dull and flat, or mere impasto, and it looks like the work of any other painter. The flat effect is also emphasized by the absence of a high-finish varnish. Johns's more usual encaustic medium was essential to the effect he sought in those early canvases. The wax distinguishes his work; it is a signature medium. What it signifies is, first, a transparency—of a sort distinct from glazes but not unrelated to the sense of depth one feels in old master paintings—together with the sense of wear and tear. Second, it suggests the semitransparent layers of paint that partly reveal and partly conceal a palimpsest. For what is seen is the pattern of flag, target, or numbers built up out of newsprint and other paper cutouts, pieced together by trial and error, and, over this, freely painted layers of semitransparent wax paint, so that earlier layers seem to have been covered over but nevertheless retain their identity. The encaustic medium, virtually Johns's trademark in the early work, sums up the effect of defacement, waiting, and recovery.

These are, in one aspect, absurd titles and palimpsests, absurd clues that elicit nothing but the existential situation of waiting (possibly for Godot; Johns completed the allusion in his illustrations for Beckett's *Fizzles*, which consist of an inventory of his current motifs).[7] For in the early paint surface there is only "paint that denotes nothing but paint"; there are no hieroglyphs to make out, as there might have been in a Pollock or a de Kooning, and as there are in Johns's

later paintings, with their Pollock-like handprints and their swaths of emotionally charged paint that recall de Kooning. Insofar as there is a hieroglyph, it is the construct as a whole, or the palimpsest *as* palimpsest.

The encaustic also draws attention to the sculptural quality of the early paintings. Figure and ground are both cut out and pasted back together, and the figure is isolated by being built up out of multiple layers of paper, paint, or both. Most of Johns's paintings are constructed of two or more panels, and sometimes, when the work is in fact a single canvas, he simulates demarcations in it with paint. The effect is of painted low-relief sculpture, and it is assisted by the monochrome of many paintings, and by the concern with tonality and texture rather than with color relationships. It therefore seems natural for Johns to mold a flag in bronze or lead, or to render a toothbrush in three dimensions. His *Green Target* (1955) already builds up the paper ground to resemble papier-mâché. The shoe and toothbrush are given alternative interpretations in rounded sculpture and bas-relief; the slice of bread maintains its two-dimensional identity in colored bas-relief. One of the ways in which Johns (in common with many contemporary artists) plays with the borderline of representation and reality is to elide the distinction between painting and sculpture, but his intention is always paint based.

Johns asks that these early paintings be seen both as a superimposition of one layer on another and as part of a series. In his middle period he lets things dangle out of his closed spaces, which he apparently feels he must break out of (or must show that he can). The serial progression as "the artist's development" is from closure and shapes related to the shape of the canvas to "Kilroy was here" appendages that not only show he can protrude and obtrude but that offer much less guarded clues to himself as artist and as man. The tension is between Freud's "mystic writing-pad" (an analogy Kozloff picks up) and something not unlike Hockney's *Rake's Progress*. The Whitney exhibition of 1977 concluded with a momentary resolution—perhaps its raison d'être—as Johns returned to the intact canvas, from the empty flagstone patterns to systems of hatching or mismatched herringbone weaves intensely painted and brought arbitrarily to a close by the edge of a panel that is related in various ways to one or more other panels. Now signs are incised or burned into (rather than obtruded out of) the encaustic surface, but on the right side only, and the effect remains one of synchrony *and* palimpsest.

We have reached the point where we must say a word about intention. Johns is generous in his acknowledgment of how "the intention loosens" when the work leaves the artist:

> Then it's subject to all kinds of use and misuse and pun. Occasionally someone will see the work in a way that even changes its significance for the person who

made it; the work is no longer "intention" but the thing being seen and someone responding to it. They will see it in a way that makes you think, that is a possible way of seeing it.[8]

What he is saying, though, is only that an artist has a primary "intention" when he or she creates a work. The artist tries to make you see *this* aspect of the work, but the buck passes to the viewer, who responds, and makes the picture his or her own. Johns has omitted his own other "intentions," secondary or even unconscious, some of which he would acknowledge, perhaps even discover with the help of a critic; others he would deny to his dying day—and perhaps the stronger the denial, the closer the critic should look at these.

It is clear from his own statements that Johns's original intention in making most of his pictures in the 1950s was of the problem-solving variety. The artist-as-craftsman is speaking. But the excitement of the paint, and the sense the picture gives of "disturbing" (the word most often used by viewers, Crichton's catalogue essay, and the Whitney docents), tell us that perhaps we ought to look for another aspect, another intention, more in line with the mystic writing-pad.

The horizon of Johns's intentions is at least partly delimited by the art world of New York in the 1950s, where, while Abstract Expressionism reaped its rewards, Duchamp was showing work in his most Surrealist-erotic manner, Magritte was coming into vogue, and Rothko, Gottlieb, and Reinhardt were "Abstract Expressionists" who had begun in the Surrealist ambience. Johns's target may be a Dada sign or an arbitrary shape in which to use Abstract Expressionist brushwork, but in the juxtaposition of target and body casts it owes its inception to Surrealism.

To read Gaeton Picon's account of the Surrealists' "sleep experiments" is to recall Johns's explanation for his first flag painting: He dreamt of painting an American flag.[9] He explains his compositions as a Surrealist series of chances and accidents, and his frottage, grattage, and collage follow in the tradition of the Surrealist search for automatic writing. What those annual manifestos of Breton show is that Johns's use of the word makes best sense in relation to Surrealist assumptions about language. The Surrealist's aim was to free the word from the lexicographer and philologist, letting its context elicit "another meaning, . . . a hidden reality capable of adding a new dimension of meaning to man's perpetual self-questionings," as Picon says. A typical Surrealist strategy was to decorate the title page of a publication, *Signe*, with a picture of a *cygne*, a swan, which is thus "seen."

Johns came into contact with Magritte's work at the Sidney Janis Gallery exhibition "*Les Mots et les Choses*" of 1954, just as he was finding his own manner. One of the virtues of Harry Torcyzner's book on Magritte is that it relates the different versions of a motif, as if Magritte had hung all of his "Empire of Light" pictures together;[10] like Magritte, Johns constructs a personal pictorial vocabulary of his own motifs. But he most directly recalls Magritte in his early sculpture, the

didactic arm of his oeuvre, which has the same matter-of-fact commonplaceness of Magritte's sculpture. He sculpts his own paintings and invents sculptural equivalents of his painterly images; and he makes his paintings themselves sculptural in the modeling of the surface, producing a paint surface that somewhat resembles Magritte's *Souvenir de voyage* and other stone paintings.

Except in these adjunct works, however, Johns is probably closer than Magritte to the Surrealist employment of the word. The matter depends on whether the word serves as a terminus or a departure. Magritte, as Picon argues persuasively, uses words to prove a point, and his paintings rather resemble illustrations for a primer (he shares none of Johns's pleasure in a paint surface). *"Ceci n'est pas une pipe"* written on a painting of a pipe demonstrates something about the arbitrary nature of the relation between word, sign, and object. Johns' "THE" of 1957 (which may recall Duchamp's "The") or "TENNYSON" of 1958 or "NO" of 1961 is much closer to the Surrealist freeing of the word to mean through its context. His stenciled color-words are not merely another version of Magritte's pipe—"red" painted in blue—but suggest different senses of "red" when it is blue surrounded by pink, or somewhere on the way to being red. Magritte's work, as Picon has said, is "conceived as the answer to an entirely conceptualized problem," "an undertaking which consists rather in defining than imagining."

Duchamp was probably a stronger factor, especially in his work and exhibitions of the 1950s. Johns says he had a dream concerning Duchamp, and he included Duchamp's profile (from a catalogue of 1959) in *According to What* (1964), which pays homage to *Tu M'*. Duchamp ordinarily progresses through studies to one chef d'oeuvre, while Johns and Magritte both paint in terms of series. But the exception, significantly, is the series of readymades, erotic subjects, and copy drawings of Duchamp's last years, which all have their equivalents in Johns's middle period. Duchamp rather than Magritte introduces the peculiar sense of pun in an object that the artist displaces from its ordinary physical or logical context. Magritte's apple is an apple, his room a room; but Duchamp's urinal/fountain is a pun in the same sense as Johns's targets and flags, and his *Female Figleaf* and *Wedge of Chastity* (1950 and '54) represent a further stage in the development of punning that corresponds to Johns's *The Dutch Wives* (1975) and to the body molds and smears of the 1970s.

The other Duchamp concept evident in Johns's pronouncements is the artist's indifference. Duchamp explains that his choice of readymades "was based on a reaction of *visual indifference* with a total absence of good or bad taste . . . in fact, a complete anesthesia." The Surrealist use of collage, which in Breton's words exploits "the chance meeting of two remote realities on an unfamiliar plane," and "may be practiced by all with even the most limited means," can be interpreted as an act of extreme impersonality. (It can also, of course, be used for proletarian art, say along Constructivist lines.) Johns, whenever asked, claims that the objects he chose just happened to be within reach in his studio, and he

used them. But as Duchamp shows in his own principle of selection, this is in fact an indifference instinct with passion, which uses apparent accident to allow a deeper meaning to break through. In Johns's case, it is a pose of indifference that consciously fails to mask passion.

One of the hatched paintings, called *Corpse and Mirror* (1974), has been taken as an allusion to the Surrealist compositional game called "exquisite corpse," where a paper is folded and each Surrealist writes or draws on his own segment, unaware of what is on the others, after which the paper is unfolded. (The name comes from one poetic result, "The exquisite corpse will drink the new wine.") Johns claims to employ this principle, but his product is very different from the monsters of Dali, which could be an illustration for Horace's strictures in *De Arte Poetica*. Johns paints familiar objects as they are, from stencils or casts, and never reorders their shapes or essential designs. He does, however, employ the folded-paper principle. His emphasis is on compartmentalization as a demonstration of the Surrealists' incongruous juxtapositions. His canvases are *about* divisions, distinctions, and differences.

Thus his oxymorons of body parts plus targets, for example, are closer to Magritte's conscious placement of a gigantic apple in a tiny room, where it is the relationship that puts into question our assumptions about space or certainty, than they are to Dali. But when Magritte produces an exquisite-corpse shape in *Le Viol*, he himself is close to Dali, creating a transformation that exposes a latent sexual content: The head of a woman reveals her body map, with its equation of mouth and vagina. Oldenburg, another artist who emerged from the 1950s milieu, transforms familiar objects of the Johns variety into loose, baggy shapes that evoke body parts. He constructs his *Dormeyer Mixer* to resemble pendulous breasts (an appearance confirmed by his working sketches) and his *Soft Drainpipe* to resemble male genitalia. Tumescence and detumescence are the essential qualities Oldenburg isolates in an ice bag or lipstick. Johns, by contrast, merely follows Duchamp in employing casts of parts of the sexual object taken out of context—a male heel, nipple, or penis decipherable by relation to a series that includes fragments of hand and foot. In one case he presses the heated bronze cast of Duchamp's *Female Figleaf*, a mold of a vagina, into the surface of *No*, and then, eliding the primary negation of the female symbol, tells us what caused this puzzling hieroglyph. "It was something I had around the studio."

In *Corpse and Mirror* he takes the principle of exquisite corpse and joins it with "mirror" to produce his own version of the uncanny, a doubling that represents the return of the repressed as the faint imprint on the mirror side, barely visible through layers of encaustic. From *Liar* (1961) onward, mirroring has been essential to the Johns painting. The most obvious cases are the hatched paintings in which the right side carries the reflection with a difference: The image's left hand reaches out to take his right. The left side of *Corpse and Mirror* is painted in oil; the right, the mirror image, has a black oil-paint ground that has been pasted over with strips of newspaper to build up the hatching pattern, and

then painted over with encaustic to correspond to (or vary from) the pattern of the paper strips. The effect is an extraordinary sense of depth and refraction.

The repressed also returns through the repetition compulsion of the series, which recovers in one form or another the contents of past pictures. In the hatching-pattern diptychs the left side follows from the flags to the targets to the flagstones and hatchings; the right from the body parts or imprints of the artist's hand or penis to his screen window, broom, and "skin prints" to the imprinting of the *Female Figleaf* sort. The basic Johns strategy is to accompany wax casts of the most personal parts of a particular body with the most impersonal patterns and social signs. (When he does not use the body casts or impressions, he expresses his unease, or sense of difference, in the paint texture barely restrained within the impersonal pattern of flag or target.) He seeks out something as far as possible detached from a sign of self, but accompanies it with signs that are clearly doubles.

Doubling for Johns is a process of breaking up as well as of repeating or abstracting. The objects are always fragmented, uncanny in the Freudian sense

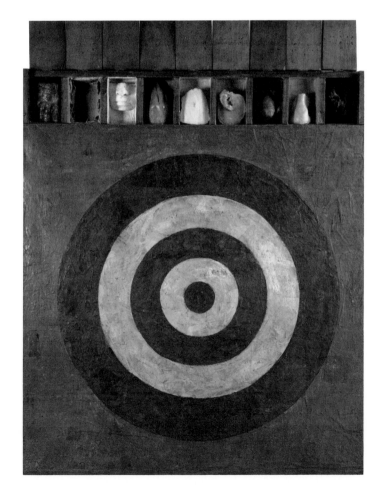

Jasper Johns, *Target with Plaster Casts,* 1955, encaustic and collage on canvas with objects. Collection of Mr. and Mrs. Leo Castelli. Copyright © Jasper Johns (Photo: Castelli Gallery).

("breaking up," as Breton said, ". . . what we do not wish to see broken up"). An early work, a drawing for his first published print, is called *Broken Target* (1958); it could have been called merely "unfinished." The bull's-eye is intact, but the target begins to come apart at the periphery, detaching the bull's-eye from its ground, leaving it floating loose.

The title also draws attention to an act of aggression, which redounds upon *Target with Four Faces* and *Target with Plaster Casts* (1955). Indeed, I think of Bacon's triptych "Crucifixions," those environments in which bodily harm is being done to one or more persons, when I look at the lath-work of *Untitled* (1972), with its attached body fragments. Johns's bolting of body parts to a crisscross of boards on a canvas stretcher may be yet another allusion to both the Artaud and Bacon sense of "Crucifixion." However much one would like to, one cannot explain these body parts as a solution to a formal problem, as objects that just happened to be lying around the studio.

Most of Johns's canvases of the 1960s and '70s are two (sometimes three) panels joined. *Painting with Ruler and "Gray"* is divided in two. In *In Memory of My Feelings—Frank O'Hara* (1961), an ostensibly personal canvas, the two vertical panels are held together by two—always two—actual hinges, and we cannot help noticing that in an apparently arbitrary fashion Johns has filled some of the holes with screws and left some empty, but the pairs are mirror images. And of course there are also two beer cans, and *Subway* (1965) is a pair of knees labeled (however) "HIS" and "HERS," on simulated separated panels. There is one shoe, not a pair, though the mirror in the toe reflects as Other the spectator in the gallery.

Doubling means that all one feels unworthy and guilty about is cast out and materialized in this Other, which, however, is a duplicate (with this difference), a quality repressed internally and expressed externally, exposed so that its illicit quality can be at once vicariously satisfied and punished. This is why critics feel the painter's aggression, which is a way of destroying the double. But the double is both a casting off of what one hates and wants to dissociate oneself from and an extension of self into a kind of permanence, what one wants to save. Johns goes considerably farther than the usual doubling that is any artist's painting. His particular kind of difference is retained in the relating of his own hands, skin, and body parts to the impersonal surface of flagstones or patterns of hatching.

Or to take another example, in *Liar* (1961), the word "LIAR" is seen backward and forward, one the impressor and the other the imprint. The first is therefore backward and upside down, the second the sign itself. But the point seems to be the masculine and feminine aspects of the doubling. The hinge, that connects the two LIARs, Steinberg verbalizes, "hinges" life and art: "Life's murky message is decoded by Art, and there it is, spelling LIAR."[11] But the point is also that the original becomes the mirror image, and not only is the status of the thing itself put in question, but two versions of an object, masculine and feminine, are hinged and reflect each other. (I think this mirror aspect is proba-

bly more important than the echo of the "All Greeks are liars" conundrum.) And
here we return to Duchamp's sense of the pun as "the coupling of two words
which are taken in two different senses," which is the ultimate, primary level of
doubling.

In the target pictures the interest of the body parts is counteracted by the in-
terest of the paint texture. In *Untitled* (1972), three of the four panels have be-
come almost purely decorative in the context of the right one, with its fragments
of flesh-colored polyester body molds bolted to a lath frame over a paint-smeared
canvas. Most striking is the Surrealist juxtaposition of hand, foot, black sock, and
floorboards—as if some visitor from outer space had wrenched up at random a
sample, floorboard and all. (John Collier's short story "Thus I Refute Beelzy"
comes to mind, and Magritte's boot and amputated foot.) There are parts of at
least two bodies. The canvas itself (as Crichton has seen) offers from right to left a
progressive abstraction from the pattern of similar-sized modules: body parts,
flagstones, hatching elements. This progressive abstraction continues in the se-
ries of drawings and prints that reduce the body casts to the merest outline, with
no formal resemblance at all, and so to the unrecognizable part labeled (in the
prints with the letters reversed) as a further distancing from their original, fleshly
sources.

In the paintings of hatching patterns the difference between the panels is
summed up in the circle and the clothes-iron, both incised or burned into the
wax surface of the right panel. The circle (imprinted as in cattle-branding,
Joseph Masheck has said) is clarified by the titles *The Dutch Wives* and *Weeping
Women* (1975).[12] "Dutch Wife" literally refers to a cylindrical bolster of about
five feet in length, used in the tropics: Clung to at night, it absorbs sweat. Meta-
phorically, this becomes one of those succedeneums known as *dames de voyage*
in France, sailor's brides in Germany, *azumagata* in Japan, merkins in England,
and love boards or whangus boards in America. They are as much a part of our
folklore—at least adolescent male folklore—as the American flag and targets.

But they become associated, in the context of the whole series of Johns's
paintings, including the skin smears, with stories of self-enclosure and jokes of
masturbatory devices upon which to displace the fear of the vagina; jokes of the
man replacing the woman with the complaisant androgynous machine, but also
of the man being devoured or destroyed by his passion for the gadget (for ex-
ample, shooting the friend he finds in bed with his love board) or being caught
and unable to extricate himself from its clutches. The iron is also the sign of a
wife or of domesticity, and in *Weeping Women* two irons are arranged, resem-
bling ready-made breasts, to complement the circle, and thus to simulate a
whole "woman."[13]

The circle is the significant motif. *The Dutch Wives* and *Weeping Women*
take us back to *No*, with its surface impressed with Duchamp's *Female Figleaf*,
related both to the O and to the denial in "NO," for the outline of the amputated
body part in Duchamp's piece is a circle, transected by the faint cleft (it is a

Jasper Johns, *The Dutch Wives*, 1975, encaustic and collage on canvas. Collection of the artist. Copyright © Jasper Johns (Photo: Castelli Gallery).

"figleaf" because a negative impression, which can be worn). And these take us back to the bull's-eye of *Target with Plaster Casts*, which has a Surrealistic-erotic aspect that relates to (rather than "levels with") the body parts boxed above it, representing, on one level, a scale of withdrawal from the real body to casts of body parts, and then to the focused (targeted) love board, which in this context can be either the denial of the female (vagina) or the affirmation of the male (anus). If the bull's-eye is eyeless, it is so in the castratory sense, with the displacement upward of the dismembered parts (including penis). In *Target with Four Faces* (the Museum of Modern Art version), we see those faces not as eyeless— eyes that are absent—but as mouths that are present, parallel to the target. Then follows the equation of mouth and eye in *The Critic Sees* and the key to the music box in *Tango*. "It takes two to tango," the verbalism Crichton thinks the painting evokes as one of a series about the viewer's perception and participation, finds a different meaning in the context of *The Dutch Wives*. The circle is a key without its musicbox (invisible, and, moreover, one that never worked), a reference to, among other things, truncation and amputation. We are in a comedy of mechanization, its juxtapositions always using the vital as an implied absence. The cast is a memory leading to the abstract sign of the target beneath. But we

are also in a long series of paintings made up of, and about, succedeneums, including those "devices"—rulers or pieces of board—for *making* circles.

The circle (or the target) is as distinct from the female principle as the two irons are from female breasts. Take *Painting with Two Balls* (1960), whose object of satire is both machismo and the devouring vagina. In this painting one can read passages of the newspaper collage, emerging into visibility through layers of encaustic. In the top panels the headlines are on foreign politics, and in panels two and three they are from the sports page ("School Track Title . . ."). The two balls, which happen to be golf balls, are related to the subjects of newspaper politics and sports (in *The News*, 1962, the balls are replaced by a folded newspaper). But the joke is that the male principle is engulfed by the female, which is a long narrow cleft. The penis, as in the later "Tantra" paintings, is lost and invisible within the cleft. The balls are detached, like the body parts that are always fragmented, uncanny in the Freudian sense. They are also a doubling as splitting,

Jasper Johns, *Painting with Two Balls*, 1960, encaustic and collage on canvas with objects. Collection of the artist. Copyright © Jasper Johns (Photo: Castelli Gallery).

like the canvases *broken* into two panels, the two beer cans, and the spectacles with two lenses.

When the personal Johns symbols are not cylindrical ale cans or Savarin cans, they are phallic brooms or multiple-phallic handprints given the function of sweeping in circular or semicircular directions. Rulers are for scraping circles, whereas balls are for propping or entering or stopping something up (in both senses of "stop"). A vocabulary of semicircles includes a "device" for paint-scraping, a color spectrum, and the arm motion of a swimmer doing a "breast" stroke. It is hardly so simple as a question of whether a circle is ordinarily a geometrical figure but becomes, for just one picture, metaphoric testicles or a loveboard; or has always been in some sense a male or surrogate female principle. In a single case, *The Dutch Wives* may be a sexual metaphor for Johns's persistent theme of the painting itself as a surrogate, a stand-in for reality, an artifact that represents something other than itself. We have to decide which is the tenor and which the vehicle, the aesthetic problem or the humanistic-personal one. But we always return to the fact that Johns does not, in any case, succeed in desensitizing the object, rendering Duchamp's *Female Figleaf* a mere roughly circular shape: The transecting line is too apparent.

Painting with Two Balls focuses the strong element of sexual joke in Johns's work—essentially a misogynist/homosexual joke involving the dismembered, detached, or substitute vagina, as well as the vagina that devours and the even more notorious vagina dentata that itself dismembers. These are the jokes on which Johns calls in his paintings, and I cannot help thinking they are not casual but essential. When Johns gave his target the centrality and painterliness we associate with the painting of the face, while giving faces the remote peripherality of casts, he was producing a graphic equivalent of the antinovel proposed and carried out by Alain Robbe-Grillet and others in the 1950s, which attempted to replace the humanist-oriented novel of tradition with a thing-centered fiction. But Johns's message is antihuman in an even more basic and disturbing sense, for it goes beyond the Surrealist convention to the negation of sexual reproduction, displaced to "devices" of masturbation or jokes of enclosure, entrapment, and castration. His doubling joins human names and words ("scene," "corpse," "wife," "weeping," "face," "buttocks") to mere strips of lath, or to unrecognizable contour lines or patterns of hatching.

We can say that Johns begins with two patterns, the flag and the target: The first gives him an allover field with a Mondrian-like pattern of vertical and horizontal lines, if also with the variety of the stars; and the second replaces this with direction to the center, toward one point of attention—though broken and dispersed by the periphery or by the row of boxes at the top of the canvas. Thereafter, Johns's return to compositions that are much closer to de Kooning's major

canvases is a significant choice; and significantly, they begin with his Crane canvases.

Periscope (Hart Crane), which in its print form is called *Hatteras*, alludes by its title to Crane's *The Bridge* (the section called "Cape Hatteras"), and to the lines:

> . . . time clears
> Our lenses, lifts a focus, resurrects
> A periscope to glimpse what joys or pain
> Our eyes can share or answer—then deflects
> Us, shunting to a labyrinth submersed
> Where each sees only his dim past reversed. . . .
>
> But that star-glistered salver of infinity,
> The circle, blind crucible of endless space,
> Is sluiced by motion,—subjugated never.
> Adam and Adam's answer in the forest
> Left Hesperus mirrored in the lucid pool.

The "device circle" has become a periscope, in both its circular lens and its circular path of enclosing movement. But it is an enclosure that is "sluiced" or cut through, as the artist's armprint sluices the circle it scrapes or creates. The passage is an image of Narcissus resurrecting himself out of his embraced image, transformed into an Eve now called Adam, who sees his own image reflected in the pool and who joins it, leaving only the evening star reflected in its surface. The painting also plays with the Narcissus myth, projecting the human through the search for the double into death: the myth Crane lived out in his dive into the Gulf of Mexico.

Crane's poetry may be used as a gloss on the series of paintings beginning with *Out the Window* of 1959, which established the pattern of three vertical panels, with "RED," "YELLOW," and "BLUE" inscribed on them. The title presumably refers to the lines separating the panels, recalling panes of glass. The words represent a schematic view of what we see "out the window," as the view from Magritte's windows merge with adjacent paintings of them. This demarcation continues in *Painting with Two Balls*, which can be seen as another view "out the window." Then, in 1962, *Out the Window Number 2* changes the sense of "out the window" from looking out to falling or jumping out: The sill is raised to the upper third, marked by a horizontal line of wire holding a spoon, over which pours an avalanche of dark paint, down into and over the word "BLUE" (reinforced by an additional, larger *B*).

The "Diver" paintings and drawings are of about the same time, with a pair of boards making a V at the bottom (mirror image); handprints appended at top and bottom; and arrows pointing downward to the lower set of hands, which

Jasper Johns, *Periscope (Hart Crane),* 1963, oil on canvas. Collection of the artist.
Copyright © Jasper Johns (Photo: Castelli Gallery).

scoop a semicircle in the paint or charcoal, downward and outward, in the motion of a swimmer's breaststroke in water.

In *Periscope*, where the "diving" has been given its full significance, the arrow reappears in the lower right, pointing down. The downward gesture connects *Periscope* and the "Diver" pictures with *In Memory of My Feelings—Frank O'Hara*, in which a dangling fork and spoon make a downward semicircular scratch in the paint, and with *Good-Time Charley* (1961), in which the circle being scraped stops at, or is stopped by, a down-turned cup; the gesture is of incompletion in the arc and rejection in the cup ("don't refill my cup"), and is related to the dangling "NO" with *Female Figleaf*. Cups are other circular devices that dangle from the bottom of canvases; in the domestic *Fool's House* the inside bottom is painted the color of coffee grounds, and in *Zone* (both 1962) it is turned into a bloody hole. (Patches of blood red, approaching the shape of a wound or bullet hole, appear in the diving pictures leading into *Periscope*, as if to augment the death by drowning.)

As the circle-scraping in *Good-Time Charley* is stopped by the downturned cup, in *Watchman* (1964) the board scraping the wet paint in a line of closure across the bottom of the canvas is stopped by a ball. I am not satisfied with Johns's explanation that the title of the "Watchman" pictures comes from his meditation (probably an after-the-fact, Duchampian rationalization) that "the watchman falls 'into' the 'trap' of looking," or with the contrast of the "watchman" with some hypothetical "spy," or with Crichton's idea that the title may have been inspired by the absence of a watchman when Johns's beach house in South Carolina burned. For what it is worth, the Crane passage I have quoted is immediately preceded by a reference to "whisperings of far watches on the main." Watchmen certainly have to do with the continuing Johns theme of perception. But to someone in New York at the time Johns was working out his first artistic problems in the 1950s, with the Surrealist ethos still part of his equipment, "watchman" would have suggested one thing: "Watchman, what of the night," a reference first to the chapter by that name in Djuna Barnes's *Nightwood*, and then to *Isaiah* 21:11.

The New Directions edition of *Nightwood*, with its T. S. Eliot encomium and with the lapidary style of Barnes's writing, was very much a cult object of that time. The watchman is Dr. Matthew-mighty-grain-of-salt-Dante-O'Connor, who is consulted in his bed at 3 A.M. by the protagonist, Nora, whose lesbian lover has deserted her. The room is full of broken objects and in utter disarray, and the doctor is dressed in drag. Nora asks him "to tell me everything you know about the night." "As she spoke, she wondered why she was so dismayed to have come upon the doctor at the hour when he had evacuated custom and gone back into his dress": that is, at the hour when one assumes the role of one's double. "He dresses to lie beside himself, who is so constructed that love, for him, can be only something special; in a room that giving back evidence of his occupancy, is

Jasper Johns, *Out the Window Number 2,* 1962, oil on canvas with objects. Collection of the artist. Copyright © Jasper Johns (Photo: Castelli Gallery).

as mauled as the last agony." The doctor tells her "how the day and the night are related by their division. The very constitution of twilight is a fabulous reconstruction of fear, fear bottom-out and wrong side up. Every day is thought upon and calculated, but the night is not premeditated." The "division" is in the horizontal panels of Johns's painting—the left, night (dark, blackish), and the right, day (with miniature red, yellow, and blue panels)—and in the dark line scraped

through black paint across the bottom. The "bottom-out" is the upside-down fragment of a nude (male or androgynous, possibly a night watchman)[14] sitting in a chair; in *According to What* (1964), this fragment becomes "wrong side up" or inside-out, balanced by a reversed canvas.

My point is that these gnomic utterances from esoteric, coterie, gay-lesbian books of the 1950s give us explanations that tally with the signs within the pictures:

> Though some go into the night as a spoon breaks easy water, others go head foremost against a new contrivance.

> Is the hand, the face, the foot, the same face and hand and foot seen by the sun? For now the hand lies in a shadow; its beauties and its deformities are in a smoke—there is a sickle of doubt across the cheek bone thrown by the hat's brim, so there is half a face to be peered back into speculation.

> A European gets out of bed with a disorder that holds the balance. The layers of his deed can be traced back to the last leaf [that is, on the bedsheet] and the good slug be found creeping. *L'Écho de Paris* and his bed sheets were run off the same press. One may read in both the travail life has had with him—he reeks with the essential wit necessary to the 'sale' of both editions, night edition and day.

These passages illuminate the series of "Diver" pictures, the painting *Untitled* with its body fragments (including the bit of mouth, chin, and cheek), and the skin prints and charcoal smears: At the heart of night, as Dr. O'Connor reiterates, is the primal bed (which was also one of the first symbols created by Johns's roommate and mentor, Rauschenberg). Those body smears of *Skin I* and *II* (both 1973) are literally bed traces (the loins of a male body in profile rolling forward, impressing the genitals in one and the buttocks in the other, and over to the other side), as are the face smears—just as the outlines of body parts that follow are the outlines the police draw around a body after a murder to mark the exact position of the "corpse." I do not mean to suggest that Johns is illustrating any literary text, but only that writers of the Barnes and Crane ambience (as well as artists like Magritte and Duchamp) help to explain the signs attached to the big empty canvases of the middle period, and the underground content that is emergent.

And so what the drawn shade refers to is the room where "unspeakable acts" (the "love that dares not speak its name," etc.) take place. The eyes that are mouths, the glasses and toothbrush, take on similar significance. The sexual reference, begun with the authority of Surrealism, progresses from Pollock's vagina to the target, which, insofar as it is vaginal, is reductive in the extreme, but is more clearly anal; and at length to the whangus board or sailor's wife. At the same time, the ambiguous but clearly feminine shapes of de Kooning are carried by Johns to polyethylene references to male/female/androgynous anatomy.

Now we can return to *The Dutch Wives:* a surrogate vagina, a hole in a board, an anus—all both surrogate vaginas *and* replacements. The term "Dutch wife" carries the negative (ironic) charge of a poor substitute. The comment is *on* the female symbols: A woman has been *reduced* to a whangus board, or, in *Weeping Women*, to an imprint of an iron and circles from a tin can. These are signs of the woman's domestic role, but also of her body parts—and again, the circles suggest (here) breasts but also, in the context of the other paintings of the time, the Dutch wife, the poor substitute for a vagina, and the anus, the actual alternative.

Some revisions of our preliminary conclusions are now in order: Johns's earliest paintings are only ostensibly public and conventional signs. They are in fact still constructed, like Rothko's and Pollock's, around a totem, whose significance is both public and personal. The target—the eye—and then the eye, periscope, and flashlight (all to be found in Crane's "Cape Hatteras"), are circular devices for seeing or vision, either physical or spiritual. But they have also, in a different code, a sexual reference.

To focus, as Johns does, on the anus is either (as in the case of a satirist like Swift) to show "the world turned upside down," or to make a claim for male homosexual relations. The "message" of the artist projected by the target paintings is thus that procreation is not through the vagina but the anus, and the result is not a baby but a work of art like this one. The act is one of collaboration not between man and woman but between two men—in the abstract, between any two men who share an experience of love, but perhaps more specifically in the case of the target paintings, between two artists as interdependent as Johns and Rauschenberg. The material result (as Freud noted) is feces—or feces-as-paint, or, literally in Johns's targets, as wax that is put into molds and comes out as exact replicas of male body parts (in one version, parts that include a penis, in another a series of repeated male mouths).[15] These objects (somewhere between artworks and "babies") are then stored in little boxes in a row above the central totem of the target. Anal sex is therefore, according to this myth, the "artist's" version of vaginal sex.

The Johns image of the 1950s and '60s was not especially aggressive as a gay statement considering the imagery of the Abstract Expressionists, or indeed of a large part of the Western tradition of art, with its heterosexually charged nudes and landscapes. But it *was* clearly a corrective to the heterosexual tradition, and so to the previous macho generation of Abstract Expressionists; and in that sense public. It was coded; and while it was bold, jokey, and coterie in its allusions, it also conveyed a revisionist message in its playing of anus against vagina, the one with a positive, the other with a negative charge. Rather than hostility one senses ambivalence in, for example, the equation of whangus board and anus; but also a willingness or eagerness to accept the associations of its own mode of love with pain, sadomasochism, even death.

Postscript, 1989

The major development since the Whitney exhibition (except for the continued, enormous, and subtle elaboration of the earlier motifs) has been the major paintings "The Seasons" (finished in 1986), an attempt at enclosed monumentality in a set of four. The number recalls the traditional set of the Four Seasons, but their size recalls an altarpiece (or a Baconian triptych), and the central feature that critics have remarked is the allusion to Grünewald's Isenheim Altarpiece, and in particular to the leprous foreground figure in *The Temptation of Saint Anthony*. Jill Johnston has published a whole essay in *Art in America* on this figure, trying to decipher its significance.[16] She pursues Johns at lunches and elsewhere, demanding to know and receiving only evasive and ironic replies. The article ends as puzzled as it began. The answer is so obvious that it hardly even needs stating, as I am sure Johns realized: The figure alludes to the AIDS "plague."

Although the deep purple tones we associate with Johns's later work began to appear as early as 1976, modifying the pale whites and primary colors of the crosshatches, in the 1980s they dominate his palette. They are especially prominent in the "Seasons." *In the Studio* (1982) covers the familiar dangling arm with what Mark Rosenthal in the most recent Johns catalogue sees as a recollection of the flagstone pattern,[17] but whatever its source within Johns's work, it appears as blotches, makes the arm look diseased, and the predominating color recalls the purplish lesions of Kaposi's sarcoma. In *Perilous Night* (1982), which emphasizes the purple tonality, the arms reappear and the colors are reduced to flesh color and the bluish mottling. *Perilous Night* also introduces a reference to Grünewald's Isenheim Altarpiece, this time to the soldier in *The Resurrection*. The title refers to music by Johns's friend John Cage, which itself refers to a fairy tale called "The Perilous *Bed*," about a bed resting on "a floor of polished *jasper*"; but "Perious *Night*" recalls the line in "The Star-Spangled Banner," enfolding both memories of Johns's flag paintings and survival in "the dawn's early light." In the context of 1982, the notion of resurrection in both the Grünewald and the "Star-Spangled Banner" allusion applies.

The facts are these: By 1980 the plethora of diseases suffered by bathhouse patrons—venereal disease, hepatitis, and enteric diseases ("gay bowel syndrome")—had become part of the gay life-style. The bathhouses and clubs had names like Glory Hole or Cornhole, not unassociated with the imagery of Johns's earlier targets.[18] The interchangeable images of skull and male genitals (the skull's eyes and nose sockets correspond to graffiti drawings of a male sexual organ) had already appeared in the 1973 *Reality and Paradoxes* portfolio, but the equation was made explicit in *Tantric Detail* (1980); and in a number of paintings after 1983, leading up to the "Seasons," the skull becomes part of an Alpine danger sign, warning of avalanches (though it has also been identified in a photo Johns had of the pope at Auschwitz).

There is no evidence as to when Johns became aware of the AIDS phenomenon, but by the end of December 1981 Robert Chelsey was writing in *New York Native* that alarmists about the "gay cancer" were proclaiming that "the wages of gay sin is death."[19] The first major stories in *Time* and *Newsweek* also appeared in late December 1981. The epidemic was referred to in the press at this time as the "gay plague." The attempts of art historians to explain Grünewald's remarkable imagery in the Isenheim Altarpiece have included the speculation that it was intended for a hospital for venereal disease or plague victims: The horrific image of Christ's body could be thus explained, and the bloated figure in *The Temptation of Saint Anthony*. The latter is easily recalled by a typical description of an AIDS case: "With his once-handsome face completely disfigured by the Kaposi's lesions and his body swollen by medications, Simon had taken on the appearance of the bloated and scarred Elephant Man."[20]

We see Johns on one level continuing the coded imagery of his earlier paintings; on another tapping into the main tradition of the Western iconography of *vanitas*, the memento mori, and the Ages of Man, but doing so by way of one of the anomalies of that tradition, Grünewald's Isenheim Altarpiece, and probably also of Artaud's thesis that art, "like the plague," "has been created to drain abscesses collectively." The earlier paintings, with their associations of love and death, also derive in a sense from the traditions of the *petit mort* in love poems and from the existentialist one of death in life, life in death, and "life" in art (a tradition witnessed for Johns's generation by Eliot's *Waste Land*, which by the end of the 1970s was being interpreted by some as a homoerotic elegy for Jean Verdenal).

One has to see these recent paintings in the context of the 1970s "revolution" of gay men who pushed experience to its limits, and so analogously of the gay artist (Johns, Rauschenberg, and Warhol, to name only the most prominent). In general, the "revolutionary" aspect applied to "closeted" men who were finally demonstrating their liberty through extreme promiscuity—as in the leftist Toronto paper that referred to "rimming as a revolutionary act."[21] By the end of the 1970s the revolution had reached to political and social matters, to representation in government and the passage of laws.

Johns said in 1978, "In my early work I tried to hide my personality, my psychological state, my emotions. This was partly due to my feelings about myself and partly due to my feelings about painting at the time." At least as he presents it, this was his (metaphoric) "closet" phase. The outside world was both the social and the painterly world of the Abstract Expressionists. "Finally," he goes on, "one must simply drop the reserve. I think some of the changes in my work relate to that."[22] The last refers to the let-it-all-hang-out paintings of the 1977 Whitney exhibition.

Serial Painting

Johns in particular dramatizes both the artist's problem of what to do next and the gallery's ability to present the artist's work as a series (and to maintain it as such in its catalogue, after the exhibition has closed). His series are *about* the variations between familiar elements, but primarily *about* his own "progress." Thus we sense the unnaturalness of the pink in *Barber Tree* (1975), as one critic has proposed, "simply because Johns has never employed it": because of the power of the serial aspect of his oeuvre. The painting called *Newspaper* (1957) uses the unit of the total outspread newspaper (as *Book* does of a book or *Flag* of a flag), and in terms of one series it draws upon all the broken, fragmented newspapers in other paintings (including the flags); in terms of another it takes its place among the total flags and targets. Johns never repeats paintings as replicas but only as variations, which shade off into differences of media as he turns them into drawings (as well as being sometimes *from* drawings) and prints. These, initially at least, seem less reproductions or commercial products than self-exploration.

The reworking of the artist's own earlier images as an aesthetic connects Johns not only with Duchamp but with Bacon, who was beginning his self-repetitions in the 1960s just as Johns launched into his. But Bacon's example forces us to distinguish between his first phase, in which he sought a variety of types—Screaming Pope, Swinging Ape, Walking Van Gogh—and the subsequent phase in which he repeated these in a lighter palette with variations. Bacon's words to Sylvester apply only to the first: They show that one thing at stake was the tension between the ideal of the one perfect image (in the manner of Rothko, Newman, and the Surrealist ethos) and the practical efficacy of seriality.

To understand the importance of serial composition in relation to Surrealism it is necessary only to think of a single enterprise like Marcel Jean's Surrealist image, a zippered-eyed, leather-covered, film-collared head, and then to imagine a dozen of these in different colors and materials. Or to imagine a single Bacon Screaming Pope, or one Johns flag. The variations are what define the "painting."

In Bacon's case, as he makes clear (in this respect echoing the intentions of Rothko and other Abstract Expressionists who also derived from the Surrealists), it is originally an effort to get the most telling image, which leads to a series of attempts, essays. His aim, he tells Sylvester, is "to paint *the one picture* which will annihilate all the other ones, to concentrate everything into one painting," whereas in reality

> in the series one picture reflects on the other continuously and sometimes they're better in series than they are separately because, unfortunately, I've never yet been able to make *the one image that sums up all the others*. So one image *against* the other seems to be able to say the thing more. (My italics.)

Bacon's ideal would be a gallery: "Ideally, I'd like to paint rooms of pictures with different subject-matter but treated serially. I see rooms full of paintings; they just fall in like slides. I can daydream all day long and see rooms full of paintings."[23] To him this may mean simply the importance of a *series* of Screaming Popes; and this series is not like Picasso's variations on Velázquez's *Las Meninas*, the elaborate play on a well-known work: First, it is the trial sketches toward a finished work that never appears, and so is replaced by the sketches—the gestures, the process, rather than the product; and second, it draws attention to the obsessive quality of the works, the touch of madness (encouraged by the stories of Bacon's induced hallucinations).

But there is a second approach to Bacon's series: Even before he needed pictures to fill out a "show," he had begun to paint diptychs and triptychs from the model of the altarpiece (ultimately, in all probability, the Isenheim Altarpiece).

In premodern art the serial aspect was evident, primarily, in studio repetitions, the copies made by assistants for a wide range of clients. The modern sense of it connects only in a secondary way with studio repetitions: In an economic sense, one could argue, that is all Johns and Bacon are producing, but in an aesthetic sense their series derive from the sequences of drawings or studies that culminated in the Raphael *Stanze*, Géricault's *Raft of the "Medusa,"* or Duchamp's *Bride Stripped Bare*; the only difference being in the increasing autonomy or self-sufficiency of the "studies." Not the *Raft of the "Medusa"* but Géricault's paintings of dismembered heads or arms, or Rembrandt's self-portraits, lead into Bacon's paintings.

With the advent of modern art, however, the series of Monet's haystacks or cathedrals (or, to use Bacon's own example, sunsets) indicate wherein the work of act actually *consists*: not in any one master machine but in the series; as if the work of art—or the real world—could only be captured in the multiplicity of aspects, the different times of day, different lighting effects, on the same object, or different sides or perspectives of the object. This is a concept already present in painting before the French Revolution, signifying the fact that the artist has moved from a world of ideal or universal forms out into the real world of innumerable particular objects. This is, perhaps, a sense of change that was given particular force by the experience of the French Revolution and by Blake's addition of *Experience* to *Innocence*, followed by the cyclic implications of his *America*, made specific in *Ahania*, *Vala*, and *Milton*; above all, followed in Spain by Goya's immense series of "Caprichos," "Disparates," and "Desastres de la guerra."[24]

What begins to emerge in 1793–1794, prophesied by Burke as a loss of faith in a single, stable, traditional entity, but developed as a thesis of history by Blake, was the movement from the idea of a unique, new occurrence, irreversible change, a continuation of the empiricists' idea of Progress, to that of post–French Revolutionary history as repetition or return: the deep, basic ambiguity in

the word "revolution," with its interlocking, old and new meaning of circularity.

If the first aspect of the breakdown into series was the despair of any longer making the one right image, the second was the disillusionment with progress. The French Revolution—as a whole, from 1793 to 1815—affected (or effected) a model for seriality insofar as it created a certain characteristic kind of progression, and showed that a phenomenon does not simply happen, uniquely and in a single definite stage (like the English Revolution of 1688 or the American of 1776), but goes through a series of stages, which appear (in retrospect, looking back, for example, at the Civil War of 1642–1660) prescribed and predictable. And these may or may not be regarded as "progress."

The breakdown into series, with an uncertain or negative sense of progression, meant in art the loss of faith in the hierarchy of genres and in the one definitive picture (the Academy piece), which could then be copied but not appreciably modified by studio assistants, on the one hand, and by the artist's subsequent work, on the other. In other words, the revolution heralded the change from belief in the static work as product to the process itself, of painting as of politics. Thus the subject was something off center or heterogeneous—Géricault's dismembered heads and arms, or Monet's haystacks *and* his cathedrals.

Of course, in a general way, we can say that the extension of rationalism combines with empiricism to make the obsessive series, which replaces the definitive image. And by the time Johns and Bacon are making their series, their attitude is affected by Freud's reflections on obsessive repetition in *Beyond the Pleasure Principle*. In the past, the structure—the order or progression or arrangement—was determined by rules of decorum and custom. Now the order is only one that reflects the mind of the maker: obsessive, as with Goya's series, or in our time with Bacon's or Johns's.

Johns's popular, commonplace sign (and usually object) is followed by his representation of it, followed by his representation of *that*—perhaps in a different medium or with variations, or only a piece of it incorporated into a design of other earlier motifs by Johns—and so on. Johns is initially saying: Invention does not matter. The artist merely establishes a design of *some* kind, it hardly matters what—a beer can or even a decorative linoleum pattern—and then works variations on sameness and difference in the manner of the complex variations that musicians may work on the most trivial ditty.

If we recall that doubling is the first stage of seriality for Johns, then perhaps seriality is his mask for the process that really concerns him, something he does not finally wish to acknowledge.

Given the symbolism we have discussed of the target/whangus board, however, Johns's seriality makes a case for textual as contrasted with biological procreation. After the first contact with the most commonplace conventional signs, filiation derives exclusively out of the artist himself. (There is the occasional intruder, like the almost subliminal images from Grünewald, or the reversible

faces from old parlor tricks.) In a larger symbolic sense, the fertile gendered cou-
pling of the sort that Pollock and de Kooning celebrate in their different ways is
consciously—programmatically—replaced by one or another form of par-
thenogenesis. The target and body parts may have begun as a response to the
machismo, the homophobic rhetoric, of the Cold War generation of artists as
well as of its politicians and diplomats. The form taken is the repetition, and the
product is the endless series: in Johns's case, of replicas with variations of his own
earlier motifs and often whole designs.

For Johns perfected a mode that was at bottom antithetical to the assump-
tions of Pollock, Rothko, de Kooning, and the New York School. Only Krasner
incorporated into her canvases pieces of her earlier paintings, but they were
used, in the manner of de Kooning's collage work, to obtain radically *new* forms,
and were, as *her* paintings, unrecognizable. Johns's own paintings, when he re-
used them, were as much public property as the earlier targets had been, in an-
other sense.

Pollock, de Kooning & Co. produced variations on a breakthrough, a re-
definition of artistic conventions of painting, or a particular image of their own
creation (Rothko's rectangles, Newman's vertical line). These were explorations
of possibilities aimed at the one perfect image or at a further (in revolutionary
terms) breakthrough or (in Protestant-American terms) conversion. Sometimes
the result became theme-and-variations, but the ground motif thereby demon-
strated its staying power and capacity for endless elaboration. Of the obvious
cases, de Kooning's "Women" and Rothko's rectangles are what Bacon would
have called armatures on which to work out all sorts of formal and coloristic
problems. Only Motherwell's "Spanish Elegies" and "Doors" can be said to have
been genuine theme-and-variation series. And here too we would have to distin-
guish between the exploration and the refinement of the series (or system, as it
comes to be).

Closest to the Abstract Expressionists in spirit were Diebenkorn's "variations
on a theme labelled Ocean Park" (in Gosling's words).[25] As a series, the Ocean
Park paintings are simply numbered consecutively. Somewhat beside the point
was the *New York Times* remark that "Diebenkorn here invites comparison with
such grand-scale enterprises of the past as the series (now in the Louvre) which
Rubens painted for Marie de Medici and the decorations which Mantegna made
for the Duke of Gonzaga in Mantua."[26] The difference is precisely that his series
is not closed but open-ended, now numbering somewhere in the hundreds.

As a student, Diebenkorn was assigned by Park, his teacher, a sequence of
drawings modeled on Wallace Stevens's "Thirteen Ways of Looking at a Black-
bird," a quintessential modern version of serial writing, and also open-ended. A
way of looking at Diebenkorn's seriality is thus to see each painting as "a different
variation or restatement of the theme (the internal subject) of the work—a theme
that in its nominal aspect is external to the work, borrowed from reality [the

ocean view, the blackbird], but that in its more essential poetic aspect is internal to the work, subsisting in its imaginative structure of (verbal) materials."[27] The series takes the object that is originally in the external world and bases its variation on the internal, absorbed object of the first rendering, *Ocean Park No. 1*. Thus the paintings begin with an external object, not the Ocean Park of the series' title, but a California seashore, seen from within the artist's studio; and carry on based on the initial internalized object—that of "No. 1," or, in reality, of Diebenkorn's earlier representational paintings of landscape seen from inside a room.

The question, in Edward Said's words, echoing Marx's, is "does repetition enhance or degrade a fact?"[28] I believe these artists, had they been asked, would have regarded repetition as a debasement, specifically recalling Marx's attack, in *The Eighteenth Brumaire of Louis Bonaparte*, on the Hegelian view of an event's repetition as a strengthening and confirmation of its value. Marx's well-known formulation was that historical events repeat themselves first as tragedy (which is of course a term Rothko applied to his paintings) and then as farce, as in a photograph of a painting, or a pedestrian exact copy of a painting. The Abstract Expressionists would have agreed with Marx that repetition shows nature being reduced from the level of natural fact to the level of copying, counterfeit, imitation, mimicry, and forgery. They were enough men of their times that their assumption was still Marx's clarion call, "*Alles, was besteht, ist wert, dass es zugrunde geht*" (All that exists deserves to be swept away), whether it applied to art or politics. Their assumptions followed from (for example) Mondrian's devotion to seriality as the search for a solution to a formal problem; like a syllogism, one's oeuvre is not complete without the first step. Mondrian's squares cannot be appreciated except in relation to, as following from, his rich but less original ginger pots and trees and plusses (in which the signs of precursors remain).

Thus from the point of view of the New York School, the generation represented by Johns, Rauschenberg, and Warhol would appear to validate Marx's claim about Bonaparte: The pretended son turns into the exposed nephew. I think this would be unfair to Johns, but it tells us something of the *next* generation, the artists who followed upon his successful career. In general, the open-ended series without an obvious beginning or end, simply different versions or variations, has become a popular mode. "All contemporary usage of serial imagery, whether in painting or sculpture, is without either first or last members," writes John Coplans; or they are like "a pack of cards, in which every card is the ace of spades; all cards are of equal value and all imprinted with the same emblem, which may or may not vary in size, color or position."[29] The authority cited is Monet's 7 views of the Gare Saint-Lazare, 15 Haystacks and 20 Poplars, and 20 Rouen Cathedrals; Alexei von Jawlensky's landscape variations, Josef Albers's Homages to the Square, and Warhol's Marilyn Monroes. These are cases in which we would have to distinguish between the importance of different

lighting, different times of day, different views of the same subject—and an ob-
sessive repetition based on the changing feeling of the painter (as perhaps in
Bacon's case).[30]

The artists of the second generation followed their own version of the "final
image" into various forms of Minimalism. In practice, this amounted to a turn-
ing of felt images into conceptualized images, often more satisfying in the verbal
description of the intention than in the presence of the actual, rather tame and
decorative object. Like late de Koonings, these paintings play with and reduce
the idea of Abstract Expressionism, or perhaps only return to Matisse's final color
concerns. Like the slash paintings of Lucio Fontana in Italy, these signify the art-
historical ultimate, which must be seen as the end of a series with a purpose/
problem to solve. In the earlier, first-generation sense of ultimate, the artist
moves beyond and out of the ordinary conceptual range altogether. Rothko and
Pollock create forms that seem more than merely an ultimate in the historical
sense, an ultimate that can be reasoned out (as Samuel Johnson said, like count-
ing to ten), as with a slash or a hole in the canvas, or a white or a black canvas.

The second generation proclaims its secondariness. In their blend of figura-
tion (which by now meant reference to something other than the paint itself) and
abstraction, the artists of the second generation used as readymades everything
from comic strips to American flags and the alphabet—but no longer, as with de
Kooning, repressing their original forms, turning figure into abstraction. Johns
hovers between the generations. After Johns, the target becomes for Kenneth
Noland a purely decorative circle, or (in his own terms) Minimal art, without
any of Johns's sinister aura.

Looking at the great expanse of Pollock's and de Kooning's accomplishment,
one is struck by the fact that compared with their boldly original and erratic
forms, the different approaches that emerged between Johns and Lichtenstein,
or, in abstraction, between Johns and Noland or Kelly, were not only extremely
intellectualized but clearly avoided risk. The forms of the later artists' work were
determined and delimited (at the least, tested) by good taste; Johns's and Lichten-
stein's alphabets and comic strip panels were determined by convention (salted
with irony), Noland's and Kelly's abstractions by standards of elegance. The
powerful element of chance that de Kooning interjected in his formal play, that
even Morris Louis relied upon in letting streams of paint streak down his canvas,
was relegated to detail in the work of Johns. Within these ironic but timid forms,
seen in this perspective, Johns produced a safe version of de Kooning. When he
did not use the armature of a flag or a map or an alphabet, he tended to paint
decorative patterns, which of course alluded to wallpaper or linoleum, perhaps
even to kitchens or bathrooms. Compared to de Kooning's bold launching out,
there is a distinct lack of vitality in the works of his epigones. Rauschenberg's act
of erasing a de Kooning drawing is to de Kooning's own erasures as academic
criticism is to the original work on which it feeds.

This book began with revolution and counterrevolution (or postrevolution)

and the problem of acting and representing revolution. In America, this took the specific shape of the two generations, the revolutionary and the postrevolutionary: the colonists who carried out the revolution and (in this case, many of the same people) those who established the retrospect on it (in the light of the French Revolution); and later, the generation of the Abstract Expressionists and the postgeneration of Warhol, Johns, Rauschenberg, Kelly, Noland, and so on.

To conclude my reductio of the revolutionary metaphor, we can mark a progression from Liberty and Equality to Fraternity. Liberty was embodied in the "revolutionary" gesture or action painting, and the return to representation, the counterrevolution, was equally libertarian. The "popular" base of the first generation in the size and brushwork of mural art was followed by Equality in the commercial, advertising, conventional reproduction of Pop art. Equality then was followed by Fraternity in the sense that art became more specifically than ever before *about* art, and artists became involved only with other "artists." Furthermore, close artist-dealer networks developed, sometimes simultaneous with the art, sometimes subsequent, but always present.

The most striking aspect of Fraternity, however, was the emergence of closed networks, like the closed systems of serial painting, most prominently gay networks, to a symbolic and commercial prominence in the 1960s and '70s. It will be noticed that of the two generations, the first (corresponding to the initial generation of revolutionary actors) was strongly heterosexual, symbolically and apparently in reality—in imagery and in act. The second was symbolically, if not predominantly, homosexual, producing (as the example of Johns shows) a hermetic, misogynist, and gay iconography consisting of a "representation" or repetition or aestheticizing of the *acts* of the first-generation artists, and leading to representation as "representation" for its own sake (picture of pictures, parodies or "exact" copies). In short, a revolutionary art became the art of (representing) the revolution.[31]

Survivals of Figure Painting

The tradition of modern art, ending in Pop, Op, Minimal, and "Postmodern" Art, was not merely the logical progression into purity but plainly the "end" or "death" of something.[32] In this ambience, one logical form that figurative art took was to copy old master paintings and either produce variations in the forms (as Picasso had done with *Las Meninas*), treat them as if they were further images of Pop art, or follow Johns by making variations within the known forms, by the lay of brushwork, texture, and paint. Larry Rivers painted in de Kooning's manner themes and variations on Rembrandt's *Syndics* as it appeared reproduced on a cigar box—and on another popular image, *Washington Crossing the Delaware*.

Some "made a statement" about elitist or merely conventional art by

parodies like Peter Saul's rubbery versions of Rembrandt's *Night Watch* or of a de Kooning "Woman," turning even a de Kooning into a Disney-like monster. These works transfer the style of Red Grooms or Robert Crumb from contemporary Manhattan—where it presumably approximates the perception of a beleaguered contemporary—to the inside of an art gallery. John Clem Clark painted American colonial images, a comfortable furry or velvety pattern of colors (produced by painting on an unprimed canvas) cutting abstractly against the figurative or iconic pattern of the Copley or Trumbull, which either makes enjoyable the thoughts of what can be done to an "American" icon, or only reminds us of those pillowcase or hot-plate reproductions of patriotic scenes that are on sale in Washington, D.C., and elsewhere. In the case of Mel Ramos's sexy, sleazy airbrushed nudes out of Varga or Petty, the echo of Velázquez's *Venus* or Manet's *Olympia* makes a joke that does not survive the distance from the pages of *Esquire*.

An occasional piece like Rivers's *Dutch Masters* and *Napoleon (The Greatest Homosexual)* repays the viewer's examination on the wall: You explore the painting's surface to see why the cutouts appear where they do and what effect their three-dimensionality has on the impact of the picture. You question the title and recognize first the copy of David's portrait and then, with the title, the Johns-like reference to the great length of Bonaparte's penis, the inference Rivers makes in his title from the familiar pose of hand-in-vest.

As Balthus's example showed, figurative artists no longer live in a time of shared myths and historical truths, and therefore they have to resort (as Blake did, or William Butler Yeats or Hart Crane) to private mythologies of their own creation, which emerge gradually out of the continuity of many individual canvases. Balthus consciously links himself with "history" by painting on a scale and in a style that recalls the great "machines" of the history-painting genre; he is often the mediating force, having shown (via Derain and Surrealism) as far back as the 1930s how to carry on the figural tradition—replacing Christianity with mystery, personal myth, sexual myth. The Americans paint on a similar scale, though more likely with the precedent of the "heroic" Abstract Expressionist paintings in their minds. In its own way, Johns's work represents another "myth for our times."

But something more than this can be said: Artists painting figures in the 1970s and '80s—and above all their audience—no longer had innocent eyes. Not only did they look at these supposedly disinterested figure paintings with eyes attuned to Abstract Expressionism but, and to an even greater degree, when they produced direct representations of rooms, artist's models, and simple kitchen utensils they remained within the pictorial framework of Surrealism, sharing its peculiar expectations.

Perhaps for all of these reasons figuration was a subject that artists practicing it felt they must explain. In a society in which art has come to be associated to a certain extent with abstraction, this is not strange. William Bailey's assertion that

it is a revolutionary act to break with the doctrine of the unity of picture plane/ canvas would seem to be the implicit subject of his remarkable paintings of table-tops and nudes. But in a painting by Jack Beal or Alex Katz it is the imminence of the figure and its coincidence with—virtual annihilation of—the picture plane that we are most aware of: Huge looming bodies or gigantic faces are brought up very close to the canvas surface. Physical contact with these figures is in its own way like the sheer presence of the paint employed by Pollock or de Kooning. Philip Pearlstein's details of rock faces and close-ups of nude models operate in the same way, as do Thiebaud's bird's-eye views of city blocks and Rackstraw Downes's of freeway systems, or Neil Welliver's huge intricate masses of color-by-the-numbers foliage.

The figurative painters who quietly went their own way during the heyday of the Abstract Expressionists nevertheless worked very much under the shadow of those painters. Louisa Mattiasdottir, for example, carried on the observed world of Hopper, but with her broad heavy strokes of paint she turned it into a formal pattern based on Cubist principles.

At an exhibition like the one called "Artists' Choice Museum, Inc." of 1979, all a spectator could do was play the game of "Find the source." Lennart Anderson's *Portrait of Barbara A.* and Milet Andrejevic's *Toward Bethesda Fountain* reflected both Balthus's portrait and his landscape modes. Paul Georges's *Fantasy about Freedom III* was a striking painting that simply made more representational, via Goya I would say (with a Goya electric blue sky), Matisse's *Dancers* in the Hermitage; Lester Johnson's *Street Scene: People Walking No. 6* joined the heads from a Marsh street scene to the tubular bodies and monumental scale of some Léger compositions, with a dash of Duchamp's *Nude Descending;* Alfred Leslie produced a contemporary version of Wright of Derby's candlelit *Experiment on a Bird in the Air Pump;* and Sidney Goodman returned to the forms and textures of Curry's regional painting of the 1930s. In short, these painters joined representation to the forms of Fauvism, Abstract Expressionism, social realism, or whatever, with an expected audience of art historians who would recognize the irony of the application. Yvonne Jacquette's *Flatiron Intersection* was a blowup of a László Moholy-Nagy photograph of a Paris street seen from above, and Aristodemos Kaldis's *White, White, a Greek Metaphysical White* was an adaptation of early Kandinsky. Among the best were Bailey's *Manfroni Still Life,* with its beautiful Giorgio Morandi-like cups and pitchers, and Leland Bell's *Morning*—with a Bacon reclining man and a strange, monumental, clearly surreal female nude (recalling Ernst) about to dive out of the picture space.

Beal's *fortitude (The Shrivers)* was a faint, ironed-out version of an Ivan Le Lorrain Albright portrait. Albright and Edwin Dickinson, figurative artists of the 1930s who influenced the artists now dominating figurative art, especially Beal and Anderson, painted within an American tradition of Surrealism but used microscopically close-up images that pressed against the picture plane and covered the canvas. It is quite possible to regard (as some art historians have) Albright's

detailed representation of the contents of a dresser drawer spread out across the canvas as a representational version of a Tobey, a Krasner, or a Pollock.

Take the example of Katz. Katz represents the extension of Abstract Expressionism from the Mexican or WPA mural (presumably by way of Warhol and Pop art) to the model of the billboard. The idea is built on the possibility of a huge blowup of a snapshot face or head or torso, to be used as a given form or structure, thus getting the problem of representation out of the way at the outset and allowing something else space to work in. Looked at in another way, however, Katz might be said to do with the face and body what Hopper did with the house or room. He simply moves the figure up so close that it becomes the room and he can devote himself to large abstract relationships. One fine picture, *Night* (1976), is made of shades of brown, and does for face, head, and shoulders (and background room) what Hopper did for landscape and cityscape. There is even some attention to texture here.

Night is exceptional. Katz does not ordinarily paint freely—as, say, Johns improvises and paints once he has escaped the problem of representation. Katz keeps revealing his origin in the Pop art movement by the use of photographs and the rendering of amateur portraits. Some of his work closely resembles in sophistication the sidewalk portraits of Greenwich Village and the convention of the smiling, happy, friendly face that hides nothing. (That face can also be seen in Lichtenstein's comic strip blowups, but there the comic strip's linearity and the halftone are explicitly imitated). The idea might be to make the commonplace monumental—that is, apparently important. But there is too much evidence (to judge by his pencil sketches) that Katz is only expanding his own limited way of making portraits. Size is the way he makes his portraits important; the analogy is Kline blowing up his faintly ideogrammatic figures into six- or eight-foot canvases.

Although indulging in representation, Katz says he wants to avoid content of any sort, and his explanation contains all the key terms:

> I like my painting to deal mostly with appearance. *Style and appearance* are the things that I'm more concerned about than what something means. I'd like to have *style* take the place of content, or the *style* be the content. It doesn't have to be beefed up by meaning. In fact, I prefer to be *emptied of meaning, emptied of content*. (my italics added)[33]

On the other hand, his rationale for the size of his canvases is not from art—from the Abstract Expressionists—but from the figurative argument that it should be the scale it has in life. This may explain boats and cattle but hardly the human face or body, which in Katz's canvases is many times its normal size.

In *Pamela and Perry* (1977), the photo fact of Perry's nose cut off by Pam's cheek derives from an accident rather than a conscious choice—though the cutoff takes on emphasis, draws the whole attention, and becomes the nexus of the composition, and so faintly comic. These paintings, with all their size, lack

the monumentality of Balthus (which in some ways they resemble) as well as the mysterious depths of Hopper.

While American artists like Bailey, Katz, and Pearlstein insist that their art reflects only formal concerns (they paint studio models, still lifes, and portraits), they also admit that the objects or figures they paint do "express something peculiar about" the artist himself, perhaps beyond his control. One of their idols is J.-A.-D. Ingres, as Bailey says, because he seems "to arrive at mystery" through the clarity of his paintings. A figurative painter seeking clarity of form or a close approximation of the spatial relations of objects within view, with nothing to go by but formal criteria or the appearance of the objects, may well arrive at mystery. That artist has simply employed another way of releasing his or her unconscious—and the spectator's. "Mystery" is the key word, suggesting that the figurative painter representing concrete reality achieves this quality even without seeking it; that, like its name, figuration has to be concerned with otherness, and so can survive without a myth of *some* sort. It may be as private as Balthus's or as coterie as Johns's, or perhaps even unconscious, and so in a special way mysterious.

Bailey says of the utensils he represents on his carefully observed tabletops, "My appropriation of these objects reflects formal concerns, with an expressive intention but not necessarily having to do with expressing anything that's peculiar to the objects themselves. More likely," he adds, however, "they express something peculiar about me." That, of course, is the case—and also the case of the viewer who has grown up with old kitchen tables and certain too familiar objects. Bailey's are, as he tells us, "the kinds of things that I've always had around me, the kinds of objects I like. They are things that I look at out of the corner of my eye, whether in the kitchen or some other place in the house"— and he adds that therefore they are "convenient." But it is precisely the homeliness and the glance "out of the corner of my eye" that evokes the sense of the uncanny in some of these paintings; and once we sense this, the truncated and empty objects evoke Magritte's use of similar forms in a more blatantly sexual way to invoke the return of the repressed.

Bailey fits in a way with the Johns generation, not only in terms of his age (he and Johns were both born in 1930) but because his still lifes of eggs and simple utensils, the most geometrical or formal objects, impose the same constraint as Johns's alphabets—for example, rules of formal balance, which he does not violate (as de Kooning never hesitates to do). But he has also the constraint of a realistic representation of colors, textures, and space; and with these elements, his freedom to arrange or space objects on a table introduces the other strand of Surrealism based on the perspective box.

Bailey's tables and objects are different from Morandi's otherwise similar paintings because Morandi leaves the traces of his brushwork and seems only concerned with formal variations and intervals. (He is another serial artist.) Bailey wants as well to represent the "truth" of color, tone, and space *as seen*, and this thrusts his paintings into competition with the illusionistic spaces and

objects of the Surrealists. His account of the painting of a nude called *Portrait of S* (1980) stresses the problem when he describes the trouble he went to "to keep that white thing that she's wearing—which I wanted to make into a kind of nightdress—from being merely drapery." That nightdress is precisely what makes one think of a Magritte or a Balthus looking at the picture: The viewer is aware of the V of the pulled-down garment; its detail, the convincing rendering, makes one wonder about its being pulled down in so forceful a way, as to reveal precisely that horizontal fold of stomach above the navel and below the breasts; and this problematic part of the picture is equaled by the blank expression of the face, which may relate to the feeling of exposure generated by the pulling down of the nightdress (perhaps as opposed to *up*).

Pearlstein, a portraitist as well as a painter of nude models, says he deliberately tries "not to be expressive about the models" he paints: "not to make any kind of comment but just to work at the formal problems of representational painting in relation to picture structure." He is clear-sighted enough to see the problem:

> But even though I try to remain objective, it looks as though I'm concerned about the people. I know that the paintings disturb a lot of people who insist on reading something into them. I guess if I looked at them as an outsider, I would begin to see disturbing things in them, too.

Pearlstein's intention may not correspond to the effect of the painting. He claims he is trying to bring objectivity to bear on these figures; and so he begins by establishing "some compositional scheme that would be interesting" (essentially cropping) and goes on from there. "I just paint them as carefully as I can, the features of the face, the expressions of the face while they are sitting there." To avoid the expression of boredom, he gives his sitters a small TV to watch; for his models he plays records, giving them something "to focus on without getting in the way" and avoiding conversation. "I do know the models as people," he adds, "but I'm not concerned with saying anything about them in the paintings other than that they are reasonably intelligent."

Pearlstein gives himself away, however, when he turns to his landscapes and admits that he painted only ruins (as he paints only close-ups of nude models):

> I won't do the landscape unless there's a ruin out there. I've wondered about that as a subject matter, and why I keep coming back to ruins. I think that in some way it's tied up with my exposure to the Roman ruins during the years I spent in Italy during the war. And probably there's something emotional or poetic on a subconscious level operating there that I admit to.

—And he adds, "much more than there is with my use of models." And so when he turned to figures he also moved in close, cutting them off at the picture edge and making them in a metaphoric way into geologic surfaces and truncated

"ruins." If his ruins are references back to his war years in Italy, his models, he feels, refer back to "the sort of experience I had with art back in my high school years"—a reference he leaves tantalizingly unexplained, but that must refer to an adolescent's experience of a life class. Perhaps we carry away with us some sense of the high school artist's interest in newly experienced parts of the female anatomy; or perhaps we sense a distant echo of Magritte's truncated bodies and the anxiety they are intended to carry.

One result may be a private mythology of the sort Balthus probably began with (in *Mitsou*, when he was 12) and then rationalized and elaborated through the doctrines of Surrealism and the Bataille circle. "Figurative" in the larger sense of metaphoric enters with the painter's choice of subject. It may even enter with the elevation of form: A painter influenced by Abstract Expressionism chooses a subject that can be flattened out on the canvas surface and cut off at its extremity to emphasize form. If this is (as with Pearlstein) a female nude, it may unconsciously focus on certain body parts or recall Magritte's truncated bodies and the anxiety they convey; it certainly continues the myth of the female developed equally, though in divergent ways, by Balthus and de Kooning.

The "modern" way of dealing with figurative art began with the decline of "history painting," the highest genre on the scale of artistic achievement, which depicted humans in heroic action. Bailey is echoing painters from Caravaggio to Hogarth to Géricault and Courbet when he says: "If I had lived in a time of shared myths and historical truths, as painters did in the past, I might have had reason to compose groups of figures instead of bowls and jars on a tabletop." In his case, he feels that his interest has to be focused "upon an individual presence that I can begin to understand and believe in." Other painters, however, attempt knowingly to create a viable subject painting for their own time. Beal's words are unambiguous: responding to a Hilton Kramerism "to the effect that meaningful subject matter never saved a bad picture," he says, "As far as I'm concerned if a painting doesn't have meaningful subject matter it's a bad picture to begin with." Here Surrealism seems to be no longer an issue. Beal's early Dickinson-like *Nude with Patterned Panel* and *Portrait of the Doyles*, with their slanting diagonals and claustrophobic space, though excuses for pattern, in fact create a tension between pattern and disarranged furniture and project the question of why the nude got into that position behind all of that Dickinsonian debris. *Still Life with Self-Portrait* is a close-up of a tabletop that strongly recalls Albright—as do the details of many of Beal's more recent paintings.

But even here Surrealism seems to remain the pictorial framework in which artists—or their viewers—see. Beal paints a modern-history version of Titian's *Danaë*. It has the illusionistic texture of Albright in the skin and bedclothes, and the model's middle-aged and unattractive body recalls not only Titian's idealized Venus but Balthus's antithetical young girls and Courbet's authority for painting the unidealized woman. The extreme emphasis on diagonals and the close attention to the pattern and color of fabrics (the looming shape of a sofa or the

invariably mussed form of a rug or blanket) evoke memories of Dickinson's interiors. Then Beal's title, *Danaë*, takes the representation off into the category of "modern history painting" and the use of a myth to raise or lower contemporary experience.

The result, however, is more Surrealist than heroic or even, in Beal's terms, "meaningful." The painting's effect depends precisely on its various elements canceling out meaning while leaving unease. This is best seen in his strange Caravaggesque groups (specifically recalling the Caravaggesque Neapolitan Gaspare Traversi) of lunging and looming figures called *Prudence, Avarice, Lust, Justice, Anger*—and *Hope, Faith, Charity*. The effect of the image relies on the candlelight mode, the emphatic chiaroscuro, the "photographic" realism of the faces and bodies, the violent movements still largely based on diagonals—*and*, hardly least, the title, which forces us to look at each face, from left to right, with the allegorical names before us. Sure enough, that one *is* Hope; and that one reading the Bible must be Faith; and the one with her hand held out is of course Charity. But then can the seated dog be Faith—he is directly under the man who is Faith—or is he Charity? These paintings equally disorient the viewer with their distortions of the figures, who seem to be suffering from ague (though the source of the problem is obviously the model of Mannerist painting), and with the disjunction of the extreme particularity of figures and the generality of the title (almost as Magritte accompanied his painting of a pipe with the inscription *"Ceci n'est pas une pipe"*).

Other paintings by Beal, still huge in scale, depict labor, have general titles like *Harvest*, and recall Courbet scenes repainted by one of the Nazarenes. These are intended to extol the dignity of simple gardening; they might be read as mock heroic. But Beal himself comes closer to their effect when he says, "The most affecting paintings that are being made are paintings that will embarrass other people." Embarrassment, he feels, is the only emotion left given the overkill of movies and TV: "By embarrassment I mean that the painter is touching on such private emotions that the person recognizes the feeling in him or herself and feels uncomfortable because of them." "Embarrassment," replacing "mystery," is his version of the uneasy feeling one has before the carefully objective figuration of a Balthus or a Bailey, a Pearlstein or an Anderson—more exaggeratedly an Eric Fischl (for its candor) and a David Salle (for its awkward painting). Our eyes—like the painter's brush—see and register some things in an Abstract Expressionist way and, presented with a perspective box scene (however distorted), other things in a Surrealist way.

NOTES

Preface

1. Arthur Danto, *State of the Art* (New York, 1987), p. 8. All subsequent quotations of Danto are from the same work.

2. Fairfield Porter, *Art in Its Own Terms: Selected Criticism 1935–1975*, ed. Rackstraw Downes (New York, 1979), p. 28.

One. Revolution and Counterrevolution

1. This chapter was originally delivered, under this title, for various celebrations of the revolutionary year 1789. It was developed from thoughts in two earlier essays: "Versions of a Human Sublime," *New Literary History* 16 (1984–1985), 427–437, and "Revolution and the Visual Arts," *Revolution in History*, ed. Roy Porter and Mikulas Teich (Cambridge, 1986), pp. 240–260.

2. Cited by Lynn Hunt, "The Political Psychology of Revolutionary Caricatures," in *French Caricature and the French Revolution, 1789–1799*, ed. James Cuno (Los Angeles, 1988), p. 3.

3. François Furet, *Interpreting the French Revolution*, trans. Elborg Forster (Cambridge, 1981).

4. See E. J. Hobsbawm, "Revolution," in Porter and Teich, *Revolution in History*, p. 10.

5. Leon Trotsky, in *Leon Trotsky on Literature and Art*, ed. Paul N. Siegel (New York, 1970), p. 112. Italics added.

6. Trotsky, "Literature and Revolution," in *Leon Trotsky*, ed. Siegel, p. 60.

7. Trotsky, "Art and Politics in Our Epoch," *Partisan Review* (August–September 1938), in *Leon Trotsky*, ed. Siegel, pp. 104, 117.

8. Morse Peckham, *Man's Rage for Chaos: Biology, Behavior and the Arts* (New York, 1967), p. 41.

9. T. E. Hulme, "Romanticism and Classicism" (1924), in *Critiques and Essays in Criticism, 1920–1928*, ed. R. W. Stallman (New York, 1949), pp. 3–4.

10. See Ronald Paulson, *Breaking and Remaking: Aesthetic Practice in England, 1700–1820* (New Brunswick, 1989), chapter 1.

11. Abbé Le Blanc, *Letters on the English and French Nations* (Dublin, 1747), 1:163.

12. Mona Ozouf, *Festivals and the French Revolution*, trans. Alan Sheridan (Cambridge, Mass., 1988).

13. For which, see *French Caricature and the French Revolution*, ed. Cuno.

14. Edmund Burke, *Reflections on the Revolution in France* (1791), ed. William B. Todd (New York, 1959), p. 93.

15. Michel Melot, "Caricature and the Revolution: The Situation in France," in *French Caricature and the French Revolution*, ed. Cuno, p. 26.

16. Karl Griewank, quoted in Hobsbawm, *"Revolution,"* p. 9.

17. Ernst Gombrich, Freud Lecture, delivered at Yale University, Fall 1979 (so far as I know, unpublished).

18. The same laugh was elicited by what I find the one powerful piece of graphic humor produced by the French Revolution. This is an anonymous etching that shows Robespierre guillotining the executioner: The *last* man. The people of France have been replaced by machines—the numberless guillotines that fill up the picture space, with, now, its virtual absence of humans. But there are two other implications: First, the central symbol of this clean, sharp break with the past—with the ancien régime, with the monarch's head, with *any* head, with *all* heads—is the guillotine blade, which sums up so much. And second, the elegant pattern, the neoclassical *form*, made by the shapes of all the columnlike guillotines (intersecting the pyramidal tomb), shows how, even here, *in* the Terror, the artist, at the same moment that he attacks, *aestheticizes* the fact of the Terror.

19. See Gary Shapiro, "From the Sublime to the Political," in *New Literary History* 16 (Winter 1984–1985), 213–235; and my "Versions of a Human Sublime," pp. 431–432.

20. Jean Charlot, foreword to Eva Cockcroft, John Webber, and James Cockcroft, *Toward a People's Art: The Contemporary Mural Movement* (New York, 1980). This section of my book originally appeared as "Representations of Revolution" in *Bennington Review* no. 2 (1978), 62–74. (Hereafter cited as *BR*.)

21. José Clemente Orozco, quoted in Cockcroft, Webber, and Cockcroft, *Toward a People's Art*, p. 238.

22. Carlos Pellicer, *Mural Paintings of the Mexican Revolution, 1921–1960* (Mexico City, n.d.), pp. 38–41. See also Antonio Roderiguez, *Arte murale nel Messico* (originally *Der Mensch in Flammen*, Dresden, 1967; Milan, n.d.).

23. Pellicer, *Mural Paintings*.

24. As Charlot notes, they were reacting against the formalism of Cubism and yet "Parisian Cubism remains at the core of our murals" (Cockcroft, Webber, and Cockcroft, *Toward a People's Art*, p. xvii).

25. Danto, *State of the Art*, p. 190.

26. Robert C. Williams, *Artist in Revolution: Portraits of the Russian Avant-Garde, 1904–1925* (Bloomington, Ind., 1977), p. vii. See also John E. Bowlt, *Russian Art and the Avant-Garde: Theory and Criticism 1902–1934* (New York, 1976).

27. See George Rickey, *Constructivism: Origins and Evolution* (New York, 1967); Stephanie Barron and Maurice Tuchman, eds., *The Avant-Garde in Russia 1910–30*

(Cambridge, Mass., 1980); and Christina Lodder, *Russian Constructivism* (New Haven, 1984).

28. Harold Rosenberg, "Metaphysical Feelings in Modern Art," *Critical Inquiry* 2 (1975), 224–225.

29. Trotsky, in *Leon Trotsky*, ed. Siegel, p. 109.

30. Ibid.

31. See James H. Billington, *The Icon and the Axe* (New York, 1970), pp. 36–37.

32. Mary Wollstonecraft, *An Historical and Moral View of the Origin and Progress of the French Revolution* (London, 1794), pp. 106, 142. The material of this section I first explored in a review of Irma Jaffe's *John Trumbull* in *Georgia Review* 30 (1976), 460–467, and then in a much longer essay, "John Trumbull and the Representation of the American Revolution," *Studies in Romanticism* 21 (1982), 341–356. Anyone interested in the full annotation should consult that essay.

33. *Works of the Right Honourable Edmund Burke* (London, 1777–1784), 2: 462, 460 ("Speech on Conciliation with America"); 32 ("Letter to the Sheriffs of Bristol").

34. Revere's engraving was probably stolen from a design by John Singleton Copley's half-brother Henry Pelham (who also issued it as a print).

35. Kenneth Clark, *Looking at Pictures* (London, 1960), p. 127.

36. Joan Dolmetsch, *Rebellion and Reconciliation: Satirical Prints on the Revolution at Williamsburg* (Williamsburg, 1976), no. 23 and p. 7.

37. For this paragraph and the next, see Kenneth Silverman, *A Cultural History of the American Revolution* (New York, 1976), pp. 84–85.

38. Ibid., p. 275.

39. August 1774; quoted in Arthur M. Schlesinger, *Prelude to Independence: The Newspaper War on Britain, 1764–1776* (1958; reprint ed. New York, 1965), p. 196.

40. *Virginia Gazette*, 23 December 1775.

41. Quoted in Silverman, *A Cultural History*, p. 264.

42. Other subjects were projected but never carried out: *The Battle of Eutaw Springs, The Treaty with France, The Signing of the Peace Treaty, The Evacuation of New York by the British, The President Received by the Ladies of Trenton*, and *The Inauguration of the President*.

43. See Jaffe, *John Trumbull: Patriot-Artist of the American Revolution* (New York, 1975), p. 109.

44. Ibid., p. 73.

45. Ibid., p. 88.

46. See Robert Rosenblum, *Transfiguration in Late Eighteenth Century Art* (Princeton, 1967), pp. 30–31.

47. There were, moreover, other versions of the death of General Mercer in pietàlike poses—for example, by William Dunlap, and by Charles Willson Peale in the background of a portrait of Washington.

48. *New England Chronicle*, 13 July 1775. Significantly, in *America* (plate 11), Blake has Warren alive and standing with Washington and Paine, "Foreheads reared toward the east." Cf. Silverman's thesis on Trumbull's series and the religious nature of the deaths (*A Cultural History*, pp. 466–467).

49. The voting of independence was on 2 July, the signing on 2 August—whereas the report of the committee for drafting the Declaration was on 28 June. For the allusion to Brenet, see Jaffe, *John Trumbull*, p. 110.

50. Perry Miller, *The New England Mind* (New York, 1939), 1:398.

51. Richard Price, *Observations on the Importance of the American Revolution*, in *Colonies to Nation: 1763–1789*, ed. Jack P. Greene (New York, 1967), pp. 424–425; see also Silverman, *A Cultural History*, pp. 504–515, for examples.

52. On the Niagara phenomenon, see Elizabeth McKinsey, *Niagara Falls: Icon of the American Sublime* (Cambridge, 1986), and my "Horror at the Honeymoon Hotel," *TLS*, 28 March 1986, pp. 325–326.

53. Letter to Jonathan Trumbull, Jr., 9 August 1789 (Yale).

54. Jaffe, *John Trumbull*, p. 144.

55. Letter to Jonathan Trumbull, Jr., 7 September 1789 (Yale).

Two. The New York School

1. Willem de Kooning, interview with David Sylvester on the BBC, in Thomas B. Hess, *Willem de Kooning* (New York, 1968), p. 147. Many of my subsequent quotations of de Kooning come from the same source. This section began as a response to George Steiner at the *Salmagundi* anniversary celebration, Saratoga Springs, in April 1980; it was published as "American Art" in *Salmagundi*, no. 10 (Fall 1980–Winter 1981), 119–130.

2. Danto, *State of the Art*, p. 60.

3. Porter, *Art in Its Own Terms*, p. 250. The following quotations of Porter are from pp. 56 and 60.

4. Leo Steinberg, *Other Criteria* (New York, 1972), p. 29; but, as Michael Fried reminds me, the *model* for Eakins's painting was Courbet's *Atelier*, not Gérôme's.

5. See Danto, *State of the Art*, p. 157.

6. This is the first of five or six quotations I have not been able to track back to their sources. The original reviews on which this chapter is based were published in journals that did not permit annotation.

7. Rosenberg, "Parable of American Painting," *The Tradition of the New* (New York, 1962), p. 16.

8. Porter, *Art in Its Own Terms*, p. 108.

9. Frank O'Hara, *Art Chronicles, 1954–1966* (New York, 1975), p. 34.

10. Hugh Kenner, *A Homemade World: The American Modernist Writers* (New York, 1975), p. 209. My earlier references to "homemade" are, of course, to Kenner's book.

11. William Faulkner, quoted in Kenner, *A Homemade World*, p. 210.

12. That Pollock thought of his paintings as related to landscape is clear from the titles he gave them—and some, like the remarkable *The Deep*, convey landscape experience.

13. De Kooning, quoted in Porter, *Art in Its Own Terms*, p. 107.

14. My point of reference for Still is the exhibition at the Metropolitan Museum of Art, New York, selected by Still himself, in 1979, but my comments apply as well to the selections he made for the Albright-Knox Gallery in Buffalo and the San Francisco Museum of Modern Art. For the Metropolitan show see John P. O'Neill, ed., *Clyfford Still* (New York, 1979); and my review, *BR*, no. 8 (April 1980), 73.

15. O'Neill, *Clyfford Still*, pp. 29, 47.

16. Pollock, quoted in *Jackson Pollock*, 4 vols., ed. Francis V. O'Connor and Eugene V. Thaw (New Haven, 1978), 4:275. This section is based on my review of

O'Connor's and Thaw's catalogue raisonné of Pollock, and on the exhibition "Abstract Expressionism, The Formative Years," at the Whitney Museum of American Art, New York, fall 1978 (with catalogue, cited in note 17); in *BR*, no. 6 (1979), 78–86.

17. See, for example, Robert Carleton Hobbs, "Early Abstract Expressionism: A Concern with the Unknown Within," *Abstract Expressionism: The Formative Years* (New York, 1978), pp. 14–18.

18. Ibid., p. 14.

19. See Robert Goldwater, *Primitivism in Modern Art* (1938; rev. ed. New York, 1967), pp. 178–224.

20. See Rosenberg, "Action Painting: Crisis and Distortion," *The Anxious Object* (New York, 1964), pp. 39–47, in which he refers constantly to "the crisis-dynamics of contemporary painting" and its "crisis-content" (for example, pp. 42, 44): a fiction that relates closely to the "revolutionary." "Action Painting never doubted the radicalism of its intentions or its substance. Certain ruptures were taken for granted. Foremost among these was the rupture between the artist and the middle class."

21. Cockcroft, Webber, and Cockcroft, *Toward a People's Art*, p. 25.

22. See Serge Guilbaut, *How New York Stole the Idea of Modern Art* (Chicago, 1983), and his bibliography on the use of this art in Cold War politics.

23. Barbara Rose, *Lee Krasner* (New York, 1983), p. 10. Rose is actually noting that Krasner did *not* see art history in this way. See also, e.g., Hobbs, *Abstract Expressionism*, p. 14; or Irving Sandler, *The New York School* (New York, 1978), p. ix.

24. Danto, *State of the Art*, pp. 196, 198.

25. See Fried, *Morris Louis* (New York, 1970).

26. Hilton Kramer, *New York Times Book Review*, 3 December 1978.

27. Hobbs, *Abstract Expressionism*, p. 8.

28. Joan Miró, quoted in James Johnson Sweeney, *Joan Miró* (1941; reprint ed. New York, 1969), p. 98.

29. John Graham, *John Graham's System and Dialectics of Art*, annotations and introduction by Marcia Epstein Allentuck (Baltimore, 1971), p. 95. See also Graham, "Primitive Art and Picasso," *Magazine of Art* 30 (April 1937), pp. 237–238.

30. Nicoles Calas, *Confound the Wise* (New York, 1942), p. 244.

31. Hobbs, *Abstract Expressionism*, p. 18.

32. Pollock, quoted in O'Connor and Thaw, *Jackson Pollock*, 4:263.

33. Pollock, quoted in Charles Stuckey, "Another Side of Jackson Pollock," *Art in America* 65 (November 1977), 80–91.

34. Fredric Jameson, "Imaginary and Symbolic in Lacan," in *Literature and Psychoanalysis*, ed. Shoshana Felman, *Yale French Studies*, nos. 55/56 (New Haven, 1977), p. 353.

35. Stuckey, "Another Side of Jackson Pollock," pp. 81–91; Fried, "Painter into Painting: On Courbet's *After Dinner at Ornans* and *Stonebreakers*," *Critical Inquiry* 8 (1982), 619–649.

36. Hobbs, *Abstract Expressionism*, pp. 21, 24; referring to Anton Ehrenzweig's *The Psychoanalysis of Artistic Vision and Hearing: An Introduction to a Theory of Unconscious Perception* (London, 1953).

Three. Abstract Figuration I: Woman and Landscape

1. This began as a review of the exhibition at the Solomon R. Guggenheim Museum, New York, and of Diane Waldman's accompanying catalogue, *Mark Rothko*,

1903–1970: A Retrospective (New York, 1978), in *BR*, no. 4 (1979), 73–84.

2. This was from the joint statement of Rothko, Adolph Gottlieb, and Newman, *New York Times*, 13 June 1943; quoted in Waldman, *Mark Rothko*, p. 39.

3. Peter Selz, *Mark Rothko* (New York, 1961), p. 60.

4. Waldman, *Mark Rothko*, p. 68.

5. Robert Hughes, in *The New York Review of Books*, 21 December 1978.

6. For the ubiquitous word "breakthrough" see Waldman, *Mark Rothko*, p. 48; and again Hobbs, *Abstract Expressionism*, p. 8.

7. Meyer Schapiro, "The Younger American Painters of Today," in *The Listener* 40 (26 January 1956), 146–147. Cf. Louis Finkelstein, "Gotham News," in *The Avant-Garde: Art News Annual* 34 (1968), 114–123.

8. On whiteness, see John Irwin, *American Hieroglyphics* (New Haven, 1980), pp. 205–225.

9. This section was originally written as a review of the 1980 Marsden Hartley exhibition at the Whitney Museum (*BR* no. 8, September 1980, pp. 63–68). It was revised and reprinted in *Hartley in Nova Scotia*, ed. Gerald Peterson (Halifax, 1987).

10. My citations in this section are from Barbara Haskell's *Marsden Hartley* (New York, 1980), the catalogue of the Whitney exhibition.

11. Porter, *Art in Its Own Terms*, p. 56.

12. My quotations are from William Howarth's edition of *The Maine Woods* in *Thoreau in the Mountains* (New York, 1982), pp. 140, 144, and 148.

13. Lawrence Alloway, "Art," *Nation* 212, no. 11 (March 1971), 349–350.

14. See Bryan Wolf, *Romantic Re-Vision* (Chicago, 1982), chapter 5. For the Abstract Expressionist Sublime see, for example, Alloway, "The American Sublime," *Topics in American Art since 1945* (New York, 1979), pp. 31–41.

15. These thoughts were the result of the Whitney retrospective of 1983 and the catalogue *Willem de Kooning*, by Paul Cummings, Jorn Merkert, and Claire Stoullig (New York, 1983).

16. Stuckey, "Bill de Kooning and Joe Christmas," *Art in America* 68 (March 1980), 77.

17. Rosenberg, interview, *Art News* 71 (September 1971), 51, reprinted in Rosenberg, *Willem de Kooning* (New York, 1978).

18. Stuckey, "Bill de Kooning," pp. 66–79.

19. Porter, *Art in Its Own Terms*, p. 37.

20. Motherwell and Ad Reinhardt, eds., "Artists' Session at Studio 35" (1950), *Modern Artists in America*, First Series (New York, 1951), p. 21.

21. D. H. Lawrence, "Introduction to These Paintings," *Phoenix: The Posthumous Papers of D. H. Lawrence* (New York, 1936), pp. 561–584.

22. De Kooning, quoted, in Hess, *Willem de Kooning*, p. 75.

23. Hess, ibid., p. 103.

24. De Kooning, quoted in ibid., p. 74.

25. Hess, ibid., p. 75.

26. I could not have written this section without the contributions of Susan de Sola Rodstein, whose insights into the workings of misogyny in popular graphic art, too numerous to list, opened up comic images of my adolescence that had remained closed. This and the section on comic strips (in chapter 4) were originally composed for a delegation to the USSR in June 1988, sponsored by the magazine *Krokodil*, to represent

American "humor." The format proved to be the press conference, and the material was never delivered; it *was* delivered in October 1988 at a conference on humor at the Johns Hopkins Medical School.

27. *La Révolution surréaliste*, no. 11, 1928; quoted in Mary Ann Caws, "Ladies Shot and Painted: Female Embodiment in Surrealist Art," in *The Female Body in Western Culture*, ed. Susan R. Suleiman (Cambridge, Mass., 1985), p. 262.

28. See Janet Bergstrom, "Sexuality at a Loss: The Films of F. W. Murnau," in ibid., p. 246.

Four. Abstract Figuration II: History Painting, Political Cartoon, and Comic Strip

1. See my *Literary Landscape* (New Haven, 1982), pp. 133–139.

2. Harry F. Gaugh, *The Vital Gesture: Franz Kline* (New York, 1985), p. 129.

3. Ibid., p. 32.

4. These remarks are quoted in Gaugh, *The Vital Gesture*, pp. 119, 106.

5. Kline, quoted in ibid., pp. 114, 107.

6. Ibid., pp. 71, 111. Or even: "Kline may have equated sharp diagonal movement with artistic personality" (ibid.).

7. Kline, quoted in ibid., p. 93.

8. Hughes, *Time*, 10 February 1986, p. 85.

9. Hess, "Mondrian and New York Painting," *Six Painters* (Houston, 1967), p. 12.

10. Gaugh, *The Vital Gesture*, p. 75.

11. Harry Rand, *Arshile Gorky: The Implication of Symbols* (Montclair, N.J., 1981). This section is based on my review in *BR*, no. 12 (Winter 1981–82), 81–86.

12. Hughes, *Time*, 11 May 1981, p. 81.

13. Peter Conrad, *TLS*, 19 June 1981, p. 695.

14. Rand, *Arshile Gorky*, p. 186.

15. Kierkegaard, *Dairy of a Seducer*, in *Either/Or*, trans. D. F. and L. M. Swenson (New York, 1959), p. 440.

16. I was writing in *BR*, no. 12 (Winter 1981–82), 86, reviewing the exhibition at the Whitney and the catalogue *Philip Guston* (San Francisco, 1980).

17. Actually the army vehicle was labeled "G.P.," for "General Purpose," and G.P. led naturally to Jeep. In this section too I am indebted to the perceptive eye and quick wit of Susan de Sola Rodstein (see chapter 3, note 26).

18. Gilbert Seldes, *The 7 Lively Arts* (1924; rev. ed. New York, 1957), p. 3.

19. Elmer Bischoff, quoted in Gerald Nordland, *Richard Diebenkorn* (New York, 1987), p. 34.

20. For the chronology and basic facts, see Patrick McDonnell, Karen O'Connell, and Georgia Riley de Havenon, *The Comic Art of George Herriman* (New York, 1986).

Five. Abstract Figuration III: The Closed Room

1. I refer to Gail Levin, *Edward Hopper as Illustrator* (New York, 1979), and the Whitney exhibition that accompanied it. This chapter is based on my reviews of *Edward Hopper as Illustrator*, followed by *Edward Hopper, The Complete Prints* (New York,

1979) and *Edward Hopper: The Art and the Artist* (New York, 1980), the retrospective of his paintings, all by Levin, all at the Whitney: *BR*, no. 7, (April 1980), 70–73, and no. 9 (December 1980), 63–75. I am indebted for the Hopper quotations that follow to Levin's Hopper catalogues, unless otherwise indicated.

2. Gaugh, *The Vital Gesture*, p. 33.

3. Cf. John Hollander's poem "Edward Hopper's Seven A.M. (1948)," *New Republic*, 1 February 1988, p. 37.

4. René Magritte, quoted in James Thrall Soby, *René Magritte* (New York, 1965), p. 8.

5. A. M. Hammacher, *René Magritte* (New York, 1974); cf. Patrick Waldberg, *René Magritte* (New York, 1965). This section was originally a review of these books in *The Georgia Review* 29 (1975), 720–724.

6. For the best psychoanalytic account, see Ellen Spitz, *Art and Psyche: A Study in Psychoanalysis and Aesthetics* (New Haven, 1985), pp. 76–95. Spitz draws on an unpublished manuscript by the practicing psychiatrist Martha Wolfenstein, which makes use of biographical facts, etc.

7. Sylvester, *Magritte* (London, 1969), p. 5.

8. This section was originally published as "The Enthralled Photographer: Alfred Stieglitz," in *The New Republic*, 7 March 1983, pp. 28–31, as a review of Sue Davidson Lowe, *Stieglitz: A Memoir/Biography* (New York, 1983). All quotations, unless otherwise noted, are from Lowe's biography.

9. See Sarah Greenough and Juan Hamilton, *Alfred Stieglitz: Photographs and Writings* (Washington, D.C., 1982).

10. Nordland, *Richard Diebenkorn* (New York, 1987).

11. John Elderfield, *The Drawings of Richard Diebenkorn* (New York, The Museum of Modern Art, 1988), p. 33.

12. Ibid., p. 34.

13. Nigel Gosling, "A New Realist," *The Observer*, 4 October 1964, p. 25.

14. Richard Diebenkorn, quoted in Nordland, *Diebenkorn*, p. 86.

15. Elderfield, *Drawings of Richard Diebenkorn*, p. 341.

16. Diebenkorn, quoted in ibid., p. 199. Elderfield sums it up nicely: "It is not his aim to record of the process of creation, but neither will he conceal the trial and error of this process" (p. 10).

17. Diebenkorn, quoted in Nordland, *Diebenkorn*, p. 20; the following quotation of Bischoff is ibid.

18. Diebenkorn, quoted in ibid., p. 169.

19. Diebenkorn in an interview with Gail Scott, quoted in ibid., p. 88.

20. John Canaday, "Richard Diebenkorn: Still Out of Step," *New York Times*, 26 May 1968, section 3, p. 37.

21. Diebenkorn, quoted in Nordland, *Diebenkorn*, p. 85.

22. Ibid., p. 114.

23. Elderfield, *Drawings of Richard Diebenkorn*, p. 22.

24. Diebenkorn, quoted in Nordland, *Diebenkorn*, p. 145.

25. Diebenkorn, quoted in Elderfield, *Drawings of Richard Diebenkorn*, p. 41.

26. For a perceptive statement of this formulation, see Elderfield, *Drawings of Richard Diebenkorn*, p. 17.

Six. France and England: Balthus and Francis Bacon

1. See James Lord, "Balthus: The Strange Case of the Count de Rola," *New Criterion* 2 (1983), 9–25.

2. See *Balthus*, the exhibition catalogue for the Paris exhibition (1983–1984), and Sabine Rewald, *Balthus*, the catalogue for the Metropolitan exhibition (1984). The books referred to are: Jean Leymarie, *Balthus* (New York, 1979), and Stanislas Klossowski de Rola, *Balthus* (New York, 1983). My original remarks on Balthus appeared in *BR*, no. 6 (December 1979), 78–83; and *Raritan* 3 (1984), 1–21. Cf. Alice N. Benston, "Framing and Being Framed by Art: Theatricality and Voyeurism in Balthus," *Style* 22 (Summer 1988), 341–360.

3. Antonin Artaud, *Le Théâtre et son double*, trans. Mary C. Richards (New York, 1958), pp. 31, 85.

4. Albert Camus's comment on the *Wuthering Heights* illustrations is relevant (reprinted in the Detroit *Balthus* catalogue, 1969). He believes that Balthus has understood that Emily Brontë is showing how the anguish and fury of adult love expresses itself in the remembrance of the childish love between Cathy and Heathcliff, and in the terrible nostalgia for that early love, which obsesses and destroys them. He sees Balthus's aim in both his paintings of adolescent girls and in his landscapes (especially those seen through windows) as nostalgia, the adult's struggle to return upstream to the source of innocence and joy—to recover something, whether lost innocence or the original garden. This and not eroticism, he argues, is the essential element of Balthus's vision.

5. I am not extending the context, as one could, to include the sources of Bataille's doctrine in the imagery of sunlight and gold, sexual spending and money, in a tradition that includes Kant, Nietszche, and Marx.

6. Reprinted in the Detroit catalogue, 1969: "Ce n'est pas le crime qui l'intéresse, mais la pureté. Des victimes trop sanglantes garderaient la trace des assassins. Tandis qu'elles sont là, offertes, dans la profonde innocence de ce qui n'est plus, enlevées enfin au tourment infernel des villes et du temps, encore intactes mais désormais inaccessibles, revenues dans ce paradis mélancolique et cruel où Balthus se promène à la façon des chats qu'il aime tant peindre." So, as Camus concludes, all Balthus's sleeping women seem to be victims even when the elements of direct sacrifice are elided. *La Victime* gives substance to the menace implicit in the paintings of young girls outstretched, often reminiscent of Henry Fuseli's *Nightmare*, on sofas or chaises longues.

7. Cf. Leymarie, who writes of the double portrait of Miró and his daughter: Looking at "this icon-like image so forcible in its exactitude, one realizes that its formal design is that of a romanesque Virgin and Child" (*Balthus*, p. 10).

8. See Stuckey's catalogue for the Lautrec exhibition at the Chicago Art Institute in 1979 (*Toulouse-Lautrec: Paintings* [Chicago, 1979]), and also, for example, Lawrence Gowing's lecture delivered in connection with the exhibition (and shortly after at Yale). These pages are based on my review of the Chicago exhibition in *BR*, no. 7 (April 1980), 60–73; my special thanks to Linda Peterson.

9. Fried, *Absorption and Theatricality: Painting and the Beholder in the Age of Diderot* (Berkeley and Los Angeles, 1980).

10. Gowing lecture. See note 8.

11. Francis Bacon, quoted in Sylvester, *Francis Bacon* (New York, 1975), pp. 18, 56, 59.

12. John Berger makes this observation in "Francis Bacon and Walt Disney," *About Looking* (New York, 1980), p. 113.

13. John Russell, *Francis Bacon* (London, 1971), p. 11.

14. Berger, "Bacon and Disney," p. 114.

15. Russell has shown convincingly how images of Benito Mussolini from news photographs (the faceless mouth) and of Franklin Roosevelt at Yalta with his long cape fastened high at the neck are evoked by *Painting 1946* in the Museum of Modern Art, New York. See *Bacon*, p. 57.

16. John Richardson, in *The New York Review of Books*, 17 July 1980.

17. The catalogue: *Francis Bacon, with Essays by Dawn Ades and Andrew Forge, a Note on Technique by Andrew Durham and a Selected Bibliography by Krzysztof Cieszkowski* (London, 1985). This chapter follows closely my article in *Raritan* 5 (1986), 1–25, but incorporates some material from an earlier piece in *BR*, no. 13 (June 1982), 72–74.

18. Bacon's contrast of nerves and illustration may be derived from Artaud's argument that the theater is a "concrete language, intended for the *senses* and independent of speech, [which] has first to *satisfy the senses*" (*Le Théâtre et son double*, p. 37; my italics).

19. Adrian Stokes, "Coldstream and the Sitter" (1962), *Critical Works of Adrian Stokes* (London, 1978), 3:188.

20. William Bailey, in a talk delivered during the symposium accompanying the opening of the exhibition "Eight Figurative Painters" at the Yale Center for British Art (Winter 1981–82; catalogue, *Eight Figurative Painters*, New Haven, 1981). These pages are based on my review in *BR*, no. 13 (June 1982), 72–80.

21. Ibid.

22. I refer to the exhibition at the Brooklyn Museum and its catalogue, *Victorian High Renaissance* (New York, 1979); my review is in *BR*, no. 10 (April 1981), 54–64. The pages on Ben Nicholson refer to the exhibition at the Brooklyn Museum at the same time, and to the catalogue, *Ben Nicholson: Fifty Years of His Art* (New York, 1978).

23. See Ernst Gombrich, *The Sense of Order: A Study in the Psychology of Decorative Art* (Ithaca, N.Y., 1979). Cf. also above, in my section on Toulouse-Lautrec, the discussion of his use of bedclothes.

24. Vern Swanson, *Alma-Tadema* (New York, 1977).

25. Anne Hollander, *Seeing Through Clothes* (New York, 1978).

26. Roberto Tassi, *Sutherland: The Wartime Drawings*, ed. and trans. Julian Andrews (New York, 1980).

27. This paragraph comes from my review "The Englishness of English Art," *The New Republic*, 25 April 1983, pp. 23–26.

28. Clark, *Feminine Beauty* (New York, 1980).

29. The catalogue is *Stanley Spencer, R.A.* (London, 1980). See also Duncan Robinson, *Stanley Spencer: Visions from a Berkshire Village* (Oxford, 1978). The following is based on my review of the Spencer exhibition, *BR*, no. 10 (April 1981), 54–64.

30. Whitechapel Art Gallery, London, 1980–1981; catalogue, *Max Beckmann: The Triptychs* (London, 1980); reviewed in *BR*, no. 10 (April 1981), 63–64.

Seven. Jasper Johns and the Second Generation of "American" Painting

1. This essay, written at the time of the Whitney exhibition of 1977, was published in a truncated form in *BR*, no. 1 (1978), 62–71. The catalogue *Jasper Johns* (New York, 1977) is by Michael Crichton.

2. Because of the coincidence of retrospectives that were held between 1977 and 1985, I happened to see all three of the major contemporary figures of this book—Balthus, Bacon, and Johns—from the possibly unfair perspective of an exhausted, repetitious, subsequent phase that seemed in various ways secondary to their previous work. I had, of course, seen their work before, and in the case of Bacon at the Tate retrospective of 1962.

3. By "second generation" I mean the generation of distinctively different painting following that of the great Abstract Expressionists—not the second generation of Abstract Expressionists (i.e., Michael Goldberg, Alfred Leslie, and others).

4. Sylvester, "Jasper Johns at the Whitechapel," unpublished BBC talk, 12 December 1964; quoted in Max Kozloff, *Jasper Johns* (New York, 1968), p. 14.

5. Steinberg, "Jasper Johns: The First Seven Years of His Art," *Other Criteria* (New York, 1972), pp. 17–54.

6. Steinberg makes a perceptive analogy: "The shade as a window with the shade drawn is a reversal of Alberti's picture space as an open window." The artist, I suppose, has now "drawn down" the shade on "nature," on the external world that has been understood by artists as "nature," on other kinds of experience *and* representation, and has turned inward. The marks of paint are his self-expression for viewers to decipher if they can.

7. Some light is also shed by the memory that Johns was emerging at just the time that Jorge Luis Borges was beginning to receive recognition, and John Barth, Thomas Pynchon, John Hawkes, Robert Coover, and other "postmodernist" novelists were beginning to write.

8. Johns, quoted in Crichton, *Johns*, p. 10.

9. Gaeton Picon, *Surrealists and Surrealism* (New York, 1977); Crichton, *Johns*, p. 28.

10. Harry Torczyner, *Magritte: Ideas and Images*, trans. Richard Miller (New York, 1977).

11. Steinberg, *Jasper Johns*, pp. 18–19.

12. Joseph Masheck, "Jasper Johns Returns," *Art in America* 64 (March–April 1976), 65–67.

13. Crichton connects these with Duchamp's idea to "use a Rembrandt as an ironing board" and suggests punningly an "ironic handprint" (*Johns*, p. 95).

14. The leg in *Watchman* is supposed to be Barbara Rose's; but whoever's, the part is androgynous, not recognizably female.

15. As Freud wrote, feces, penis, and baby are "ill-distinguished from one another" in the unconscious and "easily interchangeable" ("On Transformations of Instinct as Exemplified in Anal Erotism," in *Standard Edition*, 17:128). See, for example, Wayne Koestenbaum, *Double Talk: The Erotics of Male Literary Collaboration* (New York, 1989).

16. Jill Johnston, *Art in America*, October 1987; and again *New York Review*, 15 June 1989, p. 61.

17. Mark Rosenthal, *Jasper Johns: Works since 1974* (Philadelphia, accompanying the Philadelphia Museum of Art exhibition, 1988), p. 62.

18. My source on the history of AIDS is Randy Shilts, *And the Band Played On* (New York, 1987; 1988), p. 19. Another analysis of the reporting of the AIDS epidemic, James Kinsella's *Covering the Plague: AIDS and the American Media* (New Brunswick, N.J., 1990), unfortunately appeared too late to be consulted for this book.

19. Robert Chelsey, quoted in Shilts, *And the Band Played On*, pp. 108–109.

20. Ibid., p. 127.

21. Quoted in ibid., p. 19.

22. Johns, quoted in Peter Fuller, "Jasper Johns Interviewed: Part II," *Art Monthly* (London), no. 19 (September 1978), 7. If Johns's imagery of the 1950s and '60s was hermetic and coded, misogynist but not especially aggressive, the next step was the very aggressive positive images of photographers like George Dureau, Joel-Peter Witkin, and Robert Mapplethorpe, emphasizing the male sexual organ and the extreme "pleasures" of fisting and other practices in a way to which only pornography had shown the heterosexual equivalent. This was intended as a provocative, possibly "revolutionary" gesture.

23. Bacon, quoted in Sylvester, *Francis Bacon*, pp. 21–22.

24. See my *Representations of Revolution* (New Haven, 1983). For a useful discussion of modern seriality, see Fried, *3 American Painters* (New York, 1965).

25. Gosling, "A New Realist."

26. Quoted in Elderfield, *Diebenkorn*, p. 187.

27. Ibid., p. 19.

28. Edward Said, "On Repetition," *The World, the Text, and the Critic* (Cambridge, Mass., 1982), pp. 111–125.

29. John Coplans, *Serial Imagery* (Pasadena, Calif., 1968), p. 12.

30. Cf. Hess, *Barnett Newman—Stations of the Cross* (New York: Museum of Modern Art, 1971), p. 99; see also pp. 95–97, 100.

31. I regret that I do not treat the important women painters of the first generation—Lee Krasner, Helen Frankenthaler, Elaine de Kooning, Joan Mitchell, and Grace Hartigan. While some of my comments about the first generation apply to them as well, I have not had the opportunity to study their works adequately (see my remarks in the preface) and do not have the methodological tools to delineate the complexity of the precise relationships among them and the male painters in the heterosexual context of their generation. A book could/should be written on the subject, and on the women artists (Jennifer Bartlett, Cindy Sherman, Eva Hesse, etc.) of the next generation who dominated the art world of the 1970s.

32. These remarks are based on two exhibitions, "Art about Art" at the Whitney in 1979 and "Artists' Choice Museum, Inc.," the name taken by a series of galleries on 57th Street in New York, exhibiting (during the fall of 1979) various kinds of representational painting and sculpture of the 1960s and '70s.

33. This and the following quotations from artists are from Mark Strand, *Art of the Real: Nine American Figurative Painters* (New York, 1983).

INDEX

(Illustrations are indicated by italicized page numbers.)

21044282
2.3nd cops.
759.06
PAU